DUMMIES

6th Edition

Resolution

Controls the number of pixels in the image. The table shows the minimum pixel count you need for good prints. Prints without enough *pixels per inch* (ppi) appear blurry and jagged.

Print Size	Pixel Count	Megapixels
4 x 6	800 x 1200	1
5 x 7	1000 x 1400	1.5
8 x 10	1600 x 2000	3
11 x 14	2200 x 2800	6

^{*}Based on 200 ppi; 1 megapixel = 1 million pixels

Format

Refers to the way the picture data is stored in the image file. For best results, select Camera Raw or the highest-quality JPEG setting. A low-quality JPEG file looks blocky and may result in random color defects called *artifacts*.

High-quality JPEG

Low-quality JPEG

150

Controls the camera's sensitivity to light. Raising the ISO setting enables you to capture an image with less light. But using a very high ISO can cause a speckled defect called *noise*. (The ISO setting at which noise becomes apparent varies from camera to camera.)

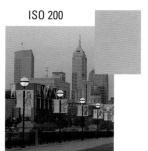

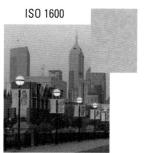

Digital Photography DUMMIES

6th Edition

Exposure Modes

Most cameras use symbols similar to these to indicate available exposure modes.

What It Looks Like	What It Does
AUTO	Automatic mode; camera selects exposure settings appropriate for most subjects
M	Manual exposure mode; user sets aperture (f-stop) and shutter speed
A or Av	Aperture-priority autoexposure; user controls aperture, camera sets shutter speed
S or Tv	Shutter-priority autoexposure; user controls shutter speed, camera sets aperture
	Portrait scene mode; automatically chooses settings most appropriate for portraits
**	Action scene mode; automatically chooses settings designed to capture moving subjects
	Landscape scene mode; chooses settings appropriate for landscape photography
*	Macro mode; chooses settings appropriate for close-up shots

File Format Guide

Rely on these popular file formats when creating and saving digital images.

Format	Description
Camera Raw	A format offered by some digital cameras. Stores raw, "uncooked" data from the image sensor, without applying normal adjustments to sharpness, color, and exposure. Gives photographers ultimate control over images and editing flexibility, but files must be converted to a standard format before sharing online, printing, or viewing in most photo programs.
JPEG	The most popular digital photography image format. JPEG compresses images to make files significantly smaller, but too much compression reduces image quality. Used for print, the Web, and e-mail.
TIFF	The leading format for files that will be used in print publications such as newsletters and magazines. Preserves all image data but usually results in larger file sizes than JPEG and can't be displayed by Web browsers and e-mail programs. The best format for storing converted RAW files and for edited JPEG files.

Wiley, the Wiley Publishing logo, For Dummies, the Dummies Man logo, the For Dummies Bestselling Book Series logo and all related trade dress are trademarks or registered trademarks or registered trademarks are property of their respective owners. Sopyright © 2009 Wiley Publishing, Inc. All rights reserved. Item 5074-7. For more information about Wiley Publishing, call 1-800-762-2974

Digital Photography

FOR

DUMMIES°

6TH EDITION

Digital Photography FOR DUMMIES® 6TH EDITION

by Julie Adair King and Serge Timacheff

Digital Photography For Dummies®, 6th Edition

Published by Wiley Publishing, Inc. 111 River Street Hoboken, NJ 07030-5774 www.wiley.com

Copyright © 2009 by Wiley Publishing, Inc., Indianapolis, Indiana

Published by Wiley Publishing, Inc., Indianapolis, Indiana

Published simultaneously in Canada

No part of this publication may be reproduced, stored in a retrieval system or transmitted in any form or by any means, electronic, mechanical, photocopying, recording, scanning or otherwise, except as permitted under Sections 107 or 108 of the 1976 United States Copyright Act, without either the prior written permission of the Publisher, or authorization through payment of the appropriate per-copy fee to the Copyright Clearance Center, 222 Rosewood Drive, Danvers, MA 01923, (978) 750-8400, fax (978) 646-8600. Requests to the Publisher for permission should be addressed to the Legal Department, Wiley Publishing, Inc., 10475 Crosspoint Blvd., Indianapolis, IN 46256, (317) 572-3447, fax (317) 572-4355, or online at http://www.wiley.com/go/permissions.

Trademarks: Wiley, the Wiley Publishing logo, For Dummies, the Dummies Man logo, A Reference for the Rest of Us!, The Dummies Way, Dummies Daily, The Fun and Easy Way, Dummies.com, Making Everything Easier, and related trade dress are trademarks or registered trademarks of John Wiley & Sons, Inc. and/or its affiliates in the United States and other countries, and may not be used without written permission. All other trademarks are the property of their respective owners. Wiley Publishing, Inc., is not associated with any product or vendor mentioned in this book.

LIMIT OF LIABILITY/DISCLAIMER OF WARRANTY: THE PUBLISHER AND THE AUTHOR MAKE NO REPRESENTATIONS OR WARRANTIES WITH RESPECT TO THE ACCURACY OR COMPLETENESS OF THE CONTENTS OF THIS WORK AND SPECIFICALLY DISCLAIM ALL WARRANTIES, INCLUDING WITH-OUT LIMITATION WARRANTIES OF FITNESS FOR A PARTICULAR PURPOSE. NO WARRANTY MAY BE CREATED OR EXTENDED BY SALES OR PROMOTIONAL MATERIALS. THE ADVICE AND STRATEGIES CONTAINED HEREIN MAY NOT BE SUITABLE FOR EVERY SITUATION. THIS WORK IS SOLD WITH THE UNDERSTANDING THAT THE PUBLISHER IS NOT ENGAGED IN RENDERING LEGAL, ACCOUNTING, OR OTHER PROFESSIONAL SERVICES. IF PROFESSIONAL ASSISTANCE IS REQUIRED, THE SERVICES OF A COMPETENT PROFESSIONAL PERSON SHOULD BE SOUGHT. NEITHER THE PUBLISHER NOR THE AUTHOR SHALL BE LIABLE FOR DAMAGES ARISING HEREFROM. THE FACT THAT AN ORGANIZA-TION OR WEBSITE IS REFERRED TO IN THIS WORK AS A CITATION AND/OR A POTENTIAL SOURCE OF FURTHER INFORMATION DOES NOT MEAN THAT THE AUTHOR OR THE PUBLISHER ENDORSES THE INFORMATION THE ORGANIZATION OR WEBSITE MAY PROVIDE OR RECOMMENDATIONS IT MAY MAKE, FURTHER, READERS SHOULD BE AWARE THAT INTERNET WEBSITES LISTED IN THIS WORK MAY HAVE CHANGED OR DISAPPEARED BETWEEN WHEN THIS WORK WAS WRITTEN AND WHEN IT IS READ.

For general information on our other products and services, please contact our Customer Care Department within the U.S. at 800-762-2974, outside the U.S. at 317-572-3993, or fax 317-572-4002.

For technical support, please visit www.wiley.com/techsupport.

Wiley also publishes its books in a variety of electronic formats. Some content that appears in print may not be available in electronic books.

Library of Congress Control Number: 2008936362

ISBN: 978-0-470-25074-7

Manufactured in the United States of America

10 9 8 7 6 5 4 3 2 1

About the Authors

Julie Adair King is the author of many books about digital photography and imaging, including the best-selling *Digital Photography For Dummies*. Her most recent titles include a series of *For Dummies* guides to the Canon EOS Digital Rebel XTi, XSi, and XS as well as the Nikon D40, D40x, and D60. When not writing, King teaches digital photography at such locations as the Palm Beach Photographic Centre. A graduate of Purdue University, she resides in Indianapolis, Indiana.

Serge Timacheff is the author of several books about digital photography, including *Canon EOS Photo Workshop*, *Digital Sports Photography*, and *Total Digital Photography*. A photojournalist and photographer whose images have been widely published, he specializes in field and "traveling" photography. Since 2003, he has been the official photographer for the International Fencing Federation, photographing numerous world championships, grand prix events, and the Summer Olympic Games. Timacheff is a graduate of the University of Houston. When not traveling, he resides in the Pacific Northwest.

Authors' Acknowledgments

Julie Adair King: I am extremely grateful to the team of talented professionals at John Wiley and Sons for all their efforts in putting together this book. Special thanks go to my awesome project editor, Kim Darosett, who is the type of editor that all authors hope for but rarely experience: supportive, skilled, and amazingly calm in the face of any storm, including my not infrequent freakouts.

I also owe much to the rest of the folks in both the editorial and art departments, especially Heidi Unger, Rashell Smith, Shelley Lea, Steve Hayes, Andy Cummings, and Mary Bednarek. Thanks, too, to agent extraordinaire, Margot Maley Hutchison, for her continuing help and encouragement and to technical editor Dave Hall for his eagle-eyed observations and thoughtful suggestions.

Serge Timacheff: Many thanks to David Hall for being a sounding board and on-call expert in a variety of digital photography issues, to Margot Hutchison for being a fabulous agent, and to Kim Darosett for being the ever-patient editor wrangling two authors at once.

Publisher's Acknowledgments

We're proud of this book; please send us your comments through our online registration form located at www.dummies.com/register/.

Some of the people who helped bring this book to market include the following:

Acquisitions, Editorial

Project Editor: Kim Darosett **Executive Editor:** Steven Hayes

Copy Editor: Brian Walls

Technical Editor: David Hall **Editorial Manager:** Leah Cameron

Editorial Assistant: Amanda Foxworth Sr. Editorial Assistant: Cherie Case

Cartoons: Rich Tennant (www.the5thwave.com)

Composition Services

Project Coordinator: Katherine Key

Layout and Graphics: Carrie A. Cesavice,
Reuben W. Davis, Christine Williams

Proofreaders: Laura Albert, Penny L. Stuart

Indexer: Palmer Publishing Services

Publishing and Editorial for Technology Dummies

Richard Swadley, Vice President and Executive Group Publisher

Andy Cummings, Vice President and Publisher

Mary Bednarek, Executive Acquisitions Director

Mary C. Corder, Editorial Director

Publishing for Consumer Dummies

Diane Graves Steele, Vice President and Publisher

Composition Services

Gerry Fahey, Vice President of Production Services

Debbie Stailey, Director of Composition Services

Contents at a Glance

Introduction	1
Part 1: Peering Through the Digital Viewfinder	
Chapter 1: Gearing Up: Does Your Equipment Fit Your Needs?	9
Chapter 2: Extra Goodies for Extra Fun	
Chapter 3: First Steps, First Shots	59
Part 11: Getting the Most from Your Camera	75
Chapter 4: Resolution, File Format, and Other Digital Details	
Chapter 5: Controlling Exposure	105
Chapter 6: Manipulating Focus and Color	137
Chapter 7: Getting the Shot: How the Pros Do It	
Part 111: From Camera to Computer and Beyond	
Chapter 8: Building Your Image Warehouse	187
Chapter 9: Fixing Minor Photo Flubs	207
Chapter 10: Printing Your Photos	233
Chapter 11: On-Screen, Mr. Sulu!	257
Part IV: The Part of Tens	
Chapter 12: Ten Ways to Improve Your Digital Images	279
Chapter 13: Ten Great Online Resources	287
Chapter 14: Top Ten Maintenance and Emergency Care Tips	291
Glossary	301
Online Resource Guide	311
Index	315

Cartoons at a Glance

by Rich Tennant

page 7

I think you've made a mistake. We do photo retouching, not family portrai....Ooh, wait a minute – I think I get it?"

page 75

page 185

"Do you think the 'Hidden Rhino' photo should come before or after the 'Waving Hello' photo?"

page 277

www.the5thwave.com

Table of Contents

Introduction	1
What's in This Book?	
Part I: Peering Through the Digital Viewfinder	2
Part II: Getting the Most from Your Camera	2
Part III: From Camera to Computer and Beyond	2
Part IV: The Part of Tens	3
Appendixes	3
Icons Used in This Book	
Conventions Used in This Book	
What Do I Read First?	4
Part 1: Peering Through the Digital Viewfinder	7
Chapter 1: Gearing Up: Does Your Equipment Fit Your Need	s?9
The Savvy Shopper's Camera Guide	10
Design options: Point-and-shoot or SLR?	10
Picture-quality features	12
Lens features	17
Photo-enthusiast features	19
Make-it-easy features	23
Speed features	26
Other fun (and practical) features	28
So is it time to upgrade?	
Equipping Your Digital Darkroom	31
Sources for More Shopping Guidance	
Chapter 2: Extra Goodies for Extra Fun	
Buying and Using Memory Cards	36
Memory shopping tips	37
Care and feeding of memory cards	38
Storing Your Picture Files	39
Adding more hard-drive space	40
CD storage	40
DVD storage	
On-the-Go Storage and Viewing	43
Protecting Your Camera	45
Seeking Software Solutions	
Image-editing software	
Specialty image software	51

	ang Your Camera	
Grabbi	ing a Few Handy Extras	55
Chapter 3:	First Steps, First Shots	59
Setting	g Up Your New Camera	59
	Adjusting the viewfinder to your eyesight	
	Exploring basic setup options	
Taking	Your First Pictures	64
	Setting the focus mode: Auto or manual?	
	Choosing an automatic exposure mode	
	Reviewing other critical capture settings	
P	Pressing the shutter button	73
Part 11: Gett	ing the Most from Your Camera	75
Chapter 4:	Resolution, File Format, and Other Digital Deta	ails
Turnin	ng Light into Pixels	77
	ing the World of Digital Color	
F	RGB: A new way of thinking about color	79
	Digging through color channels	
	More colorful terminology	
	ition Rules!	
	Pixels: Building blocks of digital photos	
	Pixels and print quality	
	Pixels and screen images	
	Pixels and file size	
	ng a File FormatPEG	
	Camera Raw	
	TFF	
Chapter 5:	Controlling Exposure	105
-	, Camera, Exposure!	
	Aperture, f-stops, and shutter speed	
	SO ratings and chip sensitivity	
	so how do I set f-stop, shutter speed, and ISO?	
	ing an Exposure Mode	
	Getting good autoexposure results	
	Jsing "priority" exposure modes	
	ing Even More Exposure Features	
	Exposure metering modes	
	Exposure histograms	
	Exposure compensation	
F	Exposure bracketing	126

Looking at Lighting	128
Using a built-in flash	129
Using an external flash	132
Switching on additional lights	
Lighting shiny objects	134
Chapter 6: Manipulating Focus and Color	137
Diagnosing Focus Problems	137
Understanding Focusing Systems	140
Working with fixed-focus cameras	
Taking advantage of autofocus	
Focusing manually	145
Showing Some Depth of Field	146
Controlling Color	151
Adjusting color with white balance	152
Using white balance for effect	157
Shooting Raw for absolute color control	
Exploring even more color options	161
Chapter 7: Getting the Shot: How the Pros Do It	163
Composing a Better Photo	163
Capturing Captivating Portraits	167
Shooting Better Action Shots	
Taking in the Scenery	
Getting Gorgeous Close-ups	176
Broadening Your Horizons: Shooting Panoramas	177
Exploring High-Dynamic-Range Imaging	
Coping with Special Situations	182
Part 111: From Camera to Computer and Beyond	185
Chapter 8: Building Your Image Warehouse	187
Downloading Your Images	100
A look at your downloading options	100 100
Tips for smoother downloading Downloading from a card reader	
Downloading from the camera	
Converting Raw Files	
Recovering Deleted Files (Maybe)	
Looking at Organizational Software	201
DOULING AL OLEGISLICATION DOLLINGS CHIMINGS	

Chapter 9: Fixing Minor Photo Flubs	207
What Software Do You Need?	
Opening Your Photos	
Saving Your Edited Photos	
Removing Red-Eye	
Cropping Your Pictures	
Fixing Exposure After the Fact	218
Basic brightness/contrast controls	218
Brightness adjustments at higher levels	
Using the Shadows/Highlights filter	223
Giving Your Colors More Oomph	
Helping Unbalanced Colors	
Sharpening Focus	229
Chapter 10: Printing Your Photos	233
Printing from a Lab	234
Buying a Photo Printer	
Inkjet printers	
Laser printers	
Dye-sub (thermal dye) printers	240
More printer-shopping tips	
Choosing Photo Paper	
Setting Print Size and Resolution	
Sending Your Image to the Printer	
Getting better results from your printer	
Comparing your monitor to your prints	
Seeing Things in Black and White	
Publishing Your Own Coffee Table Book	254
Chapter 11: On-Screen, Mr. Sulu!	257
Step into the Screening Room	257
Sizing Pictures for Screen Display	260
Understanding monitor resolution and picture size	
Creating a screen-sized copy of a high-resolution photo	
Sizing screen images in inches	
Nothing but Net: Photos on the Web	
Following basic Web rules	267
JPEG: The photographer's friend	
Viewing Photos on TV	
Digital Photo Frames	275

Part IV: The Part of Tens	277
Chapter 12: Ten Ways to Improve Your Digital Images	
Remember the Resolution!	
Don't Squish Your Images	28
Look for the Unexpected Angle	282
Turn Down the Noise	285
Press the Shutter Button Correctly	
Turn Off Digital Zoom	
Take Advantage of Your Photo Editor	283
Print on Good Paper with Good Ink	
Practice, Practice!	285
Read the Manual (Gasp!)	
Chapter 13: Ten Great Online Resources	287
Digital Photography Review	
The Imaging Resource	288
Megapixel.net	
PCPhoto Magazine	
Photography Review	
Shutterbug	289
PhotoJoJo	
Photo.net	
PhotoWorkshop	
Manufacturer Web Sites	
Chapter 14: Top Ten Maintenance and Emergency Care Tips	
Keep Spare Batteries On-Hand	
Format Your Memory Cards	292
Keep Your Memory Cards Clean	
Clean the Lens and LCD with Care	
Update Your Firmware	29
Protect Your Camera from Temperature Extremes	290
Keep Your Camera Away from Water	29
Clean the Image Sensor	
Back Up Your Images Regularly	29
Clean Out Your Computer's Hard Drive	300
Glossary	301
Online Resource Guide	311
Index	315

Introduction

t's official: Digital photography is no longer considered a fleeting fad or solely a game for techno-types. Today, everyone from preteens to great-grandmothers is recording their memories with digital cameras, abandoning their old film models to the attic, the basement, or worse.

This growing enthusiasm for digital photography is for good reason, too. The features and quality packed into today's digital cameras are nothing short of astounding. Tiny, fit-in-your pocket cameras are now capable of producing images that, in some cases, surpass those of professional models from five or six years ago — and at prices that were unheard of in years past. Digital SLR models, which accept interchangeable lenses, are now remarkably inexpensive, too, making the step up to semi-pro features much more accessible to enthusiastic shutterbugs.

For many people, though, figuring out how to use all the features offered by today's cameras, let alone how to download, organize, and share digital photos, is an intimidating proposition. First you have to deal with all the traditional photography lingo — *f-stop*, *shutter speed*, *depth of field* — and on top of that, you then have to decode a slew of digital buzzwords. Just what *is* a megapixel, anyway? If your professional photographer friend keeps talking about "shooting Raw," does that mean that you should do the same — whatever it is?

Digital Photography For Dummies answers all these questions and countless more. As did the first five editions of this book, this brand spankin' new, sixth edition takes you by the hand and helps you get up to speed with all the latest digital photography tools, tricks, and techniques. In easy-to-understand language, with a dash of humor thrown in to make things more enjoyable, this book spells out everything you need to know to make the most of your digital camera. Whether you're taking pictures for fun, for work, or a little bit of both, you'll find answers, ideas, and solutions in the pages to come.

What's in This Book?

Digital Photography For Dummies covers all aspects of digital photography. It helps you assess your current digital photography needs, determine the best gear and products to suit your style, and learn how to combine the newest digital innovations with tried-and-true photography techniques. In addition, this book explains what happens after you get the shot, detailing the steps you need to take to download and organize your picture files, produce great prints to hang on the living room wall, and share your favorite images online.

Here's just a little preview of what you can find in each part of the book.

Part 1: Peering Through the Digital Viewfinder

This part helps you stock your camera bag with the right equipment for the type of photography that interests you and then gets you started on your picture-taking adventures.

- Chapter 1 provides an overview of the latest and greatest camera features, explaining how they affect your pictures and your photography options.
- Chapter 2 introduces you to some cool (and useful) camera accessories, picture-storage products, and computer software that enables you to do everything from retouching your pictures to making them look like watercolor paintings.
- Chapter 3 gets you up and running, guiding you through camera setup and showing you how to take best advantage of the automatic picturetaking modes found on most cameras.

Part 11: Getting the Most from Your Camera

You're embarking on what will hopefully be a long and fruitful relationship with your new camera. To do so, you'll want to spend some time understanding how it works and thinks, and know when (and how) to step in to help it do its job better. That's what this part helps you accomplish.

- ✓ Chapter 4 explains the critical technical aspects of digital photography, but in plain language that even your Aunt Tillie could understand.
- Chapter 5 covers exposure, explaining fundamentals such as f-stops, shutter speeds, and ISO, and offering tips on using flash and other lighting options.
- Chapter 6 introduces focus techniques that can help you add drama to your pictures and also looks at options that enable you to control color.
- Chapter 7 wraps up this part with a summary of the best settings and techniques to use for specific types of pictures, from portraits to landscapes to action shots.

Part 111: From Camera to Computer and Beyond

After you fill up your camera with photos, you need to get them off the camera and out into the world. The chapters in this part show you how.

Chapter 8 explains the process of transferring pictures to your computer and also discusses ways to organize all those images.

- Chapter 9 provides step-by-step instructions for using your photo software to repair common picture problems, such as red-eye.
- Chapter 10 gives you a thorough review of your printing options, including information about different types of photo printers.
- Chapter 11 looks at ways to display and distribute images electronically placing them on Web pages and attaching them to e-mail messages, for example.

Part IV: The Part of Tens

Information in this part is presented in easily digestible, bite-sized nuggets.

- Chapter 12 offers ten easy ways to instantly improve your digital photos.
- Chapter 13 lists ten great Web sites where you can find equipment reviews, chat with other digital photographers, and more.
- Chapter 14 describes ten critical steps you should take to protect and maintain your gear and also offers advice about what to do if disaster strikes.

Appendixes

As you probably have already discovered, the digital photography world is very fond of jargon. Terms and acronyms you need to know are explained throughout the book, but if you need a quick reminder of what a certain word means, head for the glossary, where you can find quick translations from geek-speak to everyday language. Following the glossary, an Online Resource Guide provides a listing of all the Web sites mentioned throughout the book.

Icons Used in This Book

Like other books in the *For Dummies* series, this book uses icons to flag especially important information. Here's a quick guide to the icons used in *Digital Photography For Dummies*:

This icon represents information that you should commit to memory. Doing so can make your life easier and less stressful.

Text marked with this icon breaks technical gobbledygook down into plain English. In many cases, you really don't need to know this stuff, but boy, will you sound impressive if you repeat it at a party.

The Tip icon points you to shortcuts that help you avoid doing more work than necessary. This icon also highlights ideas for creating better pictures and working around common digital photography problems.

When you see this icon, pay attention — danger is on the horizon. Read the text next to a Warning icon to keep yourself out of trouble and to find out how to fix things if you leaped before you looked.

In sections of the book that discuss photo retouching, steps and figures feature Adobe Photoshop Elements 6.0, the leading program of its type. This icon marks information specific to that program. But if you're using other software (or another version of Elements), rest assured that you can easily adapt the steps and general advice to your program, so don't skip paragraphs marked with this icon.

Note that although most figures feature the Windows version of Elements, things work just the same in the Macintosh version unless specifically stated otherwise.

Conventions Used in This Book

In addition to icons, *Digital Photography For Dummies* follows a few other conventions. When you need to choose a command from a program menu, you see the menu name, an arrow, and then the command name. For example, if you need to choose the Print command from the File menu, you see this instruction: Choose File Print.

Sometimes, you can choose a command more quickly by pressing keys on your keyboard than by clicking through menus. These keyboard shortcuts are presented like so: Press Ctrl+A. This simply means press the Ctrl key and the A key at the same time, and then let up on both keys. When shortcuts differ depending on whether you're a Windows or Mac user, the PC shortcut appears first, followed by the Mac shortcut.

What Do 1 Read First?

The answer depends on you. You can start with Chapter 1 and read straight through to the index, if you like. Or you can flip to whatever section of the book interests you most and start there.

Digital Photography For Dummies is designed so that you can grasp the content in any chapter without having to read the chapters that came before it. So if you need information on a particular topic, you can get in and out as quickly as possible.

The one thing this book isn't designed to do, however, is insert its contents magically into your head. You can't just put the book on your desk or under your pillow and expect to acquire the information by osmosis — you have to put eyes to page and do some actual reading.

With our hectic lives, finding the time and energy to read is always easier said than done. But if you spend just a few minutes a day with this book, you can increase your digital photography skills tenfold. Heck, maybe even elevenfold or twelvefold. Suffice it to say that you'll soon be able to capture any subject, from a newborn baby to an urban landscape, like a pro — and have a lot of fun along the way.

Part I Peering Through the Digital Viewfinder

In this part . . .

he past few years have seen an explosion of new digital photography tools — new cameras, new software, tons of gadgets and accessories, and gaggles of features, all coming at you like a tidal wave of technology. And that can be pretty darned intimidating, even for professional photographers. What's a regular person to do? Read this part of the book, that's what.

Chapter 1 helps you determine what camera features you need for the type of photography you'd like to pursue, and Chapter 2 introduces you to some accessories that can make your photography easier, more fun, or both. As you no doubt already know, there's a considerable amount to ponder before you head to the checkout lane, but these two chapters should help you sort everything out.

When you're ready to start shooting, Chapter 3 guides you through setting up your camera and taking your first pictures. It also introduces you to automatic shooting modes that simplify getting great results when you take certain types of pictures — portraits, landscapes, and so on.

They say the best way to eat an elephant is one bite at a time (no, not *literally*, silly), and technology and digital photography are the same way. So take things step-by-step, chew your virtual food 20 times on each side, and you'll find yourself acting like a photo-techie in no time.

Gearing Up: Does Your Equipment Fit Your Needs?

In This Chapter

- Finding the ideal camera for your style of photography
- Picking enough megapixels
- Deciding what camera features you really need
- Choosing between point-and-shoot and SLR
- Equipping your digital darkroom
- Getting the best buys

erhaps you picked up this book because you're finally ready to part with your film camera and join the digital photography ranks. Or, if you're like a lot of people, you might be considering putting your first (or even second) digital camera into mothballs and finding a snazzier model. Either way, the news is all good: Today's digital cameras offer an amazing array of features and topnotch picture quality at prices far below what you would have paid even a year ago.

Now that there are so many high-quality cameras from which to choose, however, it can be tough figuring out which one is best-suited to your needs. To help you make sense of all your options, this chapter provides an overview of the current digital photography scene, discussing what's new and noteworthy and offering some advice on matching camera features to the types of pictures you like to take. In addition, this chapter provides some insights on outfitting the rest of your digital photography studio, describing the computer hardware you need to store, organize, and edit your digital photos.

Later chapters get into much more detail about many of the features introduced here. So if you have a burning question that's not answered by this overview, flip to the index to find where to look for more information.

The Savvy Shopper's Camera Guide

In a fervent battle for your camera-buying dollar, each manufacturer tries to outdo the other by adding some hot new option that promises to make your picture-taking life easier, more fun, or more rewarding. All the new bells and whistles might appeal to your impulse-buying tendencies, but whether you need them depends on how you want to use your camera.

So that you can better understand which options are essential and which ones you can do without, the next sections review the most common (and most critical) features offered by the current crop of digital cameras, along with a few specialty options that may be of interest depending on your photographic interests.

Design options: Point-and-shoot or SLR?

Before digging into specific camera features, it helps to review the two basic design types of digital cameras: compact, point-and-shoot models like the one in Figure 1-1 and digital SLR models like the one in Figure 1-2.

Digital SLR models are often called dSLRs. The acronym *SLR*, by the way, means *single-lens reflex* and refers to some internal mechanisms used by this type of camera. Delving deeper into that bit of business

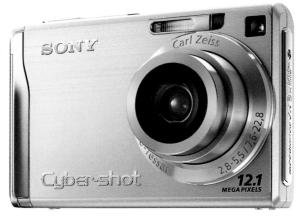

Sony Corporation of America

Figure 1-1: Many point-and-shoot digital cameras offer surprising power in a small package.

isn't critical; the important thing to know is that SLR cameras enable you to swap lenses. You can use a wide-angle lens for your travel photography, for example, and switch to a close-up lens for pictures of flowers and other small subjects. Point-and-shoot models do not offer this flexibility.

Both types of cameras have their pros and cons:

dSLRs: These models offer the greatest degree of creative control, not only because you can swap out lenses but also because you get advanced options for manipulating exposure, focus, and color not found in most point-and-shoot models. And dSLRs do tend to be a cut above in the quality arena because they tend to have larger image sensors, although many point-and-shoot models also produce excellent images. (See the upcoming sidebar "All pixels are not created equal" for an explanation of how the size of the image sensor affects picture quality.)

In addition, dSLRs offer the options that professionals and serious amateurs demand. They're made to work well with external flashes. and they're also able to connect to external lighting systems (such as studio flashes and modeling lights). Some dSLRs can shoot up to 10 frames per second for highspeed, no-lag photos of action and sports. and many are "rugge-

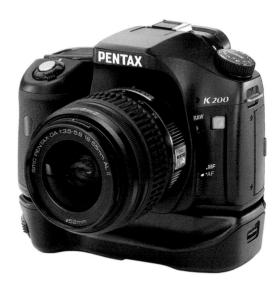

Pentax Imaging Company

Figure 1-2: A dSLR camera can accept a variety of lenses and offers other higher-end capabilities.

dized" for use in foul weather and other tough environmental conditions.

On the downside, dSLRs are expensive; expect to pay \$400 and up just for the body, plus additional dollars for lenses. If you already own lenses, you may be able to use them with a digital body, however, and lenses for one dSLR often work with other models from the same manufacturer. So if you buy an entry-level Nikon dSLR, for example, and really catch the fever to go semi-pro or pro, you can use the same lenses on a higher-end Nikon body.

You should also know that with some dSLRs, you cannot use the monitor as a viewfinder as you can with point-and-shoot digitals. This isn't a major concern for most dSLR photographers, who prefer framing shots using an old-fashioned viewfinder. But if you want to have the choice, the feature in question is called *Live View* (or something similar). It's implemented in different ways, so experiment to see which design you like best.

Finally, dSLRs can be intimidating to novice photographers. If you're new to SLR photography, your best bet is to check out entry-level models, which typically offer you the choice of shooting in automatic mode or manual mode and also offer other ease-of-use features you may not get with a semi-pro, high-end model. Then you can enjoy your camera right away but have the ability to move beyond auto mode when you're ready.

✓ Point-and-shoot: These models offer convenience and ease of use, providing autofocus, autoexposure, and auto just-about-everything else. And they're typically less expensive than dSLRs, although some high-end point-and-shoots aren't all that different in price from an entry-level dSLR.

You don't necessarily have to stick with automatic mode just because you go the point-and-shoot route, either. Many point-and-shoot cameras offer just about the same advanced photographic controls as a dSLR, except for the option to use different lenses. Using those advanced controls can be somewhat more complicated on a point-and-shoot, though; on a dSLR, you may be able to access a feature through an external button, but on a point-and-shoot, external controls may be more limited because of the smaller size of the camera body.

Speaking of size, the other obvious decision you need to make is just how much camera bulk you're willing to carry around. Although dSLRs are getting more compact every year, you're not likely to be able to tuck one in your shirt pocket, as you can with many point-and-shoot models. But you can always do what some pros do: Carry both! Keep a point-and-shoot handy for quick snapshots and pull out your dSLR when you have the time (and inclination) to get more serious.

Picture-quality features

Often overlooked amidst the more glitzy, whiz-bang options touted in camera magazine and television ads are the ones that really should come first in your selection process: the features that affect the quality of the pictures the camera can produce. After all, if a camera doesn't live up to your expectations for its main purpose — producing sharp, clear, colorful photographs — nothing else really matters.

The next three sections discuss three aspects of digital photography that are critical to picture quality: resolution, image noise levels, and file format options. In all three aspects, cameras have really improved over the past few years, so if your current model is a couple of years old, you can likely enjoy an upgrade in picture quality by buying a new model.

Be sure to also check out the later section, "Lens features," for tips on getting a good lens, which is also critical to picture quality whether you shoot film or digital.

Resolution: How many pixels are enough?

Resolution refers to a camera's pixel count. *Pixels* are the tiny points on your camera's image sensor that absorb light and turn it into a digital photo. Today, the pixel count of new cameras is so high that resolution is usually stated in *megapixels*, with 1 megapixel equal to 1 million pixels.

Chapter 4 explains resolution thoroughly, but for the purposes of this discussion, all you need to know is that the higher the pixel count, the larger you can print your pictures and expect quality results. As a general rule, you need a minimum of 200 pixels per inch, or *ppi*, to produce an acceptable print; 300 ppi can be even better, depending on the printer.

Just to help you avoid doing the math, the following list shows you how many megapixels you need to produce prints at standard sizes:

4 x 6 inches: 1 megapixel
5 x 7 inches: 1.5 megapixels
8 x 10 inches: 3 megapixels
11 x 14 inches: 6 megapixels

All new digital cameras sold today (except those on cell phones) offer at least 3 megapixels; in fact, 6 megapixels is now the common entry point. And many cameras offer 8 to 12 megapixels, with pro models going even higher.

Given that 6 megapixels translate to an 11 x 14-inch print — a size that most of us don't produce on a regular basis — should you pay more for a camera that offers a higher resolution? Again, it depends. Here are a couple of questions to guide you:

- Are you a serious photographer interested in making large prints on a regular basis? If so, a monster megapixel count makes sense. See the upcoming "All pixels are not created equal" sidebar, though, for some important news about interpreting pixel count.
- ✓ **Do you often crop your photos?** Lots of pixels are also important if you like to crop your photos. As an example, see Figure 1-3. The original image, on the left, has way too much extraneous background, distracting the eye from the subject; tight cropping resulted in the much better composition shown on the right. Had this photo been taken with a low-resolution camera, the cropped area wouldn't have contained enough pixels to generate a good print at anything but a very small size. But because the image originally contained about 10 megapixels, the cropped area retains the necessary pixels for a good print in fact, it could be printed even larger than space permits here.
- ✓ **Do you rarely print photos larger than snapshot size?** If so, a 6- to 8-megapixel camera is plenty, assuming that you don't fall into the regular-cropping category just described. Again, with 6 megapixels, you can output an 11 x 14-inch print if you *don't* crop your photos. So put your money toward a more expensive lens, a faster computer, or image storage hardware instead of more megapixels.

Figure 1-3: A high-resolution camera enables you to crop and enlarge your photos without picture quality loss.

✓ Do you rarely print photos at *any* size, preferring to share your pictures online? For onscreen display, pixel count has no effect on picture quality. Pixel count determines only the *size* at which your picture is displayed, for reasons you can explore fully in Chapter 4. For most screen uses, you need very few pixels to display the picture at an appropriate size. Refer to Figure 1-4, for example: The large image shown on this online album page measures only 480 x 320 pixels, and as you can see, it consumes a good chunk of the Web page.

Whether you want to share pictures via e-mail or use them on a blog or Web site, virtually every camera made in the last five years has enough pixels — actually, way *more* than enough. So if you're just shooting pictures for, say, your eBay storefront or the like, you may be able to get a bargain by looking for a discontinued or used camera.

If you plan on both printing your photos and sharing them online, concentrate on how many pixels are appropriate for print use, knowing that if you have enough for that purpose, your online needs are more than covered. (See Chapter 11 to find out how to trim the pixel count of your original images to make them suitable for online use.)

Figure 1-4: Low-resolution images are fine for online sharing; the large photo on this Web page has just 480 x 320 pixels.

All pixels are not created equal

Because digital camera advertisements make a big deal about megapixels, you may be tempted to rush out and simply buy the model that has the highest pixel count. Not so fast. You need to know that more pixels are not necessarily the key to better image quality. The size of the sensor on which the pixels live also matters.

Here's the scoop: Larger, high-end cameras tend to have bigger sensors than pocket-sized point-and-shoot models, for obvious reasons. And as it turns out, cramming more pixels onto a smaller sensor can actually have a detrimental effect on picture quality.

For reasons that aren't really important, if you put the same number of pixels onto a large sensor and a smaller sensor, the camera with the larger sensor typically produces better images. So even though two different cameras — say a subcompact model and a digital SLR — may both boast a 10-megapixel sensor, the dSLR probably has a bigger sensor and therefore provides more quality per pixel.

Of course, pixel count is only one factor contributing to picture quality; other factors, such as lens quality, are also critical.

150: How high can you go (without noise)

Through a common digital-camera control, you can adjust the light sensitivity of the image sensor, which is the part of the camera that absorbs light and converts it into a digital photograph. These light-sensitivity settings are stated in *ISO numbers*, such as ISO 100, ISO 200, and so on.

The higher the ISO number, the more sensitive the camera is to light. That means that you can capture an image in dim lighting without flash, use a faster shutter speed, or use a smaller aperture. (These last two controls are explained in Chapter 6.)

However, raising the ISO can also produce *noise*, a defect that gives your image a speckled look. Noise also can be caused by long exposure times, which are sometimes necessary in low-light conditions whether you raise the ISO or not. Finally, low-quality image sensors sometimes create a little bit of noise because of the heat and electrical processes that occur when the camera is used.

Today's cameras are much less noisy than in years past, but noise can still be a problem with high ISO settings and very long exposures. Only a few, high-end cameras can be set to ISOs above 800 without producing noise, for example. Some cameras start to exhibit noise at ISO 400.

Because noise levels vary from camera to camera, this is an important characteristic to study during your camera search. Camera reviews online and in photography magazines regularly include noise tests; see Chapter 13 for a few of our favorite online resources. See Chapter 5 for a more thorough discussion of ISO and noise.

File format options: Can you (should you) go Raw?

File format refers to the type of data file that's used to record the pictures you take. The standard format is JPEG (*jay-pegg*), but some higher-end cameras also offer a second format called Camera Raw, or just Raw for short.

Chapter 4 explains both formats completely, but the short story on Raw is that it offers two benefits that appeal to pro photographers and serious photo enthusiasts:

Raw files give the photographer more control over the look of a picture. With JPEG, the camera translates the data captured by the image sensor into a final image, making decisions on such picture characteristics as color saturation, brightness, sharpness, and so on. With Raw, none of this happens. Instead, the Raw file contains "uncooked" picture data, and the photographer then specifies how that data should be converted into a picture. This step is done on the computer, using a software tool known as a Raw converter. (Some cameras also offer a built-in tool for doing the conversion.)

✓ Raw files deliver the maximum image quality. During the file-creation process, JPEG files go through a process called *lossy compression*, which reduces file size by eliminating some picture data. And any time picture data is discarded, image quality can be reduced. Raw files, on the other hand, retain all the original picture data to avoid this problem.

All this is not to say that you should bypass cameras that offer only JPEG, however. First, as long as you stick with your camera's highest quality settings, JPEG compression isn't a big deal or even noticeable to most people unless the photo is greatly enlarged. And the compression means that JPEG files are smaller than Raw files, so you can fit more pictures on your camera memory card and on your computer's hard drive.

Perhaps most important, though, consider whether you really want to spend the computer time required to process Raw images — and understand that until you take that step, you can't do much of anything with your photos. You can't share them via e-mail, put them on a Web page, or take them to your local retailer for printing. JPEG files, on the other hand, are ready for use right out of the camera.

All other things being equal, though, a camera that offers both formats beats one that offers only JPEG. You may not be interested in Raw now, but as your skills grow, it may be more appealing to you. And if you're already doing the kind of photography that requires top-notch control and quality, such as for photo contests, galleries, weddings, or other important uses, shooting in Raw is something you'll want to consider.

Lens features

Also important to your long-term satisfaction with a camera are the type and quality of its lens and its related bits and pieces. When comparing cameras, consider these lens factors:

✓ **Optical quality:** Without getting into technical details, the quality of the image that a lens can capture depends on both its material and manufacture. To get an idea of the difference that optical quality can make, just imagine the view that you get when looking through sunglasses that have cheap, plastic lenses versus pristine, real-glass lenses.

Optical quality has improved significantly over the past several years, especially among point-and-shoot cameras. Many models now sport lenses that are made from professional-quality materials and offer powerful optical zoom capabilities. Of course, you're always going to get the best optics from the types of lenses used by digital SLR cameras — and thankfully, the prices of those models now make them an affordable choice for many people. (See the earlier section, "Design options: Point-and-shoot or SLR?" for more guidance on choosing between the two types of cameras.)

Unfortunately, it's tough to evaluate a camera's optical quality; it's not something you can judge just by playing around with a few models in the store. So again, your best bet is to study reviews in camera magazines and at online photography sites, where optics are tested according to rigorous technical standards.

✓ Focal length: The focal length of a lens, stated in millimeters, determines the angle of view that the camera can capture and the spatial relationship of objects in the frame. Focal length also affects depth of field, or the distance over which focus remains sharp.

You can loosely categorize lenses according to the following focal length groups:

- Wide-angle: Lenses with short focal lengths generally, anything under 35mm are known as wide-angle lenses. A wide-angle lens has the visual effect of pushing the subject away from you and making it appear smaller. As a result, you can fit more of the scene into the frame without moving back. Additionally, a wide-angle lens has a large depth of field so that the zone of sharp focus extends a greater distance. All these characteristics make wide-angle lenses ideal for landscape photography.
- *Telephoto*: Lenses with focal lengths longer than about 70mm are called *telephoto* lenses. These lenses seem to bring the subject closer to you, increase the subject's size in the frame, and produce a short depth of field, so that the subject is sharply focused, but distant objects are blurry. They're great for capturing wildlife and other subjects that don't permit up-close shooting.
- Normal: A focal length in the neighborhood of 35mm to 70mm is considered "normal" — that is, somewhere between a wide-angle and telephoto. This focal length produces the angle of view and depth of field that are appropriate for the kinds of snapshots that most people take.

Figure 1-5 offers an illustration of the difference that focal length makes, showing the same scene captured at 42mm and 138mm. Of course, the illustration shows you just two of countless possibilities, and the question of which focal length best captures a scene depends on your creative goals. So you may want to visit a camera store, where you usually can find brochures that illustrate the types of shots you can capture at specific focal lengths. Then just think about the subjects you usually shoot and match the lens focal length to your needs.

Also, check out Chapter 6 for a further explanation of how you can manipulate depth of field to achieve different creative results.

✓ **Zoom power:** With a zoom lens, you get a range of focal lengths in one unit. For example, a lens might zoom from 18mm to 55mm. Do note that with a lens that offers a really large focal range — say, 18 to 200 — you tend to see some quality drop-off at certain points in the range. (Here again, camera magazines routinely measure this type of thing.)

42mm

138mm

Figure 1-5: A short focal length captures a wide angle of view (left); a long focal length brings the subject closer (right).

When testing a point-and-shoot camera, make sure that the button or knob you use to manipulate the zoom is conveniently positioned and easy to use. On a digital SLR, you zoom by twisting the lens barrel, so this isn't an issue. However, you do want to watch out for so-called *lens creep:* Some SLR zooms have a tendency to slide from one focal length to another, without any input from you, when you tilt the camera.

✓ Optical versus digital zoom: For zoom lenses on point-and-shoot cameras, another important factor to note is whether the lens offers an optical or digital zoom. An optical zoom is a true zoom lens and produces the best picture quality. Digital zoom is a software feature that simply crops and enlarges your image, just as you might do in a photo-editing program. Because you're then left with fewer original image pixels, the result is typically a reduction in image quality.

You don't have to disregard cameras that have digital zoom; just don't think that it's a benefit to your photography. And if the camera offers both an optical and digital zoom, find out whether you can disable the digital part. Some cameras automatically shift into digital zoom mode when you reach the end of the optical zoom range and don't alert you to that change.

Photo-enthusiast features

Today's digital cameras offer fully automatic everything, so you really can just "point and shoot." But if you're a photography enthusiast or ready to move out of automatic mode, look for advanced features that enable you to take more control over exposure, color, and other picture characteristics. You can explore some of these features in the next few sections.

Advanced exposure options

In order to get creative with exposure, you need a camera that gives you some control over two critical settings: aperture (f-stop) and shutter speed. You can get a full briefing on how these two settings work in Chapter 5, but for now, just give points to cameras that offer the following options:

✓ **Aperture-priority autoexposure:** In this mode, you can specify the aperture, or f-stop, and the camera then selects the shutter speed needed to produce a good exposure. Having control over aperture is important because the setting you use affects *depth of field*, or the distance over which objects in the scene appear in sharp focus. So if you're shooting a portrait, for example, you can select an aperture that keeps the subject sharp while blurring the background.

This mode typically is represented on camera dials by the initials A or Av (aperture value).

- ✓ Shutter-priority autoexposure: In this mode, you select the shutter speed, and the camera selects the aperture setting needed to expose the picture properly. Because shutter speed determines whether moving objects appear blurry or "frozen" in place, gaining control over this exposure setting is especially important if you shoot lots of action pictures.
 - Shutter-priority autoexposure mode is usually labeled S or Tv (time value) on the camera's exposure dial.
- Exposure compensation: Sometimes known as EV (exposure value) compensation, this setting enables you to tell the camera that you want a slightly darker or lighter picture than the autoexposure system thinks is appropriate. Some cameras only let you apply this adjustment when you use shutter-priority or aperture-priority autoexposure; others make the control available even when you shoot in fully automatic exposure modes.
- Manual exposure: In this mode, you can specify both aperture and shutter speed to precisely control exposure. Doing so isn't as hard as you may think by the way, because most cameras still guide you by displaying a meter that lets you know whether your picture will be properly exposed.

These four controls are the most critical for photographers who want to manipulate exposure, but they're just the start of the multitude of exposure-related features found on today's high-end point-and-shoot and digital SLR cameras. You can read about additional features and get the complete story on exposure in Chapter 5.

Advanced white-balance controls

Digital cameras use a process called *white balancing* to ensure accurate colors in any light source. In most cases, automatic white balancing works

fine, but problems can occur when a scene is lit by multiple light sources — a classroom illuminated by a mix of window light and fluorescent light, for example. So having the ability to adjust color manually is helpful. Just a few feature names to look for:

- Manual white balance modes enable you to choose a white-balance setting designed for a specific light source, which can solve some color problems.
- White-balance bracketing records the shot three times, using a slightly different white-balance adjustment for each image.
- White-balance shift (or correction) makes minor tweaks to the color adjustment that the camera applies for different light sources.
- Custom white-balance presets enable you to create and store your own white-balance setting. So if you have special photography lights that you use for studio shooting, for example, you can fine-tune the white-balance adjustment to those exact lights.

Chapter 6 fully explores white balance and other color issues.

Digital vs. film focal lengths

When you shop for a digital camera lens, you need to know that focal lengths are stated in terms of the results you would get if you put that lens on a camera body that uses 35mm film (that's the size you've probably been using in your film camera for years). But very few digital cameras have a so-called *full-frame sensor*, which is the same size as that 35mm film negative. Most sensors are smaller, and because of that reduced size, the area that any given focal length can capture is reduced when you put the lens on a digital body. The resulting picture is similar to what you would get if you took a picture with a 35mm film camera and then cropped the picture slightly.

How much frame area you lose varies from camera to camera and is called the *crop factor*. Most dSLR image sensors have a crop factor ranging from 1.3 to 1.6. To figure out how a lens

you're considering will perform, you multiply the camera's crop factor by the lens focal length. For example, if the camera has a crop factor of 1.5, a 50mm lens gives you the same angle of view as 75mm lens on a 35mm film camera. Note that the other characteristics determined by focal length — the spatial relationship of objects in the frame and depth of field — are not affected by the crop factor. In those two regards, a lens performs identically regardless of the camera body.

If you opt for a point-and-shoot camera, you typically see a specification that gives both the actual focal length of the lens and the 35mm equivalent, as in "5mm lens, equivalent to 35mm lens on 35mm-format camera." In this case, you can just ignore the actual focal length and expect the lens to produce the results indicated by the 35mm-equivalency number.

Advanced flash features

The built-in flash found on most digital cameras offers a convenient source of light but typically produces harsh lighting and strong shadows. For better flash pictures, look for a camera that enables you to attach an external flash, such as the Nikon unit shown on the left in Figure 1-6. Usually, you attach the flash via a *hot shoe*, which looks something like what you see on the right in Figure 1-6. Some cameras also enable you to attach a flash via a cable.

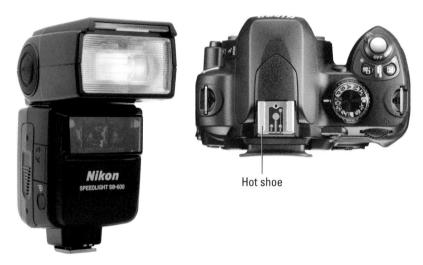

Figure 1-6: A hot shoe enables you to attach an external flash.

Nikon USA

An external flash gives you lots more flash flexibility. If the flash has a rotating head, you can angle the head so that the flash light bounces off the ceiling and then falls softly down on your subject, for example. With some external flashes, you can even position the flash on a stand, off the camera, and then trigger the flash with a remote switch.

Other important features for flash photography include the following:

- Manual flash control: For better flash photography, look for exposure modes that enable *you* to decide when the flash fires. On some point-and-shoot models, you can use flash only when the camera thinks additional light is needed. That can be problematic for outdoor photography because many pictures benefit from flash even in bright sunshine.
- ✓ Flash exposure compensation: This feature enables you to adjust the power of the flash.

Flash recycle time and power usage: If the flash on your current camera seems sluggish, you can probably enjoy a significant performance upgrade by investing in a new camera. Flashes on newer cameras also tend to have a faster recycle time — that is, they can recharge and be ready to shoot again more quickly — and use less battery power than in years past.

See Chapter 5 for more about flashes and lighting.

Viewfinder options

Some cameras lack a traditional viewfinder and instead force you to frame your shots using the LCD monitor. Manufacturers omit the viewfinder either to lower the cost of the camera or to allow a non-traditional camera design. But it can be difficult to go without a viewfinder because you have to hold the camera a few inches away to see the monitor. If your hands aren't that steady, taking a picture without moving the camera can be tricky. When looking through the viewfinder, however, you can brace the camera against your face. Additionally, monitors tend to wash out in bright light, making it hard to see what you're shooting.

Most, but not all cameras aimed at photo enthusiasts do sport a viewfinder, fortunately. If you decide that a viewfinder is critical, take a look at both traditional viewfinders — sometimes called *optical viewfinders* — and *electronic viewfinders*. Often referred to as an *EVF*, an electronic viewfinder is actually a tiny microdisplay, much like the monitor itself. The electronic viewfinder displays the same image that the camera lens sees, so you can shoot without worrying about *parallax errors*, a phenomenon that can occur with some optical viewfinders. (Chapter 3 has details.) However, some people don't like most electronic viewfinders because the display is less sharp than what you see through an optical viewfinder. Also, you usually can't see anything through the viewfinder until you turn the camera on, which means that you can't set up your shots without using up battery life.

Make-it-easy features

You say you're not interested in becoming the next Annie Liebowitz or Ansel Adams? Relax. You can take great pictures without having to know a thing about aperture, shutter speed, and all the other advanced stuff discussed in the preceding section.

New digital cameras offer a variety of features designed to make getting great shots easier than ever; just look for the options explored in the next several sections when you shop.

Automatic scene modes

Scene modes are settings that automatically set your camera to shoot a specific type of picture. Most cameras now offer a standard handful of basic scene modes, offering settings designed to shoot action shots, portraits,

close-ups, landscapes, and nighttime scenes. But some cameras add many more scene modes, offering settings designed to cope with any number of settings, subjects, and lighting conditions, from shooting underwater to capturing children playing in snow.

When evaluating cameras, pay attention not just to the number of scene modes, but also to how easily you can access them. Some cameras make you dig through layers of menus to access scene modes, and the more hassle that's required to get to a feature, the less likely you are to use it.

See Chapter 3 for more about scene modes.

Image stabilization

One common cause of blurry pictures is *camera shake*. That is, the camera moves during the period when the camera's shutter is open and light is hitting the image sensor. The longer the exposure time, the longer you have to hold the camera still to avoid this type of blur. Camera shake is also more of a problem if you shoot with a telephoto lens, especially if it's one of the long, heavy types you can buy for a digital SLR.

You can always avoid camera shake by mounting the camera on a tripod. But a feature called *image stabilization* can enable you to get sharper shots when you need to handhold the camera. The feature may go by different names depending on the manufacturer: *vibration reduction, anti-shake, vibration compensation,* and the like. Whatever the name, the feature is implemented in one of two ways:

- If you're a dSLR buyer, having the mechanism in the camera body means that you enjoy stabilization no matter what lens you attach. However, some experts argue that lens-based stabilization offers better results.
- Software-based stabilization: This type of stabilization, sometimes known as *electronic image stabilization*, or EIS, is applied by the camera's internal operating software rather than a hardware mechanism. It works differently depending on the camera. In some cases, the camera applies some complex correction filters to the image when motion is detected. Other cameras address camera shake by automatically increasing the ISO setting, which makes the camera more sensitive to light. At a higher ISO, you can use a faster shutter speed, which means that the length of time you need to hold the camera still is reduced. Unfortunately, a higher ISO often brings the unwanted side effect of image noise, as discussed earlier in the "Picture-quality features" section.

The payoff you get from image stabilization is another one of those features that is difficult to evaluate from merely playing with a camera for a few minutes in a store. In general, optical stabilization is better than software-based stabilization, but for specifics on how well the cameras you're considering perform in this arena, search out in-depth reviews.

Even the best possible stabilization system can't work miracles; you're still not able to handhold the camera for a very long time before camera shake ruins your picture. Without stabilization, most photographers can hold a camera steady down to a shutter speed of about 1/60 second if they're really good. With image stabilization, you may be able to reduce the shutter speed to 1/30 second — or even 1/15 if you're Cool-Hand Luke.

Chapter 6 talks more about ways to avoid blurry images.

In-camera Help systems

Many cameras now offer internal Help systems. If you can't remember what a particular button does, for example, you can press a button to see a screen that reminds you, as shown in Figure 1-7. This particular Help screen is from a Nikon camera, but other manufacturers offer similar displays. Built-in help is a great tool for times when you don't want to lug your manual around. Some cameras also offer hints to help you solve exposure problems and other image-capture issues.

? Image quality Choose file format used to record pictures.

Figure 1-7: Some cameras offer built-in Help systems.

Smile/face/blink detection

Camera companies are always looking for new snazzy features to impress you — and just maybe make your photos even better. One of the newest is *face recognition*. This feature automatically detects and focuses on a subject's face as long as you're at a typical portrait-taking distance. This feature is great for taking photos of kids who squirm a lot when getting their picture taken.

Taking face recognition one step further, a few companies have announced cameras capable of *smile* and *blink* detection! In this mode, the camera tracks a subject's face and then snaps the photo automatically when the person's eyes are open and smile is widest.

Of course, these features aren't foolproof; the camera sometimes misinterprets the scene and sets focus on the wrong subject. And if you're capturing a group of people, they're probably not all going to exhibit those wide smiles and bright eyes at the exact same moment. So the best way to ensure that you get a great portrait is to snap many different images of your subject. When you review your photos on the monitor, most cameras enable you to magnify the view so that you can double-check for open eyes and great smiles.

Speed features

Among both amateur and pro photographers, one of the most common complaints about digital cameras in years past was that they were slow: slow to come to life when you turned them on, slow to respond when you pressed the shutter button, and slow to finish recording one image so that you could capture another. This sluggish behavior made capturing action shots extremely difficult.

Well, camera manufacturers heard the complaints and responded with a variety of technical changes that greatly reduced the problem. So if you've been frustrated with this aspect of your current camera, a new model will likely ease the pain. Most cameras now can keep up with the most demanding rapid-fire shooter, although again, you should read reviews carefully because cameras vary in this regard.

Along with faster start-up and image-recording times, many new cameras also offer some, if not all, of the following features to make speed shooting even easier:

- Burst mode: In this mode, sometimes called *continuous capture*, you can record multiple photos with one press of the shutter button, reducing the time needed to record a series of pictures. Typically, you can capture several frames per second the exact number varies from camera to camera. In Figure 1-8, for example, a burst speed of three frames per second captured five stages of the golfer's swing.
- Modes, you can control the shutter speed, which is critical to determining whether a moving subject appears blurry. If you shoot a lot of action shots, this kind of shutter control is highly recommended. (See Chapter 5 for an explanation of shutter speed.)
- ✓ **Sports mode:** This mode enables even photography novices to capture action without having to learn all the ins and outs of shutter speed, ISO, and other exposure intricacies. Just dial in the Sports setting, and the camera automatically adjusts all the necessary controls to best capture a moving target.

Figure 1-8: Burst mode enables you to shoot a moving target. Here, a capture setting of three frames per second broke a golfer's swing into five stages.

- **Dynamic or continuous autofocus:** This autofocus mode, which may go by different names depending on the model, adjusts focus as needed right up to the time you take the shot to keep moving subjects in focus.
- Compatibility with high-speed memory cards: Camera memory cards the little removable cards that store your pictures are rated in terms of how fast they can read and write data. With a faster card, the camera needs less time to store the image data after you shoot the picture. Although older cameras often can't take advantage of the speed increases, many newer models are designed to work with even the fastest cards.

Other fun (and practical) features

Describing all the features found on the latest digital cameras is nigh on impossible; it seems that every day, some new camera option is announced. But the following list introduces you to some of the most common additional features that may be of interest to you. These options fall into the category of not necessary but nice to have — sort of like an extra cup holder in your car or a bonus track on a CD:

- In-camera editing tools: Many cameras offer built-in retouching filters that can fix minor picture flaws, such as red-eye or exposure problems. Some cameras that can capture pictures in the Camera Raw format even offer an in-camera converter that translates your Raw file into the standard JPEG format. (See the earlier section related to file formats for more about this issue.) These tools are especially helpful for times when you need to print or share a photo before you can get to your computer to fix the image in your photo software.
- Adjustable LCD monitors: Most newer cameras feature larger LCD screens than the somewhat smallish versions offered in first-generation models. In fact, some monitors are nearly as large as the back of the camera. But some cameras, such as the Canon model shown in Figure 1-9, take the monitor design a step further, featuring fold-out screens that can be rotated to a variety of angles. This adjustable type of monitor enables you to shoot at nearly any angle while still being able to see the monitor.
- ✓ Video capture: Some point-and-shoot cameras can record short digital movie clips. Although not intended as a replacement for a real camcorder, this feature can be a fun way to capture a little "live action" along with your still photos.
- Print and e-mail functions: Many cameras enable you to create an e-mail-sized copy of a high-resolution image. (See the earlier section related to resolution to find out why you don't want to simply send that high-res image through cyberspace.) And some cameras offer a feature called PictBridge, which enables you to connect your camera directly to your printer, so you can print your photos without ever downloading to your computer. (The printer also must offer PictBridge capabilities.) This feature is great for printing pictures at birthday parties, conventions, and the like.

Canon U.S.A. Inc.

Figure 1-9: Some monitors can be adjusted to different viewing angles.

- Video-out capabilities: If the camera has a video-out port, you can connect the camera to a television and view your pictures on the TV screen, as shown in Figure 1-10. This feature is a great way to share photos with the entire family or co-workers.
- Wireless image transfer: There's a lot in the air today. It seems like everything is wireless, from the WiFi connection at your local coffee shop to every-

Figure 1-10: To view pictures on a TV, you need a camera that has a video-out port.

one walking around looking like aliens with their Bluetooth cell phone earpieces. And, of course, digital photography is no exception. Some high-end dSLRs support optional wireless file transmitters that connect using networking technology so that photographers can instantly send images from the camera to a computer. This capability is useful, for example, for photojournalists who need to get images from important news or sports events posted immediately on the Web.

For consumers, some cameras can use a new type of wireless memory card, the Eye-Fi SD card, shown in Figure 1-11. This card gives you the ability to wirelessly transmit images to your home computer using a WiFi connection. Chapter 2 talks more about buying and using memory cards.

Sorgo Timachoff

So . . . is it time to upgrade?

Summing up all the details in the preceding sections, the answer to the question posed by the head-

Figure 1-11: The Eye-Fi SD card combines a 2GB memory card with a wireless file transmitter.

TEGE STOCK

line is, well, maybe. Assuming that your camera is a couple of years old, you should definitely look at a new model if any of the following statements apply:

Batteries: New life, new technology

In the early days of digital photography, it wasn't uncommon for a camera to run for a meager 20 minutes or so before battery power was depleted. Thankfully, you can expect significantly longer battery life now than in years past. Battery technology has advanced, and cameras have gotten better in terms of power management.

Some cameras run on standard AA or AAA batteries, while others use a proprietary rechargeable battery designed for use just with the camera. The nice thing about AA or AAA batteries is that you can find those batteries virtually anywhere in the world; the bad thing is that it gets costly to replace them all the time. You can save money by investing in rechargeables, but first make sure that your camera can work with them: some older models can't.

Proprietary batteries come with their own charger and typically have more endurance than

AAs or AAAs. Of course, if you run out of juice or you lose the battery, you're stuck until you recharge it or find a shop that sells a replacement. If you're heading to a remote location, it's a good idea to buy an extra battery so that you can carry a spare. Wilderness adventurers can even get solar chargers for AA and AAA as well as camera-specific batteries.

As for battery technology, common rechargeable battery types are Li-ion (lithium ion), NiCd (nickel cadmium), and NiMH (nickel metal hydride). NiMH is the best choice for AAs and AAAs; most proprietary batteries are Li-ion. All three types typically last longer than non-rechargeable, alkaline AA and AAA batteries. Remember that any rechargeable can lose power while it's sitting on the shelf, however, so be sure to charge up the night before you plan to shoot.

- ✓ You're not happy with the quality of your photos, especially when you print them larger than snapshot size.
- You have trouble capturing action shots because your camera is a slow performer.
- ✓ Your pictures appear noisy (speckly) when you shoot in dim lighting.
- You're a serious photographer (or want to be) and your camera doesn't offer any exposure controls, Raw image capture, a flash hot shoe, or other advanced features.
- You have trouble viewing your pictures on the camera monitor because it's too small and difficult to see in bright light.
- ✓ Your pictures are often ruined by camera shake (which causes blurry pictures), and you could benefit from image stabilization.

Of course, some cameras address these issues better than others, so again, be sure that you read reviews on any new model you consider. Also consult with the salespeople at your local camera store, who can point you toward cameras that best solve the picture-taking problems you're experiencing.

Equipping Your Digital Darkroom

In addition to deciding on whether your camera meets your needs, you also need to ponder whether your computer, monitor, printer, and photo software are suitable for the types of projects you like to do.

Chapter 10 provides a detailed discussion about printers, including advice on when you should print your own images and when you're better off having them printed at your local photo lab. Chapter 2 introduces you to some great photo software for editing your photos, and Chapter 8 looks at products for storing and organizing your image files.

That leaves the core component of your digital darkroom: the computer itself. Here's a quick overview of the characteristics of a system that will serve you well in the digital photography arena:

✓ **System components:** Just as the cost of digital cameras has dropped dramatically over the past few years, new computer systems, too, offer you a lot more power for your money than in the past. But at the same time, image-editing software has become more sophisticated and demanding of your system's resources. Plus, digital cameras are producing larger image files, which not only require more storage space but also require more system resources to process in your photo editor.

Long story short, having plenty of system memory (RAM), a large hard drive, a capable graphics card, and a relatively fast processor will make your digital photography work much easier and can even pay for itself in time saved during image processing.

- ✓ Operating system: The computer's operating system OS, in geek terminology also can make a difference. You can run many photography programs on older versions of Windows or the Mac OS, but the newer versions are optimized to work better with images. For example, Mac Leopard's "Quick Look" and Windows Vista's Explorer both provide much-improved ways to search for and review images than previous editions of either operating system.
- USB connectivity: New digital cameras, printers, memory-card readers, and other digital imaging devices connect to computers through a technology known as USB (Universal Serial Bus). If your computer is old enough that it doesn't yet support the latest version of this technology, USB 2.0, you may want to upgrade to that standard. (You can buy a USB 2.0 card and install it in your computer; your local computer expert can show you how.) This feature determines in part how fast you can transfer images from the camera to the computer or from a memory-card reader to the computer, and you can enjoy faster performance by moving from USB 1.0 to 2.0.
- Monitor: A monitor is another important component of your digital darkroom. It used to be that those big, bulky TV-like monitors (CRT, or cathode-ray tube, monitors, to be specific) produced the best-quality computer displays and that LCD monitors were considered amateurish and gimmicky. Not so today: LCD displays have overtaken the market as the standard, and the images they produce are nothing less than stunning. You can get ultra-high resolution monitors (that even support HDTV, for heaven's sake) at a remarkably affordable price that will make your photos look like they're alive in your studio.

One tip, however: Especially if you're doing color-critical imaging work, be sure to shop carefully to make sure that the LCD performs well for this type of use — some are better than others, as with any product. Also, if you still have a CRT monitor, and it's working well for you, there's no need to run out and replace it with an LCD. You may discover that it provides a better display than many new, low-priced LCDs, in fact. Of course, it doesn't look nearly as cool on your desk, but . . .

Mind you, this isn't to suggest that you must go out and buy a brand-new computer and all the trimmings. If you use a medium-resolution camera that doesn't produce huge picture files, and you stick with consumer-level photo software, such as Adobe Photoshop Elements, you may be just fine with a computer that's a few years old or a middle-of-the-line new system. If you do work with an older system, though, you may find it beneficial to treat yourself to some new hardware.

Sources for More Shopping Guidance

If you read this chapter, you should have a solid understanding of the features you do and don't want in your digital camera as well as in the other components of your digital darkroom. But you need to do some more indepth research so that you can find out the details on specific makes and models.

First, look in digital photography magazines as well as in traditional photography magazines (such as *Shutterbug*) for reviews on individual digital cameras and peripherals. Some of the reviews may be too high-tech for your taste or complete understanding, but if you first digest the information in this chapter as well as Chapter 4, you can get the gist of things.

If you have Internet access, you can also find good information on several Web sites dedicated to digital photography. See Chapter 13 for suggestions on a few Web sites worth visiting.

One final bit of buying advice: As you would with any major investment, find out about the camera's warranty and the return policy of the store where you plan to buy. Many retailers charge a *restocking fee*, which means that unless the camera is defective, you're charged a fee for the privilege of returning or exchanging the camera. Some sellers charge restocking fees of 10 to 20 percent of the camera's price.

Extra Goodies for Extra Fun

In This Chapter

- Buying and using camera memory cards
- Storing all your picture files
- Choosing photo software
- Protecting your camera investment
- Looking at tripods
- Exchanging your mouse for a better option

o you remember your first Barbie doll or — if you're a guy who refuses to admit playing with a girl's toy — your first G.I. Joe? In and of themselves, the dolls were entertaining enough, especially if the adult who ruled your household didn't get too upset when you shaved Barbie's head and took G.I. Joe for a spin in the garbage disposal. But Barbie and Joe were even more fun if you could talk someone into buying some of the accessories. With a few changes of clothing, a plastic con-

vertible or tank, and loyal doll friends like Midge and Ken, Dollworld was a much more interesting place.

Similarly, you can enhance your digital photography experience by adding a few hardware and software accessories. Digital camera accessories don't bring quite the same rush as a Barbie penthouse or a G.I. Joe surface-to-air missile, but they greatly expand your creative options and make some aspects of digital photography easier.

This chapter introduces you to some of the best digital photography accessories, from portable hard drives that let you store images on the road to new-fangled tripods that can grip almost anything. Be sure to also visit Chapters 8, 10, and 11, which cover some additional goodies related to downloading, printing, and sharing your photos.

All the prices quoted in this chapter and elsewhere are what you can expect to pay in retail or online stores. Because prices for many digital imaging products seem to drop daily, you may be able to get even more for your money by the time you're finished reading this book.

Buying and Using Memory Cards

Instead of recording images on film, digital cameras use removable *memory cards*. Some cameras ship with a starter card, but it's typically a small-capacity card that can hold very few pictures. So it's a safe prediction: You'll need to buy a memory card, or two, or more.

When you shop for memory cards, you encounter many different card types. But the decision about which type you need is pretty much made for you because most cameras, with the exception of a few high-end models, can use only one kind. So check your camera manual to find out which of the following card types it accepts:

- SD (Secure Digital): The most popular card type because of their small size, reliability, and high capacity, these cards are supported by a wide variety of digital cameras.
- ✓ SDHC (Secure Digital High Capacity): These cards look just like SD cards, but they use a new technology that allows greater storage capacity than SD cards.

Although you can use SD cards in most devices that support SDHC, the reverse isn't always true. Note, too, that if you want to download images to your computer using a memory-card reader, the reader also must be compatible with SDHC, not just SD. (Chapter 8 talks about image downloads.)

- MiniSD: About half the size of an SD card, MiniSD cards are often used in very small digital cameras. If your card reader doesn't support MiniSD directly, you can get a special MiniSD adapter that lets you use them in your SD card slot.
- CompactFlash: These cards, which are physically larger and square-shaped, are very popular in larger digital cameras. They support a wide variety of storage capacities ranging from small to very large; some CompactFlash cards can store more than 16GB (gigabytes) of picture data.
- xD-Picture Card: Designed by Fujifilm and Olympus, these cards are smaller than a postage stamp but hold a remarkable amount of photos.
- ✓ **Sony Memory Stick:** About the size of a stick of chewing gum, these cards are used in some Sony cameras and other Sony devices.

After finding out what card type you need, the next decision to make is what card capacity you need. The good news is that most types of removable camera memory are very affordable — unlike gasoline, memory cards have dropped dramatically in price over the past couple of years, so you can afford to carry around a lot of picture-storage capacity. Keep in mind that the more memory you can carry with you, the less often you need to stop shooting to download pictures to your computer.

How many pictures can a memory card hold? The size of a picture file depends on several factors, including what resolution and file format you use when you shoot the photo. (See Chapter 4 for an explanation of resolution and file formats.) Your camera manual should provide a table that lists the specific file sizes of pictures taken at each of the resolution and format settings the camera offers. But Table 2-1 gives you a general idea of approximately how many pictures can fit in various amounts of memory. The table assumes that the picture is taken using the JPEG file format with a minor amount of compression — a setting that translates to good picture quality. If you shoot in the Camera Raw format, your files are substantially larger. On the other hand, if you use a lower-quality JPEG setting, file sizes are much smaller.

Table 2-1	How Many Pictures Can a Memory Card Hold?				
Resolution	256MB	512MB	1GB	2GB	4GB
2 megapixels	296	592	1184	2368	4736
3 megapixels	216	432	864	1728	3456
4 megapixels	132	264	528	1056	2112
5 megapixels	100	200	400	800	1600
6 megapixels	84	168	336	672	1344
7 megapixels	76	152	304	608	1216
8 megapixels	64	128	256	512	1024

Approximate storage capacity based on high-quality JPEG images (minimum compression).

Memory shopping tips

Here are a few other pointers on buying camera memory:

- Remember, most cameras can use only one type of memory, so check your manual for specifics. You don't have to buy any particular brand, though; it's the card type that matters — CompactFlash, Memory Stick, and so on.
- Also, check your camera manual to find out the maximum capacity card it accepts. Some older cameras can't use the new, high capacity cards.
- Memory cards come in a variety of "speeds." No, this doesn't mean how fast you can stick them into the camera and shoot (sorry, Quick Draw). Rather, it refers to how fast your images can be recorded on them and moved from them to the computer. This speed is specified on the card with a number and an "x" sign: 66x, 90x, 133x, and so on, with a higher number indicating a faster card. Card speed is especially important for cameras that can shoot lots of photos in quick succession; faster cards mean that you can keep shooting without any pauses. Of course, speed equates to cost: The faster the card, the more expensive it is.

Before you buy, check to make sure that your camera is engineered to take advantage of the higher-speed cards (most point-and-shoot models are not). Also, understand that you probably won't notice a difference unless you're shooting at high resolutions — say, 5 megapixels or more. Finally, note that when it comes to how fast you can download images, the speed of the card isn't the only factor; the capabilities of the card reader and your computer come into play as well.

As with other commodities, you pay less per megabyte when you buy "in bulk." A 2GB card costs less per megabyte than a 512MB card, for example.

Care and feeding of memory cards

To protect your memory cards — as well as the images they hold — pay attention to the following care and maintenance tips:

Be careful *not* to format a card that already contains pictures, however. Formatting erases all the data on a card.

- Never remove the card while the camera is still recording or accessing the data on the card. (Most cameras display a little light or indicator to let you know when the card is in use.)
- Don't shut off the camera while it's accessing the card (although most cameras will prevent themselves from turning off if this is occurring).
- Avoid touching the contact areas of the card. On an SD card, for example, the little gold strips are the no-touch zone, as shown in Figure 2-1. On a CompactFlash card, make sure that the little holes on the edge of the card aren't obstructed with dirt or anything else. (Most cards ship with a little flyer that alerts you to the sensitive spots on a card.)
- Some types of cards, such as Secure Digital cards, have a locking feature. By sliding a little switch on the card, you can prevent access to the card, which means that no files can be erased or added. Figure 2-1 gives you a look at the lock.

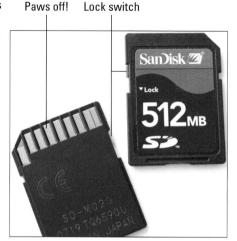

Figure 2-1: SD cards have a lock switch that prevents access to the card data.

- If your card gets dirty, wipe it clean with a soft, dry cloth. Dirt and grime can affect the performance of memory cards.
- Try not to expose memory cards to excessive heat or cold, humidity, static electricity, and strong electrical noise. You don't need to be overly paranoid, but use some common sense. Some "extreme" cards are available, made primarily for working in very high/low temperatures.
- Ignore rumors about airport security scanners destroying data on memory cards. Although scanners can damage film, they do no harm to digital media, whether in checked or carry-on bags.
- To keep your cards safe while not in use, store them in their original plastic sleeves or boxes. Or, for a handy way to store and carry multiple cards, invest in a memory card wallet. The Tenba version shown in Figure 2-2 has compartments for batteries as well as memory cards (www.tenba.com).

TENRA Gea

Storing Your Picture Files

A hot topic in the world of professional photography is *digital asset management*, which is simply a fancy term referring to the storing and cataloging of digital picture files. (If you want to be über-hip, you can refer to

Figure 2-2: A memory-card wallet provides safe storage for spare cards.

it as DAM — and, yes, it's pronounced just like the four-letter word you used to get in trouble for saying as a kid.) Professional digital photographers accumulate huge collections of images and are always striving for better ways to save and inventory their assets.

Your image collection may not be as large as that of a professional photographer's, but at some point, you, too, need to think about where to keep all those photos you take. You may be at that point now if you shoot high-resolution pictures and your computer's hard drive — the thing that stores all your data files — is already cramped for space.

The next several sections discuss the three most common strategies for expanding your digital closet space.

Adding more hard-drive space

If the existing hard drive on your computer is bursting at the seams, you can add a second (or third or fourth) drive for relatively little money. And you don't even have to crack open the computer's case to install an internal drive; plenty of companies make external drives that attach via a USB (Universal Serial Bus) connection or, in some cases, via a second type of connection called FireWire.

Nor do you have to give up much desk space to add storage; many drives are no larger than the size of a wallet For example, Figure 2-3 shows the My Passport drive from Western Digital (www.westerndigital. com), which holds 250GB of data and retails for about \$130. The great thing about this type of drive is that it's designed to be portable, so you can pack it in your camera bag when you travel as well as use it at home. (This unit does draw its power from the computer's USB connection, so you need to carry your laptop or have access to another computer at your destination, however).

Western Digital Corporation

Figure 2-3: External drives such as the Western Digital My Passport can hold a lot of data in a unit about the size of your wallet.

Although adding a second hard drive may temporarily solve your picture storage concerns, you should not rely on this option for long-term, archival storage. Hard drives are mechanical devices, and as such, they can fail on occasion. And if your hard drive goes bad, all your picture files are likely to be lost. Keeping your pictures on a hard drive for quick and convenient access is fine, but always make backup copies on archival media. This same warning applies, by the way, to Zip drives, portable thumb drives, and flash memory keys.

At present, the two best options for archival storage are CDs and DVDs, discussed next.

CD storage

For the safest long-term storage of your image files, regularly back up the images stored on your computer's hard drive (or other storage device) to a CD-ROM. If your computer is new, you likely have a built-in CD *burner* (that's the techy way to say CD recorder). If not, you can add an external model to your system for under \$100.

CD-R or CD-RW?

Two types of recordable CDs exist: CD-R and CD-RW. The *R* stands for *recordable*; *RW* stands for *rewriteable*. Most CD burners can do either dance.

With CD-R, you can record data until the disc is full. But you can't delete files to make room for new ones — after you fill the disc once, you're done. On the plus side, your images can never be accidentally erased. With CD-RW, your CD works just like most other storage mediums. You can get rid of files you no longer want and store new files in their place. However, you shouldn't rely on CD-RWs for archiving purposes. For one thing, you can accidentally overwrite or erase an important image file. For another, data on CD-RWs starts to degrade

after about 30 years, while archival-quality CD-Rs can last as long as 100 years.

One other important factor distinguishes CD-R from CD-RW: compatibility with existing CD-ROM drives. If you're creating CDs to share images with other people, you should know that those people need *multiread* CD drives to access files on a CD-RW. This type of CD drive is being implemented in new computer systems, but most older systems do not have multiread drives. Older computers can usually read CD-Rs without problems, however. (Depending on the recording software you use, you may need to format and record the disc using special options that ensure compatibility with older CD drives.)

You do need to follow a couple of precautions to get the longest life span from your CDs:

Buy disks labeled CD-R, not CD-RW. The first type can't be erased, whereas data on CD-RW discs can be overwritten. In addition, some manufacturers say that their archival-grade CD-Rs have life expectancies of as much as 100 years, while CD-RWs are said to survive about 30 years. Those claims are the subject of some pretty hot debate right now — and if you ask around, you're sure to hear horror stories of CDs going bad. Whether the problem stems from the CD itself or mishandling by the user is the question. See the "CD-R or CD-RW?" sidebar for more information about types of CDs.

- Look for blank CDs that have a gold coating and are advertised as archival quality. You pay more for the quality; archival discs cost about \$1.50 each, versus \$1 or less for the non-archival versions. But the idea is to make sure your pictures last, right?
- Don't use a permanent marker to write labels directly on the discs. The ink can damage the disc and the data stored on it.
- ✓ Just to be extra safe, burn two copies of CDs that contain your most precious photographic memories. That way, if one disc gets scratched or lost, you have a backup to your backup.

Burning your own CDs is much easier than in years past, thanks to software that walks you through the process. Still, if you're not comfortable with the job, you may prefer to let the professionals do your CD burning. Most retail photo labs and even superstore photo departments (such as Costco and Wal-mart) can burn CDs from camera memory cards.

A bigger drawback to the CD solution — and one not so easily overcome — is that CDs can hold only about 650MB of data. If you're shooting with a high-resolution camera, you can fill up a CD in no time. So for non-critical images, you may want to back up your files to DVD instead, as explained next.

For the ultimate in archiving safety, always print your best pictures, too. That way, if something does go wrong with the digital file, you can scan the print and create a new digital copy. You can make prints easily and cheaply at any retail lab if you don't care to do it yourself. See Chapter 10 for help with printing.

DVD storage

Close cousins to the CD burner, DVD burners enable you to record your photos onto a DVD (digital video disc). What's the difference between CDs and DVDs? Capacity, for one. A standard single-layer DVD stores 4.7GB of data, while a CD holds about 650MB.

That's the good news about DVDs. But this technology has some complications, too:

- Blank DVDs currently aren't available with the archival gold coating that's offered on some CDs. So the longevity of DVDs may not equal that of those archival CDs.
- Although most computers now have a DVD drive, not all systems have a DVD burner. If the DVD drive on your computer just says DVD-ROM, it can read a DVD disc that has data or a movie on it. If it says DVD-R/RW, it can actually *record* onto a DVD disc.
- If you do have a DVD burner, check its manual to find out what flavor of blank DVDs to buy. Several DVD formats exist: DVD+R, DVD-R, single layer, dual-layer, and so on.
- Although many DVD drives can use all the various types of DVDs, not all can. That means that accessing your DVD files on computers other than the one you used to burn the disc isn't always possible.
- As with CD archiving, don't use the DVDs that have the RW distinction; data on those discs can be overwritten or erased.

On-the-Go Storage and Viewing

Even if you carry several large-capacity memory cards, you can fill them up quickly if you're using a high-resolution camera or shooting Raw files. Simply buying more cards as you go may sound logical, but whenever possible, you really should download as soon as you fill a card. Memory cards have been known to fail and are easy to lose. And your camera could be lost or stolen, with all your photos in it. You might get a new camera, but you won't have those photographs any more.

For times when you don't want to travel with a computer, you can pack smaller, more portable storage options in your camera bag. Here are just a few of the alternatives:

Portable hard drives:

Several companies make portable storage units that can function independently on the road and then serve as an external drive and card reader when connected to your computer at home. Figure 2-4 shows one option, the Digital Foci Photo Safe II (www. digitalfoci.com). An 80GB model will set you back about \$140.

Drive and viewer combos: Some portable drives have screens on which you can review your pictures. This feature is especially great for photographers who work with clients in the field; you can show your work this way rather than pass your camera around after every shot. Figure 2-5 shows one

Digital Foci, Inc.

Figure 2-4: Digital Foci's Photo Safe II lets you securely store thousands of images on the road without a computer.

such product, the Epson P-5000, which offers 80GB of storage space and can be had for about \$600. (Digital Foci also offers some drive/viewer products.)

Seiko Epson Corp.

Figure 2-5: This portable storage unit from Epson has a large screen for viewing your pictures.

Portable media players (PMPs): Among the most cool and useful accessories for digital photography and travel in general, these snazzy gadgets come from several different companies in a variety of designs and with various features, but they almost always include the ability to store and play all kinds of digital media along with a bunch of other functions. One product in this category is the Creative Zen Vision W (www.creative.com), shown in Figure 2-6. This particular unit not only provides the features listed earlier, but also has a radio, a voice memo recorder, and Microsoft Outlook contact and organizer display capabilities. A 60GB version of the product sells for about \$400.

As you might expect, prices for all these devices vary greatly, depending on the storage capacity, the size of the screen, and other features. But keep in mind that when you get home from your travels, you usually can attach these on-the-go devices to a computer via a USB cable and use them as another desktop or laptop storage drive.

Do be sure that whatever device you buy either offers a card slot for the type of memory card your camera uses (or that you can buy an adapter to make your card fit the slot) or can be connected directly to your computer via USB cable for image transfer. Also, note that some viewers can't display images captured in the Camera Raw format, so if you prefer that format, read the fine print. Chapter 4 explains Camera Raw.

Creative Technology LTD.

Figure 2-6: PMPs store images as well as MP3s and videos for a great travel tool and photo backup.

Protecting Your Camera

Perhaps the most important camera accessory you can buy is a camera bag, case, or other product that will keep your investment dry, cushioned, and easy to transport. Thousands of inventive gadgets and devices are available that not only protect your gear but also let you impress your family, friends, neighbors, and anyone else willing to pay attention.

Here's just a sampling of what you can find in your local camera store (or favorite online store):

Camera bags and cases today come in virtually all sizes, shapes, and even colors (although a reliable camera-store source says that black is still by far the most popular color for a camera bag — go figure). Figure 2-7, for example, shows just a small assortment of styles from one manufacturer, LowePro (www.lowepro.com).

If you choose a backpack-style bag, a design like the Flipside pack shown in Figure 2-7 is a good idea: While you're wearing the pack, it can't be opened from the back, so you don't have to worry about someone reaching inside and snatching your camera while you're not paying attention.

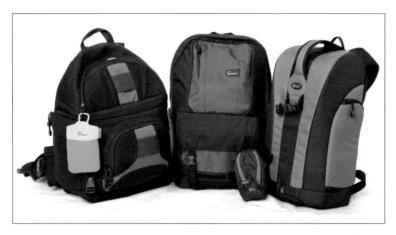

Amy A. Timacheff

Figure 2-7: Five transport options from LowePro, shown left to right: Tasca (pink), Slingshot, Fastpack, Apex (lower), and Flipside.

- ✓ For fashion-conscious photographers, a few manufacturers offer products that look more like stylish handbags than camera cases. Check out one of the offerings from Jill-e (www.jill-e.com), shown in Figure 2-8, for example.
- If you need to transport camera equipment and can't actually carry it with you, you can choose from a number of very solid, watertight cases that cushion your gear in customizable foam and seal it from any potential outside hazard. Pelican Products (www.pelican.com) produces an extensive line; many professional photographers rely on this type of product when flying to ship expensive gear as checked baggage.

Jill-E Designs, LLC

Figure 2-8: Cases like this one from Jill-e combine camera security and style.

- For point-and-shoot cameras, an interesting protective and universal case called a Wrap-Up from Made Products (www. made-products.com) is available. You keep the case permanently attached to your camera by means of the tripod mount. When you want to shoot, you just unwrap the case (you can still use a tripod with the case attached). When you're done. vou wrap it back up. Because the case never leaves the camera, it's one less thing to misplace or leave behind by accident. Figure 2-9 offers a look.

Made Products, Inc.

Figure 2-9: Basic protection, such as this Wrap-Up, may be all you need to keep your point-and-shoot camera safe.

For photography in rugged conditions, several companies sell products that protect and fit

your camera like a glove, literally. GGI International (www.ggiinternational. com) makes a wide variety of silicone *skins* that fully encase your camera, keeping out moisture and dirt, while still letting you operate it. Made Products (www.made-products.com) offers a line called Camera Armor that provides similar protection for dSLR owners, while Kata (www. kata-bags.com) includes weather covers for shooting outdoors.

Seeking Software Solutions

Flashy and sleek, digital cameras are the natural stars of the digital-imaging world. But without the software that lets you get to your images, your digital camera would be nothing more than an overpriced paperweight. Because you probably already own plenty of other had-to-have-it, never-use-it devices that serve as paperweights, the following sections introduce you to a few software products that help you get the most from your digital camera.

Image-editing software

Image-editing software lets you change your digital photos just about any way you see fit. You can

- ✓ Correct problems with brightness, contrast, color balance, and the like.
- Crop out excess background and get rid of unwanted image elements.
- Apply special effects, combine pictures into a collage, and explore countless other artistic notions.

Today's computer stores, mail-order catalogs, and online shopping sites are stocked with an enormous array of photo-editing products. The next sections present some of the most popular options.

Be sure to also find out what software, if any, came with your camera. Many camera manufacturers provide a selection of photo-editing tools on the software CD that ships in the camera box. Also note that many software companies post free, downloadable trial copies of their products on their Web sites.

Programs for beginners and casual photo editors

Several companies offer programs geared to the photo-editing novice or the digital photographer who only wants to perform simple photo surgery and creative artwork. Just a few choices in this category include

- ACDSee Photo Editor (\$50, www.acdsystems.com)
- ArcSoft PhotoImpression (\$50, www.arcsoft.com)
- Adobe Photoshop Elements (\$99, www.adobe.com)
- Corel PhotoImpact X3 (\$70, www.corel.com)

These programs provide all the basic image-correction tools that most casual photographers need, plus plenty of *wizards* (step-by-step on-screen guides), which walk you through different tasks. Figure 2-10, for example, shows the wizard feature of ACDSee Photo Editor.

Additionally, project templates simplify adding your photo to a greeting card, calendar, or photo collage, and you also get tools for creating slide shows, burning images to CDs, and more. And the nice thing about all the programs just listed is that although they provide easy, one-click corrections, they also offer some of the same higher-level tools that professionals use. So if you decide you're ready to tackle some more advanced projects, you can do so without buying a new program.

However, not all programs aimed at the consumer market offer a wide range of tools, so read product reviews. Make sure the program enables you to do the things you have in mind. (See Chapter 13 for some Web sites where you can find this kind of information.) And keep in mind that if all you want to do is simple repairs, such as removing red-eye and cropping your photo, you may be able to get the job done just using the software shipped with your camera or some other free solution, such as Google's Picasa (www.picasa.com). Another possibility is a new Adobe service, Adobe Photoshop Express (www.photoshop.com), which offers tools that enable you to upload and edit your photos online and then post the results in Web albums.

Figure 2-10: Consumer photo-editing programs, such as ACDSee Photo Editor, make simple retouching projects easy.

Programs for advanced users and pros

If you edit pictures on a daily basis or want a little more control over your images, you may want to move up the software ladder a notch. Advanced photo-editing programs provide you with more flexible, more powerful and, often, more convenient photo-editing tools than entry-level offerings.

The downside to advanced programs is that they can be intimidating to new users and require a high learning curve. You usually don't get much onscreen assistance or any of the templates and wizards provided in beginner-level programs.

Figure 2-11, for example, offers a look at Adobe Photoshop CS3 (www.adobe. com), the industry-standard professional photo editor. As you can see, the program interface isn't exactly what you'd call intuitive. Expect to spend plenty of time with the program manual or a third-party book to become proficient at using the software tools.

Serge Timacheff

Figure 2-11: Adobe Photoshop is a top choice for serious imaging enthusiasts, but it has a steep price and steeper learning curve.

Of course, Photoshop is several hundred dollars more than the less-advanced applications, too, selling for about \$650. Fortunately, several good but less-expensive alternatives exist for users who don't need Photoshop's ultra-high power. Explore these options:

- ACDSee Pro (\$130, www.acdsystems.com)
- ✓ Adobe Lightroom (\$299, www.adobe.com)
- ✓ Apple Aperture, (\$199, www.apple.com), shown in Figure 2-12
- ✓ Paint Shop Pro Photo X2 (\$80, www.corel.com)

Figure 2-12: Apple Aperture is a popular choice for people who need to quickly sort and retouch lots of photos.

Specialty image software

In addition to programs designed for photo editing, you can find great programs geared to special needs and interests, including the following:

- Image-cataloging programs: These programs are designed to help you organize your pictures. For some recommendations, see Chapter 8, which goes into detail about downloading, organizing, and archiving your images.
- ✓ **Slide show programs:** These programs make it easy to produce multimedia presentations featuring your photos. Most image-editing applications offer some kind of slide show capabilities, but a few programs are dedicated to slide shows. Photodex Corporation (www.photodex.com), for example, provides a range of products.
- ✓ Plug-ins: A plug-in is a sort of mini-program that adds functions to a larger photo-editing program. For example, Figure 2-13 offers a look at nik Color Efex Pro (www.nikmultimedia.com). This plug-in package lets you create effects similar to those produced by traditional camera filters, as well as cool special effects. It works with many popular photo editors, including Photoshop and Photoshop Elements.

Figure 2-13: Special effects plug-ins, such as Color Efex Pro from nik multimedia, add more creative options to your photo-editing software.

Frequently, plug-ins are made for specific applications; for example, Essentials for Adobe Photoshop Elements (www.ononesoftware.com) complements and enhances Elements' capabilities to let you correct color, add frames, remove backgrounds, and enlarge lower-resolution images for printing in larger formats.

- ✓ **Digital painting programs:** With digital paint, you can create original artwork or use your photos to create images that have the look of traditional art media. Many image-editing applications offer special effects filters that let you do this to a degree, but a number of programs are designed from the get-go for painting. The most famous option and as advanced as Photoshop in its own way is Corel Painter. Figure 2-14 shows only a fraction of the artistic tools available in this program.
- Scrapbooking software: Scrapbooking is a very popular category with a number of great applications. What you used to do with glue, scraps of paper, buttons, and ribbons, you can now do with special programs. Here are just two of the many scrapbooking programs available:
 - Art Explosion Scrapbook Factory Deluxe (\$40, www.nova development.com)
 - Creating Keepsakes Scrapbook Designer Deluxe by Encore, Inc. (\$40, www.broderbund.com)

Serge Timachet

Figure 2-14: Corel Painter is unsurpassed as the most advanced application used to apply artistic effects to digital photographs.

Steadying Your Camera

For nighttime shots and other photos that require long exposure times, keeping your camera steady is essential. Otherwise, you run the risk of a blurry image because of camera shake. Here's a look at some of the devices you can use any time you want to be sure that your camera remains absolutely still:

✓ Traditional tripods: You can spend a little or a lot on a tripod, with models available for anywhere from \$20 to several hundred dollars. At the higher end of the price range, you get a sturdier product, designed to safely hold heavier cameras, such as dSLR models. You also get convenience features, such as a quick-release plate for easily attaching and

removing the camera from the tripod head. Typically, you buy the tripod base separately from the head, which gives you a little more flexibility in buying the components you like best.

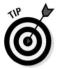

Take your camera when you shop to see how well the tripod works with it. Set the tripod at its maximum height, push down on the top camera platform, and try turning the tripod head as though it were a doorknob. If the tripod twists easily, or the legs begin to collapse, look for a different model.

✓ Small solutions: A great option for times when you don't want to carry around a full-size tripod is a product like the Joby Gorillapod (www.joby. com). Made of stiff but flexible gripping legs, it can stand as a short tripod or wrap around something and hold on — such as a tree, as shown in Figure 2-15. The Gorillapod comes in a variety of sizes, shapes, and colors for all types of cameras.

Joby, Inc.

comes in a variety of sizes, Figure 2-15: The Joby Gorillapod lets you mount a shapes, and colors for all camera nearly anywhere.

Another small solution with a similar name, The Pod (www.thepod.ca) is a beanbaglike platform that you can use to steady the camera on uneven surfaces and at various angles, as shown in Figure 2-16.

Monopods: Another way to be portable but stable is to use a *monopod*, a collapsible stick that lets you hold your camera steady but doesn't stand on its own. You frequently see sports photographers at football games traipsing around the

THE pod INDUSTRIES

Figure 2-16: The Pod offers another tiny but practical means of stabilizing the camera.

sidelines with a big camera, big lens, and a monopod. If you get tired of holding your camera, whatever its size, these are useful and easy to tote around.

✓ Hybrids: Some innovative tripod/monopod hybrids exist; they look like monopods, but you can pop out three mini-legs to let them stand on their own.

A hybrid isn't as stable as a full tripod, so don't stand too far from your camera with a strong wind blowing.

Grabbing a Few Handy Extras

To round out your shopping spree, here are a few more accessories that just don't seem to fit neatly anywhere else:

Lensbaby: If you're shooting a dSLR (meaning you use interchangeable lenses), you might enjoy trying a really different kind of lens such as the Lensbaby (actually, there are several Lensbaby models). It attaches to your camera like any other lens, but that's where the similarity stops. It looks more like a part to a vacuum cleaner with a corrugated hose and a mounting plate on one end, and a small lens element on the other, as shown on the left in Figure 2-17. You focus it and vary your image effects by pulling, pushing, and literally twisting and turning the lens body. You can get effects where only a part of the image is clear and the rest is blurred in a way that's nothing like a typical shallow depth-of-field shot, as shown on the right. Lensbabies sell for between \$150 and \$270, depending on various options (www.lensbabies.com).

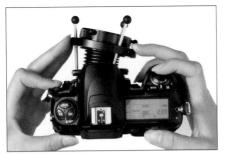

Απ

Figure 2-17: You can produce interesting effects with a Lensbaby on your dSLR camera.

f

- Tripod easy-orientation brackets: Many inexpensive tripods and monopods lack the type of rotating head that makes it easy to change the camera from a horizontal orientation to a vertical one. One solution is the ALZO Camera Flipper (www.alzodigital.com), which is a small bracket that fits between the tripod head and your camera. You still mount the camera to the tripod in the horizontal orientation, but you can open the bracket to shift the camera to a vertical position at any time.
- Graphics tablet: A tablet enables you to edit photos using a stylus (like a pen without ink) instead of a mouse. If you do a good deal of intricate touch-up work on your pictures or you enjoy digital painting or drawing, you'll wonder what you ever did without a tablet. Wacom, the industry leader in the tablet arena, offers a basic tablet called the Bamboo Fun, shown in Figure 2-18. The Bamboo Fun comes with both a stylus and a cordless mouse so you can switch back and forth easily between the two devices. Prices vary depending on the tablet size; the smallest model sells for about \$100. For details, visit www.wacom.com.

Wacom Technology

Figure 2-18: Intricate photo-editing tasks become easier when you set aside the mouse in favor of a drawing tablet and stylus like this Wacom Bamboo Fun.

Camera strap replacement:

Here's a very simple but really useful and innovative alternative to the conventional camera strap. The R-Strap series of products from Black Rapid (www.blackrapid.com) is designed primarily for dSLR cameras (although they could be used, in theory, for most point-and-shoot models as well). The R-Strap attaches to the screw mount where you attach the camera to a tripod. The strap lets you hang the camera by your side — instead of dangling from your neck — and with it, you can immediately swing your camera to shooting position.

✓ LCD shade/magnifier: Ever tried to look at your camera's LCD to check your photo, but couldn't see it because of the bright sunlight? One practical solution is the Hoodman HoodLoupe (www.hoodmanusa.com). The HoodLoupe is basically a small magnifying glass in a black case that

hangs around your neck. When you take a photo and want to view it, you put the rectangular end up against your LCD screen and look through the viewfinder on the HoodLoupe, as shown in Figure 2-19. It enables you to see your images in even the harshest sunlight, it doesn't require mounting anything on your camera, and it works with any LCD screen.

Jacques Viljoen

Figure 2-19: The HoodLoupe makes viewing your pictures in bright light easier.

First Steps, First Shots

In This Chapter

- Setting up your camera
- Setting focus and exposure automatically
- Getting better results by using the automatic scene modes
- Reviewing critical picture-taking settings

igital camera manufacturers work hard to create a good "out of box" experience — that is, to make your first encounter with your camera fun, easy, and rewarding. To that end, cameras leave the factory in automatic picture-taking mode, using default settings that are likely to produce a good picture the first time you press the shutter button.

Before you snap that first shot, however, scan the information in this chapter, which offers advice on setting up your new camera. This chapter also introduces you to some common autoexposure modes, including *scene modes* designed to best capture certain types of pictures, such as portraits and landscapes.

Setting Up Your New Camera

Every camera is different, so providing specifics on setting up your particular model is impossible. But the following list contains a few general steps that you should take to ensure that your "out of box" experience runs smoothly and that the camera is ready to perform its picture-taking magic for you:

Most cameras come with a quick-start guide to walk you through basic setup procedures. Included somewhere in that guide or in the first few pages of your manual, you should find a list of all the

- components that are supposed to come with the camera. It's a good idea to unpack and examine everything, as shown in Figure 3-1, to make sure that nothing was omitted from the box.
- Look for a card or document that enables you to register your purchase with the manufacturer. You also may be able to register online. Either way, do take the time to register the camera; the camera company needs your name and contact information in order to notify you of any updates to the camera firmware (internal software).

Serge Timacheff

Figure 3-1: Open your new camera carefully and inspect all the components.

- If your camera comes with rechargeable batteries, charge them fully before you do anything else. The batteries might have a little juice in them without charging, but it's really not a good idea to start up the camera that way — doing so can cause the batteries to have a permanently limited charge.
- Whatever type of batteries your camera uses, be sure to load them correctly with the positive (+) and minus (-) sides correctly positioned. Loading them incorrectly can damage your camera.
- Another good thing to do right away is to attach your camera strap and get into the habit of using it when you shoot. The last thing you want to do is drop your new camera while trying to figure out its functions!
- Some cameras ship with a memory card (that's the thing that stores your pictures). The type of card varies from camera to camera, but most are small enough to get lost as you rip into the camera box, so use caution. If your camera doesn't come with a card, check the manual to find out what type to buy. (Chapter 2 offers some advice on this purchase.)
- Be careful when putting the memory card in the camera. Look at your quick-start guide to see which direction to orient the card, and use gentle pressure when inserting it.

With batteries installed, card inserted, and strap attached, the camera should now be ready to go. But before you switch it on, grab your manual and keep it handy as you explore the rest of this chapter, which explains some common setup options and guides you through taking your first pictures.

Adjusting the viewfinder to your eyesight

If your camera has a viewfinder, chances are that it also has a viewfinder diopter adjustment control, or something with a similar name. This control is a little knob or wheel, usually placed along the edge of the viewfinder, that enables you to adjust the viewfinder to your eyesight. Figure 3-2 offers a close-up look at how this control appears on some Canon dSLRs. If you don't take this step, then what you see through the viewfinder may not be an accurate reflection of the scene, focusing wise.

Although you should check your manual for details, you usually adjust the viewfinder in this fashion: Point the camera at a plain surface, such as a wall or sheet of paper. Then look

Diopter adjustment control

Figure 3-2: Be sure to adjust the viewfinder to vour vision.

through the viewfinder and concentrate on the little marks inside the view-finder that indicate the camera's possible focusing areas. (These vary from camera to camera.) Concentrating just on those marks — not on the scene in front of the lens — adjust the diopter control until the marks appear sharply focused. If no amount of adjustment makes things sharp, you may be able to buy a viewfinder accessory that allows a greater amount of adjustment.

Note that if you wear glasses and will wear them when using your camera, you should have them on when you adjust the diopter.

Exploring basic setup options

Somewhere on the back of your camera, you should find a Menu button that displays the camera menus on the monitor. And on one or more of those menus, you should find a few options for customizing the camera. Again, your manual contains specifics, but here are a few bits of advice regarding the most common setup options:

✓ Date and time: This setting is perhaps the most critical of the basic operation controls. Your camera records the current date and time in the image file, along with details about what other camera settings were

in force when you shot the picture. In many photo editors and image browsers, you can view this information, known as metadata.

Having the correct date and time in the image file enables you to have a permanent record of when each picture was taken. More importantly, in many photo programs, you can search for all the pictures taken on a particular date. For example, in Adobe Photoshop Elements, you can display a calendar view, as shown in Figure 3-3, and click on a date to view thumbnails of all the pictures you shot on that date.

Format memory card: When you put a new memory card into your camera, it's always a good idea to format the card. Formatting erases any data on the card and sets it up for the specific type of camera you're using. This step is especially critical if you use the same card for different types of cameras or other devices, such as an MP3 player. Otherwise, your picture data can be lost or become corrupted.

Figure 3-3: Because the date is recorded with the picture file, you can easily track down pictures taken during a certain period.

- Auto shut-off: To conserve battery power, many cameras turn off automatically after a few minutes of inactivity. The drawback is that you can miss fleeting photographic opportunities by the time you restart the camera, your subject may be gone. If you're not happy with the way this option works, see whether you can adjust the length of time that the camera must be idle before auto shutdown occurs; some cameras also give you the option of turning the feature off entirely.
- Shoot without memory card: Most cameras will let you take a photo without a memory card. The image is stored in a tiny bit of internal camera memory but usually isn't retained for more than a few minutes. (The point of the function is to enable camera salespeople to demonstrate cameras without having to keep memory cards in all of them.) If you're worried that you might shoot all day and forget that you didn't insert a memory card, turn off this function!
- Instant review: After you take a picture, your camera may display it automatically for a few seconds. On some cameras, you can't take another picture until the review period is passed, and if that's the case with your model, you may want to turn off instant review when you're trying to capture fast-paced subjects. And because monitors consume power, also turn off instant review if you're worried about running out of battery juice. You may also be able to adjust the length of the instant-review period.
- Monitor brightness: Adjusting the monitor brightness can make pictures easier to view in bright light. But be careful: The monitor may then give you a false impression of your image exposure. Before you put your camera away, double-check your pictures in a setting where you can use the default brightness level. As another alternative, you may be able to display an exposure guide called a histogram; see Chapter 5 for details.
- Sound effects: Digital cameras are big on sounds: Some play a little ditty when the camera is turned on. Some beep to let you know that the camera's autofocus or autoexposure mechanism has done its thing, and others emit a little "shutter" sound as you take the picture. There have even been cameras that said "Goodbye" in this odd little digitized voice when you turned the camera off. Before heading to a wedding or any other event where your camera's bells and whistles won't be appreciated, check your camera menu to see whether you can silence them or at least turn down the volume.
 - Some cameras offer a Museum mode. When you choose this setting, the camera automatically stifles its vocal chords and also disables the flash because flash photography isn't permitted in most museums.
- ✓ **File numbering:** Cameras assign filenames to photos, often beginning with a few letters and a symbol (for example, IMG_0023.JPG, DSCN0038. JPG, or something similar). You can often set up your camera to number files beginning with certain numbers, and some cameras actually let you put in a few of your own letters with the file numbers (although it's usually very limited).

Some cameras have an option that automatically restarts the filenumbering sequence when you swap out a memory card. For example, if the current memory card contains a file named IMG_0001.JPG, and you put in a new memory card, the camera assigns that same filename to the first picture you take. Obviously, this option can lead to trouble after you download pictures to your computer because you can wind up with multiple pictures that share the same name. So check your manual to find out whether this option exists on your camera, and if so, avoid it.

✓ **Auto rotate:** You may be able to choose whether you want the camera to automatically rotate vertically oriented pictures so they appear as shown on the left in Figure 3-4. If you don't choose this option, the image appears on its side, as shown on the right in the figure.

When you turn on auto-rotation, the camera stores the picture-orientation information as part of the data file. Some photo software can read that orientation data, too, so that when you display the picture on your computer monitor, the image also appears in its proper orientation.

Serge Timacheff

Figure 3-4: Most cameras enable you to rotate vertical pictures to their proper orientation.

Taking Your First Pictures

After completing basic camera setup and familiarizing yourself with your camera's buttons and menus, you're ready for the big moment: time to actually take some pictures.

Although you no doubt can figure out the basics of shooting with your digital camera on your own, the following sections offer some bits of information that can help you get better results from the get-go.

More focus factors to consider

When you focus the lens, either in autofocus or manual focus mode, you determine only the point of sharpest focus. The distance to which that sharp-focus zone extends — what photographers call the *depth of field* — depends in part on the *aperture setting*, which is an exposure control. And the aperture setting varies depending on the automated photography mode you select.

The Portrait setting, for example, uses an aperture setting that shortens the depth of field so that background objects are softly focused — an artistic choice that most people prefer for portraits. On the flip side of the coin, the Landscape setting selects an aperture that produces a large depth of field so that both foreground and background objects appear sharp.

Another exposure-related control, shutter speed, plays a focus role when you photograph

moving objects. Moving objects appear blurry at slow shutter speeds; at fast shutter speeds, they appear sharply focused. On your camera, the Sports shooting mode automatically selects a high shutter speed to help you "stop" action, producing blur-free shots of the subject.

A fast shutter speed can also help safeguard against allover blurring that results when the camera is moved during the exposure. The faster the shutter speed, the shorter the exposure time, which reduces the time that you need to keep the camera absolutely still. Using a tripod is the best way to avoid the problem when you use a slow shutter speed.

For an explanation of the role of shutter speed and aperture in exposure, check out Chapter 5. Chapter 6 discusses various issues related to focusing.

Setting the focus mode: Auto or manual?

Most point-and-shoot digital cameras offer only autofocus, but a few do permit manual focusing. When you're just getting comfortable with your camera, stick with autofocus — with manual focusing on a point-and-shoot camera, you usually have to dig through menus and specify an exact camera-to-subject distance, which is tricky.

If you own a dSLR, you can either take advantage of autofocus or focus manually by twisting a focusing ring on the lens barrel. Typically, you use a switch on the lens barrel or the camera body to specify which focusing option you want to use. Look for a switch that has the labels A or AF and M or MF.

On some dSLR lenses, you also get a switch for enabling or disabling image stabilization, a feature designed to prevent blurring caused by camera movement that can occur when you handhold the camera. See Chapter 1 for a complete explanation of this feature, and check your camera or lens manual to find out how to best take advantage of it with your equipment.

Choosing an automatic exposure mode

Most digital cameras offer a variety of automatic exposure modes, which you select either via menus or an external dial or switch. In all these modes, the camera handles critical exposure decisions, such as selecting the aperture setting and shutter speed, leaving you free to concentrate on composition and your subject. Shooting in automatic mode also typically means that the camera handles most other settings, too, including those that affect color and autofocusing.

Although the number and type of automatic exposure modes vary from camera to camera, they can be broken down into two general categories:

- ✓ Full Auto: This setting is designed to deliver good results no matter what your subject. Think of it as one-size-fits-all shooting.
- ✓ **Scene modes:** These settings are specialized modes geared to specific subjects people, landscapes, and so on.

The next few sections offer some more information about shooting in Full Auto mode and give you an overview of four of the most common scene modes (Portrait, Landscape, Close-up, and Sports).

One word of advice before you move on, though: Automatic exposure modes are great in that you don't have to know much about photography or have to worry about setting a bunch of controls before you shoot. But the downside is that you typically lose access to some features that may be helpful for capturing your subject. For example, the camera usually decides whether or not a flash is needed, and you can't override that decision. And some cameras don't let you tweak color or exposure, either.

So if your camera offers more advanced exposure modes, such as aperture-priority autoexposure or manual exposure, it's worth your time to learn how to use them. They may take a while to fully grasp, but they make your life easier in the long run because you can easily tweak exposure, color, and focus settings to precisely suit your subject. See Chapters 5 through 7 for a look at the many picture-taking options you can access when you shift out of fully automatic exposure modes.

Full Auto mode

In this mode, the camera selects all settings based on the scene that it detects in front of the lens. Some cameras use different settings if they detect motion in the scene, for example, than if they detect a stationary subject. You may be able to specify the image resolution and a few other settings (explained later in this chapter), but for the most part, you get no input into how the picture is captured.

If you have exposure or color problems in this mode, check out Chapters 5 and 6 to discover some possible remedies. But again, whether you have access to the techniques covered in those chapters depends on your camera and how it implements Full Auto mode.

Portrait mode

Portrait mode attempts to select exposure settings that produce a blurry background, which puts the visual emphasis on your subject, as shown in Figure 3-5. Keep in mind. though, that in certain lighting conditions, the camera may not be able to choose the exposure settings that best produce the soft background. Additionally, the background blurring requires that your subject be at least a few feet from the background. The extent to which the background blurs also depends on the other depth-of-field factors that you can explore in Chapter 6.

Keep in mind that you can use Portrait mode any time you want a slightly blurry background, not just for people pictures. Try this mode when shooting statues, stilllife arrangements (such as a vase of flowers on a kitchen table), insects, and the like.

Serge Timacheff

Figure 3-5: The portrait setting produces a softly focused background.

Check your manual to find out what other image adjustments may

be applied in Portrait mode. Some cameras, for example, tweak color and sharpness in a way designed to produce flattering skin tones and soften skin texture. And one more tip: If you're not sure that your subject will remain motionless, the Sports mode, which is designed to capture moving subjects without blur, may deliver better results.

Landscape mode

Whereas Portrait mode aims for a very shallow *depth of field* (small zone of sharp focus), Landscape mode, which is designed for capturing scenic vistas, city skylines, and other large-scale subjects, produces a large depth of field.

As a result, objects both close to the camera and at a distance appear sharply focused. Figure 3-6 offers an example; notice that the tree as well as the road and the ridges of the mountains far behind it are all in focus.

Like Portrait mode. Landscape mode achieves the greater depth of field by manipulating the exposure settings specifically, the aperture, or f-stop setting. So the extent to which the camera can succeed in keeping everything in sharp focus depends on the available light. To fully understand this issue, see Chapter 5. And in the meantime, know that you also can extend depth of field by zooming out and moving farther from your subject, too.

Serge Timacheff

Figure 3-6: The landscape mode produces a large zone of sharp focus and also boosts color intensity slightly.

On most cameras, Landscape mode also adjusts colors to emphasize blues and greens. If you don't care for that color choice, you can try changing the camera's white-balance setting, a color control covered in Chapter 6. However, some cameras put that control off limits in automatic exposure modes. Additionally, flash is usually disabled in Landscape mode, which presents a problem only if you need some extra light on an object in the front of the scene.

Again, think beyond the Landscape moniker when you look for good ways to put this mode to use: Try it when shooting long-range pictures of animals at the zoo, for example, so that critters both near and far appear sharp. It's also good for shooting a group of people (such as a team sitting in bleachers) where you want to be able to see every smiling face crisply.

Close-up mode

On most cameras, this mode — also known as *macro* mode — is represented by a little flower icon. On some point-and-shoot cameras, selecting this mode enables you to focus at a closer distance than usual. For a dSLR, the close-focusing capabilities of your camera depend entirely on the lens you're using. But in either scenario, your camera or lens manual should spell out exactly how close you can get to your subject.

Choosing this mode typically results in exposure settings designed to blur background objects so that they don't compete for attention with your main subject. As with Portrait mode, though, how much the background blurs varies depending on the distance between your subject and the background as well as on the lighting conditions.

For example, the amount of background blurring in the macro example shown in Figure 3-7 isn't as great as in the earlier portrait example because not as much distance exists between the subject and background. Should you prefer a greater or shorter depth of field, see Chapter 6 for other ways to adjust this aspect of your pictures.

As with the other scene modes, the camera may tweak colors slightly and may or may not allow you to use flash. The region of the frame that's used to establish focus also varies, so check that manual.

Sports mode

Sports mode, sometimes also called Action mode, results in a number of settings that can help you

Serae Timacheft

Figure 3-7: Close-up mode also produces short depth of field. Notice how all the branches and leaves behind the lemon tree are blurred.

photograph moving objects such as the wind turbines in Figure 3-8. First, the camera selects a fast shutter speed, which is needed to "stop motion." *Shutter speed* is an exposure control that you can explore in Chapter 5.

Serae Timacheff

Figure 3-8: To capture moving subjects without blur, try Sports mode — even if you're not shooting a sporting event.

With some cameras, dialing in Sports mode also selects some other settings that facilitate action shooting. For example, if your camera offers *burst mode* or *continuous capture*, in which you can record multiple images with one press of the shutter button, Sports mode may automatically shift to that gear. And flash is usually disabled, which can be a problem in low-light situations; however, it also enables you to shoot successive images more quickly because the flash needs a brief period to recycle between shots.

The other critical thing to understand about Sports mode is that whether the camera can select a shutter speed fast enough to stop motion depends on the available light and the speed of the subject itself. On the other hand, a little blurring in an action photo can sometimes be acceptable and add to the effect of motion.

To fully understand shutter speed, visit Chapter 5. And for more tips on action photography, check out Chapter 7.

Reviewing other critical capture settings

In addition to choosing an exposure mode, you should review the following additional picture-taking settings before you shoot. Later chapters get into these options in more detail, but here's a quick introduction to the most critical ones so that your first photos are at least close to being perfect:

A Parallax! A Parallax!

You compose your photo perfectly. The light is fine, the focus is fine, and all other photographic planets appear to be in alignment. But after you snap your picture and view the image on the camera monitor, the framing is off, as though your subject repositioned itself while you weren't looking. You're not the victim of some cruel digital hoax — just a photographic phenomenon known as a *parallax error*.

On most point-and-shoot cameras, the viewfinder looks out on the world through a separate window from the camera lens. Because the viewfinder is located an inch or so above or to the side of the lens, it sees your subject from a slightly different angle than the lens. But the image is captured from the point of view of the lens, not the viewfinder.

When you look through your viewfinder, you may see some lines near the corners of the frame. The lines indicate the boundaries of the

frame as seen by the camera lens. Pay attention to these framing cues, or you may wind up with pictures that appear to have been lopped off along one edge.

The closer you are to your subject, the bigger the parallax problem becomes, whether you use a zoom lens or simply position the camera lens closer to your subject. Some cameras provide a second set of framing marks in the viewfinder to indicate the framing boundaries that apply when you're shooting close-up shots. Check your camera manual to determine which framing marks mean what. (Some markings have to do with focusing and exposure, not framing.)

Another solution is to simply use the monitor to frame your shots; the monitor reflects the image as seen by the lens. (On some cameras, the LCD monitor turns on automatically when you switch to macro mode for close-up shooting.)

Resolution: This option determines how many *pixels* the image will contain. Pixels are the tiny colored tiles from which all digital pictures are created. The more pixels you have, the larger you can print your photos and expect good picture quality.

Most cameras enable you to select from two or more resolution settings, each of which creates the image using a different number of pixels. For now, just select the camera's top resolution setting — it's better to have too many pixels than too few. You can also refer to the Cheat Sheet at the front of the book to find out how many pixels you need to produce different sizes of prints.

The resolution option is presented in different ways, depending on the camera. You may be given a choice of pixel dimensions or total pixel count in megapixels (1 *megapixel* equals 1 million pixels). Some cameras take another approach, using vague option names such as Large, Medium, or Small. And sometimes, you get all three methods combined,

as in Figure 3-9, which shows how the resolution setting is presented on some Nikon cameras. With some cameras, you get one set of controls for adjusting both resolution and file format, explained next. Your camera manual should spell out exactly how you go about changing the resolution and how many pixels you get with each setting.

File format: Chapter 4 fully explores the issue of file formats, which simply refers to the type of data file the camera produces. For now, consult your camera

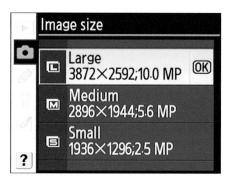

Figure 3-9: The initial pixel count determines how large you can print your picture.

manual to find out what setting results in a JPEG (<code>jay-pegg</code>) file at the highest image quality. (It will be the JPEG setting that produces the largest file.) This setting ensures the best quality images without some of the complications created by the other file type that may be available to you, called Camera Raw.

Again, your camera might combine the resolution and format options into one setting. For example, on some Canon cameras, you select Large/Fine to dial in the highest resolution with the top-quality JPEG setting, as shown in Figure 3-10. (As you can see, the symbols representing the settings are sometimes pretty cryptic; again, keep that camera manual handy!)

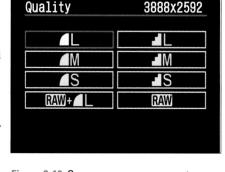

ISO: This setting, fully explained in Chapter 5, adjusts the camera's sensitivity to light. The higher

Figure 3-10: On some cameras, you set resolution and format together.

the ISO number, the less light the camera needs to expose the image. But higher ISO settings also can result in a speckly looking defect called *noise*. So whenever possible, use the lowest ISO your camera offers. Note that in automatic exposure modes, the camera may lock you out of controlling ISO, however, and raise and lower the ISO according to the lighting conditions.

- ✓ Shutter-release mode: Many cameras offer a choice of shutter-release modes, which simply control what happens when you press the shutter button. Common modes include:
 - One-shot or single mode: The camera records one image every time you fully depress the shutter button. In other words, this is normal photography mode.
 - Continuous or burst mode: You press and hold the shutter button down to record a continuous series of images at a rapid pace. The camera keeps recording pictures until you let up on the shutter button.
 - Self-timer mode: You fully press and release the shutter button, and the image is captured several seconds later. (This is the mode you use when you want to put yourself in the picture.)
 - *Remote-control mode:* Some cameras enable you to trigger the shutter button with a remote control unit; if so, this mode sets up the camera for that option.

The name of the option that controls the shutter-release mode varies; it may be named something like Drive mode, Release mode, or Shooting mode, for example.

Pressing the shutter button

With all your initial picture-taking settings dialed in, all that's left to do is frame the shot and press the shutter button.

Any time you take advantage of autoexposure, autofocus, or both, however, the way you press the shutter button is critical. In order for the automatic mechanisms to work, you must use the following two-stage approach:

After framing the shot, press and hold the shutter button halfway down.

The camera's autofocus and autoexposure meters begin to do their thing. In dim light, the flash may turn on or pop up if the camera thinks additional light is needed.

Be sure to check your manual to verify how your camera establishes focus. In some cases, for example, you need to compose your image so that your subject is within a certain area of the frame. And some cameras adjust their autofocusing behavior depending on whether they think you're shooting a still or moving subject. For still subjects, the camera may lock its focus when you depress the shutter button halfway. But if the camera senses motion, it may continually adjust focus from the time you depress the shutter button halfway.

When focus is established, the camera will likely beep at you, assuming that you didn't silence its voice during setup.

2. Press the shutter button the rest of the way and then release it to record the image.

While the camera sends the image data to the camera memory card, another light on your camera may illuminate. Don't turn off the camera or remove the memory card while the lamp is lit, or you may damage both camera and card.

When the recording process is finished, the picture appears briefly on the LCD display. If you want a longer look at the image, you'll need to put the camera into playback mode.

If the picture didn't work out as planned, move on to Part II of the book to discover all the myriad ways you may be able to manipulate exposure, color, focus, and other characteristics of your photo.

Part II Getting the Most from Your Camera

"I think you've made a mistake. We do photo retouching, not family portrai....Oooh, wait a minute – I think I get it!"

In this part . . .

igital cameras pack features and technology galore tightly into a small space. Whether you're using a point-and-shoot or a digital SLR, or something in-between, your photographic skills and the images they produce will grow by understanding more about how to use your digital marvel.

To that end, Chapter 4 explains the digital side of digital photography, explaining such critical concepts as resolution and file format. Chapter 5 provides you with the fundamentals of exposure, discussing such issues as f-stops, shutter speeds, and ISO as well as sharing some tips on using autoexposure features and flash. Chapter 6 covers focus and color, and then Chapter 7 ties everything together by summing up techniques you can use to get the best shot every time.

By studying these chapters and putting at least a few of the ideas into practice each time you pick up your camera, you can take full advantage of your photographic investment. And more important, your percentage of good shots — no, great shots — will increase. Heck, even your family might be impressed with a shot or two before long.

Resolution, File Format, and Other Digital Details

In This Chapter

- Visualizing color in the RGB world
- Exploring the murky waters of resolution
- Deciding how many pixels are enough
- Understanding the impact of resolution on file size
- Choosing a file format: Raw or JPEG?

f discussions of a technical nature nauseate you, keep a stomach-soothing potion handy while you read this chapter. The following pages are full of the kind of technical babble that makes science teachers drool but leaves us ordinary mortals feeling a little queasy.

However, you're more likely to be a successful digital photographer by becoming acquainted with the science behind the art. To that end, this chapter provides you with a foundation in the digital side of digital photography, exploring such important digital-capture concepts as resolution, file formats, bit depth, and more. It's not an exercise for the faint of heart, but it's critical to getting the best results from your digital camera.

Turning Light into Pixels

A traditional camera creates an image by allowing light to pass through a lens onto film. The film is coated with light-sensitive chemicals, and wherever light hits the coating, a chemical reaction takes place, recording a latent image. During the film development stage, more chemicals transform the latent image into a printed photograph.

Digital cameras also use light to record images, but instead of film, digital cameras capture pictures using *image sensors*, which is a fancy way of saying "lightsensitive computer chips." Currently, these chips come in two flavors: CCD, which stands for *charge-coupled device*, and CMOS, which is short for *complementary metal-oxide semiconductor*.

Eastman Kodak Company

Figure 4-1: Image sensors do the work of film in digital cameras.

(No, Billy, that information won't be on the test.) Figure 4-1 gives you a look at some image sensors from Kodak.

Although CCD and CMOS chips differ in their design and construction, both chips do essentially the same thing. When struck by light, they emit an electrical charge, which is analyzed and converted into digital image data by a processor inside the camera. The more light, the stronger the charge.

As the final step in the chain, the picture file is saved to a removable memory card. The type of card varies depending on the camera; the most common are CompactFlash, Secure Digital (or SD, for short), and, on Sony cameras, Memory Stick.

To access the images that your camera records, you just transfer them from the memory card to your computer. (Chapter 8 shows you how.) You then can use any number of software programs to view, edit, organize, print, and e-mail your pictures. Or you can take advantage of the many devices that enable you to view or print your photos directly from a memory card, from GPS units that let you display favorite photos in your car to pocketbook-size printers that can produce pro-quality prints — all with no computer required.

Of course, what you've just read only touches the surface of how digital cameras work. For an idea of just how complex the whole business really is, check out Figure 4-2, which shows a cutaway view of a Canon digital SLR camera (dSLR, in photo lingo). Suffice it to say that digital cameras are complex blends of computer technology and traditional photographic technology.

Fortunately, you don't need to explore the inner workings of your camera any further to take great pictures. In fact, perhaps the most important lesson to take from this discussion is that a digital camera is a sensitive piece of electronic equipment and, as such, should be protected from extreme temperatures, shock, water, and all the other hazards that can damage any high-tech tool.

Canon U.S.A. Inc.

Figure 4-2: Looking inside a digital camera reveals a complex mix of technologies.

See Chapter 14 for care and maintenance tips that will keep your camera in top working condition. Visit Chapter 10 for printing help, and see Chapter 11 for ways to view images onscreen and share them online.

Exploring the World of Digital Color

Like film cameras, digital cameras create images by reading and recording the light reflected from a scene. But how does the camera translate that brightness information into the colors you see in the final photograph?

The next sections explain this mystery and decode some of the color-related techie terms you may encounter when you browse digital photography magazines, Web sites, and other forums.

RGB: A new way of thinking about color

A digital camera translates light into color pretty much the same way as the human eye. To understand the process, you first need to know that light can be broken into three color ranges: reds, greens, and blues. Inside your eyeball, you have three receptors corresponding to those color ranges. Each receptor measures the brightness of the light for its particular range. Your brain then combines the information from the three receptors into one multicolored image in your head.

Because most of us didn't grow up thinking about mixing red, green, and blue light to create color, this concept can be a little hard to grasp. Here's an analogy that may help. Imagine that you're standing in a darkened room and have one flashlight that emits red light, one that emits green light, and one that emits blue light. Now suppose that you point all the flashlights at the same spot on a white wall. Where the three lights overlap, you get white, as shown in Figure 4-3. Where no light falls, you get black.

Figure 4-3: RGB images are created by blending red, green, and blue light.

In the illustration, the flashlights emit full-intensity light with no fade

over the spread of the beam, so mixing the three lights produces only three additional colors: magenta, cyan, yellow. But by varying the intensity of the beams, you can create every color that the human eye can see.

Just like your eyes, a digital camera analyzes the intensity — sometimes referred to as the *brightness value* — of the red, green, and blue light in a scene. Then the camera's computer brain mixes the brightness values to create the full-color image.

Pictures created using these three main colors of light are *RGB images* — for red, green, and blue. Computer monitors, television sets, digital projectors, and scanners also create images by combining red, green, and blue light.

Digging through color channels

After your camera analyzes the amount of red, green, and blue light in a scene, it stores the brightness values for each color in separate portions of the image file. Digital-imaging professionals refer to these collections of brightness information as *color channels*.

In sophisticated image-editing programs such as Adobe Photoshop, you can view and edit the individual color channels in a digital photograph. Figure 4-4 shows a color image broken down into its red, green, and blue color channels. Notice that each channel contains nothing more than a grayscale image. That's because the camera records only light — or the absence of it — for each channel.

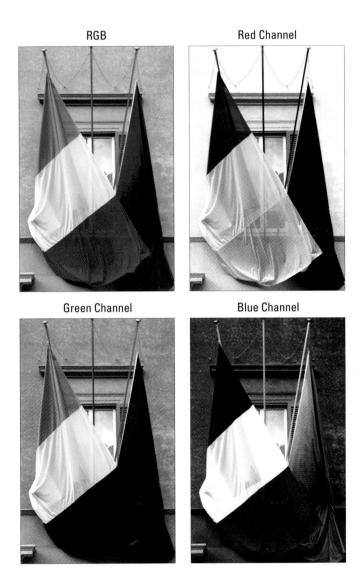

Figure 4-4: An RGB image has three color channels, one each for the red, green, and blue light values.

In any of the channel images, light areas indicate heavy amounts of that channel's color. For example, the red portion of the left flag appears nearly white in the red channel image, but nearly black in the green and blue channel images. Likewise, the blue flag poles appear very light in the blue channel images. Moreover, the center portion of the left flag is bright in all three channel images, which translates to white in the color image.

Photoshop and some other high-level programs enable you to manipulate the red, green, and blue color channels independently in order to tweak the colors in your photo. Thankfully, though, you don't need to dig that deep into imaging science to adjust the colors in the pictures you shoot; most programs, especially those designed for beginners, provide simple coloradjustment tools that do all this channel-changing for you in the background. You just tell the program that you want your photo to have a touch more of this color and a tad less of that

Note that not all digital images contain three channels. If you convert an RGB image to a *grayscale* (black-and-white) image inside a photo-editing program, for example, the brightness values for all three color channels are merged into one channel. If you convert the image to the *CMYK color model* in preparation for professional printing, you end up with four color channels, one corresponding to each of the four primary colors of ink (cyan, magenta, yellow, and black). For more on this topic, see the next section.

Don't let this channel stuff intimidate you, because until you become a seasoned photo editor, you don't need to give it much thought, if then. We bring the topic up only so that when you see the term *color channel* — which often crops up in camera reviews and photo-editing how-to articles — you have some idea what it means.

For a detailed look at how you can control color in your digital photos, check out Chapter 6.

More colorful terminology

RGB is just one of many color-related acronyms and terms you may encounter on your digital photography adventures. So that you aren't confused when you encounter these buzzwords, the following list offers a brief explanation:

RGB: Just to refresh your memory, RGB stands for red, green, and blue. RGB is the *color model* — that is, a method for defining colors — used by digital images, as well as any device that transmits or filters light. Figure 4-5 shows you how full-intensity red, green, and blue are mixed to create white, cyan, yellow, and magenta.

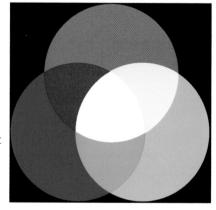

Figure 4-5: The RGB color model is based on red, green, and blue light.

Image-editing gurus also use the term *color space* when discussing a color model, something they do with surprising frequency.

cMY/CMYK: Whereas light-based devices mix red, green, and blue light to create images, printers mix ink to emblazon a page with color. Instead of red, green, and blue, however, printers use cyan, magenta, and yellow as the primary color components, as illustrated in Figure 4-6. This color model is called the CMY model, for reasons you no doubt can figure out.

Because inks are impure, producing a true black by mixing just cyan, magenta, and yellow is difficult. So most photo printers and commercial printing presses add black ink to the CMY mix. This

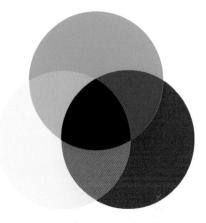

Figure 4-6: The print color model is based on cyan, magenta, and yellow ink.

model is called CMYK (the *K* is used to represent black because commercial printers refer to the black printing plate as the *Key* plate). Fourcolor images printed at a commercial printer may need to be converted to the CMYK color mode before printing.

One important note here: The colors you see in the RGB model in Figure 4-5 and the colors in the CMYK model in Figure 4-6 appear the same here. But in reality, the RGB colors are much more vibrant; what you're seeing in Figure 4-5 is the RGB chart converted to the CMYK model for printing. You simply can't reproduce in print the most vivid hues in an RGB image, which is one reason why those colors you see on your monitor never exactly match what you see in your printed photos. For more on this issue and printing in general, check out Chapter 10.

- ✓ sRGB: A variation of the RGB color model, sRGB offers a smaller gamut, or range of colors, than RGB. One reason this color model was designed was to improve color matching between on-screen and printed images. Because RGB devices can produce more colors than printer inks can reproduce, limiting the range of available RGB colors helps increase the possibility that what you see on-screen is what you get on paper. The sRGB color model also aims to define standards for on-screen colors so that images on a Web page look the same on one viewer's monitor as they do on another. In fact, the s in sRGB stands for standard. Today, sRGB is the color model used by most digital cameras.
- ✓ Adobe RGB: Many imaging purists don't like to limit their color palettes to the smaller spectrum of sRGB. For that reason, some digital cameras, especially high-end models, also enable the photographer to capture images in the Adobe RGB color model. This model, developed by Adobe, includes a wider range of colors than sRGB. Figure 4-7 offers an illustration that approximates the differences between the two spectrums; note that neither can capture all the colors that the human eye can perceive.

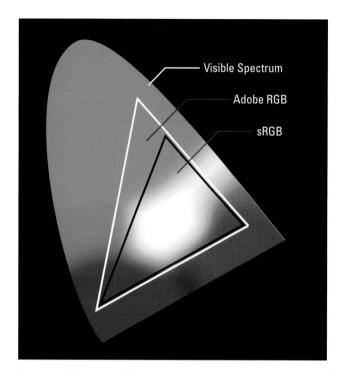

Figure 4-7: The Adobe RGB spectrum includes more colors than sRGB.

The potential downside of Adobe RGB is that some colors included in its gamut can't be reproduced in print. If a printer encounters a color that it can't handle — such colors are said to be *out-of-gamut* — it substitutes the closest possible color. However, the sRGB color space excludes some colors that *can* be printed. So if capturing the widest spectrum is more important to you than color matching, you can opt for Adobe RGB over sRGB. But if you do decide to use Adobe RGB, study your photo software and printer software manuals to find out how to work with that color model when you edit, view, and print your images. Some lower-end programs can't deal with different color models and simply convert everything to sRGB when you open the images. (You will need programs that support a thing called *color management*.) In other words, Adobe RGB may be a subject for you to explore when you become more advanced in your digital photography adventures.

Note, too, that color-matching problems between printed and on-screen images can occur with either sRGB or Adobe RGB because those discrepancies can result from many issues other than the original color model. Chapter 10 offers more on this subject.

A bit about bit depth

If you own a high-end digital camera, it may enable you to choose between two bit depth settings. A bit is a chunk of computer data. Bit depth refers to how many bits are available to store color data. A higher bit depth allows more image colors.

Bit depth is stated either in terms of total bits or in bits per color channel. For example, a standard RGB image has 8 bits per channel, for a total of 24 bits (8 each for the red, green, and blue color channels). Images that contain more than 24 bits are *high-bit images*. High-bit RGB images contain as many as 16 bits per channel, or 48 bits total.

With 24 bits, you can capture about 16.7 million colors, which is typically more than enough. So what's the advantage to more bits? Those extra bits may be useful if you need to adjust exposure, contrast, or color in your image-editing software. If you apply heavy changes to a 24-bit image, you can sometimes introduce a defect called *banding* or *posterization*, where abrupt color changes interrupt what should be

a smooth transition of hues, as shown in the right image in the following figure. Theoretically, higher-bit images withstand more correction without breaking down because you have more original color data to manipulate.

However, going to 48 bits does not guarantee that this defect won't occur. And high-bit images have two important drawbacks: Files are significantly larger, and many photo-editing programs either can't open high-bit files or severely limit the number of tools that you can use on those files.

For that reason, sticking with 24 bits is a good practice for most photographers. The exception might be when you are shooting in tricky light, in which case you might want to ramp up to 48 bits. In the photo-editing stage, first make any necessary exposure or color adjustments and then convert the photo to a 24-bit image so that you can have full access to all your photoediting tools. (To make this conversion in Adobe Photoshop Elements, choose Image Mode 8 Bits/Channel.)

✓ **Grayscale:** A grayscale image is comprised solely of black, white, and shades of gray. Some people (and some photo-editing programs) refer to grayscale images as black-and-white images, but a true black-and-white image contains only black and white pixels, with no shades of gray in between. Graphics professionals often refer to black-and-white images as *line art*.

Many digital cameras enable you to capture grayscale images — well, sort of. What they really do is capture a full-color image and then convert that photo to grayscale as it's saved to the camera memory card. Some cameras instead offer a feature that enables you to create a copy of a color image that's on your memory card and then convert that copy to a grayscale version, so you end up with both a color original and a grayscale copy. You may want to bypass these in-camera grayscale options and instead do your own color-to-grayscale conversions in your photo-editing program, however. Assuming that you own a capable program, you'll have much more control over how the colors in your image are translated to grayscale. At the very least, if your camera captures the original file in grayscale instead of creating a grayscale copy, take one shot of the subject in color and one in grayscale. You can always go from color to grayscale after the fact, but you can't do the opposite.

✓ CIE Lab, HSB, and HSL: These acronyms refer to three other color models for digital images. Until you become an advanced digital-imaging guru, you don't need to worry about them. But just for the record, CIE Lab defines colors using three color channels. One channel stores luminosity (brightness) values, and the other two channels each store a separate range of colors. (The *a* and *b* are arbitrary names assigned to these two color channels.) HSB and HSL define colors based on hue (color), saturation (purity or intensity of color), and brightness (in the case of HSB) or lightness (in HSL).

About the only time you're likely to run into these color options is when mixing paint colors in a photo-editing program. Even then, the on-screen display in the color-mixing dialog boxes makes it easy to figure out how to create the color you want.

Resolution Rules!

Without a doubt, one of the most important things you can do to improve your digital photos is to understand the concept of *resolution*. Unless you make the right choices about resolution, your pictures will be a disappointment, no matter how captivating the subject. In other words, don't skip this section!

Pixels: Building blocks of digital photos

Have you ever seen the painting *A Sunday Afternoon on the Island of La Grande Jatte*, by the French artist Georges Seurat? Seurat was a master of a technique known as *pointillism*, in which scenes are composed of thousands of tiny dots of paint, created by dabbing the canvas with the tip of a paintbrush. When you stand across the room from a pointillist painting, the dots blend together, forming a seamless image. Only when you get up close to the canvas can you distinguish the individual dots.

Digital images work something like pointillist paintings. Rather than being made up of dots of paint, however, digital images are composed of tiny squares of color known as *pixels*. The term *pixel* is short for *picture element*.

If you display an image in a photo-editing program and then use the program's Zoom tool to magnify the view, you can see the individual pixels, as shown in Figure 4-8. Zoom out on the image, and the pixels seem to blend together, just as when you step back from a pointillist painting.

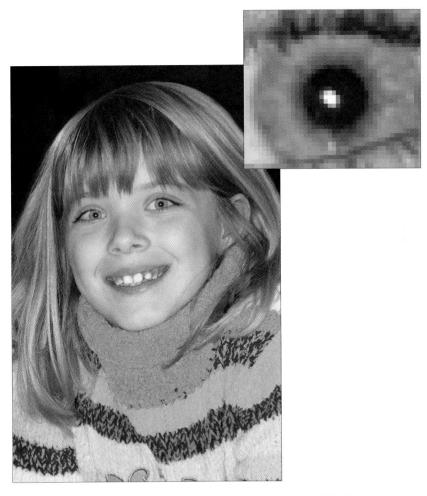

Figure 4-8: Zooming in on a digital photo enables you to see the individual pixels.

Every digital photograph is born with a set number of pixels, which you control by using the capture settings on your digital camera. (See Chapter 3 for details.) Most cameras sold today can record at least 6 million pixels, and higher-end models can capture 10 megapixels or more — and some pro models can capture as many as 15 or 20!

Some people use the term *pixel dimensions* to refer to the number of pixels in an image — number of pixels wide by number of pixels high. Others use the term *image size*, which can lead to confusion because that term is also used to refer to the physical dimensions of the picture when printed (inches wide by inches tall). In this book, *pixel dimensions* refers specifically to the pixel count, and *print size* refers to the print dimensions.

Regardless of the terminology, pixel count affects three important aspects of a digital photo:

- The maximum size at which you can produce good prints
- The display size of the picture when viewed on a computer monitor or television screen
- ✓ The size of the image file, which in turn affects how much storage space
 is needed to hold the file

To help you determine the right pixel population for your photos, the following three sections explore each of these issues.

Pixels and print quality

Generating a good print from a digital photo requires that you feed the printer a certain number of pixels per inch, or *ppi*. So the pixel count of a photo determines how large you can print the image without noticing a loss of picture quality.

Compare, for example, the images in Figures 4-9 through 4-11. The first image has resolution of 300 ppi; the second, 150 ppi; and the third, 75 ppi. For a close-up comparison of the three images, check out Figure 4-12.

For print purposes, resolution is measured in terms of pixels per *linear* inch, not square inch. So 75 ppi, for example, means 75 pixels wide by 75 pixels high, for a total of 5625 pixels in a square inch.

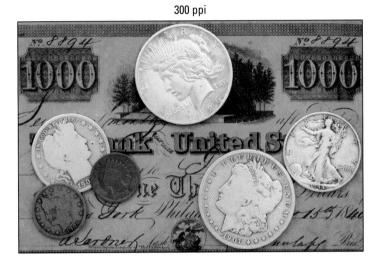

Figure 4-9: A photo with an output resolution of 300 ppi looks terrific.

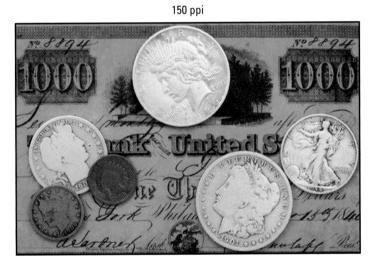

Figure 4-10: At 150 ppi, the picture loses some sharpness and detail.

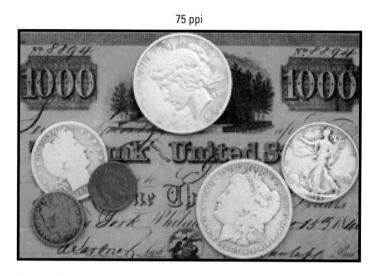

Figure 4-11: Reducing the resolution to 75 ppi causes significant image degradation.

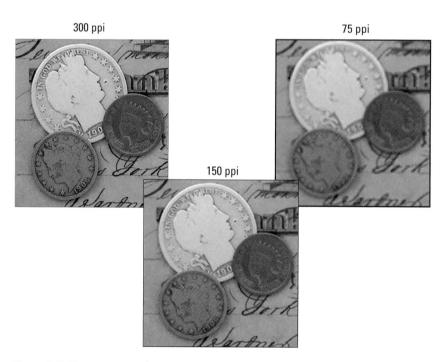

Figure 4-12: Here you see a close-up look at the difference that resolution makes.

Why does the 75-ppi image in Figure 4-11 look so much worse than its higher-resolution counterparts? Because at 75 ppi, the pixels are bigger. And the bigger the pixel, the more easily your eye can figure out that it's really just looking at a bunch of squares. Areas that contain diagonal and curved lines, such as the edges of the coins and the handwritten lettering in the figure, take on a stair-stepped appearance.

If you look closely at the black borders that surround Figures 4-9 through 4-11, you can get a clearer idea of how resolution affects pixel size. Each image sports a 2-pixel border. But the border in Figure 4-11 is twice as thick as the one in Figure 4-10 because a pixel at 75 ppi is twice as large as a pixel at 150 ppi. Similarly, the border around the 150-ppi image in Figure 4-10 is twice as wide as the border around the 300-ppi image in Figure 4-9.

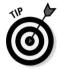

So the burning question is: Exactly how many pixels are enough to guarantee great prints? Well, it depends in part on how close people will be when viewing the pictures. Consider a photo on a billboard, for example. If you could climb up for a close inspection, you would see that the picture doesn't look very good because billboard photos are typically very low-resolution images, with few pixels per inch. But when you view them from far away, as most of us do, they look okay because our eyes blend all those big pixels together. Unless you're doing billboard photography, however, people will be viewing your images at a much closer range, so a higher resolution is required if you want the pictures to appear crisp and sharp.

The exact resolution you need to produce the best prints also varies depending on the printer. But a good range to shoot for is 200–300 ppi. For quick reference, Table 4-1 shows you the approximate pixel count you need to produce traditional print sizes at the low end of that scale. The first set of pixel values represents the pixel dimensions (horizontal pixels by vertical pixels); the value in parentheses represents the total pixel count, in megapixels (MP). One megapixel equals 1 million pixels; you arrive at this total-pixel number by multiplying the horizontal and vertical pixel count.

Table 4-1	How Many Pixels for Good Prints?
Print Size	Pixels for 200 ppi
4 x 6	800 x 1200 (1MP)
5 x 7	1000 x 1400 (1.5MP)
8 x 10	1600 x 2000 (3MP)
11 x 14	2200 x 2800 (6MP)

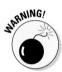

It's critical that you set your camera to the resolution setting that matches your final print needs *before* you shoot. Although some photo programs enable you to add pixels to an existing image — a process called *upsampling* — doing so isn't a good idea. The problem is that when you add pixels, the photoediting software simply makes its best guess as to what color and brightness to make the new pixels. And even high-end photo-editing programs don't do a very good job of pulling pixels out of thin air, as illustrated by Figure 4-13.

75 ppi upsampled to 300 ppi

Figure 4-13: Here you see the result of upsampling the 75-ppi image in Figure 4-11 to 300 ppi.

To create this figure, we started with the 75-ppi image shown in Figure 4-11 and resampled the image to 300 ppi in Adobe Photoshop, one of the best photo-editing programs available. Compare this new image with the 300-ppi version in Figure 4-9, and you can see just how poorly the computer does at adding pixels.

With some images, you can get away with minimal upsampling — say, 10 to 15 percent — but with other images, you notice a quality loss with even slight pixel infusions. Images with large, flat areas of color tend to survive upsampling better than pictures with lots of intricate details.

Chapter 10 provides an in-depth look at printing, talking more about the whole pixel-count issue and exploring other factors that affect print quality. In the meantime, keep these additional pixel pointers in mind:

- ✓ The numbers in Table 4-1 assume that you're printing the *entire* photo. If you crop the photo before printing, you need more original pixels to generate a given print size because you're getting rid of a portion of the image.
- ✓ If you're having your photo professionally printed, you may be required to submit a photo at a specific resolution. For example, the publisher of this book requires photos to be sent at a resolution of 300 ppi. You can establish the resolution for print output in many photo editors. Chapter 10 shows you how to do it in Adobe Photoshop Elements.
- A resolution of 300 ppi also is typically the right resolution if you're having your photos printed at a local lab such as those at Costco or Wal-Mart, although you don't need to be right on that mark. If you're uploading picture files to the lab's online printing service, the ordering screen usually displays some guidance as to the maximum recommended print size for each picture's resolution.
- ✓ For do-it-yourself printing on a home printer, 200 to 300 ppi should work just fine. A few printers, however, such as some from Epson, do request that you feed them a slightly higher ppi, so check your printer manual for guidelines.

Although you don't want to drop much below the 200 ppi threshold, neither do you need to shoot for the moon when it comes to pixel count. Once you get past 300 ppi, you usually don't gain anything in terms of print quality; in fact, many printers, when fed an excess of 300 ppi, simply dump the overage. And images with ginormous pixel counts aren't suitable for online sharing and also produce large file sizes, two drawbacks you can read about in the next two sections.

In other words, if you're shooting with a really high-resolution camera, you may not always want to set it to capture the maximum number of pixels. Instead, try to find a "sweet spot" that delivers the print size you want without bloating the pixel count unnecessarily.

Pixels and screen images

Although resolution has a dramatic effect on the quality of printed photos, it's irrelevant to the quality of pictures viewed on a monitor, television, or other screen device. The number of pixels controls only the *size* at which the picture appears on the screen. No matter what the pixel count, the quality of the display remains the same.

Here's why: Like digital cameras, computer monitors (and other display devices) create everything you see on-screen out of pixels. With a monitor, you typically can choose from various display settings — through the Windows Control Panel or the Mac System Preferences dialog box — each of which results in a different number of screen pixels. Standard settings range from 800 x 600 pixels for a small laptop screen to much more for large, wide-screen monitors, which may offer resolutions of 1920 x 1200 pixels or more. Some HDTV sets even double as giant computer monitors, and they have extremely high pixel dimensions.

At any rate, when you display a digital photo, the monitor simply uses one screen pixel to display one image pixel. For example, Figure 4-14 shows the screen of a 19-inch monitor as it appears when set to a display resolution of 1024×768 pixels. The photo inside the e-mail window contains 640×480 pixels — and therefore consumes 640 of the available 1024 horizontal screen pixels and 480 of the 768 vertical pixels.

Clearly then, a photo that contains enough pixels to produce even a mediumsize print is too large for screen use. Send someone a photo captured at, say, 6 megapixels, and only a small portion of it will be visible without scrolling.

So what do you do if you want to be able to print your pictures *and* share them online or use them for other screen purposes? Always set the camera resolution to match the print size you have in mind. As illustrated in the preceding section, you can't add pixels later successfully to achieve a good print. You can, however, dump pixels from a high-resolution original to create a copy that's appropriately sized for the screen. Chapter 11 explains how to take this step.

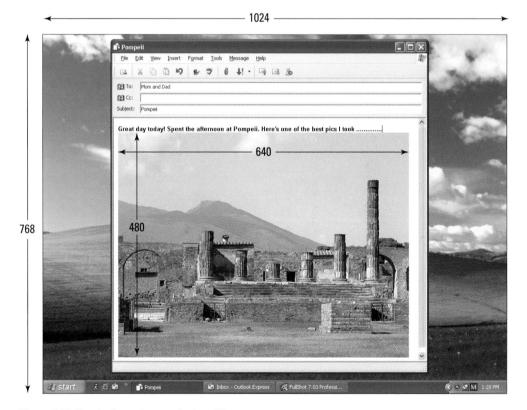

Figure 4-14: You don't need many pixels to fill a computer screen.

A few cameras offer a setting that enables you to record two copies of each image, an original, full-size one for print and one significantly smaller image for on-screen use. And some models offer a built-in photo-editing tool that you can use to create e-mail sized versions of high-resolution images, too. Check your camera manual to find out whether your camera offers these time-saving features.

Pixels and file size

Many factors affect the size of the data file needed to store a digital picture, including the complexity of the scene (the level of detail, the number of colors, and so on). The file format in which the image is stored, usually either JPEG or Raw, explained later in this chapter, also affects file size. But all other things being equal, an image with lots of pixels has a larger file size than a low-resolution image.

Of course, if your digital camera is relatively new, it creates images that contain tons of pixels, which means whopping file sizes. A 10-megapixel photo, for example, has an average file size of about 4.5MB (megabytes) when saved as a high-quality JPEG image.

Large files present the digital photographer with a number of problems:

- ✓ Large files require more storage space. When you're shooting huge files, it doesn't take too long to fill up a camera memory card or computer hard drive. And if you archive your files on CD or DVD, as we recommend, you can wind up with a huge disc collection after only a year or so of shooting. Keep in mind that a CD can hold only 650MB of data; a DVD has a capacity of about 4.7GB, or gigabytes. (One GB equals 1,000MB.)
- Large files take longer for the camera to capture. The more pixels you ask your camera to capture, the longer it needs to process and record the picture file to your memory card. That additional capture time can be a hindrance if you're trying to capture action shots at a fast pace.
- ✓ Large files strain your computer. Large files make bigger demands on your computer's memory (RAM) when you edit them. You also need lots of empty hard drive space for editing because the computer uses that space as temporary storage while it's processing your images.
- Large files are inappropriate for online use. When placed on a Web page or sent via e-mail, photos that contain bazillions of pixels are a major annoyance. First, the larger the file, the longer it takes to download. And if you send someone a high-resolution image in an e-mail, chances are that they won't be able to view the whole image without scrolling. Remember, most computer monitors can display only a limited number of pixels. (See the preceding section for details.)

PPI is not **DPI!**

The capabilities of printers are also described in terms of resolution. Printer resolution is measured in *dots per inch*, or *dpi*, rather than pixels per inch. But the concept is similar: Printed images are made up of tiny dots of color, and dpi is a measurement of how many dots per inch the printer can produce. Generally, the higher the dpi, the smaller the dots, and the better the printed image, although gauging a printer solely

by dpi can be misleading. (Chapter 10 talks more about evaluating printers.)

Some people, including some printer manufacturers and software designers, mistakenly interchange dpi and ppi. But a printer dot is not the same thing as an image pixel. Most printers, in fact, use multiple printer dots to reproduce one image pixel.

All that said, large files are a fact of life if you want to capture images at your camera's highest resolution and quality settings. But do consider whether you *always* need to max out your pixel count. Are you really going to want to print the picture of your grandma's birthday cake or your new car at 8 x 10 inches or larger? If not, dialing down resolution a notch makes sense.

Selecting a File Format

Your camera may offer a choice of file types, or *formats*, in computer lingo. The format determines how the camera records and stores all the bits of data that comprise the photo. And the format you choose affects file size, picture quality, and what types of computer programs you need to view and edit the photo.

Although many formats have been developed for digital images, camera manufacturers have settled — at least for now — on just two: JPEG and Camera Raw. A handful of high-end cameras also offer a third format, called TIFF, although that option has largely been replaced by Camera Raw.

Each of these formats has its pros and cons, and which one is best depends on your picture-taking needs. The next sections tell you what you need to know to make a file-format decision.

Be careful not to confuse your camera's *file format* control with the one that *formats* your camera memory card. The latter erases all data on your card and sets it so that it's optimized for your camera. Don't freak out about this possibility: When you choose the card format option, your camera displays a warning to let you know that you're about to dump data. You get no such message for the file format control.

As for how you select a file format, the process varies from camera to camera, so check your manual. On some cameras, you set the format and resolution together; on others, the two are controlled separately. Either way, the settings typically have vague names, such as Good, Better, Best or, for cameras that control resolution and format together, Large/Fine, Small/Basic, and the like. Chapter 3 offers a few more specifics about dialing in these and other camera settings.

IPEG

Pronounced *jay-peg*, this format is standard on every camera. JPEG stands for *Joint Photographic Experts Group*, the organization that developed the format.

JPEG is the leading camera format for two important reasons:

- ✓ Web- and computer-friendly photos: All Web browsers and e-mail programs can display JPEG images, which means that you can share your pictures online seconds after you shoot them. Furthermore, every image-editing program for both the Mac and Windows supports working with JPEG photos.
- ✓ Small file sizes: JPEG files are *compressed* and, therefore, have smaller file sizes than those captured in the Camera Raw or TIFF formats (explained later). That means that you can store more pictures in your camera's memory as well as on your computer's hard drive or whatever image-storage device you choose. Smaller files also take less time to transmit over the Web.

The drawback to JPEG is that in order to trim file size, it applies *lossy compression*, a process that eliminates some original image data. (Many digital-imaging experts refer to this process as simply JPEG compression.) Heavy JPEG compression can significantly reduce image quality, especially when the image is printed or displayed at a large size.

Figure 4-15 offers an example of the bad things that can happen with excessive JPEG compression. The image takes on a "parquet tile" look and often exhibits random color defects — notice the bluish tinges around the eyelashes and near the jaw line. These defects are known collectively in the biz as *JPEG artifacts* or simply *artifacts*.

Now for the good news: Most cameras enable you to specify the level of JPEG compression that you want to apply. And at the highest-quality setting, the file undergoes only a little bit of compression. The result is a file that provides the benefits of the JPEG format with little, if any, noticeable damage to picture quality, as evidenced by the example in Figure 4-16. Sure, your file size is larger — the high-quality JPEG in Figure 4-16 has a file size of 400K (kilobytes) versus the 33K size of the low-quality version in Figure 4-15 — but what good does that small file size do you if the picture is lousy? Both pictures contain the same number of pixels, by the way, so the quality differences you see are purely a result of compression amounts.

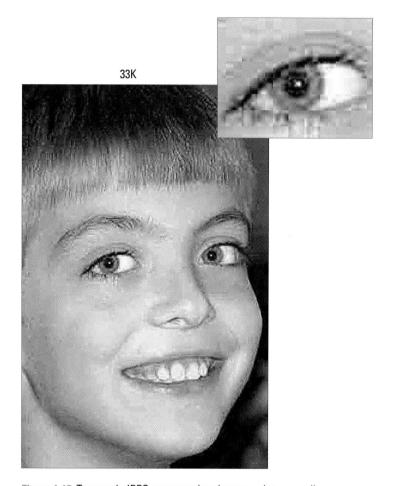

Figure 4-15: Too much JPEG compression destroys picture quality.

To sum up, as long as you stick with the highest quality JPEG file your camera can produce, this format is the right choice for all but the most demanding photographers. (If you fall in the latter camp, explore the Camera Raw format, explained in the next section.) And note that even if you choose your camera's lowest-quality JPEG setting, it's highly unlikely that you'll see the level of destruction shown in Figure 4-15 — the defects in the picture are exaggerated so that you can more easily see what JPEG artifacts look like.

Figuring out which camera setting delivers the top-quality JPEG file requires a look at your camera manual because the options differ between models. Typically, compression settings are given vague monikers: Good/Better/Best or High/Normal/Basic, for example.

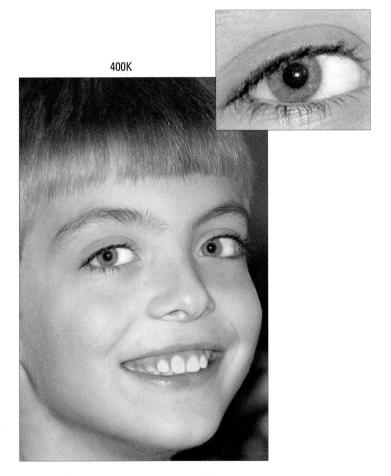

Figure 4-16: But a lightly compressed JPEG produces excellent images while keeping file sizes small.

These names refer not to the amount of compression being applied, but to the resulting image quality. If you set your camera to the Best setting, for example, the image is compressed less than if you choose the Good setting. Also, some cameras may use similar names to refer to image-size (resolution) options rather than JPEG quality options.

You should find a chart in your manual that indicates how many images you can fit into a certain amount of memory at different compression settings. But you need to experiment to find out exactly how each setting affects picture quality. Shoot the same image at all the different settings to get an idea of how much damage you do if you opt for a higher degree of compression.

If your camera offers several resolution settings, do the compression test for each resolution setting. **Remember:** Resolution and compression work together to determine image quality. You usually get away with more compression at a higher resolution. Low resolution combined with heavy compression yields results even a mother couldn't love.

When you edit your images in a photo editor, you can save your altered file in the JPEG format. If you do, though, you apply another round of lossy compression. Each pass through the JPEG compression machine does further damage, and if you edit and save to the JPEG repeatedly, you can wind up with the level of artifacting shown in Figure 4-15. So you should instead save works-in-progress in a format such as TIFF (explained later in this chapter), which does a much better job of preserving picture quality. Should you want to share your edited photo online — which requires a JPEG image — you can create a copy of your final TIFF image and save the copy in the JPEG format. Chapter 11 shows you how.

Camera Raw

When you shoot in the JPEG format, your camera takes the data collected by the image sensor and then applies certain enhancements — exposure correction, color adjustments, sharpening, and so on — before recording the final image. These changes are based on the picture characteristics that the manufacturer believes its customers prefer.

The Camera Raw format, sometimes called simply *Raw*, was developed for photo purists who don't want the camera manufacturer to make those decisions. Camera Raw records data straight from the sensor, without applying any post-capture processes. After transferring the files to a computer, you then use special software known as a raw converter to translate the sensor data into the actual photograph.

Unlike JPEG, Camera Raw is not a standardized format. Each manufacturer uses different data specifications and names for its Raw format. Nikon Raw files are called NEF files, for example, while Canon's versions go by the name CRW or CR2, depending on the camera model.

Whatever the specific name, Raw image capture offers the following advantages:

No risk of JPEG compression artifacts. Unlike JPEG files, Raw files don't undergo lossy compression. That means that when you "shoot Raw," you don't have to worry about the quality loss that can sometimes occur with JPEG compression. Again, though, as long as you stick with your camera's highest-quality JPEG setting, you may have difficulty detecting much difference in quality between the JPEG and Raw version of an image unless you greatly enlarge the photo.

- data in a raw converter, you can specify characteristics such as brightness, color saturation, sharpness, and so on, instead of dining on whatever the JPEG version might serve up. To keep up the cooking analogy, imagine that you put together a special dish and you realize after it comes out of the oven that you accidentally used cayenne pepper when your recipe didn't call for any. If your dish were like a Raw file, you'd be able to go back to the beginning of your cooking session and remove the pepper. With JPEG, that pepper would be a done deal. And that's what photographers like about Raw files captured in this format give you much more control over the final look of your images.
- bit of a photographic safety net. Suppose that you don't get the exposure settings quite right, for example, when you shoot a picture. With JPEG, the camera decides how brightly to render the shadows and highlights, which can limit you in how much you can retouch that aspect of your picture later. With Raw, you can specify what brightness value should be white, what should be black, and so forth, giving you greater ability to achieve just the image brightness and contrast you want a benefit that's especially great for pictures taken in tricky light.
- Higher bit depth. Raw files typically have a greater bit depth than JPEG files. The sidebar "A bit about bit depth" (earlier in the chapter) explains this concept in detail, but the short story is that the more bits you have, the more color and tonal information the image can contain. Of course, whether or not you will be able to spot any difference depends on the subject matter. But again, starting with a higher bit depth can give you an added level of flexibility if you decide to edit the photo.

Of course, like most things in life, the benefits of Raw do come at a price. First, most low-priced cameras don't offer the format. But Raw also costs you in the following ways, which may be enough for you to stick with JPEG even if your camera is dual-natured in terms of file format:

Raw files require some post-capture computer time. You can't take a Raw image straight from the camera and share it online, add it to a text document, use it in a PowerPoint presentation, retouch it in a photo editor, or, well, do much of *anything* with it until you process it in a Raw converter. Some photo programs provide a tool that handles this conversion in the background, requiring little input from you, but if you want to enjoy the added control that shooting Raw gives you, you need to use a converter than enables you to specify all the critical image characteristics: color, sharpness, contrast, and so on, and that takes time. Either way, after the conversion, you save a copy of the processed Raw file in a standard file format, such as TIFF (explained in the next section).

Chapter 8 details the conversion process. For now, just understand that if you're not too keen on computers. Raw may not be for you.

✓ You may not be able to view thumbnails of your images on your computer without converting them, either. If you're used to looking at thumbnails of your photos in Windows Explorer, for example, or iPhoto on the Mac, you may not be able to do so with Raw files, depending on the camera make and model. You will still see the Raw filenames, but no image thumbnails.

However — and here's some good news — most camera companies offer their own image-browsing software for free. (Look on the CD that came with vour camera.) You should be able to view and maybe even print Raw images by using those manufacturer-created programs — just not in most third-party programs.

You may need to buy a separate Raw converter program. Some camera companies include a good raw-conversion tool on the software CD that ships with the camera. But others provide only a minimally equipped converter for free, enabling you just to change from Raw to JPEG but using only a standard set of conversion settings, with no control over specific image characteristics. So you may need to buy a third-party program to really take advantage of the picture control that Raw offers.

If you already own a photo-editing program, however, check to see whether it offers a converter. For example, Adobe Photoshop Elements provides a very capable converter. Note that some photo programs are especially designed to speed up the Raw conversion process, and some programs offer more picture controls than others. So shop around and investigate all your options before you buy.

If your software has a Raw converter but balks at opening the Raw files from your camera, check the software manufacturer's Web site. You may need to download an update that provides a Raw-file translator for your model of camera. (Note that some software companies are quicker than others at posting updates when new camera models are released.)

Raw files are larger than JPEG files. Again, Raw files aren't compressed, so they can be significantly larger than JPEG files, even if you capture the JPEG image at the lowest possible amount of compression. So you can store fewer Raw files on a memory card than JPEG files. (If your camera offers the Raw format, the manual should provide details on the size of its Raw files vs. JPEG versions.) In addition, because you probably want to hang onto your original Raw files after you convert them, just for safety's sake, you ultimately wind up with at least two copies of each image — the Raw original and the one that you converted to a standard format.

In short, because of the added complication of working with Raw files, you're probably better off sticking with JPEG if you're a photo-editing novice, a computer novice, or both. Frankly, the in-camera processing that occurs with JPEG is likely to produce results that are at least as good as, if not better, than what you can do in your photo editor if you're not skilled at the task. (Just remember the earlier warning about saving files that you edit in the TIFF format instead of JPEG.)

Some cameras offer a setting called Raw+JPEG (or Raw+Basic, or something similar). With this option, the camera creates both a Raw file and a JPEG file so that you have a version of the image that you can use immediately and another that you can use if you're inclined to spend hours editing it. Of course, you consume even more camera memory with this option because you're creating two files — and later, you'll have yet one more file after you process the Raw file on your computer.

In addition, a few cameras now offer an in-camera converter that creates a converted copy of your Raw file and then saves the copy to your memory card. You can usually specify just a few image characteristics, however; and of course, you have to judge the settings you choose based on what you see on the camera monitor. Still, this is a convenient option when you want to share an image right away, and you don't have the time or opportunity to do the job on your computer.

DNG: Format of the future?

Adobe Systems offers another digital-image file format, DNG. Short for Digital Negative Format, DNG was created in response to growing concerns about the fact that every camera manufacturer uses its own, specially engineered flavor of Camera Raw. This Photo Tower of Babel makes it difficult for software designers to create programs that can open every type of Raw file, which in turn makes it difficult for people to share Raw files. That issue isn't a huge problem for the average consumer, but it's a pain for professionals who must work with Raw images from many photographers. In addition, the possibility exists that future software may not support earlier generations of Raw files, leaving people with images they can no

longer open (think Betamax videotapes and 8-track audio recordings).

The idea of DNG is to create a standard rawdata format that all camera manufacturers can embrace. That goal is still being pursued by Adobe, but if you want to translate your current Raw files to DNG, the Adobe Web site (www. adobe.com) offers a free converter that can handle files from many current digital cameras. Of course, there's no guarantee that DNG will be around 100 years from now, either, and most photo software can't yet open DNG files. But with Adobe backing the format, it's a reasonable bet that DNG will one day be as common as JPEG or TIFF.

TIFF

The third player in the image file format game is TIFF, which stands for *Tagged Image File Format*, in case you care, which you really shouldn't. Like Camera Raw, TIFF is a *lossless* image format, meaning that it retains your picture at its highest quality — as opposed to JPEG's lossy compression, which can dump critical image data. TIFF has long been the standard format for images destined for professional printing, where the highest quality is required.

Before the emergence of Camera Raw, some high-end cameras offered TIFF as an alternative to JPEG. Most cameras, now, though, don't offer the option to record images as TIFF files. Instead, TIFF is a "destination" format: You save an edited JPEG file in TIFF format, for example, so that no more compression and data loss occur. Or, if your camera offers the ability to save files in the Camera Raw format, you can save them in TIFF format after you process them so that you preserve the best image quality. Chapter 9 explains the process of saving in the TIFF format.

TIFF does present two problems: First, TIFF files are much larger than JPEG files. In addition, Web browsers and e-mail programs can't display TIFF photos. If you do want to share a TIFF file online, you need to open the file in a photo editor and save a copy of it in the JPEG format. (Chapter 11 tells you how.)

Controlling Exposure

In This Chapter

- Understanding aperture, shutter speed, and ISO
- Choosing an exposure mode: automatic, manual, or in-between?
- Getting the best autoexposure results
- Taking advantage of advanced exposure controls
- Using flash in new ways

etting a grip on the digital characteristics of your camera — resolution, white balance, and so on — is critical. But don't get so involved in these new picture-taking issues that you overlook the traditional fundamentals such as proper exposure and lighting. All the megapixels in the world can't save a picture that's too dark or too light.

This chapter tackles all things exposure-related, explaining such basics as how shutter speed, aperture, and ISO affect your pictures. Also look here for information about advanced exposure features, such as shutter-priority autoexposure, along with general tips to help you manipulate exposure to meet your creative goals.

Lights, Camera, Exposure!

As Chapter 4 explains, a digital photo is created when light passes through the camera lens and strikes the image sensor, which is a light-sensitive computer chip. The overall brightness and contrast of the resulting image depends on three main factors:

- ✓ The f-stop, or aperture setting, which controls the amount of light that strikes the image sensor.
- ✓ The *shutter speed*, which determines the length of time the light is allowed to hit the sensor.
- ✓ The ISO setting, which controls how sensitive the image sensor is to light.

How much control you have over these settings depends on your camera. On digital SLRs and some high-end point-and-shoot models, you get full manual exposure control and can adjust all three settings as you see fit. On lower-priced cameras, your options usually are more limited, with the camera handling most or all of the exposure decisions for you.

Either way, though, taking a closer look at these three exposure factors will help you better understand the possibilities and limitations of your camera. To that end, the next section explains f-stops and shutter speed; following that, you can explore the ins and outs of ISO.

Aperture, f-stops, and shutter speed

After light enters the camera lens, it must make its way past two barriers before reaching the image sensor. These light gatekeepers are called the *aperture* and the *shutter*.

Although the exact design of the system varies from camera to camera, Figure 5-1 offers an illustration of the basic concept. Just behind the lens is the aperture. which is a hole in an adjustable diaphragm. Light passes through that hole to the shutter, which serves the same purpose as shutters on a window: Normally, the shutter is closed, preventing light from reaching the image sensor. When you press the shutter button, the shutter opens briefly to let the light in, as shown in the figure, and the sensor records the image. (Chapter 4 offers more details on how the magic of turning light into a picture actually happens, if you're interested.)

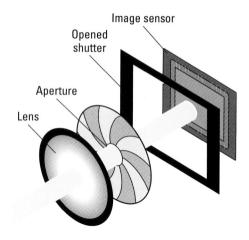

Figure 5-1: The aperture and shutter control how much light strikes the image sensor.

By controlling the aperture size and the length of time the shutter remains open, you can vary the amount of light that strikes the sensor, and thus control exposure. But the f-stop and shutter speed affect other aspects of your pictures, too, and recognizing those side effects is important to choosing settings that will produce the picture you have in mind. Here are the details you need to know:

✓ **Aperture (f-stop):** The size of the aperture is measured in f-numbers, more commonly referred to as *f-stops*. Standard aperture settings are f/2.8, f/4, f/5.6, f/8, f/11, f/16, and f/22, but the range of f-stops provided

varies from camera to camera, or, on an SLR-type model, on the lens attached to the camera.

Contrary to what you may expect, the higher the f-stop number, the smaller the aperture and the less light that enters the camera. Each f-stop setting lets in half as much light as the next lower f-stop number. For example, the camera gets twice as much light at f/11 as it does at f/16. (And here you were complaining that computers were confusing!) Where do the numbers come from? Well, let's just say that this setup is based in a series of complex math calculations that won't affect your photos much beyond understanding knowing these basics. See Figure 5-2 for an illustration that may help you get a grip on f-stops.

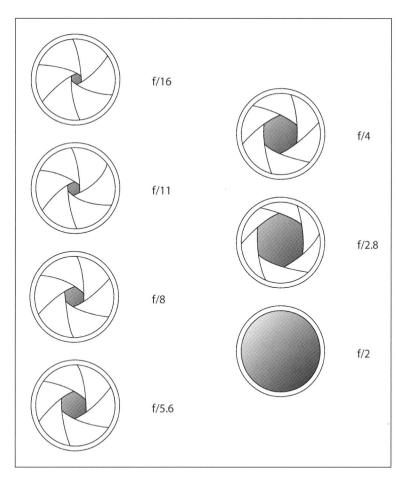

Figure 5-2: As the f-stop number decreases, the aperture size grows and more light enters the camera.

Along with altering exposure, the aperture setting also affects *depth of field,* or the distance over which objects in the picture appear sharply focused. Chapter 6 explores depth of field in detail; for now, just know that the higher the f-stop, the greater the depth of field. Figure 5-3 illustrates this issue. Notice that the background in the left image, captured at an f-stop of f/5.6, is much softer than its sibling, taken at f/16.

f/5.6, shallow depth of field

Figure 5-3: A higher f-stop increases depth of field (the zone of sharp focus).

You can use this aperture side effect to your creative advantage: For example, if you're shooting a landscape and want to keep both near and distant objects as sharply focused as possible, you choose a high f-stop number (a smaller aperture opening). Or, if you're shooting a portrait and want objects in the background to be softly focused, you choose a low f-stop number, which opens the aperture and reduces depth of field.

✓ **Shutter speed:** *Shutter speed* refers to the length of time the shutter stays open after you press the shutter button. Shutter speeds are measured in fractions of a second. A shutter speed of 1/60, for example,

means that the shutter opens for one-sixtieth of a second. The range of shutter speeds available to you depends on your camera; check the back of your manual for the scoop.

On most cameras, a shutter speed number that appears with an inches mark indicates a speed of one second or above. For example, 4" indicates a four-second shutter speed.

Like the aperture setting, shutter speed also affects the apparent focus of your image, but in a different way. Shutter speed determines whether any moving objects in the scene appear blurry or sharp. A fast shutter speed "freezes" action; a slow shutter speed blurs motion. In Figure 5-4, for example, a shutter speed of 1/60 second left the jumping children blurry. Setting the shutter speed to 1/300 second caught them cleanly in mid-jump. The speed you need to stop action depends on how fast your subject is moving, however.

1/60 second

Figure 5-4: In addition to affecting exposure, shutter speed determines whether moving objects appear blurry.

Here's one other critical shutter-speed factoid: For very slow shutter speeds, you should use a tripod or otherwise steady the camera so that it doesn't move during the exposure. Otherwise, camera shake during the time the shutter is open can cause the whole photo to be blurry. The length of time that people can successfully handhold a camera varies, so experiment to see where you enter the danger zone. Also turn on image stabilization, if your camera or lens offers it; that feature can enable sharper handheld shots at slower shutter speeds. (Check your manual, though, to find out whether you should turn off image stabilization when using a tripod; in some cases, the feature can actually cause blur in tripod shots.) Chapter 6 discusses this whole issue in more detail.

On cameras that offer manual aperture and shutter speed control, you can choose to manipulate just one of the two settings or adjust them in tandem to capture just the right amount of light.

Why would you want to do this? Here's one example: Let's say that it's around noon on a bright, sunny day, and you want to take a stop-action sports picture that requires at least a 1/500-second shutter speed. So you then choose an aperture setting that lets in the right amount of light to expose the picture at that shutter speed. If you want to take the same photo near twilight, and you want to stick with that 1/500-second shutter speed, you must open the aperture to a wider setting (lower f-stop number) to compensate for the fact that you're now shooting in less light. (You alternatively could increase the camera's light sensitivity by increasing the ISO setting, but that option carries some risks, as explained in the next section.)

Note that some digital cameras don't use a traditional shutter/aperture arrangement to control exposure, however. Instead, the chips in the image-sensor array simply turn on and off for different periods, thereby capturing more or less light. But even on cameras that use this alternative approach, the camera's capabilities are usually stated in traditional terms. For example, you may have a choice of two exposure settings, which may be labeled with icons that look like the aperture openings shown in Figure 5-2. The settings are engineered to deliver the *equivalent* exposure that you would get with a camera using the same f-stop.

150 ratings and chip sensitivity

With the aperture setting (f-stop) and shutter speed, you control how much light makes its way from the camera lens to the image sensor. But the final exposure that results from your chosen f-stop and shutter speed depends on the light sensitivity of the camera's image sensor.

Light sensitivity for both film and digital camera sensors is stated in *ISO numbers*. ISO stands for the *International Standards Organization*, which is the group that developed the light-sensitivity specifications. (Years ago, it was ASA, for *American Standards Association*, but for once the world decided to agree on something, and now we have ISO.)

Film geared to the consumer market typically offers ratings of ISO 200, 400, or 800. The higher the number, the more sensitive the film, or, if you prefer photography lingo, the *faster* the film. And the faster the film, the less light you need to capture a decent image. The advantage of using a faster film is that you can use a faster shutter speed, a smaller aperture, or shoot in dimmer lighting — or all three — than you can with a low-speed film. On the downside, photos shot with fast film sometimes exhibit noticeable *grain*, which gives the pictures a speckled appearance.

With a digital camera, you don't swap out sensors as you swap film on a film camera to change the ISO. Instead, the camera has an ISO control that boosts or decreases the sensor's light sensitivity. Some point-and-shoot cameras handle ISO for you automatically, adjusting the ISO setting according to the current light. ISO may also be adjusted behind the scenes when you shoot in certain automatic scene modes, such as a Sports mode or Nighttime Portrait mode. But many digital models today allow you to set a specific ISO number, such as 100, 200, 400, 800, 1600, and even higher.

Unfortunately, raising the ISO setting on a digital camera boosts the electronic signal that's produced when you snap a picture. And that extra signal power usually results in *noise* — the digital equivalent to the added grain that you get when you use a higher ISO film. So just as with film, the lower the ISO number, the better the picture quality.

Figures 5-5 and 5-6 illustrate the impact of ISO on quality, showing the same subject captured at ISO 200, 400, 800, and 1600. When you print pictures at a small size, as in Figure 5-5, noise may not be apparent to the eye; instead, the image may have a slightly blurry look, as in the ISO 800 and 1600 examples in Figure 5-5. Figure 5-6 shows close-up views of each image so that you can more easily compare the loss of detail and increase in noise.

Of course, for some shooting scenarios, you may be forced to use a higher ISO. For example, if you're trying to capture a moving subject in less than ideal lighting, you may need to raise the ISO in order to use the fast shutter speed necessary to freeze the action.

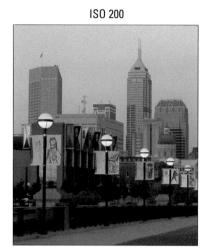

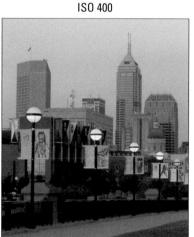

ISO 800

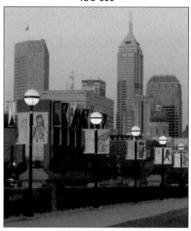

ISO 1600

Figure 5-5: Raising the ISO setting increases light sensitivity, but also can produce a defect known as *digital noise*.

It's important to note, too, that the examples you see here illustrate noise produced by a specific camera. Some cameras, especially newer models, produce much better high-ISO images than others. Bottom line: Experiment with ISO settings if your camera gives you control over this feature. Then evaluate your test shots to see how much quality you can expect to give up when you raise ISO. And if you're in the market for a new camera, read reviews to find out how models you're considering perform at different ISO settings.

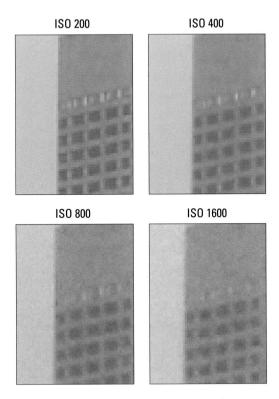

Figure 5-6: Noise becomes more apparent when you enlarge images.

Finally, if your camera gives you a choice between automatic ISO adjustment and manual ISO control, stick with manual. In automatic mode, the camera may ramp up the ISO to a point that produces more noise than is acceptable to you. Some cameras do allow you to limit the top ISO that can be selected in auto mode or to specify the shutter speed at which ISO increase occurs, which makes Auto ISO a little more palatable. But if you're a stickler for image quality, it's better to control this aspect of your picture-taking yourself.

So how do 1 set f-stop, shutter speed, and 150?

The exact steps you take to change your camera's f-stop, shutter speed, and ISO vary from camera to camera, of course. If your camera offers only automatic exposure, you may not even have any control over these settings.

However, even if your camera is fully automatic, you may still have some input over the final exposure; you may be able to request a slightly darker or brighter image through a feature called exposure compensation, for example. Keep cruising through this chapter for a look at all the possibilities and then check your manual to see what's possible.

If you own a digital SRL, you can choose to work in autoexposure mode, manual exposure mode, or "semi-automatic" mode, where you select the shutter speed and the camera selects the appropriate f-stop (or vice versa). Some high-end point-and-shoot models also offer manual and semi-automatic exposure modes. Again, the level of control you have in the non-manual modes varies, so again, look for your camera instruction book.

Also check that book to find out how the camera indicates to you the current exposure settings. On a digital SLR, you typically see the current shutter speed, f-stop, and ISO in the viewfinder display, as shown on the left side of Figure 5-7. Some cameras also display the settings in the camera monitor, as shown on the right. And with some cameras, such as the Canon model used to create the images in the figure, you can check exposure settings either way. (The viewfinder and monitor may also display several other pieces of information related to other camera settings, as they do here.)

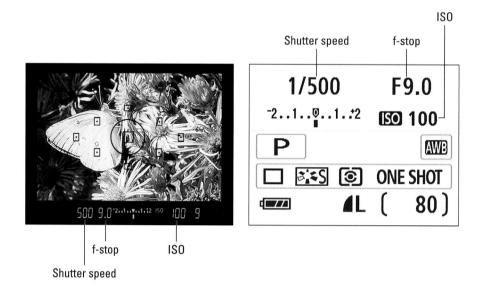

Figure 5-7: You may be able to view exposure settings in the viewfinder or on the monitor display.

If you use a point-and-shoot camera, you may only be able to view the current settings on the monitor, even if the camera has a viewfinder. And if you have a very basic, fully automatic camera that handles exposure for you, you may not be able to view the aperture and shutter speed settings at all until *after* you take the picture and download it to your computer. Then you can open the photo in a program that can read the camera *metadata*, which records the settings you used to take the picture. See Chapter 8 for more about viewing metadata. Doing so, by the way, is a great way to learn more about how aperture, shutter speed, and ISO affect the look of your pictures.

Finally, remember that if your camera offers lots of different exposure modes — full automatic, manual, semi-automatic, and specialty modes such as Portrait and Landscape — the aspects of exposure that you can control depend on the mode you choose. See the next section for a rundown of the standard exposure modes for an overview of this issue.

Choosing an Exposure Mode

Many digital cameras today offer you a choice of *exposure modes*. The mode you choose affects the level of control you have over shutter speed, f-stop, and ISO.

You may be able to select the exposure mode from a camera menu. Or your camera may sport a mode dial like the one shown in Figure 5-8, which is the type found on some Nikon dSLRs. The initials and symbols that represent the different modes vary from camera to camera, of course (although some have become almost universal, such as a picture of a flower representing Close-up mode).

Figure 5-8: Exposure modes are typically represented by symbols such as you see here.

Wherever and however you access them, exposure modes can be broken down into a few standard categories:

Full automatic: In this mode, the camera takes care of all aperture and shutter speed decisions for you. You may or may not be able to adjust ISO. Whether or not you can use flash also depends on the camera; some models enable flash only if the camera thinks extra light is needed.

You may not be able to *disable* flash, either; if the camera says you need flash, you're stuck with it, even if your creative eye says differently.

Certain other camera options, such as those affecting color or file format, may also be off limits. For example, some cameras don't enable you to shoot in the Camera Raw format in automatic exposure mode. (Chapter 4 explains file formats.)

Automatic scene modes: These modes are designed to automatically select the right exposure settings for different types of subjects: portraits, landscapes, sports pictures, and so on. Many times, scene modes also adjust color, contrast, and sharpness according to the subject as well. As with full automatic mode, you normally give up control over flash and some other camera options.

If you're interested in exploring scene modes, Chapter 3 describes the most common ones and tells you of specific pitfalls you may encounter when you use them.

Semi-automatic modes: The two standard modes in this category, shutter-priority autoexposure and aperture-priority autoexposure, ask you to specify one-half of the f-stop/shutter speed equation. The camera then assists you by selecting the other half. For example, if you set the camera to shutter-priority autoexposure, you dial in the shutter speed you want, and the camera than chooses the appropriate f-stop to expose the image properly at your chosen shutter speed. The camera makes that calculation based on the current ISO setting.

In addition to offering more control over exposure, these modes typically free you to adjust all the other camera settings (color options, file format, and so on).

Manual exposure: In this mode, you specify f-stop, shutter speed, and ISO. After you become experienced in the ways of these controls, manual mode is often the fastest way to manipulate exposure. And even in manual mode, most cameras display some sort of meter to let you know whether you're on-target with your settings.

Depending on your camera, you may have access to several other variations on these themes. Some models offer something called *flexible programmed autoexposure* or *variable programmed autoexposure*, (usually represented by the letter P, as in Figure 5-8). In this semi-automatic mode, the camera presents you with several different combinations of f-stop and shutter speed, all guaranteed to deliver a good exposure. You then can choose the combination that best matches your creative goals. And many Canon cameras offer a mode called A-DEP, which attempts to choose an f-stop that results in a depth of field that keeps all objects in the frame in sharp focus. (A-DEP stands for *automatic depth of field*.)

The next section offers some tips for getting good results in any of the automatic modes. Following that, you can find tips on using aperture-priority autoexposure and shutter-priority autoexposure.

Getting good autoexposure results

Today's autoexposure mechanisms are incredibly capable. But in order for the feature to work correctly, you need to take this three-step approach to shooting pictures:

- 1. Frame your subject in the viewfinder or monitor.
- 2. Press the shutter button halfway and hold it there.

The camera analyzes the scene and selects initial exposure settings. If you're working in autofocus mode (covered in the next chapter), focus is set at the same time. After the camera makes its decisions, it signals you in some fashion — usually with a light near the viewfinder or with a beep.

3. Press the shutter button the rest of the way to take the picture.

Normally, autoexposure works well if you use this technique. But a few points are worth noting:

- On some cameras, exposure is locked at the point you press the shutter button halfway. On other models, the camera continues to monitor the light and continually adjusts the exposure settings as necessary up to the point at which you fully depress the shutter button. If you want to lock exposure at a certain setting on this second type of camera, you can switch to manual exposure, if your camera offers that option. Or your camera may offer a feature called *autoexposure lock* or *AE lock*, which enables you to lock in the exposure settings before the shutter button is pressed all the way. Using autoexposure lock can be a little cumbersome, though, so using manual exposure is often easier if you want to specify certain exposure settings.
- Check your camera to find out how it warns you if it can't select any combination of exposure settings that will produce a good image. Some models beep at you or display a flashing light; others display a warning screen on the monitor.
- ✓ The exposure settings that the camera's autoexposure system selects are based on the current *metering mode*. That's just a fancy name for the control that determines which part of the screen the camera analyzes when calculating exposure. See the upcoming section "Exposure metering modes" for more information.

If you're not happy with your autoexposure results, find out whether your camera offers a feature called *exposure compensation*. Described later in this chapter, this option enables you to tell the camera that you want a darker or lighter picture than the autoexposure system delivered.

Using "priority" exposure modes

In addition to regular autoexposure modes, where the camera sets both aperture and shutter speed, your camera may offer *aperture-priority* autoexposure or *shutter-priority* autoexposure.

On some cameras, aperture-priority autoexposure is abbreviated as A; on others, Av. The a, of course, stands for aperture; the v stands for value. Shutter-priority autoexposure is abbreviated either by the letter S or Tv, for time value. (Shutter speed determines the exposure time.) Oh, and if you see the letters AE, as you will if you read many photography magazines, it's an abbreviation for autoexposure.

Whatever they're labeled, these options offer more control while still giving you the benefit of the camera's exposure brain. Here's how they work:

Aperture-priority autoexposure: This setting gives you control over the aperture (f-stop). After setting the aperture, you frame your shot and then press and hold the shutter button halfway as you do when shooting in fully automatic mode. But this time, the camera checks to see what aperture you chose and then selects the shutter speed necessary to correctly expose the image at that f-stop, taking the current ISO setting into account when making its decision.

By altering the aperture, you change depth of field — the range of sharp focus. The section, "Aperture, f-stops, and shutter speed," earlier in this chapter, explores this relationship between aperture and depth of field. Aperture isn't the only way to adjust depth of field, though, so see Chapter 6 for the whole story.

✓ **Shutter-priority autoexposure:** In shutter-priority mode, you choose the shutter speed, and the camera selects the correct f-stop. This mode is good for times when your scene contains moving objects because shutter speed determines whether those objects appear blurry or are "frozen" in place. See the same aforementioned section for more details about shutter speed.

Assuming that your ISO value doesn't change, you theoretically should wind up with the same exposure no matter what aperture or shutter speed you choose, because as you adjust one value, the camera makes a corresponding change to the other value, right? Well, yes, sort of. Remember that you're working with a

limited range of shutter speeds and apertures (your camera manual provides information on available settings). So depending on the lighting conditions, the camera may not be able to properly compensate for the shutter speed or aperture that you choose.

Suppose that you're shooting outside on a bright, sunny day. You take your first shot at an aperture of f/11, and the picture looks great. Then you shoot a second picture, this time choosing an aperture of f/4. The camera may not be able to set the shutter speed high enough to accommodate the larger aperture, which means an overexposed picture.

Here's another example: Say that you're trying to catch a tennis player in the act of smashing a ball during a gray, overcast day. You know that you need a high shutter speed to capture action, so you switch to shutter-priority mode and set the shutter speed to 1/500 second. But given the dim lighting, the camera can't capture enough light even with the aperture open to its maximum setting. So your picture turns out too dark unless you increase the ISO setting, making the camera more sensitive to light.

As long as you keep the camera's shutter speed and aperture range in mind, however, switching to shutter-priority or aperture-priority mode is a great way to expand your creative control over your photos until you're ready to move up to manual-exposure mode. So try them out in the following scenarios:

- ✓ You're trying to "stop" action and require a specific shutter speed. In this case, the shutter speed is your top *priority*, so choosing *shutter-priority* autoexposure is a good choice. In dim lighting, remember that you may need to raise the ISO value in order to use a really fast shutter speed.
- You want moving objects to be blurred so that you convey a sense of motion. When shooting fountains and waterfalls, for example, you can give the water a misty look by slowing down the shutter, as shown in Figure 5-9. The shutter speed for the left image was 1/200 second; the right image, 1/20 second. Here again, shutter speed is critical to the look of your photo, so shutter-priority autoexposure is the right choice.
 - For a very slow shutter speed, use a tripod or set your camera on something that's not moving (like a rock or a ledge just be careful that your camera doesn't fall off!). If you try to handhold the camera at slow shutter speeds, camera shake during the exposure may result in blurring of the entire scene.
- ✓ You want to control depth of field. Depth of field, as you may remember if you read the first part of this chapter, determines the distance over which objects in the scene stay sharply focused. And one way to

control depth of field is via the aperture setting (f-stop). So if depth of field is your primary creative concern, set the camera to aperture-priority mode and dial in the f-stop that gives the depth-of-field result you're after. Do be careful to also monitor the shutter speed that the camera selects, however, making sure that it doesn't drop so low that you risk blurring the image due to camera shake. If that happens, you can either increase the ISO, which should allow a faster shutter speed, or grab a tripod.

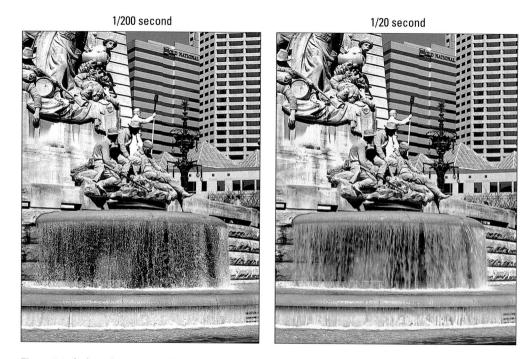

Figure 5-9: A slow shutter speed blurs motion, giving the water a softer, mistier look.

Exploring Even More Exposure Features

Depending on your camera, you may have access to a slew of other exposurerelated options. The next several sections describe the most common of these features.

Exposure metering modes

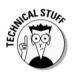

Many cameras offer a choice of exposure *metering modes*. (Check your manual to find out what buttons or menu commands to use to access the different modes.) In plain English, *metering mode* refers to the way in which the camera's exposure mechanism *meters* — measures — the light in the scene while calculating the proper exposure for your photograph. The typical options are as follows:

- Matrix metering: Also known by other names, including multizone metering, evaluative metering, or pattern metering, this mode divides the image frame into a grid (matrix) and analyzes the light at many different points on the grid. The camera then chooses an exposure that best captures both shadowed and brightly lit portions of the scene. This mode is typically the default setting and works well in most situations.
- ✓ Center-weighted metering: When set to this mode, the camera measures the light in the entire frame but assigns a greater importance weight to the center of the frame. Use this mode when you're more concerned about how stuff in the center of your picture looks than stuff around the edges. (How's that for technical advice?)
- ✓ **Spot metering:** In this mode, the camera measures the light only at the center of the frame. Or, on some high-end cameras, you can shift where the metering spot is located in the frame.

Spot and center-weighted metering are especially helpful when the background is much brighter or darker than the subject. In matrix metering mode, your subject may be under- or overexposed because the camera adjusts the exposure to account for the brightness of the background.

Figure 5-10 offers an example. The left image was taken using matrix metering. Because the camera saw so much darkness in the frame, it used an exposure that left the white rose very overexposed — almost no detail remains in the petals.

Changing to spot metering corrected the white rose, but left the red rose too dark, as shown in the middle image. For this scene, center-weighted metering produced the best exposure balance. However, if that red rose were out of the picture, the spot-metering image would be preferable because the white rose retains more detail.

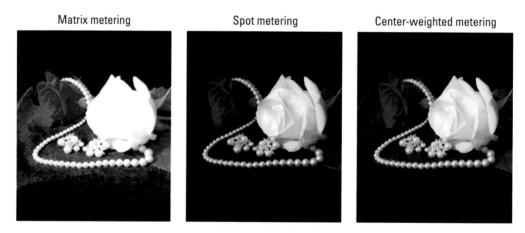

Figure 5-10: Try center-weighted or spot metering when your subject is much darker or lighter than the background.

Of course, when you switch to spot or center-weighted metering, your background may become too dark or too bright. On some newer cameras, you may find an option that brightens the shadows without also making the highlights too bright — Nikon calls this feature Active D-Lighting, for example, and Canon calls it Highlight Tone Priority. But if your camera doesn't offer such options, you just have to choose which part of the scene is the most important, exposure-wise.

Keep in mind, too, that you can correct minor lighting and exposure problems in the photo-editing stage. Generally speaking, making a too-dark image brighter is easier than correcting an overexposed (too bright) image. So if you can't seem to get the exposure just right, opt for a slightly underexposed image rather than an overexposed one.

Exposure histograms

Many digital cameras today can display on the monitor a *histogram*, which helps you evaluate the exposure of an image during playback.

The histogram is simply a chart that plots out the brightness values for all the pixels in your photo. You can see a sample histogram, along with the photo it represents in Figure 5-11. The horizontal axis of the chart displays brightness values, with shadows on the left and highlights on the right. The vertical axis shows you how many pixels fall at each brightness value. So a spike at any point indicates that you have lots of pixels at that particular brightness value.

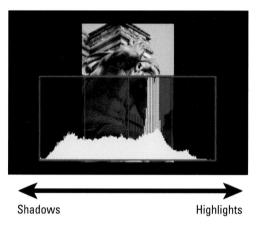

Figure 5-11: A histogram plots out the brightness values of all pixels in your image.

By reading the histogram, you can quickly see whether your picture may be underexposed (too dark) or overexposed (too light). Why not just see how the picture looks in the monitor, you ask? Because the photo may look brighter or darker than it actually is depending on the ambient light in which you view it and on the inherent brightness of the monitor itself. A histogram, on the other hand, is a scientific measurement of the actual image brightness. In fact, for some professional photographers, the histogram has replaced the light meter as a better on-the-fly measurement and representation of what they're shooting.

Normally, a histogram that resembles a bell-shaped curve, or something that looks close to it, is good because well-exposed photos typically contain more *midtones* (areas of medium brightness), accented by highlights and shadows. This isn't true exclusively, of course, and sometimes you may want more shadow or highlight in an image depending on your subject.

However, if you look at your camera's histogram and it has a big spike to the left, it may be that your photo is too dark, in which case you need to adjust your exposure settings or add a flash. If it's spiked to the right, your photo may be too bright, and you may need to use a faster shutter speed or a higher f-stop (or both). It's normal to have a few odd spikes here and there, though; don't demand that every image be a perfect curve. In other words,

a histogram is a general guideline and reference tool, not an absolute determining factor for how your image needs to be adjusted. Sorry, you statisticians out there — we're talking art here!

Exposure compensation

Whether you're working in fully automatic mode, an automatic scene mode, or using shutter- or aperture-priority mode, you may be able to tweak the exposure by using *exposure compensation*, often referred to as EV (*exposure value*) compensation. This control bumps the exposure up or down a few notches from what the camera's autoexposure computer thinks is appropriate.

How you get to the exposure compensation settings varies from camera to camera. But you typically choose from settings such as +0.7, +0.3, 0.0, -0.3, -0.7, and so on, with the 0.0 representing the default autoexposure setting. (If you're an old-school photographer, it may help you to know that these settings represent exposure stops. For example, EV -0.3 reduces the exposure by one-third of a stop.)

Regardless of how you access the EV control, the adjustment works the same way:

- ✓ To produce a brighter image, raise the EV value.
- To produce a darker picture, lower the EV value.

Different cameras provide you with different ranges of EV options, and the extent to which an increase or decrease in the value affects your image also varies from camera to camera. But Figures 5-12 through 5-14 give you an idea of the impact you can make with EV compensation.

The image in Figure 5-12 shows the exposure that the camera created at EV 0.0. The two images in Figure 5-13 show the same shot taken with negative EV values. Figure 5-14 shows what happened with positive EV values.

Figure 5-12: The original autoexposure setting produced an image that is a little too bright.

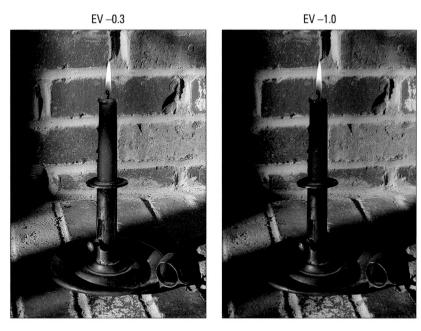

Figure 5-13: To produce a darker image than the autoexposure meter delivers, lower the EV value.

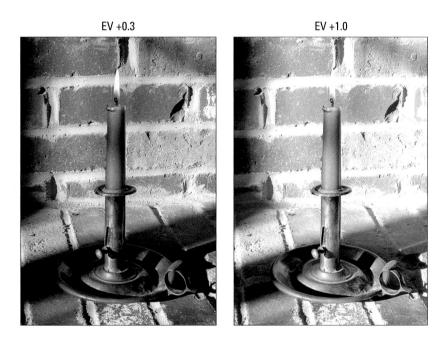

Figure 5-14: For a brighter image, raise the EV value.

The candle scene points out the benefits of exposure compensation. Suppose that you wanted an exposure dark enough to allow the candle flame to create a soft glow and to capture the contrast between the shadowed background areas and the bands of strong afternoon sunshine filtering into the scene. If the non-adjusted exposure (EV 0.0) turns out to be a bit brighter than you had in mind, you can just play with the EV values until you come up with a mix of shadows and highlights that suit your taste.

Don't forget that if your camera offers a choice of metering modes, you may want to experiment with changing the metering mode as well as using EV adjustment. Adjusting the metering mode changes the area of the frame that the camera considers when making its exposure decision. The candle image was taken using matrix metering mode, which bases exposure on the entire frame

Exposure bracketing

Your camera's monitor gives you a good idea of whether your image is properly exposed. But don't rely entirely on the monitor because it doesn't provide an absolutely accurate rendition of your image. Your actual image may be brighter or darker than it appears on the monitor, especially if your camera enables you to adjust the brightness of the monitor display.

If your camera offers a histogram, explained a few sections ago, you can get a more accurate idea of exposure. Still, to make sure that you get at least one correctly exposed image, try to *bracket* your shots if your camera offers exposure-adjustment controls. Bracketing means to record the same scene at several different exposure settings, usually one brighter and one darker than your main shot, as shown in Figure 5-15.

How you accomplish bracketing depends on what exposure modes are available to you:

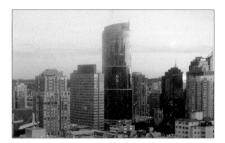

Figure 5-15: Automatic bracketing records the same subject several times, using different exposure settings for each shot.

Excuse me, can you turn down the sun?

Adding more light to a scene is considerably easier than reducing the light. If you're shooting outdoors, you can't exactly hit the dimmer switch on the sun. If the light is too strong, you really have only a few options. You can move the subject into the shade (in which case you can use a flash to light the subject), or, on some cameras, reduce the exposure by lowering the EV value.

If you have the opportunity, try to avoid shooting under a bright midday sun. You're better off waiting until later in the day during what photographers call the "golden hour." An hour or two before sunset, the sun is low in the sky, shadows are long, and the sun shines a golden, lush light onto subjects.

If you do need to shoot in bright sunlight and you can't find a suitable shady backdrop, you can create one with a piece of cardboard. Just have a friend hold the cardboard between the sun and the subject. *Voilà!* — instant shade. By moving the cardboard around, you can vary the amount of light that hits the subject. You can also buy relatively inexpensive, collapsible, and very portable photographic reflectors that are made to do this. Some of them are made of goldor silver-colored material so that they can do dual duty: When you need to add light instead of obscure it, you can use them to bounce the available light onto your subject.

- In manual exposure mode, you can just change the shutter speed, or aperture, or both between each shot.
- ✓ In automatic exposure modes (including shutter- and aperture-priority autoexposure modes), shoot the subject using three different exposure compensation settings.

Either way, you wind up with three versions of the shot, covering the possibility of your photo being too dark or too light. Of course, this assumes that you have the luxury of taking three shots of the same subject. It might be tough to set this up if you're trying to get a shot of your sister kissing her new husband at the altar — she's not likely to wait for you to take three shots.

Some cameras also offer *automatic exposure bracketing*. With this feature, often abbreviated as AEB, you take three successive shots, and the camera automatically creates three different exposures. Some cameras even let you adjust the amount of difference between the shots. Check your camera instruction book to find out what your camera offers and how it works.

Looking at Lighting

Photography lighting is a combination of art and science, and entire books are devoted to the subject. You can choose lighting solutions that range from using *ambient* (natural) light, such as sunlight streaming through a window, all the way to blowing your entire paycheck on an expensive professional lighting kit. Whatever you do, it's important to remember that lighting is a tool you use to enhance your composition — it's not an end in itself.

The rest of this chapter explores some specific lighting options and techniques. But here are some general lighting tips to help you take better photos:

- ✓ Minimize shadows. When you add light to a subject, whether with a flash, a house lamp, or by putting the subject in front of a window, you will probably add some shadows to your image. Be aware of them, and avoid shadows that are too harsh or that affect your composition. This may mean adding more lights to "fill in" the shadows. You can also reduce shadowing by putting more distance between your subject and the background.
- **But sometimes, shadows work well.** The artist in you may find that an interesting shadow adds character and dramatic effect to your image. Don't hesitate to use shadows to effect if you want that kind of shot. (This approach isn't great for a family portrait, though!)
- ✓ **Good lighting doesn't have to be expensive.** You don't necessarily have to have a pro lighting kit or an expensive external flash to get good results. With a couple of well-placed house lamps or an inexpensive light and a cone from the local hardware store, you may be able to get perfectly acceptable results.
- ✓ The larger the light, the more flattering the result. Generally speaking, a larger light creates a softer, more even light that wraps around the subject and produces fewer harsh shadows. This type of illumination is especially nice for shooting portraits.
- ✓ Diffuse the situation. Some lights especially built-in flash units create very harsh light. For a better result, try to diffuse the light. Doing so dramatically improves the quality of your images, making things like skin tones, shadows, and contrast look much better.

Inexpensive diffusers such as the one shown in Figure 5-16, from LumiQuest (about \$13, www.lumiquest.com) work well when you use a built-in flash. For other types of light, you can buy professional diffusers (such as a softbox or umbrella), but you can also try just hanging a sheet or sheer white curtain in front of your lights. (Be careful when using lights that get very hot, of course.)

- A little backlighting can help. Having a limited light behind your subject can help add some depth to your photo. For example, you might place a light on the floor, pointed upwards, behind a portrait subject.
- ✓ Try bouncing the light. When using an artificial light source, whether it's a true-blue pho-

Figure 5-16: You can buy diffusers that soften the harsh light of a built-in flash.

tography light or a makeshift solution like a desk lamp, you get better results if you don't aim the light directly at the object you're photographing. Instead, aim the light at the background and let the light bounce off that surface onto your subject. For example, when shooting a portrait, bounce the light off the ceiling. This technique further diffuses the light, creating a softer illumination of your subject.

Pay attention to color when using multiple light sources. If you light a scene with, say, a flash and a household lamp, the camera may not render colors correctly. This issue is related to white balance, a color feature that you can explore in Chapter 6.

Using a built-in flash

Most cameras have a built-in flash that operates in several modes. In addition to automatic mode, in which the camera gauges the available light and fires the flash if needed, you typically get the following options: fill flash, no flash,

red-eye reduction, and nighttime flash (called *slow-sync flash*). Higher-end cameras allow you to add an external flash unit as well.

The next several sections explain these additional flash options.

Fill flash (or force flash)

This mode triggers the flash regardless of the light in the scene. Fill-flash mode is especially helpful for outdoor shots, such as the one in Figure 5-17. The first image shows the result of using automatic flash mode. Because the picture was taken on a sunny day, the camera didn't see the need for a flash. But without flash, the shadow from the hat obscured the subject's eyes. Switching to fill-flash mode and forcing the flash to fire threw some additional light on her face, bringing her eyes into visible range.

Figure 5-17: Adding flash light brings the eyes out from the shadows created by the hat.

No flash

Choose this setting when you don't want to use the flash, no way, no how. You may also want to turn off the flash simply because the quality of the existing light is part of what makes the scene compelling, for example. Or you

may want to go flashless when you're shooting highly reflective objects, such as glass or metal, because the flash can cause blown highlights (areas that are completely white, with no tonal detail). The upcoming "Lighting Shiny Objects" section offers more help with this problem. And of course, some venues, such as museums and churches, often don't permit flash photography.

When you turn off the flash in an autoexposure mode, the camera may reduce the shutter speed to compensate for the dim lighting. That means that you need to hold the camera steady for a longer period to avoid blurry images. Use a tripod or otherwise brace the camera for best results. You also can consider raising the ISO setting to increase the camera's sensitivity to light (but be aware that you may introduce noise into the photo).

Flash with red-eye reduction

Anyone who's taken people pictures with a point-and-shoot camera — digital or film — is familiar with the so-called red-eye problem. The flash reflects against the subject's retinas, and the result is a demonic red glint in the eye. Red-eye reduction mode aims to thwart this phenomenon by firing a low-power flash before the "real" flash goes off or by emitting a beam of light from a lamp on the camera body for a second or two prior to capturing the image. The idea is that the prelight, if you will, causes the pupil of the eye to shut down a little, thereby lessening the chances of a reflection when the final flash goes off.

Unfortunately, red-eye reduction flash doesn't always work perfectly. Often, you still wind up with fire in the eyes — hey, the manufacturer only promised to *reduce* red-eye, not eliminate it, right? Worse, your subjects sometimes think the prelight is the actual flash and start walking away or blink just when the picture is being captured. So if you shoot with red-eye mode turned on, be sure to explain to your subjects what's going to happen.

The good news is that, because you're shooting digitally, you can repair redeye easily. Some cameras have an in-camera red-eye remover that you can apply after you take a picture. If not, the fix is easy to make in a photo-editing program. Chapter 9 shows you how.

Slow-sync flash

Slow-sync flash, which sometimes goes by the name *nighttime flash*, increases the exposure time beyond what the camera normally sets for flash pictures.

With a normal flash, your main subject is illuminated, but background elements beyond the reach of the flash are dark, as in the top example in Figure 5-18. The longer exposure time provided by slow-sync flash allows more ambient light to enter the camera, resulting in a lighter background, as shown in the lower example in Figure 5-18.

Whether a brighter background is desirable depends upon the subject and your artistic mood. However, remember that the slower shutter speed required for slow-sync flash can easily result in a blurred image; both camera and subject must remain absolutely still during the entire exposure to avoid that problem. As a point of reference, the exposure time for the normal flash example in Figure 5-18 was 1/60 second, while the slow-sync exposure time was a full five seconds. In addition, colors in slow-sync pictures may appear slightly warmer because of the white-balance issues that Chapter 6 discusses.

Using an external flash

Although your camera's built-in flash offers a convenient alternative for lighting your scene, the light it produces is typically narrowly focused and fairly harsh. When you're shooting your subject at close range, a built-in flash can leave some portions of the image overexposed or even cause blown highlights — areas that are so overexposed that they are completely white, without any detail. And a built-in flash often leads to red-eyed people, as all of us know too well.

Some digital cameras can accept an auxiliary flash unit, which helps reduce blown highlights and red-eye because you can move the flash farther away from, or at a different angle to, the subject. (The closer the flash is to the lens, and the more direct the angle to the subject's eyes, the better the chance of red-eye.) Additionally, external flash heads typically produce a more pleasing result, illuminating the subject with a more wide-spread,

Figure 5-18: Slow-sync flash produces a brighter background than normal flash mode.

and thus softer, light. And if you buy a flash with a rotating head like the one shown in Figure 5-19, you can bounce the light for an even more diffused effect.

When you attach an external flash, the camera's on-board flash is disabled (if the camera has one), but the auxiliary flash can work automatically with the camera, just like an on-camera flash can. This option is great for professionals and photo enthusiasts who have the expertise and equipment to use it; check your camera manual to find out what type of external flash works with your camera and how to connect the flash.

If your camera doesn't offer an external flash connection, you can use so-called "slave" flash units. These small, self-contained, battery-operated flash units have built-in photosensitive eyes that trigger the supplemental flash when the camera's flash goes off. If you're trying to photograph an event in a room that's dimly lit, you can put several slave units in different places. All the units fire when you take a picture anywhere in the room.

Switching on additional lights

You often can get better results, lighting wise, if you turn off the flash and use another light source to illuminate the scene. Studio lights are the solution used by pro photographers and even some serious photography enthusiasts. Or you may want to invest in some inexpensive photo-

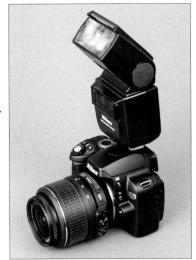

Figure 5-19: An external flash with a rotating head offers more flexibility and better illumination than a built-in flash.

flood lights — these are the same kind of lights used with video camcorders and are sometimes called "hot" lights because they "burn" continuously.

But you really don't need to go out and spend a fortune on lighting equipment. If you get creative, you can probably figure out a lighting solution using stuff you already have around the house.

You can even use something like the setup shown in Figure 5-20. The white background is nothing more than a cardboard presentation easel purchased at an art and education supply store — teachers use these things to create classroom displays. Another white board covers the table top.

The easel and board brighten the subject because they reflect light

Figure 5-20: You can create a makeshift studio using nothing more than a white presentation easel, a tripod, and household lamp.

onto it. If you need still more light, you can switch on a regular old desk lamp or a small clip-on shop light (the kind you buy in hardware stores). And if you want a colored background instead of a white one, just clip a piece of colored tissue paper, also bought at that education supply store, to the easel. Fabric remnants from your local sewing store provide another source of inexpensive backdrops.

Okay, so professional photographers and serious amateurs may turn up their noses at these cheap little setups. But hey, whatever works, works. Besides, you've already spent a good sum of money on your camera, so why not save a few bucks where you can?

Lighting shiny objects

When you shoot shiny objects such as jewelry, glass, chrome, or porcelain, lighting presents a real dilemma. Any light source that shines directly on the object can bounce off the surface and cause blown highlights, as shown in the left image in Figure 5-21. In addition, the light source or other objects in the room may be reflected in the surface of the object you want to shoot. For the jewelry shot, the reflections in the crystal earrings also distorted color.

Figure 5-21: Direct lighting creates blown highlights (left); working with a diffused light source solves the problem (right).

Professional photographers invest in expensive lighting setups to avoid these problems when shooting product shots like the one in Figure 5-21. If you're

not in the professional category — or just don't have a huge budget for outfitting a studio — try these tricks to get decent pictures of shiny stuff:

- Turn off your camera's built-in flash and find another way to light the object. A built-in flash creates a strong, focused light source that's bound to create problems. See earlier sections in this chapter to find out how various digital camera features may enable you to get a good exposure without using a flash.
- Find a way to diffuse the lighting. Placing a white curtain or sheet between the light source and the object not only softens the light and helps prevent blown highlights, but also prevents unwanted reflections.
- If you regularly need to photograph reflective objects, you may want to invest in a light cube or tent. The left photo in Figure 5-22 shows one such product, from Cloud Dome (www.clouddome.com). You can put the objects you want to shoot inside the cube and then position your lights outside of it. The white cube panels serve to diffuse the light and also provide a nice, plain backdrop for your subject.

For larger objects, you can buy a light tent, which is a little bit like a teepee made of white cloth. You can put your subject inside and then shoot through a hole in the text, as shown in the right photo in Figure 5-22, which features a tent from Lastolite (www.lastolite.com). Light cubes and tents come in a wide variety of sizes and prices, but unless you're shooting huge objects, you should be able to find a good solution for under \$100 or so. The price may seem a little steep at first, but if you do a lot of this type of photography, the amount of time and frustration it can save is well worth your investment.

Figure 5-22: Devices like the Cloud Dome (left) and Lastolite light tent (right) make

shooting reflective objects easier.

Manipulating Focus and Color

In This Chapter

- Exploring autofocus features
- Focusing manually
- Playing with depth of field
- Understanding white balance
- Adjusting photo colors

oday's digital cameras offer an abundance of focus and color features. But for many new digital photographers, sorting through all the options is so overwhelming that they throw up their hands, set everything to "automatic," and let the camera take the focus and color reins. That's a shame, because taking just a little time to understand these features can lead to much more artful photographs — not to mention a greatly reduced number of pictures that are spoiled by focus or color miscues.

This chapter puts you on the path to mastering both focus and color. The first part details the most important aspects of focus, covering such topics as getting the best results from your camera's autofocusing system and achieving different creative goals by manipulating *depth of field* (the zone of sharp focus). Following that discussion, the second part of the chapter dives into the color pool, explaining how to deal with off-kilter colors and offering tips about some subtle color adjustments that you can use to enhance different subjects.

Diagnosing Focus Problems

Several factors can affect focus, so in order to find the right solution to a focusing concern, you first have to identify the cause. Here's a quick symptom list that will point you in the right direction:

My entire picture is blurry. Illustrated in Figure 6-1, this problem is easy to diagnose: Either the camera moved during the exposure or, if you're shooting close-ups, your lens is *too* close to the subject. See the sidebar "Hold that thing still!" (later in the chapter) for a list of tricks to avoid camera shake; for close-up shooting, check your camera manual to determine the minimum close-focusing distance of your lens.

Figure 6-1: Camera shake causes allover blur (left); use a tripod to ensure sharp shots (right).

- My subject is blurry, but the rest of the picture is sharp. This problem can be caused by a couple of errors:
 - The subject moved. To catch a tack-sharp picture of a moving subject, you need a fast shutter speed (how fast depends on the speed of the subject). If your camera offers manual exposure mode or shutter-priority exposure mode, just dial in a faster shutter speed and try again. You can also set the camera to a Sports scene mode to select a higher shutter speed automatically, although you lose control over the exact shutter setting in that mode.

Remember that in order to maintain the proper exposure when you raise the shutter speed, you need to either choose a lower f-stop setting (to allow more light into the camera) or raise the ISO setting (to make the camera more sensitive to light). For more on

- shutter speed and exposure, see Chapter 5; for more about automatic scene modes, head to Chapter 3. Also check out Chapter 7, which offers more tips for shooting a moving target.
- The subject is outside the focusing zone. The camera establishes focus based on a particular area of the frame, and on some cameras, that area varies, depending on certain focusing options you can select. For example, some autofocusing systems enable you to establish focus on the center of the frame or some other specific point in the frame. Or you may be able to base focus on the average position of all objects throughout the entire frame. So you need to study your manual to find out what focusing zone the camera is using, and then make sure that your subject is within the required area when you set focus. See the upcoming section "Taking advantage of autofocus" for a bit more information on this subject.
- ✓ I want more or less of the scene to be sharply focused. When you focus the camera, whether you do it manually or by using autofocus, you establish the point of sharpest focus. You also can control the distance over which that sharp focus is maintained, otherwise known as the *depth of field.* For example, you can create a composition in which your main subject is sharp, but everything a few feet away from the subject is in soft focus. Or you can do the opposite, keeping the distant objects sharp as well.

You manipulate depth of field not by using focusing controls, but by adjusting aperture (f-stop), focal length, and camera-to-subject distance. See the section "Showing Some Depth of Field," later in this chapter, for details.

- ✓ I can't get the camera to focus at all. Assuming that your camera isn't broken, you may simply be too close to your subject. Again, every camera has a close-focusing limit, which you should be able to determine with a look at your camera manual. Another possible cause is the subject itself: In autofocus mode, some subjects can also give the camera fits, causing the autofocus motor to "hunt" continuously for a target. See the section "Taking advantage of autofocus" for tips on how to solve this problem.
- ✓ The focus of my pictures is fine, but things look blurry through the viewfinder. Try adjusting the viewfinder to your eyesight. You do this by using a *diopter adjustment control*, typically found near the viewfinder. Chapter 3 explains how to take this critical step. The other possibility is that your viewfinder is simply dirty; you can wipe it clean by using a cloth or tissue specially made for use with cameras.

Understanding Focusing Systems

Like film cameras, digital cameras offer a variety of focusing features to help you capture sharp images with ease. The following sections describe the most common focusing schemes and how you can make the most of them.

Working with fixed-focus cameras

Fixed-focus cameras are just that — the focus is set at the factory and can't be changed. The camera is designed to capture sharply any subject within a certain distance from the lens. Subjects outside that range appear blurry.

Fixed-focus cameras sometimes are called focus-free cameras because you're free of the chore of setting the focus before you shoot. But this term is a misnomer, because even though you can't adjust the focus, you have to remember to keep the subject within the camera's focusing range. There is no such thing as a (focus-) free lunch.

Be sure to check your camera manual to find out how much distance to put between your camera and your subject. Blurry images usually result from having your subject too close to the camera; most fixed-focus cameras are engineered to focus sharply from a few feet away from the camera to infinity.

Taking advantage of autofocus

Most digital cameras or lenses used with them (in the case of some digital SLRs) offer autofocus, which means that the camera automatically adjusts the focus after measuring the distance between the lens and subject. For autofocus to work, you need to take a two-stage approach to pressing the shutter button, as follows:

1. Be sure that autofocusing is enabled.

On a digital SLR, you may find a control on the lens or camera body that switches the system from manual to autofocus. For example, Figure 6-2 shows the switch as it appears on one Nikon dSLR and lens combo. You may also need to enable autofocusing through a menu option.

On a point-and-shoot camera that offers the choice between manual and autofocusing, check your manual to find out how to switch between the two — you likely establish the setting through a camera menu.

2. Frame the picture so that your subject is within the current autofocus area.

The autofocus area refers to the part of the frame that the camera uses to establish focus. This area can vary, depending on the autofocus system and settings you're using; see the notes following these steps for help.

Autofocus/Manual focus switch

3. Press the shutter button halfway and hold it there.

Your camera analyzes the picture and sets the focus. To let you know that focus is established, the camera sends you some sort of signal:

Usually, a little light in or near the viewfinder turns green, or the camera makes a beeping noise (some cameras let you turn off the beep, which can be annoying in a quiet place). Some cameras also display one or more little lighted squares or brackets in the viewfinder to tell you what part of the frame the camera used when setting focus.

Whether or not focus is set in stone at this point depends on the *autofocus mode*. Some cameras offer a continuous autofocus mode that adjusts focus as needed if the subject moves after focus is initially established. Again, see the list of upcoming tips for details.

4. After focus is established, press the shutter button the rest of the way to take the picture.

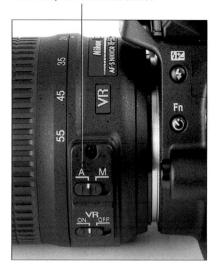

Figure 6-2: Some SLR lenses have a switch that sets the camera to autofocus mode.

Although autofocus is a great photography tool, you need to understand a few things about how your camera goes about its focusing work in order to take full advantage of this feature. Here's the condensed version of the autofocusing manual:

- ✓ **Autofocus systems:** The most common autofocusing schemes found on today's digital cameras fall into two main categories:
 - Single-spot focus: With this type of autofocus, the camera reads the
 distance of the element that's at a specific position of the frame.
 Usually, the focus area is the center of the frame. But on some
 cameras, you can select from several different focus areas throughout the frame.
 - Multi-spot focus: The camera measures the distance at several spots around the frame and sets focus relative to the nearest object or multiple points on an object taking up a large percentage of the frame (such as a group of people posing).

You need to know how your camera adjusts focus so that before you lock in the focus with the press-and-hold method just described, you frame the picture so the subject is within the area that the autofocus mechanism reads.

Some cameras enable you to choose which of these two types of focusing you want to use for a particular shot, so check your camera manual for details. Look for something that goes by a name such as *AF mode*, *AF-area mode*, and the like. (The AF stands for *autofocus*.)

Autofocus area indicators: Depending on its autofocusing system, your camera may display little dots or brackets in the viewfinder or monitor to indicate the areas used to establish focus. As an example, Figure 6-3 shows you how the markers appear on a Canon camera that has a nine-point autofocusing system and a Nikon camera that has a three-point autofocusing system. When you press the shutter button halfway, these indicators light or blink to tell you where the camera set focus.

Check your camera manual to see what the different viewfinder and monitor marks mean, though; not all are related to focusing. The center circle in the viewfinder shown on the left in Figure 6-3, for example, indicates the spot-metering zone, an exposure feature offered on some Canon cameras. And on some cameras, marks are provided to help you frame the picture. (See the sidebar, "A Parallax! A Parallax!," in Chapter 3, for more information.)

✓ Single-servo autofocus: The default autofocus setup on most digital cameras is to lock focus when you press and hold the shutter button halfway down. As long as you keep that button halfway down, focus remains locked. This focusing scheme is sometimes called *single-servo* autofocus but also goes by certain other names, such as *one-shot* autofocus.

Figure 6-3: The autofocus areas may be indicated by little squares or brackets.

Single-servo autofocus enables you to focus on a subject even if you want to frame the shot so that the subject doesn't fall into the autofocus area. For example, suppose that your camera bases focus on the center of the frame, but you want your subject to appear off-center in the picture. Frame the picture initially so that the subject is centered and then press the shutter button halfway. After focus is established, keep the button halfway down, reframe the shot as desired, and then press the shutter button the rest of the way. Figure 6-4 illustrates this technique.

Figure 6-4: After locking focus on your subject, you can reframe the shot if you want.

✓ Continuous-servo autofocus: Using single-servo autofocus to shoot a moving subject can be difficult. Say that you're trying to photograph a child running up the driveway toward you, for example. You frame the shot and lock focus at the point the little one starts off. But by the time you actually take the shot, the child is halfway up the driveway — and no longer in focus.

You can just keep locking and then relocking focus as needed, but that's difficult to accomplish and also a bit of a pain — press halfway, release, press halfway, release, mutter under breath, press halfway... you get

the idea. To offer a better solution, some higher-end cameras offer *continuous-servo* autofocus. In this mode, you still press the shutter button halfway to establish the initial focusing distance. But if the camera detects motion in front of the lens, it automatically adjusts focus as needed right up to the time you press the button the rest of the way to snap the picture.

Note that this autofocusing feature goes by different names depending on the manufacturer. Canon calls it Al Servo, for example — the Al standing for *artificial intelligence*. And some other manufacturers use the term *dynamic autofocus*.

Whatever its name, this autofocusing feature still requires some input from you after you depress the shutter button halfway. In order for the camera to correctly track focus, you typically must keep your moving target within the active autofocus area, which may mean reframing the shot after you initially establish focus.

- ✓ **Auto-servo autofocus:** In some cases, you also get a third autofocus mode in which the camera automatically shifts from single-servo autofocus to continuous-servo autofocus if it detects movement in front of the lens. Again, the mode name depends on the camera maker; on Canon cameras, this mode is called AI Focus, for example.
- ✓ Infinity and macro focusing modes: Some point-and-shoot cameras that offer autofocus provide you with one or both of these specialty focus modes. *Macro* mode allows you to focus at a closer distance than you normally could; it's designed for shooting close-ups, in other words. *Infinity mode*, sometimes also called *landscape focusing mode*, does the opposite: It sets focus at the farthest point possible and is designed for shooting subjects at a long distance. When you switch to these modes, you need to make sure that your subject falls within the focusing range of the selected mode. Check your camera's manual to find out the proper camera-to-subject distance.

Also, don't confuse these specialty focus modes with the automatic exposure scene modes that go by the same name (Macro and Landscape). Those modes are also geared to shooting close-ups and landscapes, but they typically affect exposure, color, contrast, and other picture characteristics, not focus distance. They may, however, affect depth of field, which controls the zone of sharp focus. See Chapter 3 for more about scene modes.

Finally, know that even the most capable autofocus system may have trouble doing its job in dim lighting. Certain types of subjects also confuse autofocus mechanisms: objects behind vertical bars (such as a lion at the zoo), low-contrast scenes (think gray boat sailing in foggy weather), and highly reflective objects are among the biggest trouble-makers.

If your camera offers manual focusing, the easiest solution is to switch to that mode and do the focus work yourself. The next section offers some manual

focusing tips. If your camera doesn't offer manual focus, you can fool the autofocus system by locking focus on something else that's the same distance away from the lens as your subject. After you lock focus, reframe the shot if needed.

Focusing manually

On a digital SLR, you can opt out of autofocus and instead twist the focusing ring on the lens to focus manually. You first may need to set a switch on the lens or camera body to the manual-focus mode, select manual focusing from a camera menu, or both. The steps here vary, as does the placement of the focusing ring, from camera to camera, so check out that instruction manual for details.

A few, higher-end point-and-shoot digital cameras also offer manual focusing. Although some models offer a traditional focusing mechanism where you twist a focusing ring on the lens barrel, most require you to use menu controls to select the distance at which you want the camera to focus.

Careful focusing is especially critical for close-up shots like the one in Figure 6-5 because being just an inch off in your focus judgment can mean an unacceptable picture. In this picture, for example, that inch worth of miscalculation would set focus on the stems rather than at the front part of the frame, where the most interesting textures occur. So when you shoot close-ups on a camera that requires you to dial in a specific focus distance, get out a ruler and make sure that you're using the correct camera-to-subject distance. You can't necessarily get a good idea of whether the focus is dead-on from the viewfinder or LCD. And don't forget to adjust your viewfinder to your eyesight, as explained in Chapter 3.

Serge Timacheff

Figure 6-5: Be especially careful with focus when shooting close-ups.

Hold that thing still!

A blurry image isn't always the result of poor focusing; you can also get fuzzy shots if you move the camera during the time the image is being captured.

Holding the camera still is essential in any shooting situation, but it becomes especially important when the light is dim because a longer exposure time is needed. That means that you have to keep the camera steady longer than you do when shooting in bright light.

To help keep the camera still, try these tricks:

- Press your elbows against your sides as you snap the picture.
- Squeeze, don't jab, the shutter button. Use a soft touch to minimize the chance of moving the camera when you press the shutter button.
- Place the camera on a countertop, table, or other still surface. Better yet, use a tripod. Chapter 2 offers tripod-buying advice.
- If your camera offers a self-timer feature, you can opt for hands-free shooting to eliminate

any possibility of camera shake. Place the camera on a tripod, set the camera to self-timer mode, and then press the shutter button (or do whatever your manual says to activate the self-timer mechanism). Then move away from the camera. After a few seconds, the camera snaps the picture for you automatically.

Of course, if you own a camera that offers remote-control shooting, you can take advantage of that feature instead of the self-timer mode.

If your camera or lens offers an image stabilization (or "anti-shake") mode, make sure that it's turned on when you don't use a tripod. This feature can help you get crisper handheld results, especially when you're using a slow shutter speed, a long, heavy lens, or both. Check your manual to find out whether the manufacturer recommends disabling the stabilization feature when the camera is mounted on a tripod, however.

Showing Some Depth of Field

One way to become a more artful photographer is to learn how to control *depth of field*, which refers to the distance over which sharp focus is maintained. With short, or shallow depth of field, only objects close to the subject are sharp, as in the left image in Figure 6-6. This treatment is perfect for portraits because it prevents the background from drawing attention away from the subject.

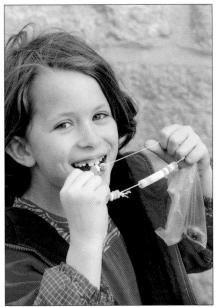

Large depth of field

Serge Timacheff

Figure 6-6: Shallow depth of field is ideal for portraits (left); landscapes benefit from a longer zone of sharp focus (right).

When you want to give equal importance to everything in the frame, on the other hand, try a large depth of field, which extends the sharp focus zone over a greater distance from your point of focus. Landscapes and architectural shots like the one on the right in Figure 6-6 typically benefit from a large depth of field. Focus in this image was set on the foreground figure, but the ones in the distance look nearly as sharp.

You can manipulate depth of field in three ways:

✓ **Adjust the aperture (f-stop).** Chapter 5 introduces you to the aperture setting, or f-stop, which is an exposure control. The f-stop also affects depth of field; the higher the f-stop number, the greater the depth of field. This option was used to produce the images in Figure 6-7, with an aperture of f/3.4 for the left image and f/11 for the right one.

WIRNING!

Remember, though, that f-stop and shutter speed are forever interwoven in the exposure equation. As you raise the f-stop, which reduces the size of the aperture, you must use a slower shutter speed to compensate for the smaller aperture opening. So, if you need a fast shutter speed to get a stop-action shot of a baseball player hitting a ball, you may have

to live with a short depth of field because you need a wide aperture to expose the photo properly at that fast shutter speed. Alternatively, you can adjust the camera's sensitivity to light via the ISO control.

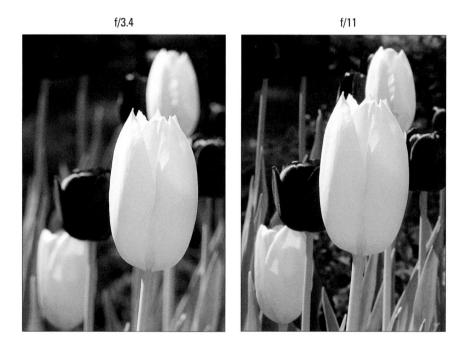

Figure 6-7: Changing the aperture is one way to adjust depth of field.

Note, too, that a short depth of field can blur objects in front of your subject, too — it's not always the background that blurs. For example, if you set focus on the yellow tulip in the background of the scene in Figure 6-7, the foreground tulip would blur with a short depth of field.

If your camera offers aperture-priority autoexposure, try that mode when depth of field is your primary concern — your *priority*, in other words. In this mode, (normally identified by an "Av" or "A" on your camera's mode dial), you set the f-stop, and the camera selects a shutter speed that will deliver a good exposure. The range of f-stops you can choose depends on your lens; check the camera manual for the specifics.

Even if your camera doesn't offer manual or aperture-priority control, you may be able to control depth of field to some extent. Some of the scene modes found on many cameras are designed to produce the depth of field appropriate for certain subjects. For example, Portrait mode typically selects a wide aperture setting to produce a shallow depth of

field, and Landscape mode typically selects a narrow aperture to produce a greater depth of field. Additionally, some Canon cameras offer an automatic depth-of-field setting (A-DEP), which attempts to select an aperture that will keep all major objects in the frame in the sharp focus zone. The extent to which these automatic modes can adjust aperture depends on the light, of course, so they're not always going to produce the desired results in terms of depth of field. Chapter 3 talks more about scene modes.

✓ Change the lens focal length. Focal length, measured in millimeters, determines the camera's angle of view, how large objects appear in the frame, and depth of field. A long focal length, such as you get from a telephoto lens, produces a shallow depth of field. A wide-angle lens, on the other hand, has a short focal length and produces a large depth of field.

Figure 6-8 offers an example. Both photos were taken at an aperture of f/5.6; however, the top image was taken at a shorter focal length (wider angle), so more of the scene remains in the sharp-focus zone. Note that both focal lengths here are in the telephoto range, which means that depth of field is relatively shallow even in the top image.

If you have an optical zoom lens, you can change focal length just by zooming in and out. (Your manual should spell out the range of focal lengths for the lens.) Or, if you own a digital SLR, you can buy different lenses with different focal lengths or even a couple of lenses that each offer a different zoom range. If your camera doesn't have an optical zoom, though, you're stuck with a single focal length.

Digital zoom does *not* produce a shift in depth of field; digital zoom simply results in cropping and enlarging your existing image. (See Chapter 1 for more about camera lenses and types of zooms.)

Change the distance between camera and subject. As you move closer to your subject, you decrease depth of field; as you move away, you extend depth of field.

Practicing these depth-of-field techniques is important because they help you achieve different compositional aims. Consider the pictures in Figure 6-9, for example. The subjects look great in both images. But notice the backgrounds: In the left image, a section of a gutter downspout extends up from the boy's shoulder, and there's a strong break in the light in the upper-left corner. Both distract the eye from the subjects. The photo on the right, where these annoyances are no longer visible, was achieved by moving the camera farther from the subjects and then zooming in. Any time you zoom in, you include less of the background in the shot because of the change in angle of view. And the background also becomes noticeably softer because of the reduction in depth of field, too, lessening the visual impact of the brick.

174 mm

270 mm

Figure 6-8: Zooming to a longer focal length also decreases depth of field.

It's important to emphasize that the subjects were in the same place for both shots, and the aperture used for both was the same (f/5.6). The huge difference between the two images is solely due to a change of camera position and focal length. If you wanted to further soften that background, you could open the aperture further (assuming that your camera offered a lower f-stop setting). Or you could zoom in without moving away from the subjects, although that choice would mean that you could no longer fit as much of their bodies in the shot.

Figure 6-9: A longer focal length also means less background area fits in the frame.

Putting it all together, then, decide how much depth of field best suits your subject and then combine aperture, focal length, and camera-to-subject distance to create the look you want. Remember the following formulas, and adapt as needed:

- ✓ For minimum depth of field (subject sharp, distant objects blurry): Use a wide aperture (low f-stop number), a long focal length, and get as close as possible to your subject. Be sure not to exceed the minimum close-focusing distance of your lens, though.
- For maximum depth of field (subject and distant objects sharp): Use a small aperture (high f-stop number), a short focal length, and move back from your subject as much as possible.

Controlling Color

In the film photography world, expert photographers manipulate color by using different films and lens filters. If you want landscapes that feature bold blues and vivid greens, for example, you choose a film known to emphasize those hues. If you're shooting portraits, on the other hand, you might add

an amber-tinted filter onto your lens to infuse the scene with a warm, golden glow that flatters skin tones.

Things work differently in the digital world, but you still have lots of options for manipulating color — in fact, more so than in the film world, and without having to lug around a bagful of different films and filters, too. The rest of this chapter explains the standard digital-camera color features and also helps vou solve some common color problems.

8000

Be sure to also visit Chapter 4 for an introduction to some of the technical terminology and basic science related to digital color.

Adjusting color with white halance

Different light sources have varying color temperatures, which is a fancy way of saying that they contain different amounts of red, green, and blue light.

Color temperature is measured on the Kelvin scale, illustrated in Figure 6-10. The midday sun has a color temperature of about 5500 Kelvin, which is often abbreviated as 5500K — not to be confused with 5500 kilobytes. also abbreviated as 5500K. When two worlds as full of technical lingo as photography and computers collide. havoc ensues. If you're ever unsure as to which K is being discussed, just nod your head thoughtfully and say, "Yes, I see your point."

The human eye manages the perception of color temperature naturally, and no matter if you're in an office with fluorescent light, under a bright sun, or in a living room with house lamps, when you see red, it looks red (assuming no difficulties with color blindness, of course). However, cameras aren't as sophisticated as your brain at accommodating various lighting conditions and the colors being illuminated by them.

Snow, water, shade

Figure 6-10: Each light source emits its own color cast.

Color temperature affects how a camera perceives the colors of the objects being photographed. If you've taken film pictures in fluorescent lighting, for example, you may have noticed a slight green tint to your photographs. The tint comes from the color temperature of fluorescent light (and, actually, fluorescent light is one of the hardest lights in which to photograph using film, because the temperature fluctuates).

Film photographers use special films or lens filters designed to compensate for different light sources. But digital cameras, like video cameras, get around the color-temperature problem by using a process known as white balancing.

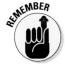

White balancing simply tells the camera what combination of red, green, and blue light it should perceive as pure white, given the current lighting conditions. With that information as a baseline, the camera can then accurately reproduce the other colors in the scene.

On many digital cameras, white balancing is handled automatically. But many models provide manual white-balance controls as well. Why would you want to make manual white-balance adjustments? Because sometimes, automatic white balancing doesn't go quite far enough in removing unwanted color casts, especially when a scene is lit by multiple light sources that have different color temperatures. If you notice that your whites aren't really white or that the image has an unnatural tint, you can usually correct the problem by shifting out of automatic mode and dialing in a manual white-balance setting that's tailored to a specific light source. Table 6-1 shows some common manual settings. These settings are usually represented by graphic icons; the ones in the table are generic, but most cameras use similar symbols to represent the white-balance settings.

Table 6-1	Manual White-Balance Settings	
Symbol	Setting	Use
*	Daylight or Sunny	Shooting outdoors in bright light
ಖ	Cloudy	Shooting outdoors in overcast skies
\\// //\\	Fluorescent	Taking pictures in fluorescent lights, such as those in office buildings
☆	Incandescent	Shooting under incandescent lights (standard household lights); also known as tungsten light
4	Flash	Shooting with the camera's on-board flash

Figure 6-11 gives you an idea of how image colors are affected by white-balance settings. As with most cameras, the one used to take these pictures handles color pretty well in automatic white-balancing mode. But this shooting location threw the camera a curve ball because the subject was lit by three different light sources. The room had fluorescent lights, which lit the subject from above; to the subject's left (the right side of the picture), bright daylight was shining through a large picture window. Adding flash made things even more complicated.

The image has a slightly yellowish cast at the Automatic setting. That's because in the Automatic mode, most cameras balance colors for flash lighting when the flash is turned on (which is why the results of the Flash mode and the Automatic mode are the same in the figure). But balancing colors for the temperature of the flash only doesn't account for the two other light sources hitting the subject. In this particular case, the Fluorescent setting achieved the most accurate color balance, with the Sunny option coming in a close second.

That's the short story on white balance: Turn to this control any time your colors look out of whack. But also investigate the tactics explored in the next few sections, which present some additional white-balance features and uses.

Get in the habit of setting your white balance back to AWB (automatic white balance) after you're done using a manual setting. Otherwise, if you shoot another photo in different light, the color is likely to appear wrong in that photo.

White-balance shift

Some cameras offer a way to refine white balance beyond what you can do with the six or seven usual manual settings. For example, suppose you're using incandescent lamps but the Incandescent setting on your camera doesn't quite produce neutral colors. You may be able to nudge the white-balance adjustment in small increments to eliminate the problem. For example, on some Canon cameras, you can tweak the white-balance adjustment by moving a little marker inside a color grid, shifting hues along both a blue/amber axis and a green/magenta axis, as shown in Figure 6-12. The setting in the figure shifts the white balance three steps toward amber and one step toward magenta.

This feature sometimes goes by the name *white-balance shift;* on other models, it may go by the name *white-balance correction* or something similar. But regardless of the label, this feature offers very precise control over white balance.

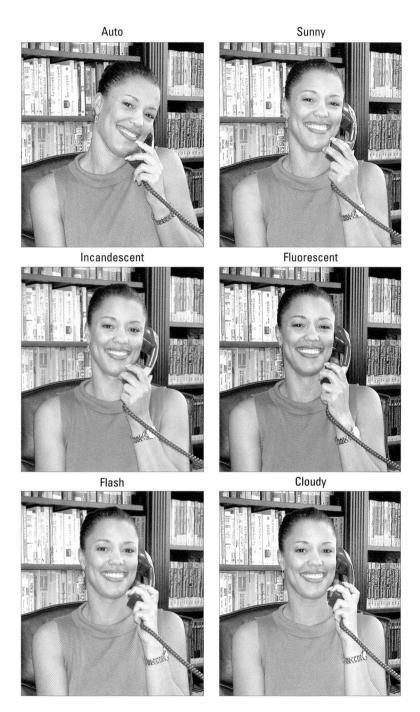

Figure 6-11: The white-balance control affects how the camera "sees" white.

Typically, the shift increments are geared to a measure called a *mired (my-redd)*, which indicates the degree of color correction applied by a traditional colored lens filter. Each white-balance adjustment increment equals so many mireds (usually, five). If you're hip to the whole mired issue, check the fine print in your camera manual for details on how your model handles things.

Custom white balancing based on a gray card

Some cameras allow you to shoot a reference photo that

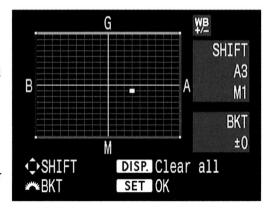

Figure 6-12: On some Canon cameras, you use this type of control to adjust white balance in small increments

the camera analyzes to determine the right amount of white balancing needed to completely remove any color casts. This feature is usually the most reliable and efficient way to ensure accurate color.

Managing colors (and color expectations)

One concern often voiced by digital photographers is that the colors they see on their camera monitors often look very different when the picture is displayed on a computer monitor. An even bigger complaint is that printed colors don't look the same as what's displayed on the monitor.

The first step to solving the problem is to get your expectations in line, which means understanding the different color worlds involved in the process: the colors that your eyes see, the colors that your camera can capture, and the colors that can be reproduced in print.

Unfortunately, no camera is as capable as the human eye at capturing certain shades and intensities of reds, greens, blues, and yellows. And no printer can reproduce with ink all the colors that can be displayed by a camera or computer monitor, which create colors by projecting red, green, and blue light. In other words, you're dealing with three different color spaces,

or gamuts, which can be compared to three boxes of crayons that each hold a slightly different assortment of colors. When your camera doesn't have the right crayon to record a color in a scene, it simply uses the closest available one — the same way you might draw with a midnight-blue crayon if you lost your navy-blue one. The printer does the same thing when outputting your photos.

To sum up, perfect color matching simply isn't possible. You can, however, do a number of things to get the best possible color consistency. See Chapter 10 for a list of steps to take to get printed colors more in line with screen colors, and review the camera color-control topics discussed in this chapter to bend the colors your camera produces to better mirror the colors that you see in a scene. See Chapter 4 for a bit more detail about color spaces, including which one to use if your camera offers a choice.

Here's how it works: You take a picture of a neutral gray card, illuminating the card with the same lighting that you plan to use for your shot. (You can buy cards made just for this purpose at your local camera store for under \$20.) The camera then determines what white-balance adjustment is needed to get that image to a neutral color state. The adjustment information is stored as a custom setting, and any time you shoot in that same light, you select that custom setting as your white-balance option, and the camera applies the same correction to ensure color accuracy.

White-balance bracketing

If you're unsure about the light illuminating your subject, you may want to try *white-balance bracketing*. This high-falootin' term simply means that you take a picture of the same thing several times with different white-balance settings.

Say that your family is sitting on the couch in your living room, and a mix of sunlight and a few lamps is shining on them. One of the lamps has a regular incandescent bulb, while another has one of those new, efficient, curly fluorescent bulbs. Depending on who's sitting in what light, your camera's color brain is very likely to get quite confused about how to render the image.

Assuming that your camera offers manual white-balance control, as explained in the preceding section, try taking the shot using a variety of settings to see which one produces the best overall colors. Later, on your computer, you can look at the photos in more detail and decide which one you prefer.

Some cameras offer automatic white-balance bracketing that's based on white-balance shifting (explained earlier in this chapter). With this feature, you first select a white balance setting — Sunny, Cloudy, whatever. Then you tell the camera to take one shot at that setting, take a second shot at a setting that slightly shifts colors in one direction, and a third that shifts colors in the other direction.

Using white balance for effect

Colors are often described as being either "cool" or "warm." Cool colors fall into the blue/green range of the color spectrum; warm colors, the red-yellow-orange spectrum. Light, too, is often said to be cool or warm: Candlelight, for example is a very warm light, whereas flash is a very cool light.

Talking about colors as being cool and warm can get confusing if you're also pondering the Kelvin scale. Colors that give off the bluish light have a higher Kelvin temperature than those that give off a warmer light, and most of us are used to thinking of a higher temperature as warmer. Don't think too much about it — it's more important that you are aware of the colors of different light sources than their Kelvin temperatures.

At any rate, back to the discussion at hand: Film photographers often apply tinted filters to the ends of their lenses to purposefully add a warm or cool cast to their subjects. With digital, however, you may be able to do the same thing simply by using your camera's white-balance controls.

Assuming that your camera offers manual white-balance settings, you can simply experiment with different settings to see which ones provide the warming and cooling effects you want. The trick is to choose a white-balance setting that's actually designed for a light source that has a different color temperature than your actual light source, as follows:

- For warmer colors: Choose a white-balance setting designed for the bluish light sources that fall at the top of the Kelvin scale, such as flash or clouds. The camera, thinking that the light is very blue, shifts colors to the warmer side of the scale. And if you're shooting in light that's actually *not* cool, the resulting colors wind up being shoved slightly past neutral to warm.
- For cooler colors: Choose a white-balance setting designed for the warm-colored light sources at the bottom of the Kelvin scale, such as Incandescent. Again, the camera applies what it thinks is the right amount of cooling needed to make your whites white, but the adjustment again takes your colors past neutral, this time to the cooler side of the color range.

As an example, take a look at Figure 6-13. The actual light in this scene was from strong, bright daylight coming in through the overhead windows. At the Daylight white-balance setting, the colors were neutral — or, to put it another way, rendered without a color cast from the light. Shooting the scene using the Cloudy setting produced the result you see in the right figure. The camera applied an overly strong warming effect, thinking that it needed to compensate for the bluish tint of cloudy skies. The change is most evident in the green ironwork at the top of the scene and in the walls, which appear almost tan in the original but golden in the Cloudy version.

Using flash in bright sunlight also produces this warming effect for the same reason. And conveniently enough, a flash also produces better outdoor illumination for many subjects. With portraits, the flash helps eliminate shadows under the nose and eyes, for example. And if you flip on your flash, you can leave your white-balance setting to Auto, because the camera automatically color-corrects for flash any time to enable flash.

Of course, this trick only works to a certain degree. If the light is cloudy, for example, you can't make colors warmer because the maximum warming happens when you select Cloudy as the white-balance setting. And if you're shooting by incandescent lamps, you can't go any cooler because the Incandescent setting already applies the greatest amount of cooling. So the

degree of color change that occurs when you select a different white-balance setting depends on how far your actual light source is from that setting.

Balanced using Cloudy setting

Figure 6-13: You can trick your white-balance control into serving as a digital warming filter.

If your camera offers white-balance shift, however, you may be able to tell the camera that you always want to push colors slightly to the warm or cool side any time you select a certain white-balance setting. So if you find that your camera consistently produces colors that are too cool for your liking at the Cloudy setting, you can dial in a correction that slightly increases warming in cloudy light.

Shooting Raw for absolute color control

Does your camera enable you to capture images in the Camera Raw format? In this format, fully explained in Chapter 4, the camera actually applies *no* white balancing — or any other color adjustments — as it does when you shoot in the JPEG format. Instead, you specify the color attributes of your picture when you convert the Raw file to a standard format (such as TIFF) on your computer.

The color controls available during conversion depend on the raw-conversion software you use; Figure 6-14 highlights those available in the Adobe Photoshop Elements version. In this program, you can apply one of your camera's preset white-balance settings (Cloudy, Sunny, and so on) or use color sliders to fine-tune those settings. You also can manipulate color saturation and vibrancy.

Figure 6-14: You can set white balance for Raw files during the conversion process.

Although Raw capture involves more time behind the computer and has a few other complications you can explore in Chapter 4, it does provide an even finer degree of color control than you get from most cameras. More importantly, it provides a color safety net. If you shoot JPEG and get the white balance wrong, you can wind up with an ugly color cast that may be difficult to fully remove in a photo editor. But with Raw, the color isn't locked in when the file is created, so you always get a second chance.

That's not to say that you can totally ignore white balance when you shoot Raw, however. First, the picture you see during playback on the camera monitor is a JPEG preview of the image as it will appear if you stick with the current white-balance setting. So if the color is way off, judging the overall result of the picture is a little difficult. It's hard to tell whether a red flower is properly exposed, for example, if the entire image has a blue color cast. And when you open your picture file in a Raw converter, the software initially translates the picture data according to the recorded white-balance setting. Getting as close as possible from the get-go can thus save you some time tweaking colors during the conversion stage.

Exploring even more color options

Especially if your camera is relatively new, you may have access to several color controls in addition to those already laid out in this chapter. Browse through your camera manual to look for features such as these:

- ✓ **Automatic scene modes:** Explained in Chapter 3, these exposure modes are geared to best capture specific types of scenes: landscapes, portraits, and so on. Primarily, these modes are meant to assist you with choosing the right exposure settings, but many also manipulate colors. Landscape mode may emphasize blues and greens, for example, while Portrait mode may slightly enhance skin colors.
- Prefer to work in an advanced exposure modes: If you prefer to work in an advanced exposure mode, such as shutter-priority autoexposure or manual exposure, you still may be able to apply automatic color adjustments to your images. Usually, you can choose from color presets, each of which renders colors a different way. One preset may be geared to richer colors, another may produce a more neutral color palette, and others may emphasize different parts of the color spectrum. On some Canon cameras, for example, you make this adjustment through a feature called Picture Styles; on some Nikon cameras, the Optimize Image feature offers these options.
- Saturation adjustments: Many cameras, even entry-level models, enable you to boost *color saturation*, or the intensity of the colors. However, use discretion: By increasing color saturation too much, you can lose picture detail. A flower petal that should reflect a variety of reds, at different saturations, for example, can become one big, lifeless blob of fully saturated red.
- ✓ **Color effects:** Many cameras offer effects filters that can turn your full-color photo into a grayscale or tinted monochrome image (blue and white, for example, or sepia-toned). Figure 6-15, for example, shows an

original full-color image along with grayscale and sepia-toned versions produced this way. In some cases, you select the filter before you press the shutter button. Some cameras enable you to preview the effect; in other cases, you can't see the results of the filter until picture playback. On other cameras, you apply the effect to an existing image on your memory card rather than before you shoot.

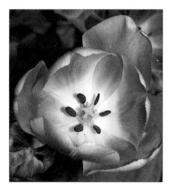

Figure 6-15: Many cameras can produce grayscale or sepia-toned images.

These in-camera filters are fun and convenient, but if you want better control over your results, capture the image as usual and then apply the color effects in your photo editor. In many photo editors, you can choose which of your original colors to emphasize in your monochrome version, and you also can make the exposure and contrast adjustments that are often needed after making the move from color to monochrome. If you do use the in-camera filters, be sure that your camera preserves the full-color version of the image; you can always go from color to monochrome, but the opposite isn't true.

Getting the Shot: How the Pros Do It

In This Chapter

- Improving composition
- Taking better portraits, action shots, and landscapes
- Discovering tricks to shoot challenging subjects
- Shooting images for a panorama
- Exploring HDR (high dynamic range) imaging

Ithough a good photo can happen unintentionally, the real trick is to be able to shoot good images consistently. Knowing how to use and manage your camera and understanding the art of composition can make a big difference in your "hit rate" of keeper shots.

This chapter offers some suggestions that can help you take more memorable, captivating photographs. Whether you're snapping pics of your children or shooting products for a sales brochure, experiment with these methods. As you'll discover, a little planning and creativity is all you need to evolve from a so-so picture taker to a creative, knock-their-socks-off photographer.

Composing a Better Photo

You don't have to be an art major to understand that your camera angle and distance, as well as how you position elements of a scene, can make the difference between a well-composed image and one that falls flat. After you practice a few techniques and learn a couple of tricks, it will quickly become second nature to you to compose an image so that the person enjoying the photo is naturally drawn to the subject you intended to portray.

Consider the image in Figure 7-1. Exposure, focus, and the other technical aspects of the picture are fine. And the subject, a statue at the base of the Soldiers and Sailors Monument in Indianapolis, is interesting enough. But overall, the picture is . . . well, dull as dishwater. In fact, with all the new scented dishwashing liquids out there, dishwater might even be more intriguing.

Now look at Figure 7-2, which shows two additional images of the same subject, but with more powerful results. What makes the difference? In a word, *composition*. Simply framing the statue differently, zooming in for a closer view, and changing the camera angle create more captivating images.

Figure 7-1: This image falls flat because of its uninspired framing and angle of view.

Figure 7-2: Getting closer to the subject and shooting from less-obvious angles results in more interesting pictures.

Not everyone agrees on the "best" ways to compose an image — art being in the eye of the beholder and all that. For every composition rule, you can find an incredible image that proves the exception. That said, the following list offers some suggestions that can help you create images that rise above the ho-hum mark on the visual-interest meter:

- For maximum impact, don't place your subject smack in the center of the frame, as shown in Figure 7-1, although that may seem like the natural thing to do. Instead, mentally divide the image area into thirds like a tic-tac-toe game, as illustrated in Figure 7-3. Then position the main subject elements at spots where the dividing lines intersect. In the sample image, the point of interest, the deer's eye and nose, fall at that placement.
- Again, refer to Figure 7-1. This image accurately represents the statue. But the picture is hardly as captivating as the images in Figure 7-2, which show the same subject from more unusual angles.
- To add life to your images, compose the scene so that the viewer's eye is naturally led from one edge of the frame to the other, as in Figure 7-4. Leaving a little margin of background in the direction the subject is looking also helps. The figure in the image, also part of the Soldiers and Sailors Monument, appears ready to fly off into the big, blue yonder. You can almost feel the breeze blowing the torch's flame and the figure's cape.

Figure 7-3: One rule of composition is to divide the frame into thirds and position the main subject at one of the intersection points.

Figure 7-4: To add life to your pictures, frame the scene so that the eye is naturally drawn from one edge of the image to the other.

- ✓ **Get close to your subject.** Often, the most interesting shot is the one that reveals the small details, such as the laugh lines in a grandfather's face or the raindrop on the rose petal. Remember, you can also get close to a subject by zooming-in on them; you don't have to always get *physically* close.
- ✓ Pay attention to the background.

 Before taking a picture, do a quick scan of the background, looking for distracting background elements such as the flower and computer monitor in Figure 7-5.

Here's a trick for capturing children against a non-invasive backdrop: Photograph them while they're lying down on the floor and looking up at the camera, as in Figure 7-6. Rooms full of children also tend to be full of toys, sippy cups, and other kid paraphernalia, which can make getting an uncluttered shot difficult. So simply shove everything off to a small area of carpet and have the kids get down on the floor and pose.

Try to capture the subject's personality. The most boring people shots are those in which the subjects pose in front of the camera and say "cheese" on the photographer's cue. If you really want to reveal something about your subjects, catch them in the act of enjoying a favorite hobby or using the tools of their trade. This tactic is especially helpful with subjects who are camera-shy; focusing their attention on a familiar activity helps put them at ease and replace that stiff, I'd-rather-be-anywhere-but-here look with a more natural expression.

Figure 7-5: Watch out for distracting background objects.

Figure 7-6: To avoid clutter, have kids lie on an empty swatch of carpet.

Capturing Captivating Portraits

The classic portraiture approach is to keep the subject sharply focused while throwing the background into soft focus, as shown in Figure 7-7. In other words, the picture features a shallow depth of field, or zone of sharp focus, as shown in the examples in this section. This artistic choice emphasizes the subject and helps diminish the impact of any distracting background objects in cases where you can't control the setting.

Chapter 6 explains depth-of-field techniques fully, but here's a quick recap on how to achieve that blurrybackground look:

or aperture-priority exposure mode. One way to shorten depth of field is to use a low f-stop setting, which opens the aperture. Portrait mode, found on many cameras, automatically opens the aperture as much as possible. This scene mode also usually applies some color and sharpness adjustments that are well suited to rendering skin tones.

However, if you want to precisely control depth of field, switch to aperture-priority autoexposure mode, if available. In this mode, you choose the f-stop setting, and the camera selects a shutter speed to properly expose the photo. (This mode is usually abbrevited as A or Ay on the camera of

Serge Timachef

Figure 7-7: A nice portrait often has a "soft" or blurry background.

ated as A or Av on the camera dial; Chapter 5 has details.)

Zoom in, get closer, or both. Zooming to a longer focal length also reduces depth of field, as does moving physically closer to your subject.

Avoid using a lens with a short focal length (a wide-angle lens) for portraits. They can cause features to appear distorted — sort of like the way people look when you view them through a security peephole in a door. Instead, use a "normal" lens in the range of 40mm–70mm.

Move your subject farther from the background. The greater the distance between the two, the more background blurring you can achieve. Increasing the distance also helps eliminate shadows that may occur behind the subject if you use flash to light indoor portraits.

After you ensure that soft background, these other tips can also improve your people pics:

For indoor portraits, shoot flash-free if possible. Shooting by available light rather than flash produces softer illumination and avoids the problem of red-eye. To get enough light to go flash-free, turn on room lights or, during daylight, pose your subject next to a sunny window. Do remember that the camera may need a fairly slow shutter speed to expose the image in low light, however, so you may want to use a tripod and ask your subject to remain as still as possible. Or, you can try raising the ISO setting to increase the camera's light sensitivity, although that can also produce noise (the defect that gives your image a speckled look).

Portraits by flash light: Getting better results

If using a flash for your indoor and nighttime portraits is necessary, these techniques can produce better results:

- Turn on as many room lights as possible to reduce the flash power needed to expose the picture. This step also causes the pupils to constrict, reducing the chances of red-eve.
- Try using Red-Eye Reduction flash mode. Warn your subject to expect a preflash or other beam of preliminary light, which constricts pupils, and the actual flash.
- Try Night Portrait exposure mode. In this mode, the camera automatically selects a slower shutter speed than normal. This enables the camera to soak up more ambient light, producing a brighter background and reducing the flash power that's needed to light the subject. A slow shutter, however, means that you may need to use a tripod to

- avoid camera shake, which can blur the photo. You also need to warn your subjects to remain very still during the exposure.
- Soften the flash light by attaching a diffuser to the flash head. The more diffused the flash, the more flattering the light.
- If you have an external flash, rotate the head to bounce the light off the ceiling. Again, this diffuses the light so that it falls back softly on the subject.
- To reduce shadowing from the flash, move your subject farther from the background.
- Shoot with your camera in a horizontal position. When a camera is held vertically with the flash on, it's very common to get a strong, unattractive shadow along one side of your subject.

In Portrait mode, the camera may not even allow you to shoot without flash in dim lighting. If your camera offers a No Flash scene mode (it may be called Museum mode or something similar), you can try that instead, although the camera may not choose an aperture setting that throws the background into soft focus in that mode.

■ But experiment with using flash in outdoor portraits. This technique is called adding fill flash. The little pop of light eliminates shadows that can occur on the face in strong overhead lighting. (You can see an example in the flash discussion in Chapter 5.) But even in the shade, a flash offers better illumination for outdoor portraits. If your camera lets you control the power of your flash, you may want to use a lower-power setting for fill flash so that you don't overdo it.

your subjects' heads.

Amy A. Timacheff

Figure 7-8: Frame portraits a little
loosely to allow later cropping to a

Most cameras don't let you use flash in Portrait mode if the light is very bright, unfortunately. You may be able to move your subject into a shady enough area that the camera thinks flash is needed, however.

✓ Frame your subject loosely to allow for later cropping to a variety of frame sizes. Leaving a little "head room," as shown in Figure 7-8, is a good idea because it gives you added flexibility when you print the photo. If you camera creates images with a proportion of 3:2, the entire photo will fit a 4 x 6-inch print. But if your originals are 4:3, which is the case on many cameras, some of the photo must be cropped to fit that 4 x 6 print. And either way, you need to crop the photo to fit other traditional print sizes (8 x 10, 5 x 7, and so on). So if you don't leave that

margin of empty space, you may find yourself cropping off the top of

Check image colors if your subject is lit by both flash and ambient light. If you set the camera's white-balance setting to automatic, enabling the flash tells the camera to warm colors to compensate for the cool light of a flash. If your subject is also lit by room lights or daylight, the result may be colors that are slightly warmer than neutral. This warming effect typically looks nice in portraits, giving the skin a subtle glow. But if you aren't happy with the result or want even more warming, you may need to try a different white-balance setting or adjust the image color in your image-editing application. See Chapter 6 for help.

Shooting Better Action Shots

A fast shutter speed is the key to capturing a blur-free shot of any moving subject, whether it's a butterfly flitting from flower to flower, a car passing by, or a running baseball player. Even something moving slowly, such as the 135-meter-high London Eye observation wheel (see Figure 7-9), benefits from a faster shutter speed to capture a non-blurry image. This photo was taken at 1/320 second.

What shutter speed you need depends on the speed at which your subject is moving. But generally speaking, 1/500 second should be plenty for all but the fastest subjects — speeding race cars, boats, and so on. For slower subjects, you can even go as low as 1/250 or 1/125 second.

Whatever the speed of your subject, try setting your camera to one of the following exposure modes to capture action:

Shutter-priority autoexposure: Usually abbreviated S or Tv (for time value), this mode enables you to specify an exact shutter speed. The camera then chooses the f-stop needed to expose the image properly. Of course, you can always switch to Manual exposure and set both shutter speed and aperture yourself.

Serge Timacheff

Figure 7-9: To produce crisp shots of things in motion — even when they're moving slowly — use a fast shutter speed.

Many cameras will tell you if you have set a speed that is too fast to get a good exposure. For example, in some cameras if the aperture value blinks after you set the shutter speed, the camera can't select an f-stop that will properly expose the photo at that shutter speed. Other cameras may prevent you from choosing a shutter speed that puts you into the exposure danger zone.

✓ **Sports mode:** Almost all cameras offer a Sports mode these days, although it may go by some other name (Action, for example). Whatever the name, this mode automatically dials in a fast shutter speed for you. In some cases, other camera settings such as ISO (light sensitivity) may also be selected for you.

Here are a few other tips that pros use when capturing action:

- ✓ Raise the ISO setting to enable a faster shutter if needed. In dim lighting, you may not be able to get a good exposure at your chosen shutter speed or in Sports mode without taking this step. Raising the ISO does increase the possibility of noise, but a noisy shot is often better than a blurry one. (Note that some cameras automatically raise the ISO for you in dim lighting as well as when you put the camera into Sports mode.)
- ▶ Forget about flash. Using flash isn't usually a workable solution for action shots. First, the flash needs time to recycle between shots, so it slows your shot-to-shot time. Second, most built-in flashes have limited ranges so don't waste your time if your subject isn't close by. And third, the maximum shutter speed decreases when you enable flash; the top speed is usually 1/200 or 1/250 second. That may not be fast enough to capture your subject without blur.
 - If you do decide to use flash, you may have to bail out of Sports mode, though; it probably doesn't permit you to use a flash.
- Set the camera to burst mode, if available. This mode may be called Continuous or something similar; often, the option is set through an option called *Drive mode*, *Release mode*, or *Shooting mode*. Whatever the name, it enables you to record a continuous series of images with a single press of the shutter button. As long as you keep the button down, the camera captures image after image at a rapid pace two to four frames per second is common, but some high-end cameras can be faster.
- For fastest shooting with a dSLR, switch to manual focusing. You then eliminate the time the camera needs to lock focus in autofocus mode. Again, some cameras are faster than others, so you'll probably need to try it both ways.
 - Note that with most point-and-shoots that offer manual focusing, you have to specify the exact camera-to-subject distance by using a menu control or some similar process that can actually slow you down. So unless you can preset the focus distance, stick with autofocus (in this case, anyway).
- In autofocus mode, try continuous-servo mode, if available. Again, the name of the mode varies from camera to camera on Canon models, it's often called *AI Servo*, for example. When this feature is enabled, the camera initially sets focus when you depress the shutter button halfway but continues to adjust focus as necessary up to the time to take the picture, just in case the subject moves. All you need to do is reframe the shot as needed to keep the subject within the area the camera's using to calculate focus.
- ✓ If continuous-servo autofocus isn't available, lock in autofocus in advance. Press the shutter button halfway to do so. Now when the action occurs, just press the shutter button the rest of the way. Your image-capture time is faster because the camera has already done the work of establishing focus.

- ✓ If possible, turn off automatic image review. Most cameras display each picture for a few seconds on the camera monitor immediately after you capture the shot. In many cases, you can't take another picture until this "instant review" period is over. If your camera enables you to turn off the feature, doing so is a good idea for action shooting. (Some cameras limit image review automatically in Sports mode.)
- **✓ Compose the subject to allow for movement across the frame.** To make sure that your subject doesn't move out of the frame before you press the shutter button, compose the image with some extra room at the edges. You can always crop the photo later to a tighter composition.

Using these techniques should give you a better chance of capturing any fastmoving subject. But action-shooting strategies also are helpful for shooting candid portraits of kids and pets. Even if they aren't currently running, leaping, or otherwise cavorting, snapping a shot before they do move or change positions is often tough. So if an interaction or scene catches your eye, set your camera into action mode and then just fire off a series of shots as fast as you can.

Also, remember that some moving subjects will actually look better if you keep a little blurriness to convey motion. That's what we call "artistic judgment" (even if you never intended the picture to turn out that way — don't worry, we won't tell). While the photo in Figure 7-10 is certainly no awardwinning image, a lot of kids (especially) find it to be a fun image — and it just wouldn't be the same without the blurriness.

Figure 7-10: Using a slow shutter speed to intentionally blur a moving subject can make for some interesting and fun effects.

Taking in the Scenery

Providing specific camera settings for scenic photography is tricky because there's no single best approach to capturing a beautiful stretch of country-side, a city skyline, or other vast subject. Take depth of field, for example: One person's idea of a super cityscape might be to keep all buildings in the scene sharply focused. But another photographer might prefer to shoot the same scene so that a foreground building is sharply focused while the others are less so, thus drawing the eye to that first building.

That said, the following tips can help you photograph a landscape the way *you* see it:

Shoot in aperture-priority autoexposure mode, if available, so that you can control depth of field.

Again, this mode enables you to adjust the aperture, which is one factor in determining depth of field. (Chapter 6 explains depth of field fully). The camera then handles the rest of the exposure equation for you by dialing in the right shutter speed.

For a long depth of field, dial in a high f-stop number; for a shallow depth of field, a low number. The portrait examples earlier in this chapter feature a shallow depth of field; contrast those images with the one in Figure 7-11, taken at f/22. Notice that the fence in the foreground and the church in the distance are both in sharp focus.

Serae Timachef

Figure 7-11: An f-stop of f/22 kept both foreground and background in sharp focus.

Try Landscape mode if

aperture-priority autoexposure isn't available. This scene mode automatically selects a high f-stop number to produce a large depth of field, so that both near and distant objects are sharply focused. Of course, if the light is dim, the camera may be forced to open the aperture, reducing depth of field, to properly expose the image.

If you prefer your landscape to have a shallow depth of field, try Portrait mode instead. That mode automatically selects a lower f-stop setting.

- If the exposure requires a slow shutter, use a tripod to avoid blurring. The downside to a high f-stop is that you need a slower shutter speed to produce a good exposure. If the shutter speed drops below what you can comfortably hand-hold, use a tripod to avoid picture-blurring camera shake. No tripod handy? Look for any solid surface on which you can steady the camera (or nestle it into a camera bag or jacket). You can always increase the ISO setting to increase light sensitivity, which in turn allows a faster shutter speed, too, but that option brings with it the chances of increased image noise.
- For dramatic waterfall and fountain shots, consider using a slow shutter to create that "misty" look. The slow shutter blurs the water, giving it a soft, romantic appearance. Figure 7-12 shows you a close-up of this effect. Again, use a tripod to ensure that the rest of the scene doesn't also blur due to camera shake.
- ✓ At sunrise or sunset, base exposure on the sky. The foreground will be dark, but you can usually brighten it in a photo editor if needed. If you base exposure on the foreground, on the other hand, the sky will become so bright that all the color will be washed out a problem you usually can't fix after the fact.

This tip doesn't apply, of course, if your sunrise or sunset is merely serving as a gorgeous backdrop for a portrait. In that case, you should enable your flash and expose for the subject.

Serge Timacheff

Figure 7-12: For misty waterfalls, use a slow shutter speed (and tripod).

MEMBEA

For cool nighttime pics, experiment with a slow shutter. Assuming that cars or other vehicles are moving through the scene, the result is neon trails of light. Sometimes, if it's *really* dark, you may have to bump-up your ISO to a point that it produces a lot of digital noise — but otherwise you might not get the shot, even with a very slow shutter speed.

The photo of the Aurora Borealis (Northern Lights) in Figure 7-13 was taken in Lapland, Finland about 100 miles north of the Arctic Circle in the middle of winter; it took a shutter speed of 30 seconds at ISO 800 to capture this image (and using a tripod, of course).

Figure 7-13: Photographing at night may require using a high ISO setting.

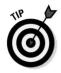

Some cameras will require that you run in a *bulb* mode in order to take very long exposures, such as the one in Figure 7-11. Typically available only in Manual exposure mode, the bulb setting records an image for as long as you hold down the shutter button.

- For the best lighting, shoot during the "magic" or "golden" hours.

 That's the term photographers use for early morning and late afternoon, when the light cast by the sun is soft and warm, at a strong angle, giving everything that beautiful, gently warmed look with nice indirect light, such as you see in Figure 7-14, which shows a picture of St. Tropez taken late in the day.
- In tricky light, bracket shots. Bracketing simply means to take the same picture at several different exposures to increase the odds

Figure 7-14: The time of day when you shoot can create some very dramatic effects.

that at least one of them will capture the scene the way you envision. Bracketing is especially a good idea in difficult lighting situations such as sunrise and sunset.

Getting Gorgeous Close-ups

Close-up, or *macro* shots can be wonderfully artistic, but they can also be challenging to take. To take good macro shots, try the following settings and techniques:

- Check your owner's manual to find out the minimum close-focusing distance of your camera and/or lens. How "up close and personal" you can get to your subject depends on your lens, not the camera body itself. Many cameras and lenses also have a Macro mode, identified by a little flower icon; you may have to turn this on somewhere on the camera either as a button, a preset mode, or perhaps on the LCD menu, to achieve the closest focusing distance.
- ✓ Take control over depth of field by setting the camera mode to aperture-priority autoexposure. Whether you want a shallow, medium, or deep depth of field depends on the point of your photo, although many macro shots look best with a shallow depth of field.

Capturing the image shown in Figure 7-15 at a low aperture setting of f/2.8, for example, created a very shallow depth of field that draws the viewer's attention to the ice crystals forming on the subject's eyelashes.

✓ If aperture-priority autoexposure isn't available, try the Macro scene mode. In this mode, sometimes also called Close-up mode, the camera automatically opens the aperture to achieve a short depth of field. Usually, the camera also bases focus on the center of the frame.

Do note that Macro mode means and does different things depending on the camera. In some cases, it simply adjusts the close-focusing distance; in others, it affects aperture as well as some color and contrast characteristics of the image. So check your manual for details.

Serge Timacheff

Figure 7-15: Shallow depth of field helps emphasize the part of the scene that you found most interesting.

When shooting flowers and other nature scenes outdoors, pay attention to shutter speed, too.

Even a slight breeze may cause your subject to move, causing blurring at slow shutter speeds.

- Try using fill flash for better outdoor lighting. Just as with portraits, a tiny bit of flash typically improves close-ups when the sun is your primary light source. You may need to reduce the flash output slightly, however, because when you fire a flash very close to a subject, it may be overpowering. If you can control your flash directly, turn it down; if not, you may need to cover it with something to diffuse its light (even taping a napkin over the flash may be sufficient).
- When shooting indoors, try not to use flash as your primary light source. Because you'll be shooting at close range, the light from your flash may be too bright and harsh even if you're able to tone it down. If flash is inevitable, turn on as many room lights as possible to reduce the flash power that's needed even a hardware-store shop light can do in a pinch as a lighting source. (Remember that if you have multiple light sources, though, you may need to tweak the white-balance setting, or adjust your color settings in your image-editing program.)

Broadening Your Horizons: Shooting Panoramas

You're standing at the edge of the Grand Canyon, awestruck by the colors, light, and majestic rock formations. "If only I could capture all this in a photograph!" you think. But when you view the scene through your camera's view-finder or LCD screen, you quickly realize that you can't possibly do justice to such a magnificent landscape with one ordinary picture.

Wait — don't put down that camera and head for the souvenir shack just yet. When you're shooting digitally, you don't have to try to squeeze the entire canyon — or whatever other subject inspires you — into one frame. You can shoot several frames, each featuring a different part of the scene, and then stitch them together just as you would sew together pieces of a patchwork quilt.

You can create a panoramic shot that's horizontal or vertical. In Figure 7-16, for example, you see two horizontal images, each showing a different part of a historic farmhouse. Figure 7-17 shows the stitched panorama. And Figure 7-18 shows a vertical panorama, creating by joining two vertically oriented shows: one of the parasailor in the sky and the other of the water and land below.

Although you could conceivably combine photos into a panorama using your photo-editor's regular cut-and-paste editing tools, a dedicated stitching tool makes the job easier. You simply pull up the images you want to join, and the program assists you in stitching the digital "seam."

Figure 7-16: These two images served as the "material" stitched together to form the panorama shown in Figure 7-17.

Figure 7-17: The resulting panorama provides a larger perspective on the farmhouse scene.

Some camera manufacturers provide proprietary stitching tools as part of the camera's software bundle. In addition, many photo-editing programs, such as Photoshop Elements, offer a stitching tool. You also can buy stand-alone stitching programs such as ArcSoft Panorama Maker (\$40, www.arcsoft.com).

The stitching process is easy if you shoot the original images correctly. If you don't, you wind up with something that looks more like a crazy quilt than a seamless photographic panorama. Here's what you need to know:

- Capture each picture using the same camera-to-subject distance. If you're shooting a wide building, don't get closer to the building at one end than you do at another, for example.
- Poverlap each shot by at least 30 percent. Say that you're shooting a line of ten cars. If image one includes the first three cars in the line, image two should include the third car as well as cars four and five. Some cameras provide a panorama mode that displays a portion of the previous shot in the monitor so that you can see where to align the next shot in the series. If your camera doesn't offer this feature, you need to make a mental note of where each picture ends so that you know where the next picture should begin.
- Maintain the right axis of rotation. As you pan the camera to capture the different shots in the panorama, imagine that the camera is perched atop a short flagpole, with the camera's lens aligned with the pole. Be sure to use that same alignment as you take each shot. If you don't, you can't successfully join the images later.

on top of your camera.

Serge Timacheff

Figure 7-18: Here, two images were joined to create a vertical panorama.

- For horizontal panorama, keep the camera level. For best results, use a tripod. Some tripods include little bubble levels that help you keep the camera on an even keel. If you don't have this kind of tripod, you may want to buy a little stick-on bubble level at the hardware store and put it
- ✓ **Use a consistent focusing approach.** If you lock the focus on the foreground in one shot, don't focus on the background in the next shot.
- ✓ If possible, stick with manual focusing and exposure. This approach guarantees that the focus and exposure remain consistent across all your shots.
- If autoexposure is necessary, find out whether your camera offers an autoexposure lock function. This feature retains a consistent exposure throughout the series of panorama shots, which is important for seamless image stitching.

If your camera doesn't provide a way to override autoexposure, you may need to fool the camera into using a consistent exposure. Say that one-half of a scene is in the shadows and the other is in the sunlight. With autoexposure enabled, the camera increases the exposure for the shadowed area and decreases the exposure for the sunny area. That sounds like a good thing, but what it really does is create a noticeable color shift between the two halves of the picture. To prevent this problem, lock in the focus and exposure on the same point for each shot, and then reframe as you capture each segment of the scene. Choose a point of medium brightness for best results. (Whether this technique will work depends on your camera because some cameras continually adjust exposure up to the time you capture the image.)

Avoid including moving objects in the shot. If possible, wait for bypassers to get out of the frame before you take each picture. If someone is walking across the landscape as you shoot, you may wind up with the same strolling figure appearing at several spots in the stitched panorama. Ditto for cars, bicycles, and other moving objects.

If you really enjoy creating panorama images or need to do so regularly for business purposes, you can make your life a little easier by investing in a special panoramic tripod head, which helps you make sure that each shot is perfectly set up to create a seamless panorama. Manufacturers of these specialty tripods include Manfrotto (www.manfrotto.com) and Kaidan (www.kaidan.com). Expect to pay several hundred dollars for these specialty devices.

Exploring High-Dynamic-Range Imaging

Those are some big words, but what they mean is really quite simple. Imagine you're taking a photo of a beautiful sky and countryside below it. Usually it's one or the other — the sky or the landscape — that turns out well, but not both. Either the sky is washed-out and overexposed, or the landscape is too dark, when what you really want is to get the best of both. Achieving that feat is what photographers call *HDR*, which is short for *high-dynamic-range imaging* (try out that term at your next social event and see where it gets you).

Dynamic range refers to the range of brightness values in an image, from shadows to highlights. So a high-dynamic-range image contains more brightness values than a camera can normally capture in one shot.

To capture your sky/landscape scene with HDR, you shoot multiple photos of the scene, all at different exposure settings, making sure that some shots render the sky as you want it and some capture the landscape well. Aside from exposure, everything else about your shots remains the same — framing, focus, and so on.

The next part of the magic happens in a photo editor that offers a feature that enables you to automatically merge the images in a way that retains the proper exposure for each part of the scene. In Adobe Photoshop, for example, the feature is called Merge to HDR. You also can buy dedicated software applications such as Photomatix from HDRSoft (\$100, www.hdrsoft.com) made specifically to do the same task.

For a great example of HDR work, take a look at the images in Figures 7-19 and 7-20, both from photographer Dan Burkholder. In the first image, you see the scene captured at a single exposure. The second image offers the HDR version, created by combining the shot from Figure 7-19 with seven additional exposures. If you want to learn more about Dan's techniques, see images from an amazing book of HDR photographs featuring post-Katrina New Orleans, or (better yet) to attend one of his workshops, visit www. danburkholder.com.

Dan Burkholder

Figure 7-19: Here you see one of the images that photographer Dan Burkholder used to create the HDR image in Figure 7-20.

While this approach can ultimately yield an image much closer to what your eye might see, it is an involved process that is not a procedure for the computer or software novice. The resulting image file is a 32-bit image that often cannot be viewed or used with some less-advanced image-editing applications.

Dan Burkholder

Figure 7-20: The final HDR image includes a much greater tonal range than can be captured in a single exposure.

Coping with Special Situations

A few subjects and shooting situations pose additional challenges not already covered in earlier sections. Here's a quick list of ideas for tackling a variety of common "tough-shot" photos:

Shooting through glass: To capture subjects that are behind glass, try putting your lens flat against the glass. Then switch to manual focusing if possible; the glass barrier can give the autofocus mechanism fits. Disable your flash to avoid creating any unwanted reflections, too.

- Some newer point-and-shoot cameras have a special "museum" or "aquarium" preset scene modes optimized for shooting through glass.
- ✓ **Shooting out a car window:** Set the camera to shutter-priority autoexposure or manual mode and dial in a fast shutter speed to compensate for the movement of the car; or, if your camera doesn't offer those modes, try Sports mode. Even so, however, you still may get a significant amount of blur, especially at night. But sometimes, as in Figure 7-21, that blur can create an interesting effect.

Serge Timacheff

Figure 7-21: Sometimes, a distorted, sbstract image can be interesting..

- ✓ Shooting in strong backlighting: When the light behind your subject is very strong and lighting the subject with flash isn't an option, you have a couple of choices: You can either expose the image with the subject in mind, in which case the background will be overexposed, or you can expose for the background, leaving the subject too dark. By taking the latter route and purposely underexposing the subject, you can create some nice silhouette effects. (In computerland, this is what we call "turning a bug into a feature.") Otherwise, if you turn on your flash so that it is forced to fire even with the bright backlighting, it will help illuminate your subject. Some point-and-shoot cameras also have a preset "backlighting" scene mode that will, in many cases, do all the work for you.
- Shooting fireworks: First off, use a tripod; fireworks require a long exposure, and trying to handhold your camera simply isn't going to work. If your camera has a zoom lens, zoom out to the shortest focal length. For dSLR and point-and-shoot cameras capable of manual operation, switch to manual focusing and set focus at infinity (the farthest focus point possible on your lens).

If available, use the Manual exposure setting. Choose a relatively high f-stop setting — say, f/16 or so — and start a shutter speed of 1 to 3

seconds. From there, it's simply a matter of experimenting with different shutter speeds.

No Manual exposure mode? Try shutter-priority autoexposure mode instead. Some point-and-shoot cameras now have a Fireworks scene mode, too, in which case you can let the camera take the reins. Be especially gentle when you press the shutter button — with a very slow shutter; you can easily create enough camera movement to blur the image.

If your camera offers a noise-reduction feature, you may want to enable it, too, because a long exposure also increases the chances of noise defects. (Keep the ISO setting low to further dampen noise.)

✓ **Shooting reflective surfaces:** If you have a dSLR or a point-and-shoot camera that accepts accessory lens filters, you can reduce daytime glare from reflective surfaces such as glass, water, and metal by using a *circular polarizing filter*, which ranges in price from about \$30 to \$200, depending on size and brand. A polarizing filter can also help out when you're shooting through glass.

But know that in order for the filter to work, the sun, your subject, and your camera lens must be precisely positioned. Your lens must be at a 90-degree angle from the sun, for example, and the light source must also reflect off the surface at a certain angle and direction. In addition, a polarizing filter also intensifies blue skies and water in some scenarios, which may or may not be to your liking. In other words, a polarizing filter isn't a surefire cure-all.

A more reliable option for shooting *small* reflective objects is to invest in a light cube or light tent. You place the reflective object inside the tent or cube and then position your lights around the outside. The cube or tent acts as a light diffuser, reducing reflections. For more on this type of product, see Chapter 5.

Part III From Camera to Computer and Beyond

In this part . . .

ne major advantage of digital photography is how quickly you can go from camera to final output. In minutes, you can print or electronically distribute your images to the world via the Web. But it's important to get familiar and comfortable with the best ways to transfer images between your camera and computer, and to make sure you have everything stored securely.

The chapters in this part of the book will help you get your recently photographed images from your memory card to your computer, where you can have your way with them. Chapter 8 covers details about safely downloading and archiving images so they'll be around for years to come. Chapter 9 gives you an introduction to digital photo retouching, showing how to fix common problems such as red-eye. Chapter 10 is all about printing your photos, while Chapter 11 shows you how to prepare your images for e-mail, Web sharing, and other on-screen uses.

Building Your Image Warehouse

In This Chapter

- Downloading photos from a card reader
- Transferring files via a camera-to-computer connection
- Organizing your picture files
- Processing Camera Raw files
- Restoring files you accidentally erase
- Exploring organizational software options

or most people, the picture-taking part of digital photography isn't all that perplexing — the process is pretty much the same as shooting with a film camera, after all. Where the confusion arises is the step of getting pictures from the camera to the computer, especially for people who don't have much computer experience.

This chapter sorts out the mysteries of this part of the digital photography routine, showing you the fastest and easiest ways to transfer pictures to your computer. Look here, too, for details on how to work with pictures taken in the Camera Raw format, for tips on how to organize your picture files, and for a look at some software tools that you can use to view and catalog your images.

If you *are* a computer novice, we encourage you to also pick up a copy of the appropriate *For Dummies* book for your Windows or Mac operating system. Although we try to provide enough information to get you started, this book doesn't have enough room to cover all the nuts and bolts of working with various operating systems. And without a good grip on computer basics, your digital photography experience will be more frustrating and less enjoyable than it should be.

Downloading Your Images

You have a camera full of pictures. Now what? You transfer them to your computer, that's what. This step can be one of the scariest tasks for a lot of people, which is why more than a few novice photographers use their cameras for months before even considering transferring their images. Not to worry! The next few sections show you exactly how to get your images moved from camera to computer, safe and sound.

A look at your downloading options

Digital camera manufacturers have developed several ways for users to transfer pictures from camera to computer. Here's a brief overview of your choices:

✓ **Use a card reader:** A *card reader* is simply a little gadget that enables you to transfer files to a computer without using the camera itself. Many computers, printers, and monitors now have built-in card readers; if yours doesn't, you can buy an external one that plugs into your computer's USB port. Either way, you just pop the card out of the camera and into the card reader, and you can then transfer files just as you would when moving them from a CD, DVD, or old-fashioned floppy disk. (Remember those?) See the upcoming section "Downloading from a card reader" for more details on this transfer method.

USB stands for *Universal Serial Bus*, which is a technology developed for connecting printers, cameras, and other devices to a computer. A USB *port* is simply a slot on the computer where you can plug in a USB cable. Figure 8-1 offers a close-up look at a USB plug and ports.

Connect the camera to the computer: You can also connect your computer directly to your camera using the cable that came in your camera box. Normally, it connects via USB. When attached, your camera appears on your computer as just another storage device, and you can then transfer images from the camera's memory card.

Although this method isn't all that much more complicated than using a card reader, it does require you to keep your camera turned on during the transfer, which eats up your batteries. And you have to keep track of your camera's connection cable, which is a bother you don't have to take if you use a built-in card reader (or keep the card reader permanently connected to the computer). Read through the upcoming section "Downloading from the camera" to get a better idea of the process.

Figure 8-1: Most card readers and cameras connect to the computer via a USB cable.

Use a camera dock: A camera dock, or docking station, is a small base unit that you leave permanently connected to your computer. To download pictures, you place the camera into the dock. From there, the process is the same as downloading from a card reader or camera (although some docks give you a button or menu that you use to initiate the transfer). Most docks also serve as the camera's battery charger, and some offer features that simplify e-mailing and printing pictures. You can even buy docks that have a built-in snapshot printer; the Kodak model shown in Figure 8-2 is an example.

Eastman Kodak Company

Figure 8-2: Some docking stations do dual duty as snapshot printers.

A few cameras ship with a docking station; sold alone, docks usually run in the \$50 to \$200 range, depending on whether they incorporate a printer. Check your camera manufacturer's Web site to see what types of docks may be available, if any, for your camera.

✓ Wireless transfer: A few cameras now offer wireless transfer, taking advantage of the same technologies employed by wireless Internet connections, television remote controls, and other wireless devices. In order to take advantage of this feature, both your camera and computer must have the right wireless equipment. Chapter 1 gives you a look at one new product that enables wireless connection, the Eye-Fi memory card. (Only some cameras can use this type of card.)

Because setting up wireless transfer varies depending on the specific technology, camera, and computer, we must refer you to your camera manual for help with that process.

Let a pro do it for you. Not all that comfortable with computers? You may find it easier to have your local photo lab copy your files to a CD for you. You can have a CD made at the same time you print your pictures. Then you can put only the pictures you want to edit, e-mail, or access on your computer's hard drive — you just put the CD in the CD drive and copy pictures just as you may have done with music files or data files. Almost any place that can print digital photos offers this service.

Tips for smoother downloading

Whichever transfer option you choose, a couple of pointers can help the whole thing run more smoothly:

- ✓ Transfer speed: The speed at which your image files travel from memory card to your computer depends on the size of the picture files, the speed of the card, the speed of the computer, and the speed of the connection type itself. If you use a USB connection, make sure that your equipment offers USB 2.0, which is the latest (and fastest) version of that technology. Chapter 2 talks a little more about memory card speeds; see Chapter 4 to get details about two of the factors that affect file size, resolution, and file format.
- Transfer software: When your computer detects the presence of digital images, whether they're on a CD, a DVD, a connected camera, or a memory card, it's likely that the computer will automatically display some sort of window or program that offers to help you download your photos. In fact, multiple windows may appear. You may see a Windows utility, for example, as shown in Figure 8-3, or iPhoto on the Mac, as shown in Figure 8-4. And then a few seconds later, a download tool that's part of your photo software or camera software may pop up and beg you to let it do your downloading.

Figure 8-3: On a Windows-based computer, the system may display this screen full of download options.

Figure 8-4: On a Mac, iPhoto may automatically start up when the computer detects a memory card or camera.

You can use whichever of these tools you find easiest; just close the windows for the ones that you want to ignore. Better yet, consult the Help systems of those programs to find out how to disable the automatic launch. And if nothing pops up, you can start up your favorite download program as you normally launch any program.

Also note that even though you download images using one program, you don't have to stick with that program for editing your images. You can download using iPhoto, for example, and then open and edit the transferred photos in Adobe Photoshop Elements.

Transfer options: Although it's impossible to provide specifics on all the possible download tools, they all pretty much work the same way: You click the thumbnails of the images you want to download and then click a button (usually labeled Download or Import or something similar), and the program takes it from there.

Most downloaders do provide you with lots of ways to customize the download. For example, you typically can specify the folder and drive where you want to store your photos. (In true geeky fashion, the option is usually referred to as the destination folder.) See the upcoming sidebar "File-organization tips" for some suggestions on the best choices to make.

Do look out for a couple of potentially dangerous options:

- Erase originals after download: One typical option is to automatically erase the original images on your card as you transfer them to the computer. Disable that option just in case something goes haywire. It's not a good idea to erase the images on your card until you're confident that they're safely stored on your hard drive.
- Automatically fix red-eye: A couple of downloaders, including the one provided with Photoshop Elements, automatically attempt to try to remove red-eye during the download process. This option can cause your downloads to take forever as the program tries to locate and fix areas that it thinks may be red-eye. It's better to do the job yourself after downloading; see Chapter 9 for the step-bystep instructions.
- ✓ **Drag-and-drop transfer:** If you're an experienced computer user, you may prefer not to use any photo-download software. Instead, you can just use the system file-management tools — Windows Explorer or the Mac Finder — to drag and drop files from your card or camera to the hard drive. The next section, "Downloading from a card reader," demonstrates the drag-and-drop technique.

File-organization tips

When you transfer picture files to your computer, you can store them in any folder on your hard drive that you like. But it's a good idea to stick with the default location that your computer's operating system sets aside for digital pictures. The folder is named either Pictures or My Pictures, depending on your operating system (Windows XP, Windows Vista, Mac Leopard, and so on). Most photo-editing programs, as well as other programs that you may use to work with your pictures, look first in the default folders when you go to transfer, edit, and save pictures. So keeping your images in those folders saves you the trouble of hunting down some custom folder every time you want to work with your photos.

After you amass a large image collection, you may want to create subfolders inside the Pictures or My Pictures folder so that you can

better organize your photos. For example, you can create a Travel subfolder to hold travel photos, a Family subfolder for family images. and so on.

You might even like to rename your individual photos with file names that let you reference them specifically. For example, suppose you took pictures in France in the year 2008. You might rename the files this way:

Original File Name:

DSCN0223.jpg

Your New File Name: France 08-0223.jpg

That way, you can identify the picture subject and year by looking at the first part of the filename, yet by keeping the original file number, each image has a unique identifier. Some photo programs offer automated file renaming tools that can make this organizational step a breeze, too.

Downloading from a card reader

If you own a relatively new computer or photo printer, it may be equipped with one or more memory-card slots. Assuming that one of those slots accepts the type of memory card that your camera uses, you're set: Just take the card out of the camera and put it in the slot. (For a printer slot, be sure to turn the printer on, or your computer won't see the card.)

No built-in card slots? You can buy a card reader for very little cash at any electronics, office supply, or camera store. You can either buy a reader that accepts just one type of card or a product like the Kingston reader shown in Figure 8-5, which works with 19 different card types. Either way, to install the card reader, simply plug it in to an empty USB port on your computer. In most cases, card readers are "plug-and-play" — that is, your computer recognizes the reader without any further help from you. But some card readers ship with some software that you need to install, so be sure to check the instructions on the product box.

If you happen to have a card reader that doesn't support your type of memory card, you may be able to buy an adapter that makes the two devices compatible or allows you to plug the memory card right into a USB port.

In any case, the computer should automatically recognize the card, seeing it as just another drive, like a CD drive or DVD drive. From this point, you can either use one of the aforementioned photo downloaders, following the instructions provided by the specific program, or you can simply drag and drop the files from the card to the computer. The process is the same as you use to copy and move any type of file using Windows Explorer or the Mac Finder.

Kingston Technology Company, Inc.

Figure 8-5: Just push the memory card into the matching slot on the card reader.

For example, Figure 8-6 shows how a four-slot card reader shows up in Windows Vista version of Windows Explorer. (This Explorer is the Windows file-management tool, not Internet Explorer, which is a Web browser.) Each slot on the card reader shows up as a separate drive in the list on the left side of the window. In some cases, the camera brand name appears along with the drive letter; in the figure, for example, the card contained images taken with a Canon EOS camera, so EOS_Digital appears.

Normally, you have to open a folder or two to get to the actual image files. They're typically housed inside a main folder named DCIM (for *digital camera images*), as shown in Figure 8-6, and then within a subfolder that uses the camera manufacturer's name or folder-naming structure. After you open the folder, you may see thumbnails of the images, as in the figure, or simply the names of the files. (In Windows Explorer, you can display thumbnails by opening the View menu and choosing Large Icons or Medium Icons.)

On a Mac, the card should appear as a drive on the desktop. Double-click the drive icon to open a Finder window and access the card contents, as shown in Figure 8-7. Again, you have to open a series of folders to get to the actual images.

Figure 8-6: The memory card appears as a regular drive on the computer.

Figure 8-7: On a Mac, you can drag and drop files using the Finder.

If you're shooting Camera Raw images, they may not appear as thumbnails depending on the camera model and the version of the Windows or Mac operating system you use. But you can see the filenames and still transfer them to your computer. (This applies to photo downloaders too, unless you're using software provided by the camera manufacturer, in which case the thumbnails should be visible.)

After opening the folder that contains the images, select the ones you want to transfer and then just drag them to the folder on your hard drive where you want to store them, as shown in Figure 8-8. Although it's not visible in the figure, you should see a little plus sign next to your cursor when you drag. The plus sign indicates that you're placing a *copy* of the pictures files on the computer; your originals remain on the card. When you're sure that the files made it to their new home, you can put the card back into the camera and erase the originals.

Figure 8-8: After selecting the pictures you want to transfer, just drag them to their new home.

To select one image file for copying, click it. To select additional files, Ctrl+click them in Windows or 光+click them on a Mac. Or, to select all the files, press Ctrl+A (Windows) or 光+A (Mac).

Downloading from the camera

As an alternative to using a memory-card reader, you can attach your camera to the computer and transfer images directly. Virtually all digital cameras today connect to your computer via a USB hookup, introduced at the start of this chapter. You might have to plug the USB cable into your camera, or your camera may sit in a docking station that plugs into your USB port on your computer.

Either way, your camera manual undoubtedly provides specifics on the process of connecting to a computer. As you work through the download steps for the first time, keep the manual handy so that you can find out whether you need to follow any special procedures along the way. For example, you may need to install software that shipped with the camera before you even connect the camera to the computer.

With those caveats in mind, the following steps provide a basic look at the process:

1. Check the camera's battery status.

If the battery is low, charge it before moving on. You can damage the camera, the memory card, and your picture files if the battery dies in the middle of the transfer process.

Alternatively, if your camera came with an AC adapter, power the camera that way for downloads.

2. Turn the computer on, but turn the camera off.

With some cameras, connecting to the computer while the camera is powered up can cause problems.

3. Use the USB cable that shipped with your camera to connect the camera to an open USB port on the computer.

The camera's USB port is usually tucked under a little rubber flap or door; check the camera manual for help if you can't find the port.

On the computer side, try to use a built-in USB port rather than one that's on a keyboard or an external USB hub. Sometimes the external hubs don't work as smoothly for camera connections.

5. Set the camera to the proper mode for image transfer.

For this step, you need to consult your camera manual. With some cameras, you have to choose a PC connection setting, for example, or you may need to switch to playback mode.

What happens next depends on what software you have installed on your system. But at the very least, an icon representing the camera should appear in Windows Explorer or on the Mac desktop. You can then drag and drop your picture files to the hard drive by using the same technique outlined in the preceding section. Or you can use your favorite photo-download software, as described earlier in the chapter.

6. When the download is complete, turn the camera off before disconnecting it from the computer.

Converting Raw Files

Many new, high-end digital cameras can capture images in the Camera Raw file format, or just Raw, for short. As discussed in Chapter 4, this format stores raw picture data from the image sensor, without applying any of the usual post-processing that occurs when you shoot using the JPEG format.

Although you can transfer Raw files to your computer using the same processes outlined in the first part of this chapter, you won't be able to see them until you use an image-editing program that can recognize the files created by your specific camera. Most camera manufacturers provide software in the camera box that enables you to view your pictures, and some third-party software can also display Raw files. (In the case of third-party programs, though, you may need to go to the software manufacturer's Web site and download a "Raw update" to make the program compatible with your camera.)

You usually can print your Raw files immediately from the camera maker's software. But if you want to be able to edit your photos, share them online, or use them in any other programs, such as a multimedia program, you need to *process* the Raw files and then save them in a common image format. You take this step by using a software tool known as a Raw converter. Again, your camera software may offer a Raw converter, and many photo-editing programs also offer this tool.

When you process Raw files, you usually have some options as to how you want the raw data translated into a photo. You may, for example, be able to adjust brightness, color tone, white balance, and so on. The extent to which you can control these characteristics of your photos varies depending on the converter. Some converters are pretty sophisticated, but others, including some provided by camera manufacturers, automatically set all the image characteristics for you. These simplistic converters simply change the file format from Raw to a standard format, usually either TIFF or JPEG, applying the same picture-characteristic choices you would get if you shot them in the JPEG format instead of Raw.

Just to give you an idea of how the Raw conversion process works with a converter that does enable you to specify image characteristics, the following steps give you an overview of the process in Photoshop Elements:

- 1. Follow your normal process for transferring files to your computer.

 Again, the first part of this chapter explains the transfer process.
- 2. In Elements, choose File⇔Open to launch the Open dialog box.
- 3. Track down the file and click Open.

Elements recognizes that the file is in the Raw format and launches the Adobe Camera Raw window, shown in Figure 8-9. Be sure that the Preview check box at the top of the window is turned on; if not, click it. Now you can see the results of any changes you make.

4. Use the controls on the right side of the window to tweak the image appearance if necessary.

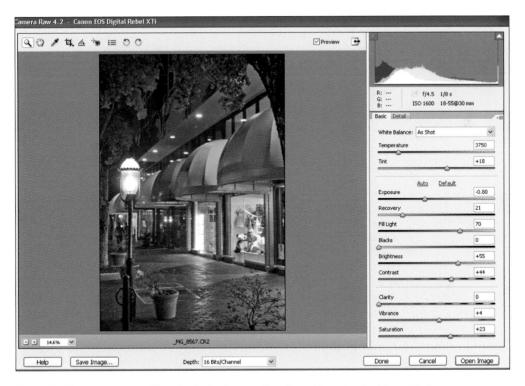

Figure 8-9: You must convert files shot in the Camera Raw format to a standard format before you can open them.

The preview that appears initially shows the image according to the camera settings that were in force when you shot the image. To put it another way, the preview shows you the image as it would have appeared if you captured it in the JPEG format, and the camera applied its normal color, sharpness, and exposure settings. However, this preview just represents your starting point. You can tweak exposure, white balance, color saturation, and image sharpness by using the controls on the right side of the dialog box. You can find complete details about what each control does in the Elements Help system.

5. Click Open Image to finish opening the file.

Your picture opens in the Elements editing window.

6. Choose File⇔Save As to open the Save As dialog box.

7. Save the file in the TIFF format.

This format retains your image at its highest quality. Don't save in the JPEG format; when you do, the picture can lose some quality because of the way the file is compressed during the saving process. For details on TIFF and JPEG, see Chapter 4; skip ahead to Chapter 9 for specifics about the file-saving process and options that appear when you save in the TIFF format.

Again, for details about the specific conversion settings in your Raw converter, check the program's Help system. You can also find lots of good tutorials online for popular programs, such as Elements and Photoshop.

Whichever converter you use, however, a few general tips apply:

- Don't erase your original Raw file. You may someday want to convert the file using different settings. And retaining the Raw file means that you always have an original image in pristine condition that you can return to if necessary.
- The settings you use when making your Raw conversion stay with the Raw file, sort of like an invisible recipe card. So the next time you re-open the file in the converter, you don't have to go through all the adjustments again; they're automatically applied as you did them the first time. But because your picture data still is technically "raw," you can apply a whole new set of adjustments without doing any damage to your picture.
- ✓ Before you do any Raw conversions or any photo editing, for that matter — you should calibrate your monitor to ensure that you're looking at an accurate representation of the picture brightness, color, and so on. Chapter 10 talks more about monitor calibration.
- Remember that Raw files have different filenames depending on the camera manufacturer. Nikon files go by the name NEF; Canon, CR2; and so on. In Windows, you see these three-letter extensions at the ends of the filenames.

Recovering Deleted Files (Maybe)

It happens to everyone sooner or later: You accidentally erase an important picture — or worse, an entire folder full of images. Don't panic yet — you may be able to get those pictures back.

The first step: *Stop shooting*. If you take another picture, you may not be able to rescue the deleted files. If you must keep shooting, and you have another memory card, replace the one with the accidental erasure with the other card. You can work with the problem card later.

For pictures that you erased using the camera's delete function, go online or to your local computer store to buy a file-recovery program such as MediaRECOVER (\$30, www.mediarecover.com) or RescuePRO (\$40, www.lc-tech.com). For these programs to work, your computer must be able to access the camera's memory card as if the card were a regular drive on the system. So if your camera doesn't show up as a drive when you connect it to the computer, you need to buy a card reader.

If you erased pictures on the computer, you may not need any special software. In Windows Explorer, deleted files go to the Recycle Bin and stay there until you empty the Bin. Assuming that you haven't taken that step, just open the Bin, click an erased file, and then choose FileDRestore to "un-erase" the picture. On a Mac, deleted files linger in the Trash folder until you choose the Empty Trash command. Until you do, you can open the Trash folder and move the deleted file to another folder on your hard drive.

Already emptied the Recycle Bin or Trash? You also can buy programs to recover files that were dumped in the process; start your software search at the two aforementioned Web sites.

Looking at Organizational Software

Some camera manufacturers provide a custom photo-browsing and organizing tool on the software CD that ships in the camera box. Many photo-editing programs also offer this kind of tool; Figure 8-10 shows the organizer utility included for the Windows version of Photoshop Elements 6, for example. (If you're running Elements 6.0 on the Mac, you also get a file-browsing tool, but it's a little different from the one provided for the Windows version.)

Depending on your computer's operating system, it also may offer tools for browsing through thumbnails of your digital photo files:

Figure 8-10: Photoshop Elements provides a built-in photo organizer; here, you see the Windows version.

- Recent versions of Windows, for example, enable you to view thumbnails in Windows Explorer, as shown in Figure 8-6, earlier in this chapter. Explorer also has a very convenient search function that can track down the location of a specific file, provided you can tell it the filename.
- ✓ If you work on a Macintosh computer running OS X 10.1.2 or later, you have access to iPhoto, also shown earlier, in Figure 8-4. (The window may look different depending on what version of the operating system and iPhoto you use.) Apple provides a copy with all new Mac systems, and you can then purchase subsequent updates from the Apple Web site.

Again, these Windows and Mac system tools may not display files if you shoot them in the Camera Raw format, and the same may hold true for some third-party organizer programs. See the preceding discussions of the Raw format for more information.

I never metadata I didn't like

Digital cameras store *metadata* along with picture data when recording an image to memory. Metadata is a fancy name for extra information that gets stored in a special area of the image file. Digital cameras record such information as the aperture, shutter speed, exposure compensation, and other camera settings as metadata.

To capture and retain metadata, digital cameras typically store images using a variation of the JPEG file format known as EXIF, which stands for *exchangeable image format*. This flavor of JPEG is often stated in camera literature as JPEG (EXIF). Note, though, that metadata is also stored when you shoot in the Camera Raw format instead of JPEG. (Chapter 4 explains all this file format stuff.)

The important point is that you can view metadata in many photo-editing and cataloging programs. For example, the area highlighted in red in the following figure shows a portion of the metadata panel found in a program provided with some Canon cameras, Canon ZoomBrowser EX. (For Mac users, the program is called ImageBrowser instead.)

By reviewing the metadata for each image, you can get a better grasp on how the various settings on your camera affect your images. It's like having a personal assistant trailing around after you, making a record of your photographic choices each time you press the shutter button—only you don't have to feed this assistant lunch or provide health insurance.

You also can find many good third-party picture-organizing programs; these tools are sometimes called *digital asset management*, or DAM applications by digital photography aficionados. (Yes, you pronounce it just the way it looks, believe it or not.)

Figure 8-11 offers a look at one good option, ACDSee Pro (www.acdsystems. com). A couple of other choices to investigate include ThumbsPlus (www.cerious.com) and Extensis Portfolio (www.extensis.com).

A significant advantage of these products lies in their database features, which you can use to assign keywords to images and then search for files using those keywords. For example, if you have an image of a Labrador retriever, you might assign the keywords "dog," "retriever," and "pet" to the picture's catalog information. When you later run a search, entering any of those keywords as search criteria brings up the image. You can also then rate and prioritize your photos in any order you like.

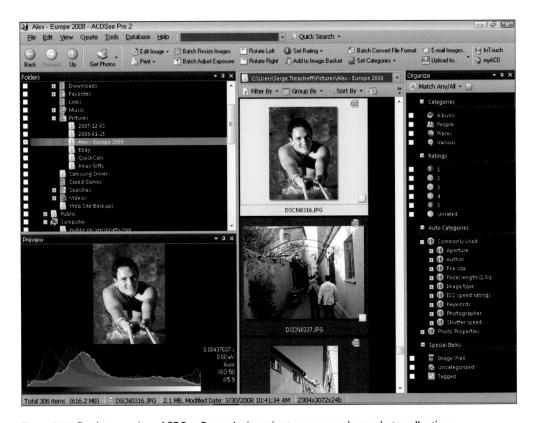

Figure 8-11: Products such as ACDSee Pro make it easier to manage a large photo collection.

Again, your photo editor may offer some of the same features as you find in third-party organizers. So be sure to explore those tools before you invest in an unneeded extra program. And note that you can download free trials of most programs from the vendor's Web site, which enables you to try before you buy.

Fixing Minor Photo Flubs

In This Chapter

- Opening and saving pictures
- Cropping out unwanted elements
- Removing red-eye
- Tweaking exposure and color
- Creating the illusion of sharper focus

ne of the great things about digital photography is that you're never limited to the image that comes out of the camera, as you are with traditional photography. With film, a lousy picture stays lousy forever. Sure, you can get one of those little pens to cover up red-eye problems, and if you're really good with scissors, you can crop out unwanted portions of the picture. But that's about the extent of the corrections you can do without a full-blown film lab at your disposal.

With a digital image and a basic photo-editing program, however, you can fix many common picture problems with surprisingly little effort. This chapter explains the basics, offering simple steps for correcting exposure, color, red-eye, and more.

What Software Do You Need?

In this chapter, and in others that describe specific photo-editing functions, we show you how to get the job done using Adobe Photoshop Elements. We chose this software for two reasons. First, it costs less than \$100, yet offers many of the same features found in the more sophisticated (and more expensive) Adobe Photoshop, the leading professional-level photo editor. In addition, Elements is available for both Windows-based and Macintosh computers, which is a rarity in today's Windows-centric computing world.

Here are a few additional notes about the photo-editing instructions in this book:

- Text marked with an Elements How-To icon relates specifically to Elements. This chapter is just intended to help you get your feet wet with Elements, however. If you want to dig deeper into the program, many excellent books are available, and the program's built-in Help system is quite good as well.
- In figures, the Elements toolbox appears as a two-column affair running down the left side of the program window, as shown in Figure 9-1, but yours may occupy just a single column. The arrangement depends on the size of the program window; if the window is small, the toolbox shrinks itself in height so that you can see the entire toolbox at all times.
- Whatever the toolbox arrangement, you select a tool by clicking its icon in the toolbox. Controls related to that tool then appear on the options bar, labeled in Figure 9-1. On a Mac, choose Window⇔Options Bar if you don't see the options bar.
- In addition, we hid the Palette Bin and Project Bin in the figures to leave more room for the image itself. You can hide and display these components via the Window menu.
- Finally, instructions assume that you're working in Full Edit mode. If your screen is set to one of the other two modes, Quick Edit or Guided Edit, open the Palette Bin. Then click the Full Edit button at the top of the bin. You can then close the bin. Again, you can toggle the bins on and off by clicking their names on the Window menu.

Readers who own Adobe Photoshop will find that many of that program's tools work exactly as they do in Elements, although the Photoshop versions may offer a broader array of options. If you use a photo editor other than Elements or Photoshop, be assured that you can easily adapt the information provided in this book to your software. Most photo-editing programs provide similar tools to the ones we discuss here. And the basic photo-retouching concepts and photographic ideas are the same no matter what photo software you prefer.

So use this chapter as a guide for understanding the general approach you should take when editing your digital pictures, and consult your software's manual or online Help system for the specifics of applying certain techniques.

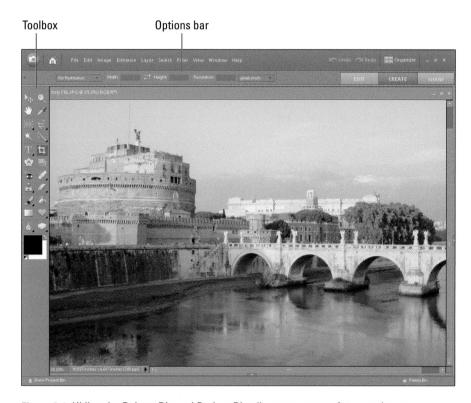

Figure 9-1: Hiding the Palette Bin and Project Bin allows more room for your photos.

Opening Your Photos

Before you can work on a digital photo, you have to open it inside your photo-editing program. In just about every program on the planet, you can use the following techniques to crack open a picture file:

- ✓ Choose File

 Sopen.
- ✓ Use the universal keyboard shortcut for the Open command: In Windows, press Ctrl+O; on a Mac, press \(\mathbb{H}\)-O.

Whichever method you choose, the program displays the same dialog box you see when you open files in any program. Just track down your picture file and click the Open button as usual. For help getting your files onto your computer in the first place, check out Chapter 8.

Why is my photo software so sluggish?

Photo editing requires a substantial amount of free RAM (system memory). If your computer slows to a crawl when you open a picture, try shutting down all programs, restarting your computer, and then starting your photo software only. (Be sure to disable any startup routines that launch programs automatically in the background when you fire up your system.) Now you're working with the maximum RAM your system has available. If your computer continues to complain about a memory shortage, consider adding more memory — memory is relatively cheap right now, fortunately.

Understand, too, that your photo software uses your computer's hard drive space as well as RAM when processing images. In Elements, you see a message saying that your *scratch disk* is full when you run out of drive space; other programs may use different terminology. In any case, you can solve the problem by deleting unneeded files to free up some room on the hard drive. Another option is to buy an external hard drive and move your less-used files to that drive.

Just a few other file-opening points to note:

- Some programs, including Elements, offer a built-in file browser that you can use to preview thumbnails of your picture files before you open them. After you locate the picture you want to edit, you usually can just double-click the thumbnail to open the file.
- ✓ If you captured your pictures using the Camera Raw file format, you need to convert them to a standard file format such as TIFF before you can edit the files. Chapter 8 offers a look at the Raw-conversion process.

✓ If your picture opens on its side, use your software's Rotate commands to set things right. In Elements, the commands reside on the Image⇔Rotate submenu.

Saving Your Edited Photos

Chapter 2 discusses options for preserving your original photo files. You also need to take precautions to preserve any changes you make to your pictures in your photo editor.

Until you save the edited picture, all your work is vulnerable. If your system crashes, the power goes out, or some other cruel twist of fate occurs, everything you did since the last time you saved the picture is lost forever. So commit the following image-safety rules to memory:

If you don't want to overwrite your original photo file, be sure to give the picture a new name, choose a different file format, or store it in a separate folder from the original.

✓ Saving works in progress: As you work on a photo, resave the file periodically. You can usually simply press Ctrl+S in Windows or ૠ+S on a Mac to resave the image without messing with a dialog box.

Do *not* use this tactic to save an altered file for the first time, or you'll overwrite the original image file.

In most programs, you can specify a file format when you choose the Save As command. Always choose a non-destructive format to hold onto all your original picture quality. The most universally available non-destructive format is TIFF, first introduced in Chapter 4.

When you save an image as a TIFF file, you may see a dialog box like the one shown in Figure 9-2, which is from the Windows version of Elements.

Set the dialog box options as follows:

- ✓ Image Compression: Choose None. The LZW compression option is also safe in terms of preserving all your image data, but some programs can't open files saved with LZW.
- ✓ Byte Order: Choose IBM PC if you know you'll be using the file on a
 Windows-based system; choose Macintosh for a Mac system. But don't
 stress too much about this one most programs can open either type
 of file.
- ✓ **Save Image Pyramid:** Give this one a pass, too. When enabled, it creates a file that some programs won't open.
- ✓ Save Transparency and Layer Compression: These options don't come into play until you start using advanced Elements tools. For details about when you need to worry about them, check your program's Help system. (Many photo programs don't even offer these TIFF options.)

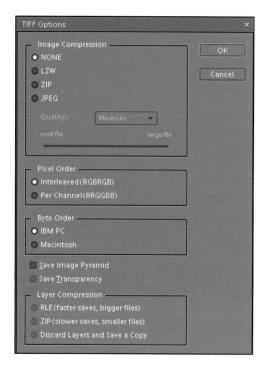

Figure 9-2: Save edited files in a non-destructive format such as TIFF; select the options shown here, if available.

What about the two standard digital camera file formats, JPEG and Camera Raw? Well, as covered in Chapter 4, JPEG applies a form of file compression that degrades picture quality. So if you need a JPEG copy for some reason, perhaps for online sharing, wait until you're completely finished retouching the photo, save the finished file in the TIFF format, and then create a copy in the JPEG format. Chapter 11 shows you how.

As for Camera Raw, only cameras can create files in that format. A noncamera format called Photoshop Raw does exist, but it's not the same thing and isn't appropriate for saving your edited picture files.

Removing Red-Eye

Shooting portraits with flash often leads to red-eye, that phenomenon that makes your subjects' eyes appear to glow red. You may be able to lessen the problem by using your camera's red-eye reduction flash mode, but even that feature doesn't always do the trick.

Some cameras offer a built-in red-eye removal filter that you can apply to pictures on your memory card. If your camera doesn't offer that tool or if the camera's filter doesn't fix the picture successfully, you can usually remove red-eye in your photo software. Almost all photo-editing programs today sport a red-eye removal tool.

In Photoshop Elements, follow these steps to try it out:

1. Zoom in closely on the red-eye area.

Click the image with the Zoom tool, labeled in Figure 9-3, to zoom in. (To zoom out, Alt-click with the tool in Windows or Option-click on a Mac.)

- 2. Select the Red-Eye Removal tool, labeled in Figure 9-3.
- 3. Click on a red pixel in the eye.

Red-Eye Removal tool

Elements replaces the red pixels with pixels that it thinks produces a natural result. If you're not happy with the outcome, choose Edit Undo. Then try again.

Zoom tool Pupil Size: 50% Darken Amount: 50% Auto HPIM0003.JPG @319%(RGB/8*) T to A to T to T to A to T to T to A to T to

Figure 9-3: The Elements Red-Eye Removal tool does a decent job on most eyes.

If the replacement pixels are too dark or too light, adjust the Darken Amount setting on the options bar. To cover up a larger or smaller portion of the eye, adjust the Pupil Size setting.

Although red-eye removal tools work well most of the time, they can falter if the red-eye pixels are very bright. Red-eye tools also don't work on animal eyes; the tools only know how to replace red pixels, and animal eyes take on a green, yellow, or white glow in flash pictures. In both scenarios, the easiest solution is to simply paint in a new eye color with your photo editor's paint brush. Just dab over the red pixels with dark paint, making sure that you don't cover up the natural white highlight pixels that should occur in the eye. (If you happen to do so, just put the highlight back by painting with white.)

Cropping Your Pictures

Chapter 7 offers tips on photo composition. But if you're not happy with the composition you created when you took a picture, you may be able to improve it by cropping.

Figure 9-4 offers an example. In this photo, the subject was posing in front of a nicely textured, old wall in Barcelona, Spain. But there's just *too* much wall and not enough subject in the photo. Cropping away some of the excess background resulted in the better image shown in Figure 9-5.

Serge Timachef

Figure 9-4: Suffering from an excess of boring background, this image begs for some cropping.

The following steps explain how to give your image a haircut by using the Elements Crop tool. Every photo program offers a comparable tool, most of which work similarly to the Elements version.

1. Click the Crop tool icon in the toolbox.

The Crop tool is located in the position shown in Figure 9-6.

2. Specify the proportions you want for your cropped photo by using the Aspect Ratio options.

Click open the Aspect Ratio dropdown list, labeled "Set crop proportions" in Figure 9-6. The list contains a variety of traditional print sizes — 4 x 6 inches, 5 x 7, and so on. If your goal is to produce a photo that fits one of those sizes, click it in the

Figure 9-5: A tight cropping job restores emphasis to the subject.

list. You then see the dimensions appear in the neighboring Width and Height boxes. (If you want to reverse the values, click the little arrows between the two boxes.)

Don't see the size you want on the list? Just enter the dimensions in the Width and Height boxes yourself. Or, if you're not yet sure what proportions you want the photo to have, choose No Restriction from the dropdown list.

Avoid the Use Photo Ratio option that appears on the list. If you choose this setting, the program resamples your photo after you crop, adding enough pixels to the photo to restore the original image pixel count. The same thing occurs if you enter a value in the Resolution box (next to the Height box), so be sure that box is empty. Adding pixels usually reduces picture quality, for reasons you can explore in Chapter 4.

3. Drag across the image to create your initial crop outline, as shown in Figure 9-6.

When you release the mouse button, you see a dotted outline that has little square boxes on the sides and corners. Figure 9-7 gives you a close-up look at these boxes, officially known as *handles*. The area outside the outline appears dimmed to help you better see the photo that will result from your current crop boundary.

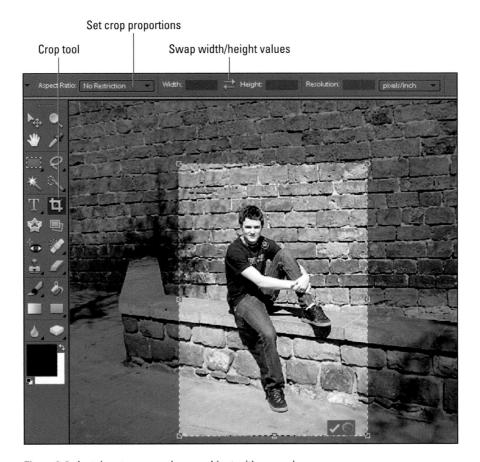

Figure 9-6: Just drag to surround your subject with a crop box.

As you decide how much of your original image to crop away, keep image resolution in mind if you plan to print the photo: You need enough pixels in the cropped photo to produce a good print. How much of the original image you need to keep depends on the initial pixel count. For help with this issue, see Chapter 4.

4. Refine the crop outline if needed.

You can resize and relocate the crop outline as follows:

• *Drag a handle to resize the crop box.* As you drag, the program limits you to drawing a crop outline that matches the proportions you selected from the Aspect Ratio drop-down list in Step 2. If you chose

No Restriction, however, you can create a crop boundary of any proportions.

Be careful when you drag a corner handle! If you place the cursor outside a corner handle, it changes to a curved, two-headed arrow, and dragging rotates the crop box. And after you apply the crop, the image is rotated according to the angle of the box. To avoid this, move the cursor directly over the handle to return to the straight, twoheaded arrow cursor. You can then drag the corner handle safely.

 Drag inside the crop box to move it. If you have trouble precisely positioning the crop box by dragging, put your cursor inside the box and then press an arrow key on your keyboard to nudge it one pixel at a time in the direction of the arrow.

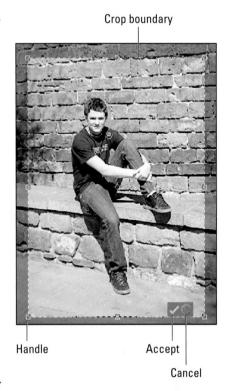

Figure 9-7: Drag a handle to adjust the crop boundary.

5. To apply the crop, click the green Accept check box (labeled in Figure 9-7).

The Cancel button, also labeled in the figure, lets you escape the crop operation instead. (Note that the position of your Accept and Cancel buttons may be different than in the figure depending on the size of your crop box.)

6. Save the cropped image.

To do so, choose File➪Save As. For best results, choose TIFF as the file format. See the file-saving information at the start of this chapter for the complete story on saving edited files.

Fixing Exposure After the Fact

At first glance, the underexposed picture on the left side of Figure 9-8 appears to be a throwaway. But don't give up on images like this because you may be able to rescue that too-dark image, as shown on the right here. The next three sections explain how to use a variety of exposure-repair tools.

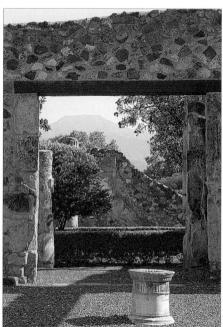

Figure 9-8: An underexposed image (left) sees new light (right).

Basic brightness/contrast controls

Many photo-editing programs offer one-shot brightness/contrast filters that adjust your image automatically. These automatic correction tools tend to do too much or too little and, depending on the image, can even alter image colors dramatically.

Fortunately, most programs also provide exposure controls that enable you to specify the extent of the correction. These controls are easy to use and almost always produce better results than the automatic variety.

The most basic exposure and contrast tools work like the Elements Brightness/Contrast filter, found on the Enhance⇔Adjust Lighting menu and shown in Figure 9-9. You just drag the sliders to adjust brightness or contrast.

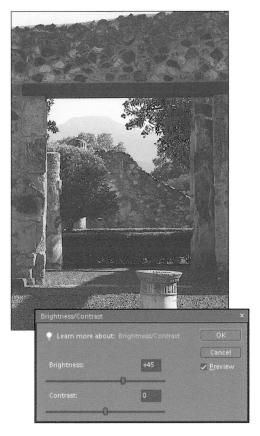

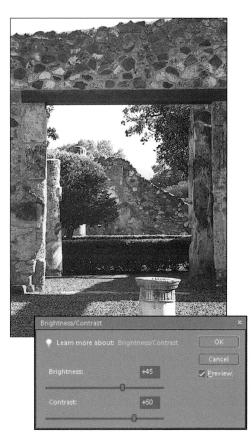

Figure 9-9: Raising the Brightness and Contrast values brought midtones into an acceptable range, but also blew out all color in the sky.

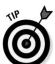

Although the Brightness/Contrast filter is easy to use, it's not always a terrific solution because it adjusts all pixels by the same amount. That's fine for some pictures, but often, you don't need to make wholesale exposure changes.

For example, in the too-dark image shown in Figure 9-8, the shadows are where they need to be, exposure-wise. Only the highlights and *midtones* — areas of medium brightness — need lightening. In the left image in Figure 9-9, raising the Brightness value enough to get the midtones to the right level created a new problem: Pixels that were formerly very light became white, and pixels that used to be black jumped up the brightness scale to dark gray. The result was a decrease in contrast and a loss of detail in the highlights and shadows. Raising the Contrast value only made the situation worse, as shown in the right image in the figure. The contrast shift amped up the highlights way too much, blew out detail in the sky, and caused the distant mountaintop to disappear.

For a better alternative, find out whether your photo editor offers more-sophisticated exposure-correction tools, such as two described in the next sections (the Levels filter and Shadows/Highlights filter).

Brightness adjustments at higher levels

Advanced photo-editing programs provide a Levels filter, which enables you to darken shadows, brighten highlights, and adjust midtones (areas of medium brightness) independently. Depending on your software, the Levels filter may go by another name; check the manual or online Help system to find out whether you have a Levels-like function. In Elements, choose Enhance Adjust Lighting Levels to access the filter.

When you apply this filter, you typically see a dialog box that's full of strange-sounding options, graphs, and such. Figure 9-10 shows the Levels dialog box from Elements, along with the original too-dark image from the preceding section. Don't be intimidated — after you know what's what, the controls are easy to use.

The chart-like thing in the middle of the dialog box is a *histogram*. You may have seen a histogram on your camera's LCD monitor associated with each image. This is the same histogram, just showing up with your image in the software instead of on your camera.

Chapter 5 introduces you to histograms, but as a review, a histogram maps out all brightness values in the image, with the darkest pixels plotted on the left side of the graph and the brightest pixels on the right. The histogram in Figure 9-10 reveals a heavy concentration of pixels at the dark end of the exposure range and a limited pixel population in the middle and high end.

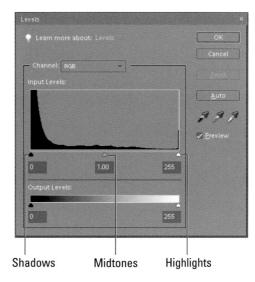

Figure 9-10: Drag the sliders under the histogram to adjust shadows, midtones, and highlights independently.

Being able to read a histogram is a fun parlor game, but the real goal of the Levels filter is to adjust those brightness values to create a better-looking picture. Here's what you need to know:

- ✓ Levels dialog boxes offer separate controls for adjusting shadows, highlights, and midtones. Often, these three controls are labeled Input Levels. In Elements, you can adjust the Input Levels values by entering numbers in the boxes below the histogram or dragging the sliders beneath the histogram.
 - *Shadows*: Adjust shadows by changing the value in the leftmost Input Levels option box or dragging the corresponding slider, labeled in Figure 9-10. Drag the slider to the right or raise the value to darken shadows. Some programs refer to this control as the *Low Point control*.
 - *Midtones*: Tweak midtones using the middle box or slider, labeled *Midtones* in Figure 9-10. Drag the slider left or raise the value to brighten midtones; drag right or lower the value to darken them. This control sometimes goes by the name *Gamma* or *Midpoint control*.

• *Highlights*: Manipulate the lightest pixels in the photo by changing the value in the rightmost box or dragging its slider, labeled *Highlights* in the figure. To make the lightest pixels lighter, drag the slider to the left or lower the value. In some programs, this control goes by the name *High Point control*.

Dragging the midtones and highlights sliders to the positions shown in the dialog box in Figure 9-11 produced the corrected image.

Figure 9-11: Dragging the midtones and highlights sliders to these positions created the final image.

When you adjust the shadow or highlights slider in Elements, the midtones slider moves in tandem. If you don't like the change to the midtones, just drag the midtones slider back to its original position.

Adjusting Output Levels values reduces contrast. Levels dialog boxes also may contain Output Levels options, which enable you to set the maximum and minimum brightness values in your image. In other words, you can make your darkest pixels lighter and your brightest pixels darker — which has the effect of decreasing the contrast. Sometimes, you can bring an image that's extremely overexposed into the printable range by setting a slightly lower maximum brightness value. However, in Elements and Photoshop, a better approach is to use the Shadows/Highlights filter, explained next.

Adjust all color channels together. For color pictures, you may be able to adjust the brightness values for the red, green, and blue color channels independently. (For an explanation of channels, see Chapter 4.) In Elements, you select the channel that you want to adjust from the Channel drop-down list, which appears at the top of the Levels dialog box when you're editing a color photo. However, adjusting brightness levels of individual channels affects the color balance of your photo more than anything else does, so for exposure correction, leave the Channel option set to RGB, as it is by default.

Using the Shadows/Highlights filter

With the Levels filter, you can darken shadows and brighten highlights. To make the opposite shift — to lighten shadows and darken highlights — poke about your photo editor to see whether it offers something akin to the Elements Shadows/Highlights filter, shown in Figure 9-12. This filter provides a more capable option than the Levels filter's Output controls or the Brightness/Contrast filter for coaxing details out of murky shadows or toning down too-bright highlights. To access the filter in Elements, choose Enhance⇔Adjust Lighting⇔Shadows/Highlights.

Figure 9-12: The Shadows/Highlights filter lets you lighten shadows and darken highlights.

The street scene shown on the left in Figure 9-13 is an ideal candidate for this filter. The settings shown in Figure 9-12 brought back details formerly lost in the shadows.

Depending on the image, you may need to apply both the Shadows/Highlights filter and the Levels filter. For example, the "after" image in Figure 9-13 is vastly improved from the original. But following up with the Levels filter, brightening the highlights and midtones with the Levels filter, produced an even better result, as shown in Figure 9-14.

Figure 9-13: Lightening the shadows and boosting midtone contrast slightly produced the image on the right.

What's an adjustment layer?

Some photo-editing programs, including Photoshop Elements, offer adjustment layers. Adjustment layers enable you to apply exposure and color-correction filters to a photo in a way that doesn't permanently alter the picture. You can go back at any time and easily change the filter settings or even remove the filter. You also can easily expand the image area affected by the filter or remove the filter entirely from just a portion of the picture.

We don't have room in this book to cover adjustment layers, but we urge you to get acquainted with them if your photo software provides this feature. Using adjustment layers may seem a little complicated at first, but after you get the hang of using them, you'll appreciate the added flexibility and convenience they offer.

Figure 9-14: Applying the Levels filter further improved the image, brightening highlights and midtones.

Giving Your Colors More Oomph

Images looking dull and lifeless? Toss them in the photo-editing machine with a cup of Saturation — the easy way to turn tired, faded colors into rich, vivid hues.

Take the image in Figure 9-15, for example. The colors just aren't as brilliant as they looked in real life. All that's needed to give the photo the more colorful outlook shown on the right is a Hue/Saturation filter, found in nearly every photo-editing program, including Photoshop Elements.

To adjust saturation in Elements, follow these steps:

- 1. Choose Enhance Adjust Color Adjust Hue/Saturation.

 The dialog box shown in Figure 9-16 opens.
- 2. Be sure the Colorize box is not selected.
- 3. Be sure the Preview box is selected, as shown in the figure.
- 4. Drag the Saturation slider to the right to increase color intensity; drag left to remove color from your image.

If you select Master from the Edit drop-down list at the top of the dialog box, *all* colors in your picture receive the color boost or reduction. You also can adjust individual color ranges by selecting them from the list. You can tweak the reds, magentas, yellows, blues, cyans, or greens.

Figure 9-15: Amping up color saturation brought more life to this photo.

Figure 9-16: Drag the Saturation slider to the right to boost color intensity.

Helping Unbalanced Colors

Incorrect white balance or other factors can cause an image's *color balance* to be off. In other words, the pictures look too blue, too red, or too green, or exhibit some other color sickness.

The top picture in Figure 9-17 is a case in point. This photo, which shows a portion of an antique clover huller, has a slight blue color cast. You can spot the problem most easily in the belts and the top of the wooden wheel (lower-right corner), which should be black or dark gray.

You can remove a color cast by applying a color-balancing filter. This type of filter is typically designed around three color pairs; red and cyan; green and magenta; and blue and vellow. You manipulate the image by adjusting the balance of colors within those pairs, adding more of one color while subtracting the other. For example, the lower image in Figure 9-17 shows the huller picture after adding red and yellow and subtracting blue and cyan. Now the belts and wheel look gray, as they should. The color-balancing act also brought out the faded red and vellow paint of the clover huller.

In Elements, the color-balancing filter goes by the name Color Variations. To access it, choose Enhance⇔Adjust Color⇔Color Variations. The dialog box shown in Figure 9-18 appears.

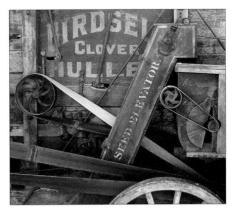

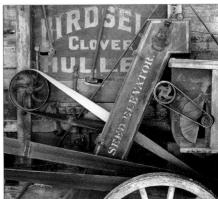

Figure 9-17: A slight blue color cast (top) is removed by applying a color-balance filter (bottom).

The filter controls work as follows:

- You can adjust highlights, shadows, and midtones independently. Click one of the Range buttons, labeled in Figure 9-18, to specify which component you want to alter.
- After selecting the range, use the color-shift thumbnails, also labeled in the figure, to adjust the colors.

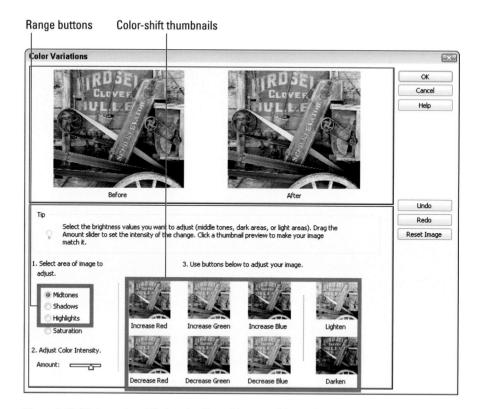

Figure 9-18: Click a color-shift thumbnail to add more of that color and subtract its opposite.

To add cyan, click the Decrease Red thumbnail; to add magenta, click the Decrease Green thumbnail; and to add yellow, click the Decrease Blue thumbnail.

- Use the Amount slider, located underneath the Range buttons, to control how much your picture changes with each click of a thumbnail.
- Although the Variations filter also offers controls for adjusting saturation and exposure, you get more control over those aspects of your picture if you instead use the techniques outlined earlier in this chapter. See the sections "Fixing Exposure After the Fact" and "Giving Your Colors More Oomph" for details.

Sharpening Focus

Although no photo-editing software can make a terribly unfocused image appear completely sharp, you can usually improve things a bit by using a *sharpening filter*. Figure 9-19 shows an example of how a little sharpening can give extra definition to a slightly soft image.

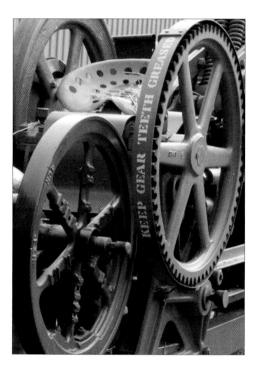

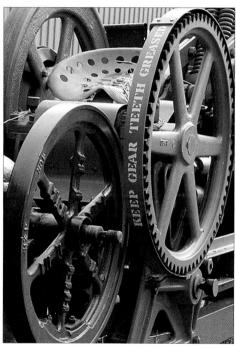

Figure 9-19: Sharpening increases contrast to create the illusion of sharper focus.

It's important to understand that sharpening doesn't actually adjust the focus of your photo. What it does is create the *illusion* of sharper focus by adding small halos along the borders between light and dark areas of the image. The dark side of the border gets a dark halo, and the light side of the border gets a light halo.

Take a look at Figure 9-20, for example, which offers close-up views of the original and sharpened photo from Figure 9-19. See the area where the light gray area meets the red area? The gray side of the border gets lighter, the red side gets darker. The border between the light gray and dark gray areas is similarly altered.

Figure 9-20: The light side of a color boundary gets lighter; the dark side gets darker.

With that little sharpening lesson in mind, check your photo software's Help system to find out what type of sharpening filter it offers. Some programs provide you with a fairly crude manual sharpening tool. You drag a slider one way to increase sharpening and drag in the other direction to decrease sharpening. Elements, Photoshop, and other more advanced photo-editing programs provide you with a much more capable filter, however, which goes by the curious name of Unsharp Mask.

The Unsharp Mask filter is named after a focusing technique used in traditional film photography. In the darkroom, unsharp masking has something to do with merging a blurred film negative — hence, the *unsharp* portion of the name — with the original film positive in order to highlight the edges (areas of contrast) in an image. And if you can figure that one out, you're smarter than the average bear.

Despite its odd name, Unsharp Mask gives you much better control over the sharpening effect than the one-slider sharpening filters. You can sharpen either your entire image or just the *edges* — areas of high contrast, in imaging lingo. You also can control the size of the sharpening halos. And of course, you get precise control over how much sharpening is done.

To use the Unsharp Mask filter in Elements, choose Enhance Unsharp Mask. (If you use Elements 4.0 or earlier, the filter is instead located on the Filter Sharpen submenu.) The dialog box shown in Figure 9-21 appears.

The Unsharp Mask dialog box contains three sharpening controls: Amount, Radius, and Threshold. You find these same options in most Unsharp Mask dialog boxes, although the option names may vary from program to program. Here's how to adjust the controls to apply just the right amount of sharpening:

- Amount: This value determines the intensity of the effect. Higher values mean more intense sharpening.
- Radius: The Radius value controls how many pixels neighboring an edge are affected by the sharpening in other words, the size of the sharpening halos. Generally, stick with Radius values in the 0.5 to 2 range. Use values in the low end of that range for images that will be displayed on-screen. Values at the high end work better for printed images.
- Threshold: This option tells the program how much contrast must exist between two pixels before the boundary between them receives the sharpening effect. By default, the value is 0, which means that the slightest

Figure 9-21: For professional sharpening results, make friends with the Unsharp Mask filter.

difference between pixels results in a kiss from the sharpening fairy. As you raise the value, fewer pixels are affected; high-contrast areas (edges) are sharpened, while the rest of the image is not.

When sharpening photos of people, experiment with Threshold settings in the 3 to 8 range, which can help keep the subject's skin looking smooth and natural. If your image suffers from graininess or noise, raising the Threshold value can enable you to sharpen your image without making the noise even more apparent.

The right combination of settings depends on your original photo. But be careful not to go overboard. Too much sharpening gives the picture a rough, grainy look. In addition, you can wind up with obvious, glowing color halos along areas of high contrast.

Printing Your Photos

In This Chapter

- Reviewing your printing options
- Choosing a photo printer
- Printing your own photos
- Getting better monitor-to-printer color matching
- Making black-and-white prints
- Printing photo albums

etting a grip on all there is to know about digital photography can be a little overwhelming — we know, we've been there. So if you're feeling like your head is already about to pop from all the new terms and techniques you've stuffed into it, we have great news for you: You need to read only the first section of this chapter to find out how to get terrific prints of your digital photos.

Those first paragraphs introduce you to retail photoprinting services that make getting digital prints easy, fast, and amazingly inexpensive. If you like, you can handle the whole thing via the Internet, without ever leaving home.

When you're ready for do-it-yourself printing — and that process, too, has been greatly simplified since the first days of digital photography — the rest of the chapter offers tips on buying a photo printer and getting the best results from it. And whether you're printing your own photos or letting someone else do the honor, this chapter also discusses ways to get your printed colors to match what you see on your monitor (or closer to that goal, anyway).

Printing from a Lab

In the first years of digital photography, the only option for people who didn't want to print their own photos was to find a professional photo lab that could handle digital files. Unless you lived in a major city, you probably didn't have access to such a lab, and if you did, you paid big bucks to get your prints.

Now, any outlet that offers film developing, from your local drugstore to bigbox retailers such as Costco or Wal-Mart, also offers quick and easy digital photo processing. You just take your camera memory card to the store and specify what pictures you want to print. Depending on the service and the specific store, you can have the staff handle everything for you or upload your photos at a special kiosk and input your desired sizes, paper selections, and quantities. You can also do this online from the comfort of your own home, if you like; you simply upload the photos onto the store's photo Web site.

The cost of retail printing continues to get less expensive, too. Depending on the number of prints you make, you can get 4×6 -inch prints for as little as 17 cents apiece, and spend as little as \$1.49 for an 8×10 -inch print. And remember, the only prints you pay for are those you choose to upload, as opposed to how things worked in film days, when you paid to print the entire roll, including the pictures that didn't turn out so great.

You have a variety of options for getting your digital prints:

One-hour printing: Take in your memory card, leave instructions about your print job, and go run other errands or do your shopping. Come back in an hour and pick up your prints.

- If you're worried about a lab losing your memory card, by the way, you usually have the option of copying your pictures to a CD or some other removable media, such as one of those tiny flash memory keys, and taking that to the photo lab. Just make sure that the lab can accept the type of media you want to use.
- Instant-print kiosks: In a hurry? You may not even need to wait an hour for those prints. Many stores have kiosks that can print your pictures immediately. Again, you just put in your memory card, push a few buttons, and out come your prints. You can even do some retouching, such as cropping and eliminating red-eye, right at the kiosk.
- Order online, print locally: You can send your image files via the Internet to most retail photo printers and then specify the store

where you want your prints made. Then pick up the prints at your convenience.

This option also makes it easy to get prints to faraway friends and relatives. Instead of having the prints made at your local lab and then mailing them off, you can simply upload your files to a lab near the people who want the prints. They can then pick up the prints at that lab. You can either prepay with a credit card or have the person getting the prints pay upon picking them up.

For help finding a lab that's conveniently located, check out www.take greatpictures.com, which is provided by the Photo Marketing Association and lists lots of locations by zip code. (Look for the Find a Photo Lab link.) Or, you can go directly to the Web sites of major retailers, such as Wal-mart or Costco, and find a list of printing services offered at each one. (Note that to use the Costco service, you have to be a Costco member.)

✓ Order online, get prints by mail: Some major retailers also offer this option. In addition, you can order prints by mail from online photosharing sites such as Kodak Gallery (www.kodakgallery.com), Snapfish (www.snapfish.com), and Shutterfly (www.shutterfly.com). You can read more about photo-sharing sites in Chapter 11.

Buying a Photo Printer

Even if you have most of your prints made at a retail lab, adding a photo printer to your digital-photography system is still a good investment, for several reasons:

When you need only a print or two, it's more convenient to do the job yourself than to send the pictures to a lab.

Hewlett-Packard

Figure 10-1: With this HP D7460 printer, you can output borderless inkjet prints up to 8.5 x 24 inches.

- For times when you're feeling artistic, you can print on special media, such as canvas-textured paper. With a model such as the \$150 HP Photosmart D7460, shown in Figure 10-1, you can even output borderless prints in sizes up to 8.5 x 24 inches.
- Doing your own printing gives you complete control over the output, which is important to many photo enthusiasts, especially those who exhibit or sell their work.

Today's photo printers can produce excellent results. In fact, most people can't tell the difference between prints made at home and those made at a lab.

When you go printer shopping, you'll encounter several types of printers. Each offers advantages and disadvantages, and the technology you choose depends on your budget, your printing needs, and your print-quality expectations. To help you make sense of things, the following sections discuss the three main types of consumer and small-office printers.

Inkjet printers

Inkjet printers work by forcing little drops of ink through nozzles onto the paper. Inkjet printers designed for the home office or small business cost anywhere from \$50 to \$1,300.

Inkjets fall into three basic categories:

- ✓ **General-purpose models:** These printers are engineered to do a decent job on both text and pictures, but are sometimes geared more to text and document printing than photos.
- ✓ **Photo printers:** Sometimes referred to as *photocentric* printers, these models are designed with the digital photographer in mind and usually produce better-quality photographic output than all-purpose printers. But they're sometimes not well suited to everyday text printing because the print speed can be slower than on a general-purpose machine. They also require more individual ink cartridges and may only output small, snapshot-size images. However, many printers do have a foot in both the general-purpose and photo printer camps, offering good results for all printing uses.
- Multi-purpose printers: These models combine a printer with a flatbed scanner (which can also be used as a document copier) and sometimes also a fax machine. So you can print an image file or scan a printed photo and turn it into a digital file — and then print it again! Figure 10-2 shows one all-in-one model, the Epson Stylus Photo RX680. This particular machine can even print directly onto printable CDs and DVDs, so you can label your own disks. Today, many multi-purpose printers offer great photo-printing abilities, but some are more business oriented and are engineered more to document printing.

Typically, photo-printing quality peaks as you reach the \$150 price range, though. Higher-priced inkjets offer speedier printing and extra features, such as the following:

- ✓ Ability to print on wide-format paper (larger than the usual 8½ x 11-inch letter size)
- ✓ More than four ink cartridges, for better color rendering

Seiko Epson

Figure 10-2: The Epson Stylus Photo RX680 is a scanner, copier, and photo printer that also prints onto CDs and DVDs.

- Borderless printing
- Computer-network connections
- Wireless Bluetooth connections
- Printing directly from a camera or memory card
- Built-in monitors that you can use to preview your pictures
- Integrated fax, copier, and scanner

Most inkjet printers enable you to print on plain paper or thicker (and more expensive) photographic stock, either with a glossy or matte finish. That flexibility is great because you can print rough drafts and everyday work on plain paper and save the more costly photographic stock for final prints and important projects.

The downside? Well, you've no doubt discovered this for yourself: Although most inkjet printers themselves are inexpensive, *printing* is not necessarily cheap because the inks they use can be pretty pricey. And inkjet printer manufacturers will almost always tell you that you need to use their own brand of ink instead of less-costly third-party inks.

Another option is to have your inkjet cartridges professionally refilled at a local store; this service is becoming common, especially in large metropolitan areas. The vendors guarantee the quality of the ink, and if you don't like the results, you have a place you can go to with your prints to get help.

Either way, using a third-party, aftermarket brand of ink, while less expensive and sometimes perfectly adequate, can *potentially* produce unsatisfactory results and, worse yet, can invalidate your warranty. So beware before buying a bunch of cheap inkjet cartridges, and do your homework by researching the topic to see what other users of your printer have experienced. And do stop to consider that printer manufacturers spend lots of research time and money developing ink formulas that best mesh with their printers' ink delivery systems and with various papers, including those they manufacture and sell themselves. So it does make sense that the media offered by the manufacturer — both inks and papers — would stand the best chance of producing optimum results.

All that said, inkjets are the best option for most digital photographers. The exception is if you have high-volume printing needs or care as much about regular document printing as photo printing. If that describes you, check out laser printers, too, described next. And if you're interested only in printing snapshot photos — perhaps you already have a printer for outputting letters and other documents — the upcoming section about dye-sub printers may also be of interest.

Laser printers

Laser printers use a technology similar to that used in photocopiers. You probably don't care to know the details, so here's the general idea: The process involves a laser beam, which produces electric charges on a drum, which rolls toner — the ink, if you will — onto the paper. Heat is applied to the page to permanently affix the toner to the page.

The upsides to laser printers include:

- Color lasers can produce near-photographic quality images as well as excellent text.
- They're faster than inkjets.
- You can use plain paper or special photo paper, just as with an inkjet (although you get better results if you use a high-grade laser paper as opposed to cheap copier paper).

- Although you may pay more up front for a laser printer than for an inkjet, you should save money over time because the price of toner is usually lower than for inkjet ink.
- Many color lasers are designed for high-volume, networked printing, making them attractive to offices where several people share the same printer.

The downsides?

- Although they've become much more affordable over the past two years, color lasers still run \$150 and up, with a much higher average price than inkjet printers (although prices are still going down).
- These printers tend to be big in stature as well as price this typically isn't a machine that you want to use in a small home office that's tucked into a corner of your kitchen.
- Most laser printers don't have the digital-photography niceties found in many inkjets: memory-card slots, monitors for viewing photos on your cards, and the like. However, this situation is starting to change, with a few lasers now offering these and other photo-printing features.

As for photo quality, it varies from machine to machine, so be sure to read reviews carefully. Some laser-printed photos aren't quite as impressive as those from the best inkjets, but some new models come very close. Many people can't tell the difference between an inkjet and laser print. Figure 10-3 offers an example of a color laser printer from Konica Minolta.

Konica Minolta Photo Imaging

Figure 10-3: Color lasers are now very affordable and can produce good photo prints.

Dye-sub (thermal dye) printers

A third type of printer you may encounter, although it's not nearly as common as inkjets and laser printers, is called a *dye-sub* printer.

Dye-sub is short for *dye-sublimation*, which is worth remembering only for the purpose of one-upping the science-fair winner who lives down the street. Dye-sub printers transfer images to paper using a plastic film or ribbon that's coated with colored dyes. During the printing process, heating elements move across the film, causing the dye to fuse to the paper.

Dye-sub printers are also called *thermal-dye* printers — heated (thermal) dye . . . get it?

Some popular snapshot printers, including certain models from Kodak, use this technology. Dye-sub printers fall within the same price range as quality inkiets, and most produce good-looking prints.

However, dye-sub machines present a few disadvantages that may make them less appropriate as your primary home or office printer:

- Most dye-sub printers can output only snapshot size prints.
- You have to use special stock designed to work expressly with dye-sub printers. (Typically, you buy a printing pack that includes both the requisite paper and the dye film or ribbon.) That means that dye-sub printers aren't appropriate for general-purpose documents; these machines are purely photographic tools.
- Printing can be slower than with an inkjet or laser because the paper has to pass through the printer's innards several times, once for each color of dve and, usually, a final pass for the application of a clear overcoat.

More printer-shopping tips

After narrowing down what type and size of printer you need, a few additional shopping tips can help you pick the right product off the store shelves:

✓ Don't spend on extras you won't use. Decide whether you really need all the bells and whistles found on some new printers. For example, some will print directly onto a CD or DVD (although you need special but commonly available CDs or DVDs that accept inkjet ink printing), print from a wireless Bluetooth connection, or let you print directly from a memory card. These features may be handy for you, but if you don't need them, they will also make a printer more expensive than a similar-quality model without the extra whiz-bang features.

Protecting your prints

No matter what the type of print, you can help keep its colors bright and true by adhering to the following storage and display guidelines:

- If you're framing the photo, mount it behind a matte to prevent the print from touching the glass. Be sure to use acid-free, archival matte board and UV-protective glass.
- Display the picture in a location where it isn't exposed to strong sunlight or fluorescent light for long periods of time.
- In photo albums, slip pictures inside acidfree, archival sleeves.
- Don't adhere prints to a matte board or other surface using masking tape, scotch tape, or other household products. Instead, use acid-free mounting materials, sold in art-supply stores and some craft stores. And don't write on the back of the print with anything but a pen made for printing on photographs.

- Limit exposure to humidity, wide temperature swings, cigarette smoke, and other airborne pollutants, as these can also contribute to image degradation. You can do this by having a framer "seal" the photo into a frame.
- Although the refrigerator door is a popular spot to hang favorite photos, it's probably the worst location in terms of print longevity. Unless protected by a frame, the photo paper soaks up all the grease and dirt from your kitchen, not to mention jelly-smudged fingerprints and other telltale signs left when people open and close the door.
- For the ultimate protection, always keep a copy of the image file on a CD-R, DVD-R, or other storage medium so that you can output a new print if the original one deteriorates. See Chapter 9 for advice on archiving your digital files.
- Don't worry too much about the specification known as *dpi*. This abbreviation stands for *dots per inch* and refers to the number of dots of color the printer can create per linear inch. A higher dpi means a smaller printer dot, and the smaller the dot, the harder it is for the human eye to notice that the image is made up of dots. So in theory, a higher dpi should mean better-looking images. But because different types of printers create images differently, an image output at 300 dpi on one printer may look considerably better than an image output at the same or even higher dpi on another printer. And frankly, any new printer you buy today is probably going to offer enough resolution to produce print quality that's plenty good. So although printer manufacturers make a big deal about their printers' resolutions, dpi isn't always a reliable measure of print quality.
- ✓ For inkjets, look for a model that uses four or more colors. Most inkjets print using four colors: cyan, magenta, yellow, and black. This ink combination is known as CMYK (see the sidebar "The separate world of CMYK," later in this chapter). But some lower-end inkjets eliminate the black

ink and just combine cyan, magenta, and yellow to approximate black. "Approximate" is the key word — you don't get good, solid blacks without that black ink, so for best color quality, avoid three-color printers.

Some high-end photo inkjets feature six or more ink colors, adding lighter shades of the primary colors or several shades of gray to the standard CMYK mix. The extra inks expand the range of colors that the printer can manufacture, resulting in more accurate color rendition, but add to the print cost.

If you enjoy making black-and-white prints — *grayscale* prints, in official digital-imaging lingo — look for a printer that adds the extra gray cartridges. Some printers that use only one black cartridge have a difficult time outputting truly neutral grays — prints often have a slight color tint. Browse magazines that cover black-and-white photography for leads on the best machines for this type of printing.

Inkjets that use separate cartridges for each color save you money. On models that have just one cartridge for all inks, you usually end up throwing away some ink because one color often becomes depleted before the others. With multiple ink cartridges, you just replace the ones that are running out.

A few printers require special cartridges for printing in photographicquality mode. These cartridges are normally more expensive than standard inks. So when you compare output from different printers, find out whether the images were printed with the standard ink setup or with more expensive photographic inks.

In some cases, these cartridges lay down a clear overcoat over the printed image. The overcoat gives the image a glossy appearance when printed on plain paper and also helps protect the ink from smearing and fading. In other cases, you put in a cartridge that enables you to print with more colors than usual — for example, if the printer usually prints using four inks, you may insert a special photo cartridge that enables you to print using six inks.

✓ **Compare print speeds if you're a frequent printer.** If you use your printer for business purposes and you print a lot of images, be sure that the printer you pick can output images at a decent speed. And be sure to find out the per-page print speed for printing at the printer's *highest* quality setting. Most manufacturers list print speeds for the lowest-quality or draft-mode printing. When you see claims like "Prints at speeds *up to* . . . ," you know you're seeing the speed for the lowest-quality print setting.

The separate world of CMYK

As you know if you read Chapter 4, on-screen images are *RGB* images. RGB images are created by combining red, green, and blue light. Your digital camera and scanner also produce RGB images. Professional printing presses and most, but not all, consumer printers, on the other hand, create images by mixing four colors of ink — cyan, magenta, yellow, and black. Pictures created using these four colors are called *CMYK* images. (The *K* is used instead of *B* because black is called the *key* color in CMYK printing.)

You may be wondering why four primary colors are needed to produce colors in a printed image, while only three are needed for RGB images. (Okay, you're probably not wondering that at all, but go with it, will you?) The answer is that unlike light, inks are impure. Black is needed to help ensure that black portions of an image are truly black, not some muddy gray, as well as to account for slight color variations between inks produced by different vendors.

What does all this CMYK stuff mean to you? First, if you're shopping for an inkjet printer, be aware that some models print using only three inks, leaving out the black. Color rendition is usually worse on models that omit the black ink.

Second, if you're sending your image to a service bureau for printing, you may need to convert your image to the CMYK color mode and create color separations. If you read Chapter 4, you may recall that CMYK images comprise four color channels — one each for the cyan, magenta, yellow, and black image information. Color separations are nothing more than grayscale

printouts of each color channel. During the printing process, your printer combines the separations to create the full-color image. If you're not comfortable doing the CMYK conversion and color separations yourself or your image-editing software doesn't offer this capability, your service bureau or printer can do the job for you. (Be sure to ask the service rep whether you should provide RGB or CMYK images, because some printers require RGB.)

Don't convert your images to CMYK for printing on your own printer, however, because consumer printers are engineered to work with RGB image data. And no matter whether you're printing your own images or having them commercially reproduced, remember that CMYK has a smaller *gamut* than RGB, which is a fancy way of saying that you can't reproduce with inks all the colors you can create with RGB. CMYK can't handle the really vibrant, neon colors you see on your computer monitor, for example, which is why images tend to look a little duller after conversion to CMYK and why your printed images don't always match your on-screen images.

One more note about CMYK: If you're shopping for a new inkjet printer, you may see a few models described as CcMmYK or CcMmYKk printers. Those lowercase letters indicate that the printer offers a light cyan, magenta, or black ink, respectively, in addition to the traditional cyan, magenta, and black cartridges. As mentioned earlier, the added inksets are provided to expand the range of colors that the printer can produce.

- "Computer-free printing" options give you extra flexibility. Some printers can print directly from camera memory cards no computer required. Several technologies enable this feature:
 - *Built-in memory card slots*: You insert your memory card, use the printer's control panel to set up the print job, and press the Print button. Be sure that the printer offers card slots that are compatible with the type of memory card you use, though.
 - PictBridge: This feature enables you to hook up your camera to your printer for direct printing. (Both the camera and the printer must offer PictBridge capabilities.)
 - DPOF (dee-poff): This acronym stands for digital print order format and enables you to select the images you want to print through your camera's user interface. The camera records your instructions on the memory card. Then, if you use a printer that has memory card slots, you put the card into a slot, and the printer reads and outputs your "print order." Again, both the camera and the printer must offer DPOF technology.
 - Wireless connections: Manufacturers are offering a number of Bluetooth-enabled printers, too. If you use a Bluetooth cell phone that has a camera, you can send your pictures from the phone to the printer wirelessly.

Of course, direct printing takes away your chance to edit your pictures; you may be able to use camera or printer settings to make minor changes, such as rotating the image, making the picture brighter, or applying a prefab frame design, but that's all. Direct printing is great on occasions where print immediacy is more important than image perfection, however. For example, a real-estate agent taking a client for a site visit can shoot pictures of the house and output prints in a flash so that the client can take pictures home that day.

- Research independent sources for cost-per-printer information. Consumer magazines and computer publications often publish articles that compare current printer models based on cost per print. Some printers do use more expensive media than others, so if you're having trouble deciding between several similar models, this information could help you make the call. Note that some printer ads and brochures also state a cost per print, but the numbers you see are approximations at best and are calculated in a fashion designed to make the use costs appear as low as possible. As they say in the car ads, your actual mileage may vary.
- Read reviews and blog comments for other input, too. Once again, it pays to check out reviews in magazines and online sites to find detailed reviews about print quality and other printer features. You also can get lots of good real-world information by searching out blogs and user forums where people discuss their experiences with models that you're considering.

Choosing Photo Paper

With photo paper, as with most things in life, you get what you pay for. The better the paper, the more your images will look like traditional print photographs. In fact, if you want to upgrade the quality of your images, simply changing the paper stock can do wonders.

If your printer can accept different stocks, print drafts of your images on the cheaper stocks, and reserve the good stuff for final output. "Good stuff," by the way, means photographic paper from a well-known manufacturer, not the cheap store brands. Start with paper from the manufacturer of your printer because that paper is specifically engineered to work with your printer's inks. The prints you make with that paper can give you a baseline from which you can compare results on other brands.

Don't limit yourself to printing images on standard photo paper, though. You can buy special paper kits that enable you to put images on calendars, stickers, greeting cards, window decals, transparencies (for use in overhead projectors), and all sorts of other stuff. Some printers even offer accessory kits for printing your photos on coffee mugs and t-shirts. And if you use an inkjet printer, try out some of the new textured papers, which have surfaces that mimic traditional watercolor paper, canvas, and the like.

Setting Print Size and Resolution

As mentioned several times earlier in this chapter, many printers enable you to output prints right from a memory card or from the camera. If you're going that route, just follow the instructions in your printer manual. There's really not much to do in advance of printing except specify the size of the print and the number of copies, which you do either via your camera menus or buttons on the printer.

Many photo-editing programs also offer simplified printing, providing wizards that ask you to set only print size and other basics. If you like the results you get from these automated printing utilities, great. But keep in mind that when you set the print size this way, you let the printer software or your imaging software make the all-important resolution decision for you.

Chapter 4 explains this issue fully, but here's a quick recap:

Resolution — pixels per inch — has a major impact on print quality. To do their best work, most printers need 200 to 300 pixels per inch. If you're having your picture output at a professional lab, you may be required to submit the file at a specific resolution.

- When you enlarge an image, one of two things happens: The resolution goes down and the pixel size increases, or the software adds new pixels to fill the enlarged image area (a process called *resampling*). Both options can result in a loss of image quality.
- ✓ To figure out the maximum size at which you can print your image at a desired resolution, divide the horizontal pixel count (the number of pixels across) by the desired resolution. The result gives you the maximum print width (in inches). To determine the maximum print height, divide the vertical pixel count by the desired resolution.
- What if you don't have enough pixels to get both the print size and resolution you want? Well, you have to choose which is more important. If you absolutely need a certain print size, you just have to sacrifice some image quality and accept a lower resolution. And if you absolutely need a certain resolution, you have to live with a smaller image. Hey, life's full of compromises, right?

Again, if you're happy with the prints you get when you go the automatic route, that's terrific. Some print utilities offer guidance as to how large you can print your picture without losing quality; pay attention to those onscreen messages, and you'll be fine.

But if you *do* want to take control over output resolution, you must set the print size and resolution *before* you send the image to the printer. Here's how to do the job in Elements:

1. Choose Image Size. Size. 1. Choose Image Size.

The Image Size dialog box shown in Figure 10-4 appears.

2. Turn off the Resample Image check box.

This option controls whether the program can add or delete pixels as you change the print dimensions. When the option is turned off, the number of pixels can't be altered.

Click the box to toggle the option on and off. An empty box means that the option is turned off, which is what you want in this case.

3. Enter the print dimensions or resolution.

Enter the print dimensions in the Width or Height boxes; as you change one value, the other changes automatically to retain the original proportions of the picture. Likewise, as you change the dimensions, the Resolution value changes automatically. If you prefer, you can change the Resolution value, in which case the program alters the Width and Height values accordingly.

Figure 10-4: Set print size and output resolution (ppi) in the Image Size dialog box.

If you want your picture to print at a traditional photo size — say, 4×6 inches or 5×7 inches — you need to crop it to those proportions before you set the image size, depending on the proportions of your original digital image. Many cameras produce images that have a 4:3 aspect ratio, for example, which means that the entire image can't fit a 4×6 print size, which has an aspect ratio of 3:2. See Chapter 9 for help with cropping.

Also note that for good print quality, you should strive for a resolution between 200 and 300. But you usually don't have to be dead-on with any particular resolution unless you're sending your photo to a lab that requires a specific value. (See the notes following these steps for details on how to handle that situation.)

4. Click OK or press Enter.

If you did things correctly — that is, deselected the Resample Image check box in Step 2 — you shouldn't see any change in your image onscreen, because you still have the same number of pixels to display. However, if you choose View-Rulers, which displays rulers along the top and left side of your image, you can see that the image will, in fact, print at the dimensions you specified.

If you want to retain the current settings after you close the image, save the file.

Chapter 9 explains the process of saving files.

Now about that situation mentioned in Step 3: If you are sending your photo to a lab or for some other reason need to resample the image in order to achieve a certain print resolution, select the Resample Image check box. (Click the box so that a check mark appears inside.) Turn on the Constrain Proportions box and the Scale Styles box, if it's available. Then set your desired Width, Height, and Resolution values.

When the Resample Image option is enabled, a second set of Width and Height boxes becomes available at the top of the dialog box. Use these options if you want to set your photo dimensions using pixels or percent (of the original dimensions) as the unit of measure.

After resampling, be sure to *save your image with a new name*. You may want the image at the original pixel count some day.

If you're using another photo editor, be sure to consult the program's Help system or manual for information on resizing options available to you. Advanced photo-editing programs such as Elements offer you the option of controlling resolution as you resize, but some entry-level programs don't. Instead, these programs automatically resample the image any time you resize it, so be careful.

How can you tell if a program is resampling images upon resizing? Check the "before" and "after" size of the image file. If the file size changes when you resize the image, the program is resampling the photo. (Adding or deleting pixels increases or reduces the file size.)

Sending Your Image to the Printer

Printing from your photo-editing or cataloging software is similar to printing a file in any computer program. Here's the general overview:

- 1. Open the photo file.
- Set the image size and resolution as discussed in the preceding section.

If your photo software doesn't offer this capability, you can probably set the print size through the Printer dialog box, later in the steps. Setting the image size and resolution in the way discussed in the preceding section is a "best practices" type of thing, however.

3. Choose the Print command.

In almost every program on the planet, the Print command resides on the File menu. Choosing the command results in a dialog box through which you can change the print settings, including the printer resolution or print quality and the number of copies you want to print. You can also specify whether you want to print in *portrait mode*, which prints your image in an upright position, or *landscape mode*, which prints your image sideways on the page. Figure 10-5 shows the dialog box that appears when you choose the Print command in Elements.

4. Specify the print options you want to use.

The available options — and the manner in which you access those options — vary widely depending on the type of printer you're using and whether you're working on a PC or a Mac.

Please read your printer's manual for information on what settings to use in what scenarios, and, for heaven's sake, follow the instructions. Otherwise, you aren't going to get the best possible images your printer can deliver.

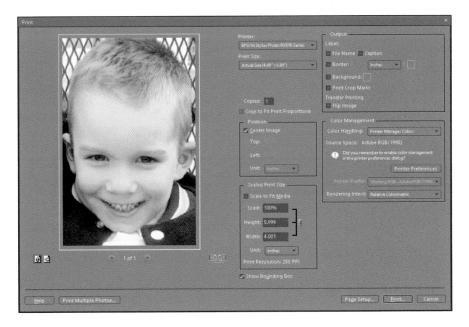

Figure 10-5: The Elements Print dialog box offers a variety of print settings.

If you did establish print size and resolution before starting the print process, stay away from any options inside the Print dialog box that adjust the picture size or resolution, or you undo that work. In Elements, leave the Print Size option set to Actual Size, and keep your paws off the Scaled Print Size options.

5. Send that puppy to the printer.

Look in the dialog box for an OK or Print button and click the button to send your image scurrying for the printer.

Getting better results from your printer

With the general printing info under your belt — and with your own printer manual close at hand — you're ready for some more specific tips about making hard copies of your images. So here are a few tips that can help you get the best output from any printer:

- ✓ Better paper equals better prints. For those special pictures, invest in glossy or "luster" photographic stock or some other high-grade option.
- When setting up the print job, be sure to choose the right paper settings. If the printer is set to print on matte paper, for example, and you instead feed it glossy stock, you might have a smeary mess on your hands.
- ✓ Do a test print using different printer-resolution or print-quality settings. This process enables you to determine which settings work best for which types of images and which types of paper. The default settings selected by the printer's software may not be the best choices for the types of images you print. Be sure to note the appropriate settings so that you can refer to them later. Also, some printer software enables you to save custom settings so that you don't have to reset all the controls each time you print. Check your printer manual to find out whether your printer offers this option.
- ✓ Don't forget to install the printer *driver* (software) on your computer. Follow the installation instructions closely so that the driver is installed in the right folder in your system. Otherwise, your computer can't communicate with your printer. This is usually a matter of following the "quick setup" instructions that came with your printer. If you don't have them, you can usually find drive and setup files on the manufacturer's Web site (look for "downloads" and/or "support").
- ✓ **Use the right printer cable.** Most printers connect using a USB cable; if your printer didn't come with one, you can easily get one at a local office supply store. There are variations in quality, so don't just opt for the cheapest one. Also, remember that usually a longer cable means lessened performance, so try to work with a shorter printer cable, if possible.

✓ Don't ignore your printer manual's instructions regarding routine printer maintenance. Print heads can become dirty, inkjet nozzles can become clogged, and all sorts of other gremlins can gunk up the works. But don't get obsessive about it, because the cleaning process consumes ink, costing you money as well as time.

As for the number-one printing complaint — printed colors that look different from on-screen colors — move to the next section.

Comparing your monitor to your prints

You may notice a significant color shift between your on-screen and printed images. This color shift is due in part to the fact that you simply can't reproduce all RGB colors using printer inks, a problem explained in the sidebar "The separate world of CMYK," earlier in this chapter and in the color section in Chapter 4. In addition, the following variables are at work:

- Brightness of the paper
- Purity of the ink
- Lighting conditions in which you view the image

Although perfect color matching is impossible, you can take a few steps to bring your printer and monitor colors closer together, as follows:

- On an inkjet printer, check your ink status. An empty or clogged ink cartridge is very often the culprit when colors are seriously off.
- Changing your paper stock sometimes affects color rendition. Typically, the better the paper, the truer the color matching.
- The software provided with most color printers includes color-matching controls designed to get your screen and image colors to jibe. Check your printer manual for information on how to access these controls.
- If playing with the color-matching options doesn't work, the printer software may offer controls that enable you to adjust the image's color balance. When you adjust the color balance using the printer software, you don't make any permanent changes to your image. Again, you need to consult your printer manual for information on specific controls and how to access and use them.
- Don't convert your images to the CMYK color model for printing on a consumer printer. These printers are designed to work with RGB images, so you get better color matching if you work in the RGB mode.
- Many image-editing programs also include utilities that are designed to assist in the color-matching process. Some of these are very userfriendly; after printing a sample image, you let the program know which

- sample most closely matches what you see on-screen. The program then calibrates itself automatically using this information.
- Photoshop Elements, Photoshop, ACDSee, and other advanced imageediting programs offer more sophisticated color-management options. If you're new to the game, leave these settings in their default positions, as the whole topic is a little mind-boggling, and you can just as easily make things worse as improve them. Many of the color settings aren't designed to improve matching between your printer and monitor, anyway, but to ensure color consistency through a production workflow — that is, between different technicians passing an image file along from creation to printing.
- ✓ If your photography work demands more accurate color-matching controls than your printer or photo-editing software delivers, you can invest in a color management system, or CMS, for short. Incorporating special software and hardware tools, a CMS enables you to calibrate all the different components of your image-processing system — scanner, monitor, and printer — so that colors stay true from machine to machine. Among companies offering color-management products for consumers are Colorvision (www.colorvision.com) and X-Rite (www.xrite.com).

Finally, remember that the colors you see both on-screen and on paper vary depending on the light in which you view them. It is best to do this in a room with a limited amount of light shining on your screen. Additionally, the color of your clothing and even the surrounding walls can reflect off the monitor, causing more color confusion. So you may even want to don gray or black clothing when you're doing color-critical work.

While most of the pictures people take today are in color, you can easily change them to black and white using an image-editing program. Photoshop Elements, for example, has an easy-to-use tool for just this task, shown in Figure 10-6. And with many images, such as the photo in Figure 10-6, you may

discover that you like the black-and-white version of some pictures better than the color original.

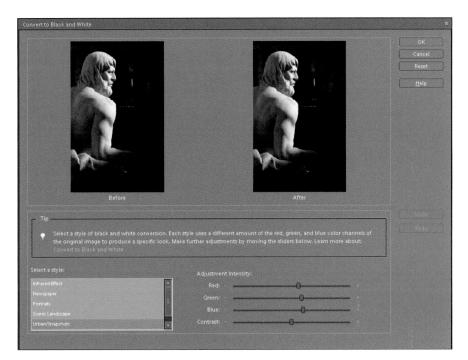

Serge Timacheff

Figure 10-6: Photoshop Elements makes converting color images to black-and-white easy.

After you do your conversion, save your image with a different filename using the Save As option (usually found under the File menu on your editing program). This ensures that you will have your original image *and* your new black-and-white version. (See Chapter 9 for help with file-saving and photoediting in general.)

Printing your black-and-white images can be a challenge, though, because most photo printers are designed more for color printing. So follow these tips to get the best reproduction:

✓ A printer that uses two or more shades of black ink as well as the usual color inks produces the best results. Epson, Canon, and HP all offer a number of dedicated photo printers that use either two or three shades of black ink and are capable of printing great looking black-and-white prints. These printers are more expensive, however, and can sell for \$800 and up.

- Paper matters, too. There are a number of inkjet papers with a variety of coatings and textures made specifically for monochrome (black-andwhite) images, and using these products can make a big difference.
- If you can't get good results from your own printer, the easiest solution is to look for a lab that offers black-and-white printing. Labs that work with professional photographers, especially, offer various options, so check around especially if you're printing an important photo that you are going to frame or have around for a long time.

Publishing Your Own Coffee Table Book

Ever seen a coffee-table-style book of photographs from a wedding? It used to be that you had to print copies of the best photos from a wedding or other event and then insert them into a leather- or linen-bound fancy book to keep as a high-quality showpiece.

Today, you can do the same thing online by uploading your favorite photos from virtually any event or collection and have them printed in a beautiful book like the one shown in Figure 10-7. You can have anywhere from a few photos to several hundred in a single book. And, as an added bonus, you can even create "virtual" copies of the book for sharing online, complete with music.

Amy A. Timacheff

Figure 10-7: Photobooks are easy to produce online and have printed for a high-quality keepsake from weddings, graduations, and other events.

Many companies offer photo printing into books of all sizes and styles, including the following:

- Picaboo (www.picaboo.com)
- Shutterfly (www.shutterfly.com)
- Lulu (www.lulu.com)
- Snapfish (www.snapfish.com)
- Kodak Gallery (www.kodakgallery.com)

You simply create an online account, decide on a design, upload your photos, and then use the various templates and layouts provided to create your book.

For something on a smaller scale, you can create a mini album like the one shown in Figure 10-8. This product, from ZoomAlbum (www.zoomalbum.net), is only 3 inches square — perfect for carrying in your pocket to your next supper club or family reunion. You typically can create an album on a single sheet of paper (provided with the kit) and your own printer. You then peel the photos from a special backing and stick them into the album cover. A kit that makes about three albums sells for around \$30.

ZoomAlhum, Inc

Figure 10-8: ZoomAlbums are 3-inch photo albums you can make at home and take anywhere.

On-Screen, Mr. Sulu!

In This Chapter

- Creating pictures for screen display
- Preparing photos for a Web page or e-mail
- Trimming your file size for faster image downloading
- Saving a JPEG file
- Viewing pictures on your television
- Using digtial photo frames

hen you print pictures, you need lots of pixels — a high-resolution photo, that is — to get good results. But when you display your pictures on-screen, you need very few pixels. Even the most inexpensive, low-megapixel, entry-level cameras can deliver enough pixels to create acceptable images for Web pages, online photo albums, multimedia presentations, and other on-screen uses. In some cases, a camera-phone image might even be good enough.

The process of preparing your pictures for the screen can be a little confusing, however — in part because so many people don't understand the correct approach and keep passing along bad advice to newcomers.

This chapter shows you how to do things the right way. You find out how to set the display size of onscreen photos, save the resized photo in the JPEG file format, display your image in a digital photo frame, send a picture along with an e-mail message, and more.

Step into the Screening Room

With a printed picture, your display options are fairly limited. You can pop the thing into a frame or photo album. You can stick it to a refrigerator with one of those annoyingly cute refrigerator magnets. Or you can slip it into your wallet so that you're prepared when an acquaintance inquires after you and yours.

In their digital state, however, photos can be displayed in all sorts of new and creative ways, including the following:

✓ On a Web page: If your company has a Web site, add interest by posting product pictures, employee photos, and images of your corporate head-quarters. Many folks these days even have personal Web pages devoted not to selling products but to sharing information about themselves. (Your Internet provider may provide you with a free page just for this purpose.) And, if you have a teenager, you probably know that Web sites like Facebook.com and MySpace.com are all the rage — and very photo-oriented.

You can even create an online photo gallery — and you don't need to be an experienced Web designer, either, because many photo-editing programs provide a wizard that practically automates the process. Figure 11-1 shows the wizard provided in Photoshop Elements, for example. Figure 11-2 offers a look at the finished Web page. See "Nothing but Net: Photos on the Web," later in this chapter, for details on preparing a digital photo for use on a Web page.

Figure 11-1: Putting together a simple Web gallery is easy, thanks to step-by-step wizards provided in many photo-editing and cataloging programs.

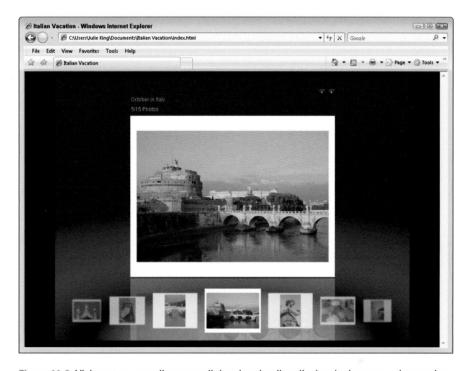

Figure 11-2: Visitors to your gallery can click a thumbnail to display the image at a larger size.

- ✓ **Via e-mail:** E-mail a picture to friends, clients, or relatives, who then can view the image on their computer screens, save the image file, and even edit and print the photo if they like.
- On a photo-sharing site: When you have more than a few pictures to share, forego e-mail and instead take advantage of photo-sharing sites such as
 - Kodak Gallery (www.kodakgallery.com)
 - Phanfare (www.phanfare.com)
 - PhotoBucket (www.photobucket.com)
 - Snapfish (www.snapfish.com)
 - Shutterfly (www.shutterfly.com)

After uploading pictures, you can invite people to view your album and to buy prints of their favorite photos. You generally can create and share albums at no charge; the Web sites make a profit through their photo-printing services.

Do *not* rely on photo-sharing sites for archival picture storage, however. Many sites delete your pictures if you don't buy prints within a certain amount of time. And some sites that have had glorious beginnings went through a bad spell and shut down, taking all their customers' photos with them. See Chapters 2 and 8 for information on how to archive your digital files properly.

- In a multimedia presentation: Import the picture into a multimedia presentation program such as Microsoft PowerPoint or Corel Presentations. The right images, displayed at the right time, can add excitement and emotional impact to your presentations and also clarify your ideas. Check your presentation program's manual for specifics on how to add a digital photo to your next show.
- ✓ **As a screen saver:** Create a personalized screen saver featuring your favorite images or pick a single image to use as your desktop wallpaper, as shown in Figures 11-4 and 11-5, in the next section.
- As a slide show: Put together a digital slide show using a specialty program such as Photodex ProShow Gold (www.photodex.com), shown in Figure 11-3. You can burn the show to CD for playback on any computer and on some DVD players. Many photo-editing and cataloging programs also offer a tool for making slide shows, although they're usually more limited than what you get in a stand-alone program.
- ✓ **On TV:** With many digital cameras, you can view your photos on a TV. You can then show your pictures to a living room full of guests. Some new HDTVs also include a computer connection so you can play your images directly from your desktop or laptop. For more about this option, see the section "Viewing Photos on TV," later in this chapter.
- On a digital photo frame: The newest rage for enhancing your living room, digital photo frames offer yet another way to display your photographs. See the last section in this chapter for some tips on these products.

Sizing Pictures for Screen Display

Preparing pictures for on-screen display requires a different approach than getting them ready for the printer. The following sections tell all.

Figure 11-3: Programs such as Photodex ProShow Gold make creating digital slide shows easy.

Understanding monitor resolution and picture size

When you prepare pictures for on-screen use, remember that monitors display images using one screen pixel for every image pixel. (If you need a primer on pixels, flip back to Chapter 4.) The exception is when you're working in a photo-editing program or other application that enables you to zoom in on a picture, thereby devoting several screen pixels to each image pixel.

Most monitors can be set to a choice of displays, each of which results in a different number of screen pixels, or, in common lingo, a different *monitor resolution*. Standard monitor resolution settings include but aren't limited to

✓ 800 x 600 pixels

✓ 1024 x 768 pixels

✓ 1280 x 1024 pixels

✓ 1600 x 1200 pixels

The first number always indicates the number of horizontal pixels.

To size a screen picture, you simply match the pixel dimensions of the photo to the amount of screen real estate that you want the picture to consume. If your photo is 1024 x 768 pixels, for example, it consumes the entire screen when the monitor resolution is set to 1024 x 768.

At a higher monitor resolution, the same photo no longer fills the screen. A higher screen resolution means smaller screen pixels, so everything appears smaller — including your photo.

For a clearer idea of how monitor resolution affects the size at which your photo appears on-screen, see Figures 11-4 and 11-5. Both examples show an 800 x 600-pixel digital photo as it appears on a 19-inch monitor. (This example was created by using Windows Desktop Properties control to display the photo as the desktop background, or *wallpaper*, in geek speak.)

Figure 11-4: An 800 x 600-pixel digital photo fills the screen when the monitor resolution is set to 800 x 600.

Figure 11-5: At a monitor resolution of 1600×1200 , an 800×600 -pixel photo consumes onequarter of the screen.

- ✓ In Figure 11-4, the monitor resolution is 800 x 600. The image fills the entire screen (although the Windows taskbar hides a portion of the image at the bottom of the frame).
- ✓ In Figure 11-5, the monitor resolution is 1600 x 1200. The 800 x 600-pixel image now eats up one-fourth of the screen.

Unfortunately, you often don't have any way to know or control what monitor resolution will be in force when your audience views your pictures. Someone viewing your Web page in one part of the world may be working on a 19-inch monitor set at a resolution of 1920 x 1200, while another someone may be working on a 13-inch monitor set at a resolution of 800 x 600. So you just have to strike some sort of compromise.

For Web and e-mail images, a good practice is to size your photos assuming an 800×600 monitor resolution — the least common denominator, if you will.

If you create an image larger than 800×600 , people who use a monitor resolution of 800×600 have to scroll the display back and forth to see the entire photo. Of course, if you're preparing images for a multimedia presentation and you know what monitor resolution you'll be using, work with that display in mind. And if you know that most of your audience has high-resolution monitors, then you can size your photos larger. For online use, also keep in mind that the Web browser or e-mail window itself takes up some of the available screen space.

Creating a screen-sized copy of a high-resolution photo

Some digital cameras offer an option that automatically creates two copies of each image: one with lots of pixels for making prints, and another that has the appropriate number of pixels for e-mail or Web use. But if your camera doesn't offer this feature, you can easily make a resized copy of a photo for online sharing.

Here's how to do the job in Photoshop Elements:

1. Save a backup copy of your picture.

In all likelihood, you're going to trim pixels from your photo for onscreen display. You may want those original pixels back someday, so save a copy of the picture with a different name before you go any further. Then you can work on the copied image and know that your original is safe and sound.

- 2. Choose Image⇔Resize⇔Image Size to display the Image Size dialog box.
- 3. Select the Resample Image check box, as shown in Figure 11-6.

This option, when turned on, enables you to *resample* the picture — that is, to add or delete pixels. After you select the option (by clicking the check box), the Pixel Dimensions area at the top of the dialog box offers a set of Width and Height controls, as shown in the figure. You use these controls to add or delete pixels in Step 7.

4. Select Bicubic from the drop-down list next to the Resample Image option.

The options in this list affect the method the program uses when adding and deleting pixels. Bicubic, the default setting, produces the best results when you're trimming pixels.

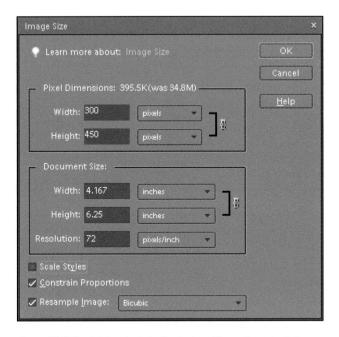

Figure 11-6: To delete pixels in Photoshop Elements, select the Resample Image check box.

5. Select the Constrain Proportions check box, as shown in the figure.

This option makes sure that the original proportions of your picture are maintained when you change the pixel count.

- 6. Select the Scale Styles box, if it's available.
- 7. Using the top set of Width and Height boxes, enter the new pixel dimensions for your photo.

Pixel dimensions is just a nerdy way of saying "number of pixels across by number of pixels down."

Before setting the new pixel count, select Pixels as the unit of measurement from the drop-down list next to the Width or Height box. Because the Constrain Proportions option is turned on, the Height value automatically changes when you adjust the Width value, and vice versa.

8. Click OK or press Enter.

To view your photo at the size it will display on-screen, choose View Datual Pixels.

Keep in mind that this view setting displays the photo according to your current monitor resolution; if displayed on a monitor using a different resolution, the photo size will change. For more on this sticky bit of business, refer to the preceding section.

9. Save the resized photo in the JPEG format.

The upcoming section, "JPEG: The photographer's friend," offers specifics on this step. If your original image was in the JPEG format, be sure to give the resized copy a new name so that you don't overwrite the original file.

The steps for resizing a photo in other programs should be similar. For specifics, check your software's Help system for information about how to resample pictures. Your software may even offer a wizard that automates the process of downsampling a picture and sending it via e-mail.

Whatever program you use to resample your photos, remember that the more pixels you have, the larger the image file. If you're preparing photos for the Web, file size is a special consideration because larger files take longer to download than smaller files. If your images are too large, your site may never get seen by impatient Web surfers because they will give up quickly on downloading your Web page. See the section "Nothing but Net: Photos on the Web" for more information about preparing images for use on Web pages.

Sizing screen images in inches

Newcomers to digital photography often have trouble sizing images in terms of pixels and prefer to rely on inches as the unit of measurement. And some photo-editing programs don't offer pixels as a unit of measurement in their image-size dialog boxes.

If you can't resize your picture using pixels as the unit of measurement or you prefer to work in inches, do this:

1. Set the image width and height as usual.

2. Set the output resolution to 72 or 96 ppi.

In Photoshop Elements, follow the same steps as outlined in the preceding section, but set the picture size and output resolution using the Width, Height, and Resolution boxes in the Document Size section of the Image Size dialog box.

Where do these 72 and 96 ppi figures come from? They are based on default monitor resolution settings on Macintosh and PC monitors. Mac monitors usually leave the factory with a monitor resolution that results in about 72 screen pixels per linear inch of the viewable area of the screen. PC monitors are set to a resolution that results in about 96 pixels for each linear inch of screen. So if you have a 1 x 1-inch picture and set the output resolution to 72 ppi, for example, you wind up with enough pixels to fill an area that's 1-inch square on a Macintosh monitor.

Note that this approach is pretty unreliable because of the wide range of monitor sizes and available monitor resolution settings — the latter of which the user can change at any time, thereby blowing the 72/96 ppi guideline out of the water. For more precise on-screen sizing, the method described in the preceding section is the way to go.

Nothing but Net: Photos on the Web

If your company operates a Web site or you maintain a personal Web site, you can easily place pictures from your digital camera onto your Web pages.

Without knowing what Web-page creation program you're using, providing specifics on the commands and tools you use to add photos to your pages isn't possible. But the next few sections offer some advice on a general artistic and technical level.

Following basic Web rules

If you want your Web site to be one that people love to visit, take care when adding photos (and other graphics, for that matter). Too many images or images that are too big quickly turn off viewers, especially viewers with slow dialup connections. Every second that people have to wait for a picture to download brings them a second closer to giving up and moving on from your site.

To make sure that you attract, not irritate, visitors to your Web site, keep these nuggets of information in mind:

- For business Web sites, make sure that every image you add is necessary. Don't junk up your page with lots of pretty pictures that do nothing to convey the message of your Web page in other words, images that are pure decoration. These kinds of images waste the viewer's time and cause people to click away from your site in frustration.
- If you use a picture as a hyperlink, also provide a text-based link. (A hyperlink, in case you're new to the Internet, is a graphic or bit of text that you click to travel to another Web page.) This suggestion applies whether you use a single image as a link or combine several images into a multi-link graphic, or image map. Why the need for both image and text links? Because many people with slow Internet connections set their browsers so that images do not automatically download. Images appear as tiny icons that the viewer can click to display the entire image. This setup reduces the time required for a Web page to load. But without those text links, people can't navigate your site unless they take the time to load each image.
- ✓ **Save Web-bound photos in the JPEG file format.** This format produces the best-looking on-screen pictures, and all Web browsers can display JPEG files. PNG (pronounced *ping*) is a less-common image standard on the Web, and JPEG 2000 is a newer version of JPEG that has yet to be adopted and put into use.
- ✓ **Don't save photos in the GIF or TIFF format.** If you're familiar with Web design, you may be wondering about using the GIF format for your online photos. GIF, which stands for *G*raphics *I*nterchange *F*ormat, is a great format for small graphics, such as logos. But it's not good for photos because a GIF image can contain only 256 colors. As a result, photos can turn splotchy when saved to this format, as illustrated by Figure 11-7. And the TIFF format, although great for printing, produces files that are too large for Web use and can't be displayed in Web browsers.

People argue about whether to say *jiff*, as in *jiffy*, or *gif*, with a hard *g*. We go with *jiff* because our research turned up evidence that the creators of the format intended that pronunciation. But it doesn't matter how you say GIF as long as you remember not to use it for your Web photos.

✓ **Understand how pixel count affects display size.** Set the display size of your photos following the guidelines discussed earlier in "Sizing Pictures for Screen Display." To accommodate the widest range of viewers, size your images with respect to a screen display of 800 x 600 pixels. Don't forget that the Web browser or e-mail program needs part of the available screen space. For e-mail pictures, a maximum image width of 450 pixels and a maximum height of 400 pixels are good guidelines.

Note that with this low pixel count, people can't make a decent print from your pictures. Consider using a photo-sharing Web site instead of e-mail if you want people to have the option of printing your photos.

Figure 11-7: For better-looking Web photos, use the JPEG file format (top). GIF images can contain only 256 colors, which can leave photos looking splotchy (bottom).

- File size determines how long it takes other people to download your pictures. It also determines how long you sit and wait for pictures to make it from your computer to the Web. If you need to send someone high-resolution images for printing, you can either mail the images on a CD or use a specialized Web application designed to upload, store, and distribute large files, such as the Online File Folder from GoDaddy.com.
- ✓ **Pixel count, not ppi, determines file size.** File size is determined by the total number of pixels in the image, not the output resolution (pixels per inch, or ppi). The file size of an 800 x 600-pixel image is the same at 72 ppi as it is at 300 ppi. Check out Chapter 4 for a more detailed explanation of all this file-size, pixel-count, and output resolution stuff.
- Increasing the amount of JPEG compression is another way to reduce file size. The next section explains this option.

✓ If you want to control the use of your photos, think twice about posting them online. Remember, anyone who visits your page can download, save, edit, print, and distribute your image — without your knowledge or approval unless you have a way of protecting your images online (provided by some online photo gallery services, such as Printroom.com). To prevent unauthorized use of your pictures, you may want to investigate digital watermarking and copyright protection services. To start learning about such products, visit the Web site of one of the leading providers, Digimarc (www.digimarc.com). The Web site operated by the organization Professional Photographers of America (www.ppa.com) provides good background information on copyright issues in general. Many image-editing programs also let you add a watermark to your photos (such as your name or a logo) to protect them.

JPEG: The photographer's friend

JPEG (*jay-peg*) is the standard format used by digital cameras to store picture files. If you don't need to resize your JPEG originals, you can share them via e-mail or post them on a Web page immediately. All Web browsers and e-mail programs can display JPEG photos.

Chances are, though, that your originals are too large for on-screen use, which means that you need to dump some pixels, following the instructions earlier in this chapter. After you take that step — or do any other photo editing — you must resave the file in the JPEG format before sharing it online.

When you save a file in the JPEG format, the picture undergoes *lossy compression*. This feature creates smaller file sizes by dumping some image data, which can reduce picture quality. (Chapter 4 offers an illustration.) The greater the level of compression, the worse the picture appears. In most programs, you can specify the amount of compression you want when you save your JPEG file.

The following steps show you how to use the Photoshop Elements Save for Web utility to save your picture in the JPEG format. Using this feature enables you to see how much damage your picture will suffer at various levels of JPEG compression. If you're using another image editor, check the Help system for the exact commands to use to save to JPEG. The available JPEG options should be much the same as described here, although you may or may not be able to preview the compression effects on your picture.

1. Choose File

Save for Web to display the Save for Web dialog box, shown in Figure 11-8.

The preview on the left side of the dialog box shows your original picture; the right-side preview shows how your photo will look when saved at the current settings.

Would you like that picture all at once, or bit by bit?

When you save a picture in the JPEG format inside a photo editor, you usually encounter an option that enables you to specify whether you want to create a *progressive* image. This feature determines how the picture loads on a Web page.

With a progressive JPEG, a faint representation of your image appears as soon as the initial image data makes its way through the viewer's modem. As more and more image data is received, the picture details are filled in bit by bit. With nonprogressive images, no part of your image appears until all image data is received.

Progressive images create the *perception* that the image is being loaded faster because the viewer has something to look at sooner. This type of photo also enables Web-site visitors to

decide more quickly whether the image is of interest to them and, if not, to move on before the image download is complete.

However, progressive images take longer to download fully, and some Web browsers don't handle them well. In addition, progressive JPEGs require more RAM (system memory) to view. For these reasons, most Web design experts recommend that you don't use progressive images on your Web pages.

If you decide to go with the GIF format instead of JPEG, by the way, you encounter an option called *interlacing*, which has the same result as a progressive JPEG. For reasons illustrated in this chapter (refer to Figure 11-7), you shouldn't really use GIF for photos, but if you do, don't create interlaced files.

2. Select JPEG from the Format drop-down list, labeled in Figure 11-8.

After you select JPEG, you see the other save options shown in the figure.

A higher Quality setting results in less compression and a larger file.

The Quality drop-down list offers five general settings:

- Maximum (provides the best picture quality/least compression)
- Very High
- High
- Medium
- Low (provides the least quality/most compression)

Figure 11-8: The Quality settings determine how much compression is applied.

If you want to get a little more specific, use the Quality slider on the right. You can specify any Quality value from 0 to 100, with 0 giving you the lowest image quality (maximum compression) and 100 the best image quality (least compression).

When you adjust either control, the right preview in the dialog box updates to show you the effect on your photo. Beneath the preview, the program displays the approximate file size and download time at a specific modem speed. To specify the modem speed, open the Preview menu by clicking the button labeled in Figure 11-8.

4. Deselect the Progressive and ICC Profile check boxes.

If you see a check mark in a box, click the box to remove the check mark and turn off the option. Progressive JPEG files aren't a good idea (for

reasons discussed in the "Would you like that picture all at once, or bit by bit?" sidebar). The ICC Profile option concerns some color management issues that professional imaging folks may want to investigate, but us ordinary mortals don't need to worry about. In addition, the option adds to the file size.

5. If your picture contains transparent areas, choose a Matte color.

This feature comes into play only if you're using some advanced Elements features (namely, a multi-layered image that has transparent areas on the bottom layer). So you can ignore it if that doesn't fit your scenario.

6. Click OK.

The Save for Web dialog box disappears, and the Save Optimized As dialog box comes to life. This dialog box works like any file-saving dialog box. Just give your picture a filename and specify where you want to store the file. The correct file format is already selected for you.

If the original picture file was captured in the JPEG format, be sure to give your Web version a different name, or you overwrite the original image.

7. Click Save or press Enter.

The program saves the JPEG copy of your picture. Your original photo remains open and on-screen. If you want to see the new JPEG version, you have to open that file.

You can actually adjust the pixel count in the Save for Web dialog box as well, so you can resize and save your original image in the JPEG format all in one step if you choose. Make the pixel count change using the Image Size area of the dialog box. First, select the Constrain Proportions box and enter either the new pixel width or height. Then click the Apply button to dump those unneeded pixels. From that point, just follow the preceding steps to set the JPEG file-saving options.

Viewing Photos on TV

Want to share your photos with a group of people? You may be able to display those photos on your TV, which is a great alternative to passing around your camera or having everyone huddle around your computer monitor.

Displaying your photos on a television also can help you get a better look at your pictures than you can on your camera monitor or even your computer monitor, especially if your computer sports a smallish monitor. Small defects that may not be noticeable on a small screen become readily apparent when viewed on a 27-inch television screen.

You can get those photos up on the "big screen" in a number of ways:

- Memory card slots: Some TVs and DVD players offer memory card slots that accept the most popular types of camera memory cards. You can then just pop the card out of the camera and into the slot. Some DVR (digital video recorder) and VCR units also offer card slots. If your equipment doesn't have such slots, you can buy stand-alone card readers made especially for this purpose.
 - Most television devices can't display Raw images, however; your photos must be in the standard JPEG format to work. Some stand-alone reader units can display Raw files, however. (See Chapter 4 for a description of Raw and JPEG.)
- ✓ **Video-in/video-out ports:** If your camera has a video-out port, you can connect it with a video cable to the video-in port on your TV (or DVD or whatever), as shown in Figure 11-9. Then you turn on the camera and navigate through your pictures using the camera's own playback controls.

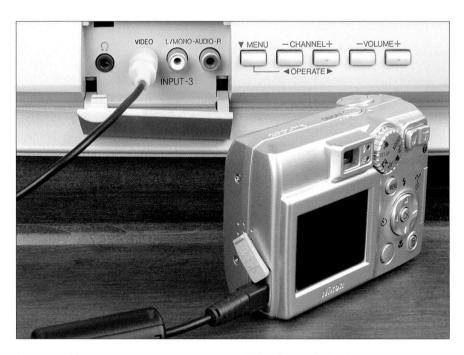

Figure 11-9: You can connect some cameras to a TV for picture playback.

Most digital cameras sold in North America output video in NTSC format, which is the video format used by televisions in North America. You can't display NTSC images on televisions in Europe and other countries that use the PAL format instead of NTSC. So if you're an international business mogul needing to display your images abroad, you may not be able to do it using your camera's video-out feature. Some newer cameras do provide you with the choice of NTSC or PAL formats.

- ✓ USB connection: A few new TV and video devices even have a USB port. This enables you to connect your camera for picture playback or hook the TV to your computer and access pictures stored on your hard drive (or other computer storage device).
- ✓ DVD playback: If you can't get your pictures onto the TV via any of the above routes, you can always create a video DVD of your pictures; many photo programs and slide-show programs offer tools to help you do this. Then you can just pop the DVD into your DVD player for playback. (Check your DVD player's manual to find out what format of DVD recordings it accepts, and make sure that you burn the DVD using that specification.)

For all these viewing options, you need to track down the manual for your television, DVD player, or whatever device you're using to get the pictures to the screen to find specifics on how to proceed from here. You may need to set the device's input signal to a special auxiliary input mode or use certain buttons on your remote controls to initiate and control picture playback.

Digital Photo Frames

Wouldn't it be nice if you could have all your best photos displayed in your living room or office, but without having to print and frame all of them? A digital photo frame allows you to do just that, by providing a framed LCD screen that displays photos without needing to be connected to a computer.

Frames come in a variety of sizes and styles, ranging from 6-inch screens to 15 inches and larger. And, just like regular photo frames, they come with various frame styles, as well, such as wood finishes, white, black, and so on. The photos are displayed in a slide show format on the digital photo frame.

Although there are a few variations, most frames have a slot into which you put your camera's memory card, as shown in Figure 11-10. The figure features a frame from Smartparts (www.smartparts.com). Some frames also offer USB ports, in which case you can connect your camera or some portable hard drives.

Smartparts Inc.

Figure 11-10: Digital photo frames offer a fun new way to display your pictures.

Some frames require that you size your photos ahead of time; newer models automatically resize your images for you. Many frames even have speakers and can play digital movies and MP3 files, so you can have music or dialogue accompanying your show.

Some things to remember about digital frames:

- Some frames support only one kind of memory card, such as Compact-Flash or Secure Digital (SD) — the two most common types — but many also support a wide variety of cards.
- The number of photos you can put onto a digital frame depends, of course, on the size of the memory card and the size of the photos.
- ✓ All digital frames use JPEG as the standard file type.
- ✓ You have the option to display your photos in order or randomly.
- Digital frames sometimes feature various ways of "transitioning" images (meaning how the images fade from one to the next, and how long the frame stays on a single shot).

Part IV The Part of Tens

'Waving Hello' photo?"

In this part . . .

ome people say that instant gratification is wrong. We say, phooey. Why put off until tomorrow what you can enjoy this minute? Heck, if you listen to some scientists, we could all get flattened by a plunging comet or some other astral body any day now, and then what will you have for all your waiting? A big fat nothing, that's what.

In the spirit of instant gratification, this part of the book is designed for those folks who want information right away. The three chapters herein present useful tips and ideas in small snippets that you can rush in and snag in seconds. Without further delay. Now, darn it.

Chapter 12 offers ten techniques for creating better digital images; Chapter 13 lists ten great Internet resources for digital photographers; and Chapter 14 offers ten tips to help you maintain your gear, prevent catastrophes, and deal with emergency digital camera situations.

Ten Ways to Improve Your Digital Images

In This Chapter

- Capturing the right number of pixels
- Composing a scene for maximum impact
- Lessening noise
- ▶ Perfecting your shutter-button technique
- Correcting flaws using your photo software
- Paying attention to the manufacturer's instructions

igital cameras have a high "wow" factor. That is, when you whip out your camera and start taking pictures, you have a good chance that some bystander will say, "Wow!" and ask for a closer look. Sooner or later, though, people stop being distracted by the flashy technology of your camera and start paying attention to the quality of the pictures you turn out. And if your images are poor, whether in terms of photo quality or composition, the initial "Wows" turn to "Ews," as in, "Ew, that picture's *terrible*. You'd think after spending all that money on a digital camera, you could come up with something better than *that*."

So you don't embarrass yourself — photographically speaking, anyway — this chapter presents ten ways to create better digital images. If you pay attention to these guidelines, your audience will be as captivated by your pictures as they are by your shiny digital camera.

Remember the Resolution!

When you print digital photos, the image output resolution — the number of *pixels per inch*, or *ppi* — has a big impact on picture quality, as illustrated by Figure 12-1. The first image has a resolution of 300 ppi; the second, 75 ppi.

Figure 12-1: The poor quality of the right image is due to a lack of pixels.

Most digital cameras offer a few different capture settings, each of which delivers a certain number of pixels. Before you take a picture, consider how large you may want to print the photo. Then select the capture setting that delivers enough pixels to print a good picture at that size.

You need at least 200 ppi to produce a good print on most printers, so multiply your desired print size by that number to determine your pixel requirements. (The Cheat Sheet at the front of the book offers a resolution reference table for math haters in the crowd.) Your printer may produce better results when fed more pixels, however, so check the manual and experiment with different pixel counts.

Keep in mind that you usually can get rid of excess pixels in your photo software without affecting picture quality, but you almost never get good results from adding pixels. In other words, it's better to wind up with too many pixels than too few.

For the complete lowdown on resolution, see Chapter 4.

Don't Squish Your Images

Today's digital cameras commonly store images in the JPEG (*jay-peg*) file format. As the image is saved, it goes through a process known as *JPEG compression*. JPEG compression dumps some image data in order to create smaller picture files, enabling you to fit more pictures on a memory card or a CD. This process is sometimes referred to as *lossy compression* because it results in a loss of picture data.

Many cameras give you a choice of JPEG settings, each of which applies a different amount of compression. In most cases, these settings have quality-related names — Best, Better, Good, for example, or Fine and Normal. For best results, always stick with the top JPEG setting available. At that setting, you can expect very good picture quality.

If you edit your files in a photo editor, however, don't save your works-in-progress in the JPEG format. Each time you open, edit, and save in the JPEG format, you apply another round of lossy compression. And after a while, you *will* be able to notice a loss of image quality. Instead, save in a lossless format such as TIFF.

Also understand that compression and pixel count work together to determine picture quality. Combine heavy compression with too few pixels, and you get a blurry, blocky mess like the one you see in Figure 12-2. This image shows the low-resolution photo from Figure 12-1 after it was subjected to maximum JPEG compression.

For photographers who want to avoid any chance of JPEG defects, some cameras also enable you to shoot in the Camera Raw format. This format delivers raw picture data, with no compression applied. However, Raw picture files are sub-

Figure 12-2: Low resolution combined with heavy JPEG compression results in unacceptable picture quality.

stantially larger than JPEG files, and depending on your subject and how large you print or display the photo, you may notice little, if any, difference between a picture shot at the highest JPEG setting and one captured in Raw. Additionally, you can print, share, and view JPEG pictures immediately, whereas you must convert Raw files to a standard format before doing much of anything with them.

To find out more about this whole file-format issue, flip to Chapter 4.

Look for the Unexpected Angle

As explored in Chapter 7, changing the angle from which you photograph your subject can add impact and interest to the picture. Instead of shooting a subject straight on, investigate the unexpected angle — lie on the floor and get a bug's-eye view or perch on a sturdy chair and capture the subject from above. Or have your subject turn to look at you.

As you compose your scenes, also remember the *rule of thirds*. Divide the frame into vertical and horizontal thirds and position the main focal point of the shot at a spot where the dividing lines intersect.

Turn Down the Noise

Digital photos sometimes suffer from a defect called *noise*, which makes your image appear as though someone sprinkled colored sand over it. Noise becomes more apparent as you enlarge the photo.

You can combat noise in two ways:

- ✓ Use a low ISO setting. The ISO setting adjusts the camera's sensitivity to light. A higher ISO enables you to capture an image in less light, but also increases the possibility of noise. So whenever possible, dial in the lowest ISO setting your camera offers.
- ✓ **Increase shutter speed.** Noise can also result from a very long exposure time. The longer the exposure time in other words, the slower the shutter speed the greater the opportunities for noise.

In dim lighting, you may need to add light to avoid having to use a high ISO or slow shutter. Chapter 5 offers some lighting tips and also explains ISO and shutter speed in detail.

Press the Shutter Button Correctly

This tip usually sounds silly to people who hear it for the first time. But one of the most common reasons for improperly exposed or out-of-focus pictures is improper shutter-button technique.

Most digital cameras offer automatic exposure and automatic focus. For these automatic mechanisms to work correctly, take this approach to snapping a picture:

1. Frame the shot.

2. Press the shutter button halfway and hold it there.

In a second or two, the camera beeps or displays a light, which is your signal that the focus has been set. The camera also determines the correct exposure settings at this time.

3. Hold the camera steady as you press the shutter button the rest of the way to record the image.

If you push the shutter button too hard or jab it suddenly, you may move the camera, making your nice composition not-so-nice anymore.

Note that some cameras adjust exposure settings right up to the time you record the image, while others lock exposure after your half-press of the shutter button. For more about exposure, see Chapter 5; for focus tips, see Chapter 6.

Turn Off Digital Zoom

Digital zoom is offered on most point-and-shoot digital cameras. From its name, you'd naturally expect that digital zoom does the same thing as an optical (traditional) zoom lens — that is, make faraway objects appear closer and larger in the frame.

In truth, though, digital zoom is simply a software process that crops your photo and then enlarges what's left; it's a gimmick used to make the features on your camera seem bigger and better when you're reading the description at the store or online. You get exactly the same results as if you use your photo software to crop and enlarge the image. And as covered in Chapter 4, enlarging a digital photo can reduce picture quality, so turn off digital zoom for best results.

Digital zoom also doesn't affect *depth of field* — the zone of sharp focus — like a real zoom lens. For more about depth of field, see Chapter 6. Chapter 1 offers more advice about evaluating camera lenses.

Take Advantage of Your Photo Editor

Don't automatically toss photos that don't look as good as you'd like. With some judicious use of your photo software's retouching tools, you can brighten underexposed images, sharpen slightly *soft* (blurry) photos, correct color balance, crop out distracting background elements, and even cover up small blemishes.

You can also get really creative and make a photo appear as if it was produced using traditional art media, such as watercolors, chalk, or crayons. Figure 12-3 offers just one example; this image is the result of applying an artistic filter and some color enhancements in Photoshop Elements.

Figure 12-3: Using creative tools like Photoshop Elements filters can give ordinary photos an artistic look.

Applying an artistic filter is a great way to hide flaws that you can't remove in your photo editor, by the way. Got a photo that's too blurry to be repaired using a sharpening filter, for example? Turn it into a faux watercolor. People don't expect images created with watercolor to be "sharp," and so your focus problems are gone!

Being able to edit your photographs is one of the major advantages of digital photography. Take a few minutes each day to become acquainted with your photo software's correction commands, filters, and tools. After you start using them, you'll wonder how you got along without them. Chapter 9 gets you started by showing you a few photo-retouching basics.

Print on Good Paper with Good Ink

As discussed in Chapter 10, the type of paper you use when printing can have a dramatic effect on how your pictures look. The same picture that appears blurry, dark, and oversaturated when printed on cheap copy paper can look sharp, bright, and glorious when printed on special glossy photographic paper.

If you're printing photos at a lab, you can count on getting good-quality paper. But if you're doing the job on a home printer, check your printer's manual for information on the ideal paper to use with your model. Some printers are engineered to work with a specific brand of paper, but don't be afraid to experiment with paper from other manufacturers. Paper vendors are furiously developing new papers specifically designed for printing digital images on consumer-level color printers, so you may find something that works even better than the recommended paper.

For inkjet printers, another critical factor is the type of ink you use. You can use third-party inks to save money. However, many third-party inks are of poor quality or even produce incorrect color combinations. In addition, printer manufacturers carefully engineer print heads and other ink-delivery systems to work with specific ink formulations, and any variance in the formula can muck up the works. So for the most reliable results, stick with the ink recommended by the printer manufacturer.

Practice, Practice, Practice!

Digital photography is no different from any other skill in that the more you practice, the better you'll be. Shoot as many pictures as you can, in as many different light situations as you can.

After you download your pictures, open them in a photo browser that can display the camera's *metadata*. That metadata records all the settings that you used for each shot, so you can evaluate the pictures to see which settings worked the best in which situations. (See the end of Chapter 8 for a look at some actual metadata.)

After you spend some time experimenting with your camera, you'll gain an instinctive feel for what tactics to use in different shooting scenarios, increasing the percentage of great pictures in your portfolio.

Read the Manual (Gasp!)

Remember that instruction manual that came with your camera? The one you promptly stuffed in a drawer without bothering to read? Go get it. Then sit down and spend an hour devouring every bit of information inside it.

Yes, manuals are deadly boring, especially when compared with this book, which is so dang funny you find yourself slapping your knee and snorting milk through your nose at almost every paragraph. But you aren't going to get the best pictures out of your camera unless you understand how all its controls work. This book can give you general recommendations and instructions, but for camera-specific information, the best resource is the manufacturer's own manual.

Can't find your manual or you don't have one? No worries! Most camera manufacturers' Web sites usually offer the manuals as PDF files available to download.

3 Walls

Ten Great Online Resources

In This Chapter

- Exploring camera review sites
- Chatting with other photographers
- > Viewing online tutorials and discovering other helpful hints
- Getting troubleshooting and technical support help
- Finding pages of photographic inspiration

t's 2:00 a.m. You're aching for inspiration. You're yearning for answers. Where do you turn? No, not to the refrigerator. Well, okay, maybe just to get a little snack — some cold pizza or leftover chicken wings would be good — but then it's off to the computer for you. Whether you need solutions to difficult problems or just want to share experiences with like-minded people around the world, the Internet is the place to turn. At least, it is for issues related to digital photography. For anything else, talk to your spiritual leader, psychic hotline, Magic

This chapter points you toward ten great online digital photography resources to get you started. New sites are springing up every day, so you can no doubt uncover more great pages to explore by doing a Web search on the words digital photography or digital cameras.

8-Ball, or whatever source you usually consult.

The site descriptions provided in this chapter are current as of press time. Because Web sites are always evolving, some of the specific features mentioned may be updated or replaced by the time you visit a particular site.

Digital Photography Review

www.dpreview.com

Click here for a broad range of digital photography information, from news about recently released products and promotional offers to discussion groups where people debate the pros and cons of different camera models. An educational section of the site is provided for photographers interested in delving into advanced picture-taking techniques.

The Imaging Resource

www.imaging-resource.com

Point your Web browser here for equipment-buying advice and digital photography news. An especially helpful Getting Started section offers thorough, easy-to-understand answers to *frequently asked questions (FAQs)* about choosing and using digital cameras. In-depth product reviews and discussion forums related to digital photography round out this well-designed site.

Megapixel.net

www.megapixel.net

This site offers in-depth product reviews and technical information, as well as articles covering all aspects of digital photography. It also maintains an excellent glossary of photographic terms and is home to several discussion groups.

PCPhoto Magazine

www.pcphotomag.com

Geared to beginning digital photographers, the print magazine *PCPhoto* makes articles from past issues and more available at its Web site. Along with equipment reviews, the magazine offers tutorials on photography and photo editing, as well as interviews with noted photographers.

Photography Review

www.photographyreview.com

Whether you're shopping for your first camera or looking for accessories to enhance your digital photography fun, this site helps you make good choices. You can find hardware and software reviews as well as an online community where you can share information with other digital photographers. A large how-to section makes this site even more useful.

Shutterbug

www.shutterbug.com

At this site, you can explore the online version of the respected magazine *Shutterbug*, which offers how-to articles and equipment reviews related to both film and digital photography. Comprehensive reviews, in addition to forum, gallery, and technique sections, provide extensive information about digital cameras and other imaging tools. If you're looking for some fame, the site's contest section is a good place to enter your best photos.

PhotoJoJo

www.photojojo.com

This is a fun digital photography Web site, plain and simple. The forum section, especially, is as diverse and creative as any online photography community.

Photo.net

www.photo.net

This large online photography community Web site offers galleries for inspiration, a wealth of how-to articles, discussion forums, and much more. You can even upload photos and get critiques from other members.

PhotoWorkshop

www.photoworkshop.com

This interactive, online photography community Web site is for everyone interested in digital photography, amateur to professional. You can find scads of free tutorials, enter photo contests, and get in-depth help with a variety of hardware and software issues. If you upgrade to a paid subscription, additional features are available.

Manufacturer Web Sites

Most camera manufacturers maintain Web sites that offer technical support as well as updates to camera *firmware* (the software inside your camera). You can find similar assistance and updates at sites run by printer and software vendors.

But don't stick just with the sites related to your specific equipment. Although most manufacturer Web sites are geared to marketing the company's products, many also offer terrific generic tutorials and other learning resources for newcomers to digital photography. For example, check out the following sites:

- ✓ **ACD Systems (www.acdsystems.com):** This site has an extensive newsletter section about various topics involving digital photography.
- Adobe (www.adobe.com): Travel via the Communities link to the Adobe TV section, where you can watch free movies demonstrating various photo-editing techniques.
- Canon (www.canon.com): Review the Canon Digital Learning Center for a variety of digital photography tips.
- **Fujifilm (www.fujifilm.com):** Find your way to the Picture Your Life pages offered in the Consumer Products section of this site.
- Kodak (www.kodak.com): In the Consumer Products section, explore the Tips and Projects link.
- Nikon (www.nikon.com): Travel to the United States section of the site to check out the Nikon Digital Learning Center and other educational resources.
- ✓ **Sony (www.sony.com):** Navigate to the digital camera section of this site to access a learning area called Digital Photography 101.

Top Ten Maintenance and Emergency Care Tips

In This Chapter

- Keeping fresh batteries at the ready
- Erasing images properly
- Protecting your memory card
- Safeguarding your camera from heat, cold, and water
- Backing up regularly
- Taking care of your computer's hard drive

he old Boy Scout motto, "Be prepared," applies in spades when it comes to digital photography. Although you can't foresee all potential incidents that might snag your photo shoot, you can keep your camera in tip-top condition and practice some basic preventative measures to ensure that your equipment stays safe and in good working order. This chapter provides ten strategies to help you do just that.

Keep Spare Batteries On-Hand

Digital cameras are hungry for power, which means you will have to replace or recharge the batteries from time to time. To avoid missing important photographic opportunities, always keep a spare set of batteries or an extra rechargeable on-hand. That way you don't waste precious time running to the store or waiting for your battery to recharge when you could be taking pictures. The same holds true for an external flash, if your camera supports one.

The amount of time and number of photos that you can shoot before replacing your batteries vary, depending on how you use your camera. If you start to run low on battery power, try these energy-conservation tips:

- Limit the use of the monitor. The monitor is one of the biggest power drains, so wait to review your pictures until you have fresh batteries. When you're not using the monitor to take pictures, turn it off, even if you leave the camera itself powered up.
- ✓ Turn on your camera's auto-off function. Most cameras offer a feature that automatically shuts the camera off after a period of inactivity to save power. You may even be able to reduce the wait time that must pass before the shutdown occurs.
- ✓ **Go flash-free.** The internal flash also consumes lots of battery juice. When the flash recycle time starts to slow down, that's a clue that your batteries are fading.
- ✓ Turn off image stabilization. On some cameras, turning off this feature saves battery power (but check your manual because this tip doesn't apply to all models of cameras and lenses).
- Avoid using continuous autofocus, if your camera offers it. In this mode, the camera continuously adjusts focus from the time you press the shutter button halfway until the time you actually take the picture. And because the autofocus motor consumes power, you can preserve some battery life by sticking with regular autofocus or, on a dSLR, shifting to manual focus.
- ✓ Keep spare batteries warm. Batteries deplete faster when they get cold, so tuck your extra batteries in a shirt pocket or find some other way to keep the chill off.

Always do whatever you can to protect spare, loose batteries from short-circuiting as well. That means protecting the metal electrical contacts from connecting (both touching the same piece of aluminum foil, for example). Most batteries come with little caps that cover the contacts, and it's a good idea to use them; otherwise cover them with tape or keep them in separate containers.

Format Your Memory Cards

After you download images from a memory card, always *format* the card when you put it back into your camera. Also format new cards when you put them into your camera for the first time.

You typically can find a Format or Format Memory Card option somewhere on your camera's setup menus. (Don't confuse this option with the one that enables you to set the picture's *file format*, usually JPEG or Camera Raw; Chapter 4 explains this issue.)

Formatting your card does two things:

- ✓ It ensures you've gotten rid of the previous files on the card.
- It ensures your card is correctly configured for your camera.

If you simply erase pictures from your card, you're essentially leaving cookie crumbs behind. (Techies call these *fragments*.) When enough fragments are left behind, they eat up space on your card and can make some cards unusable.

Keep these additional dos and don'ts in mind, too:

- If you're using an image-editing program to transfer files automatically from your card to your computer, *don't* select any option that lets you delete your files on the card as you transfer them. This is simply asking for trouble; wait until you're sure the files transferred successfully before you think about wiping the originals from the card.
- ✓ Don't delete images on your card from your computer; doing so can cause problems when you go to use the card in the camera again.
- Before formatting your card, do make absolutely sure you've down-loaded all the pictures that you want to keep before pushing the OK button. And remember that formatting wipes out all files on the card, not just picture files so if you use your card to store other things, such as music files, beware.

If you accidentally format a card that contained images that you didn't want to delete, don't despair yet: A variety of image-recovery software programs can usually recover many lost pictures — especially if you haven't photographed more images on the newly formatted card. Most Web sites for popular memory-card brands (www.lexar.com and www.sandisk.com, among others) offer various types of image recovery software programs you can purchase and download should disaster strike.

Keep Your Memory Cards Clean

If any dirt gets onto the copper strips or holes in your memory card, you may not be able to transfer images, or your images may become corrupt during transfer. The key to preventing this from happening is to keep cards as clean as possible. You can store them in your camera, the little plastic cases they shipped in, or a memory card case.

While memory cards are remarkably durable (there are stories of them going through the washing machine and still working), they're still somewhat fragile and very easily lost. CompactFlash pinholes are especially susceptible to things like lint in your pocket. (On a side note: Be careful to insert CompactFlash cards gently and in the right direction; they connect to little pins inside your camera and card reader, and you can easily bend those pins if you're too forceful.)

Lastly, try not to expose memory cards to extreme cold or heat. Setting one on your dashboard on a sunny day, for example, is asking for trouble.

Clean the Lens and LCD with Care

Is there anything more annoying than a dirty lens? Let's face it: Fingerprints, rain drops, and dust happen, and they all get in the way of the perfect image. And LCD monitors also can get gunked up pretty easily.

To clean your lens and LCD, stick with these tools:

- A microfiber cloth (like the ones used for cleaning eyeglasses). It works either with or without lens-cleaning fluid. And yes, you can go ahead and breathe onto the glass or plastic LCD to fog it up with some moisture first.
- Any cotton product, such as a t-shirt or dishtowel, is usually okay as long as it's clean and lint-free.
- A manually operated bulb blower commonly available in any camera store. Some come with a little natural-fiber brush, which is also okay. It's a good idea to use this type of tool *before* wiping your lens if it's especially dirty to ensure that bigger particles of dirt aren't rubbed into the lens.

Do not use any of the following to clean a lens or LCD:

- ✓ The same microfiber cloth you use for your glasses. It may have oily residue from your face.
- Facial tissue, newspaper, napkins, or toilet paper. These are made from wood products and can scratch glass and plastic and can harm a lens coating.

- Household cleaning products (window cleaner, detergent, toothpaste, and the like).
- Compressed air. These cans contain a chemical propellant that can coat your lens or LCD with a permanent residue. Even more scary, compressed air can actually crack the monitor.
- Synthetic materials (like polyester). They usually don't clean well, anyway.
- Any cloth that's dirty or that's been washed with a fabric softener.

If you're using interchangeable lenses on a dSLR camera, you can attach a clear protective filter on the lens — look for something called a *UV/Haze* filter (the UV stands for *ultraviolet*). You can also buy these filters for some point-and-shoot models.

Of course, you should always carry and store your camera in a quality case or bag; see Chapter 2 for a look at some options.

Update Your Firmware

Just when you thought software and hardware were confusing enough, along comes another techno-term to deal with: *firmware*. This special software lives permanently on your camera, telling it how to operate and function — in essence, it's your camera's gray matter.

Every now and then, camera manufacturers update firmware to fix problems and bugs, enhance features, and generally do housekeeping that makes your camera operate better. Sometimes these changes are minor, but occasionally they fix pretty serious problems and errors.

To benefit from these updates, you have to download the new firmware files from your camera manufacturer's Web site and install them on your camera. If you signed up for manufacturer e-mail updates when you registered your camera (you *did* do that, right?), the company should inform you of updates when they occur. But it's a good idea to also simply check the manufacturer's camera support page every three months or so to make sure that you don't miss an important firmware update.

Depending on the camera brand and model, you typically can update your camera one of two ways:

✓ Download and install the files from a memory card: Put a memory card in a card reader connected to your computer and then download the firmware files from the Web site to the card. After the files are on

- the card, put it in your camera and follow the directions in your camera manual (or on the Web site) to install the firmware.
- Download and install directly to your camera: You also may be able to download directly to your camera by connecting the camera to your computer using a USB cable. Again, check your camera manual for specifics on this process.

Don't push any buttons or disconnect the camera until the update is finished. Cameras don't like being interrupted during brain surgery. (Be sure your camera batteries are fully charged before you begin, too.)

Protect Your Camera from Temperature Extremes

Extreme cold can cause various mechanical functions in your camera to freeze; it can stop your lens from zooming or your shutter release button from operating. Your LCD may stop functioning as well, and your battery power may drop so much that your camera won't even turn on.

If you must take your camera into the cold, keep it in a camera case under your jacket until you're ready to use it. In the photo shown in Figure 14-1 — taken while on a snowmobile safari in the Arctic region of northern Finland at -42° Fahrenheit — you can just see the camera case beneath the jacket, for example.

Figure 14-1: Extreme cold can be especially bad for your camera, and you need to protect it from the elements.

On the flip side of the temperature scale, extreme heat can damage your camera as well and can be especially hard on your LCD screen, which can "go dark" if it gets too hot. If this happens, simply get your camera to a cooler place. Typically, it will return to a normal viewing state. Although heat generally doesn't cause as many problems as cold, leaving your camera in direct sunlight (such as in a car) isn't a good idea. If you can at least cover it with a towel or t-shirt, your camera will be happier.

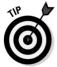

Changing temperature extremes, such as going from a warm room into subfreezing weather, are especially bad for your camera. Condensation forms on the camera parts and lens elements, which can (at best) obstruct your ability to take good photos and (at worst) cause permanent moisture damage. To avoid problems, store your camera in a sealed Ziploc-type bag until it adjusts to the new temperature.

Keep Your Camera Away from Water

Digital cameras, like most other electronic devices, don't do well if they get wet. Water — especially salt water — can short important camera circuitry and corrode metal parts. A few raindrops probably won't cause any big problems, but exposure to enough water, even momentarily, can result in a death sentence for a camera.

Did you leave your camera on the picnic table during a brief downpour? Did you drop it into the fountain? If you think your camera is potentially damaged, but not enough that it's clearly beyond hope, the following steps may help you salvage it:

- 1. Remove the batteries and memory card.
- 2. Wipe the camera with a clean, dry cloth.

Try not to push any buttons.

- Set it in a warm place where it can dry out as much and as quickly as possible.
- 4. Get your camera to a good-quality, authorized repair facility or send it to the manufacturer.

While these steps aren't a guarantee that your camera will make it, sometimes you can get lucky.

Obviously, preventing your camera from getting wet is always preferable to having it repaired, and keeping it in a water-resistant or waterproof case is the best way to avoid getting it wet. Most camera bags are at least moderately water-resistant, and some even have completely sealed, waterproof

compartments. Barring that, put your camera in a large, locking, plastic sandwich bag (or two).

If you want to try underwater photography, you can buy waterproof housings that are designed to let you operate all the camera's buttons and such but still keep the innards safe and dry. Some companies also make a variety of products that protect your gear when you shoot in the rain. See Chapter 2 for an introduction to just some protection options.

Clean the Image Sensor

The *image sensor* is the part of your camera that absorbs light and converts it into a digital image. If dust, hair, or dirt gets on the sensor, it can show up as small spots on your photos. For example, you can see two spots in Figure 14-2, in the sky to the right of the pyramid. (Image-sensor spots are often most visible in the sky or in bright, clear areas of your image, but can be seen just about anywhere.)

Serge Timacheff

Figure 14-2: Spots on a dSLR's image sensor appear in the same place on multiple images.

Many new cameras have an internal cleaning system designed to remove any stray flotsam and jetsam from the sensor. Usually, the camera is set up at the factory to go through a cleaning cycle each time you turn the camera on, off, or both. You may also be able to initiate a cleaning cycle at other times through a menu option.

If the camera's internal cleaning mechanisms don't do the trick, you need to take your camera to a repair shop to have the sensor cleaned manually. Although you can find products designed to help you do this job yourself, you do so at your own peril. This job is a delicate one, and really should be done only be a trained technician. Call your local camera store to find out the best place in town to have the cleaning done. (Some camera stores offer free cleaning for cameras purchased from them.)

You can help limit the amount of dust and dirt that finds its way to your image sensor by keeping the camera stored in a case or camera bag when not in use and being cautious when shooting in dicey environmental situations — windy days on the beach, for example. If you own a dSLR, be especially careful when changing lenses, because that's a prime occasion for dirt to sneak into the camera. Also try to point the camera slightly downward when you attach the lens; doing so can help prevent dust from being sucked into the camera by gravity.

Back Up Your Images Regularly

When disasters such as fires or floods occur, photos are one of the first things people try to save. Photographs are precious memories and often can't be replaced.

Digital images can be destroyed not only by fire or flood, but also by a hard-drive failure if that's the only place you have them stored. While not extremely common, hard drives have been known, on occasion, to simply stop working. It's difficult and expensive — and occasionally impossible — to retrieve files from one that's gone bad.

The key to preventing a disaster such as this is simple: Back up your images on a CD or DVD. Store the disks in a location separate from your originals. Some people keep backups in safe-deposit boxes at banks, in other family members' homes, or in their offices, for example.

For the complete story on image backup, including information about storage devices designed to hold your favorite photos, see Chapter 2.

Clean Out Your Computer's Hard Drive

You probably know that computers need lots of RAM (random-access memory) in order to run smoothly and quickly. But you may not know that a computer also needs a significant amount of empty space on its hard drive — that's the component that holds all your files and programs — to perform well. The computer uses that free space, sometimes called scratch disk space, to temporarily store data as it's processing your files. Without enough free space, the computer slows down and may not be able to perform some photo-editing tasks at all, especially on large image files.

Generally speaking, you should keep at least 10GB (gigabytes) of free space on your hard drive, although some photo programs may request even more. Keeping that free space available may mean moving data files onto external hard drives, CDs, or DVDs for storage; it may also mean uninstalling unused applications.

Chapter 2 gives you a look at some of your storage options; see Chapter 8 for a look at some software that can help you organize and manage your photo files.

Glossary

an't remember the difference between a pixel and a bit? Resolution and resampling? Turn here for a quick refresher on that digital photography term that's stuck somewhere in the dark recesses of your brain and refuses to come out and play.

24-bit image: An image containing approximately 16.7 million colors.

AE Lock: A way to prevent the camera's autoexposure system from changing the current exposure settings if you reframe the picture or the lighting changes before the image is recorded.

aperture: One of three critical exposure controls; an opening made by an adjustable diaphragm, which permits light to enter the camera lens and reach the image sensor. The size of the opening is measured in f/stops (f/2.8, f/8, and so on). Aperture also affects depth of field, or the distance over which sharp focus is maintained.

aperture-priority autoexposure: A semi-automatic exposure mode; the photographer sets the aperture, and the camera selects the appropriate shutter speed to produce a good exposure.

artifact: A defect created by too much JPEG compression.

aspect ratio: The proportions of an image. A 35mm-film photo has an aspect ratio of 3:2; the standard digital-camera image has an aspect ratio of either 3:2 or 4:3.

autoexposure: A feature that puts the camera in control of choosing the proper exposure settings. *See also* aperture-priority autoexposure and shutter-priority autoexposure.

backlight: Bright light coming from behind your subject, which can cause your subject to be underexposed in autoexposure shooting modes.

bit: Stands for *binary digit*; the basic unit of digital information. Eight bits equals one *byte*.

bit depth: Refers to the number of bits available to store color information. A standard digital camera image has a bit depth of 24 bits. Images with more than 24 bits are called *high-bit images*.

burst mode: A special capture setting, offered on some digital cameras, that records several images in rapid succession with one press of the shutter button. Also called *continuous capture* mode.

byte: Eight bits. See bit.

Camera Raw: A file format offered by some digital cameras; records the photo without applying any of the in-camera processing or file compression that is usually done automatically when saving photos in the other standard format, JPEG. Also known as *Raw*.

card reader: A device used to transfer images from your CompactFlash, Secure Digital (SD), or other type of memory card to your computer.

catchlight: The bright, small, reflective spots seen in a subject's eyes in a photo that can come from a flash or natural light.

CCD: Short for *charge-coupled device*. One of two types of imaging sensors used in digital cameras.

CIE Lab: A color model developed by the Commission Internationale de l'Eclairage. Used mostly by digital-imaging professionals.

CMOS: Pronounced *see-moss.* A much easier way to say *complementary metal-oxide semiconductor.* A type of imaging sensor used in some digital cameras.

CMYK: The print color model, in which cyan, magenta, yellow, and black inks are mixed to produce colors.

color correction: The process of adjusting the amount of different colors in an image (for example, reducing red or increasing green).

color model: A way of defining colors. In the RGB color model, for example, all colors are created by blending red, green, and blue light. In the CMYK model, colors are produced by mixing cyan, magenta, yellow, and black ink.

color temperature: Refers to the color cast emitted by a light source; measured on the Kelvin scale.

CompactFlash: A type of removable memory card used in many digital cameras; about the size and thickness of a matchbook.

 $\textbf{compositing:} \ \textbf{Combining two or more images in a photo-editing program}.$

compression: A process that reduces the size of the image file by eliminating some image data.

continuous autofocus: An autofocus feature on some digital cameras, in which the camera continuously adjusts focus as needed to keep a moving subject in focus.

contrast: The amount of difference between the brightest and darkest values in an image. High-contrast images contain both very dark and very bright areas.

crop: To trim away unwanted areas around the perimeter of a photo, typically done in a photo-editing program.

depth of field: The zone of sharp focus in a photograph. With shallow depth-of-field, the subject is sharp but distant objects are not; with large depth of field, both the subject and distant objects are in focus. Manipulated by adjusting the aperture, focal length, or camera-to-subject distance.

digital zoom: A feature offered on most digital cameras; crops the perimeter of the image and then enlarges the area at the center. Results in reduced image quality.

diopter: An adjustment on a camera viewfinder to accommodate your eyesight.

downloading: Transferring data from your camera to a computer or from one computer device to another.

dpi: Short for *dots per inch*. A measurement of how many dots of color a printer can create per linear inch. Higher dpi means better print quality on some types of printers, but on other printers, dpi is not as crucial.

DPOF: Stands for *digital print order format*. A feature offered by some digital cameras that enables you to add print instructions to the image file; some photo printers can read that information when printing your pictures directly from a memory card.

driver: Software that enables a computer to interact with a digital camera, printer, or other device. Usually this installs automatically when you plug your device into your computer, but sometimes you have to use a CD to install it.

dye-sub: Short for *dye-sublimation*. A type of photo printer.

edges: Areas where neighboring image pixels are significantly different in color; in other words, areas of high contrast.

EV compensation: A control that slightly increases or decreases the exposure chosen by the camera's autoexposure mechanism. EV stands for exposure value; EV settings typically appear as EV 1.0, EV 0.0, EV -1.0, and so on.

EVF: An electronic viewfinder, which delivers an electronic pixel version of what the camera lens actually captures through a small viewfinder display. Different from an optical viewfinder, which employs lenses to approximate the camera lens view or looks directly through the lens (on an SLR camera).

EXIF metadata: See metadata.

exposure: The overall brightness and contrast of a photograph, determined mainly by three settings: aperture, shutter speed, and ISO.

file format: A way of storing image data in a digital file. Popular digital-camera formats include Camera Raw, JPEG, and TIFF.

fill flash: Using a flash to fill in darker areas of an image, such as shadows cast on subjects' faces by bright overhead sunlight or backlighting.

flash EV compensation: A feature that enables the photographer to adjust the strength of the camera flash.

f-number, f-stop: Refers to the size of the camera aperture. A higher number indicates a smaller aperture. Written as f/2, f/8, and so on. Affects both exposure and depth of field.

gamut: Say it *gamm-ut*. The range of colors that a monitor, printer, or other device can produce. Colors that a device can't create are said to be *out of gamut*.

GIF: Short for *graphics interchange format*. A file format often used for Web graphics; not suitable for photos because it can't handle more than 256 colors.

gigabyte: Approximately 1,000 megabytes, or 1 billion bytes. In other words, a really big collection of bytes. Abbreviated as GB.

grayscale: An image consisting solely of shades of gray, from white to black. Often referred to generically as a *black-and-white image* (although in the truest sense, a black-and-white image contains only black and white, with no grays).

histogram: A graph that maps out shadow, midtone, and highlight brightness values in a digital image; an exposure-monitoring tool that can be displayed

on some cameras. Also found inside some of the exposure-correction filter dialog boxes displayed in some photo-editing programs.

HSB: A color model based on hue (color), saturation (purity or intensity of color), and brightness.

HSL: A variation of HSB, this color model is based on hue, saturation, and lightness.

image sensor: The CMOS or CCD chip in your camera that senses light and converts it into digital information.

ISO: Traditionally, a measure of film speed; the higher the number, the faster the film. On a digital camera, it means how sensitive the image sensor is to light. Raising the ISO allows faster shutter speed, smaller aperture, or both, but also can result in a noisy (grainy) image. Stands for *International Standards Organization*.

jaggies: Refers to the jagged, stair-stepped appearance of curved and diagonal lines in low-resolution photos that are printed at large sizes.

JPEG: Pronounced *jay-peg*. The primary file format used by digital cameras; also the leading format for online and Web pictures. Uses *lossy compression*, which eliminates some data in order to produce smaller files. A small amount of compression does little discernible damage, but a high amount destroys picture quality. Stands for *Joint Photographic Experts Group*, the group that developed the format.

JPEG 2000: An updated version of the JPEG format; not yet fully supported by all Web browsers or other computer programs.

Kelvin: A scale for measuring the color temperature of light. Sometimes abbreviated as K, as in 5000K. (But in computerland, the initial K more often refers to kilobytes, as described next.)

kilobyte: One thousand bytes. Abbreviated as *K*, as in 64K.

LCD: Stands for *liquid crystal display*. Often used to refer to the display screen included on most digital cameras.

lossless compression: A file-compression scheme that doesn't sacrifice any vital image data in the compression process, used by file formats such as TIFF. Lossless compression tosses only redundant data, so image quality is unaffected.

lossy compression: A compression scheme that eliminates important image data in the name of achieving smaller file sizes, used by file formats such as JPEG. High amounts of lossy compression reduce image quality.

manual exposure: An exposure mode that enables you to control aperture, shutter speed, and ISO. Usually represented by the letter M on the camera's exposure mode dial.

manual focus: A setting that turns off autofocus and instead enables you to set focus by twisting a ring on the lens barrel or by specifying a specific focusing distance through camera menus.

megabyte: One million bytes. Abbreviated as MB. See bit.

megapixel: One million pixels; used to describe the resolution offered by a digital camera.

Memory Stick: A memory card used by most Sony digital cameras and peripheral devices. About the size of a stick of chewing gum.

metadata: Extra data that gets stored along with the primary image data in an image file. Metadata often includes information such as aperture, shutter speed, and EV setting used to capture the picture, and can be viewed using special software. It can also include information you add in a photo-editing program, such as a copyright, your name, keywords, or a photo caption. Often referred to as *EXIF metadata*; EXIF stands for *Exchangeable Image File Format*.

metering mode: Refers to the way a camera's autoexposure mechanism reads the light in a scene. Common modes include spot metering, which bases exposure on light in the center of the frame only; center-weighted metering, which reads the entire scene but gives more emphasis to the subject in the center of the frame; and matrix, evaluative, pattern, or multizone metering, which calculates exposure based on the entire frame.

monopod: A telescoping, single-legged pole onto which you can mount a camera and lens in order to hold it more stably while shooting. It will not stand on its own, unlike a tripod.

MultiMediaCard: A type of memory card used by some digital cameras.

noise: Graininess in an image, caused by a very long exposure, a too-high ISO setting, or a defect in the electrical signal generated during the image-capture process.

NTSC: A video format used by televisions, DVD players, and VCRs in North America and some parts of Asia (such as Japan, Taiwan, South Korea, and the Philippines). Many digital cameras can send picture signals to a TV, DVD player, or VCR in this format.

optical zoom: A traditional zoom lens; has the effect of bringing the subject closer and shortening depth of field.

output resolution: The number of pixels per linear inch (ppi) in a printed photo; the user sets this value inside a photo-editing program.

PAL: The video format common in Europe, China, Australia, Brazil, and several other countries in Asia, South America, and Africa. Some digital cameras sold in North America can output pictures in this video format (*see also* NTSC).

PCMCIA Card: A type of removable memory card used in some digital cameras. Now often referred to simply as PC Cards. (PCMCIA stands for *Personal Computer Memory Card International Association.*)

PictBridge: A universal standard that allows digital cameras and photo printers to connect directly by USB cable, without the computer serving as a middleman. Any PictBridge camera can connect to any PictBridge printer, regardless of whether both are made by the same manufacturer.

pixel: Short for *picture element*. The basic building block of every digital image.

pixelation: A defect that occurs when an image has too few pixels for the size at which it is printed; pixels become so large that the image takes on a mosaic-like or stairstepped appearance.

platform: A fancy way of saying "type of computer operating system." Most folks work either on the Windows platform or the Macintosh platform.

plug-in: A small program or utility that runs within another, larger program. Many special-effects filters operate as plug-ins to major photo-editing programs such as Adobe Photoshop Elements.

ppi: Stands for *pixels per inch*. Used to state an image's output (print) resolution. Measured in terms of the number of pixels per linear inch. A higher ppi usually translates to better-looking printed images.

Raw: See Camera Raw.

Raw converter: A software utility that translates Camera Raw files into a standard image format such as JPEG or TIFF.

red-eye: Light from a flash being reflected from a subject's retina, causing the pupil to appear red in photographs. Can sometimes be prevented by using a red-eye reduction flash setting; can also be removed later in most image-editing programs.

resampling: Adding or deleting image pixels. Adding a large amount of pixels degrades images.

resolution: A term used to describe the number of pixels in a digital image. Also a specification describing the rendering capabilities of scanners, printers, and monitors; means different things depending on the device. (See Chapter 4 for details.)

RGB: The standard color model for digital images; all colors are created by mixing red, green, and blue light.

rule of thirds: A philosophy for composing images where various parts of your image are separated and flow among nine squares, aligned tic-tac-toe style. Normally you center elements of your subject onto cross-points of the vertical and horizontal lines.

SD Card: A type of memory card used in many digital cameras; stands for *Secure Digital*.

SDHC Card: A high-capacity form of the SD card; requires a camera and card reader that specifically supports the format.

sharpening: Applying an image-correction filter inside a photo editor to create the appearance of sharper focus.

shutter: The device in a camera that opens and shuts to allow light into the camera.

shutter-priority autoexposure: A semi-automatic exposure mode in which the photographer sets the shutter speed and the camera selects the appropriate aperture.

shutter speed: The length of time that the camera shutter remains open, thereby allowing light to enter the camera and expose the photograph. Typically measured in fractions of a second, as in 1/60 or 1/250 second.

slow-sync flash: A special flash setting that allows (or forces) a slower shutter speed than is typical for the normal flash setting. Results in a brighter background than normal flash.

SmartMedia: A thin, matchbook-size, removable memory card used in some older digital cameras.

TIFF: Pronounced *tiff,* as in a little quarrel. Stands for *tagged image file format*. A popular image format supported by most Macintosh and Windows programs. It is *lossless,* meaning that it retains image data in a way that maintains maximum image quality. Often used to save Raw files after processing and all pictures after editing.

tripod: Used to mount and to stabilize a camera, preventing camera shake that can blur an image; characterized by three telescoping legs.

TWAIN: Say it *twain*, as in "never the twain shall meet." A special software interface that enables image-editing programs to access images captured by digital cameras and scanners.

unsharp masking: The process of using the Unsharp Mask filter, found in many image-editing programs, to create the appearance of a more focused image. The same thing as *sharpening* an image, only more impressive-sounding.

uploading: The same as downloading; the process of transferring data between two computer devices.

USB: Stands for *Universal Serial Bus*. A type of port now included on all computers. Digital cameras come with a USB cable for connecting the camera to this port.

white balance: Adjusting the camera to compensate for the color temperature of the lighting. Ensures accurate rendition of colors in digital photographs.

xD-Picture Card: A type of memory card used in digital cameras.

Online Resource Guide

he Internet offers a wealth of information for the digital photographer, from tips on taking better pictures to reviews of the latest equipment and photo software. For quick reference, here's a summary of all the Web sites listed in this book, grouped by category.

Color management tools

www.colorvision.com

www.xrite.com

Equipment cases and protective gear

www.blackrapid.com

www.ggiinternational.com

www.jill-e.com

www.kata-bags.com

www.lowepro.com

www.made-products.com

www.pelican.com

www.tenba.com

Data storage products

www.creative.com

www.digitalfoci.com

www.westerndigital.com

Lighting products

www.clouddome.com

www.lastolite.com

www.lumiquest.com

Memory cards and card readers

www.lexar.com

www.sandisk.com

Miscellaneous accessories

www.hoodmanusa.com (camera LCD accessories)

www.lensbabies.com (SLR special-effects lenses)

www.smartparts.com (digital picture frames)

www.wacom.com (drawing tablets)

Photo sharing and printing products

www.epson.com

www.hp.com

www.kodakgallery.com

www.lulu.com

www.phanfare.com

www.photobucket.com

www.photoshop.com

www.picaboo.com

www.shutterfly.com

www.snapfish.com

www.zoomalbum.net

Photo software

www.acdsystems.com

www.adobe.com

www.apple.com

www.arcsoft.com

www.broderbund.com

www.cerious.com

www.corel.com

www.extensis.com

www.hdrsoft.com

www.lc-tech.com

www.mediarecover.com

www.nikmultimedia.com

www.novadevelopment.com

www.ononesoftware.com

www.photodex.com

www.picasa.com

Reviews, inspiration, tips, and techniques

www.canon.com

www.danburkholder.com

www.digimarc.com

www.dpreview.com

www.fujifilm.com

www.imaging-resource.com

www.kodak.com

www.megapixel.net

www.nikon.com

www.pcphotomag.com

www.photo.net

www.photographyreview.com

www.photojojo.com

www.photoworkshop.com

www.ppa.com

www.shutterbug.com

www.sony.com

www.takegreatpictures.com

Tripods and other stabilization products

www.alzodigital.com

www.joby.com

www.kaidan.com

www.manfrotto.com

www.thepod.ca

Index

• Numerics •

24-bit images, 301

• A •

accessories, resources on, 312 ACD Systems Web site, 290 ACDSee Photo Editor software, 48, 49 ACDSee Pro software, 50, 204-205 action shots. See also shutter speed: Sports scene mode burst mode, 26-27, 70, 73, 171, 301 composition, 172 features for, 26-28 focusing, 171 image review, 172 ISO setting, 171 lighting, 70, 171 shutter speed, 170 Active D-Lighting (Nikon), 122 A-DEP exposure setting (Canon), 116, 149 adjustment layers, 224 Adobe Lightroom software, 50 Adobe Photoshop Elements software adjustment layers, 224 bit depth adjustments, 85 black and white image options, 252–253 brightness/contrast controls, 218–220, 222, 223-224, 229 characteristics, 48, 207 color balance, correcting, 157-159, 227-228 color saturation, 161, 225-226 cropping images, 13, 93, 214–217, 303 date, locating images by, 62 Essentials plug-in, 52 JPEG compression, 270–273 levels filters, 220-223, 225

modes, available, 208 opening images, 209-210 organizer utility, 201-202 Photoshop compared, 208 print size, selecting, 246-248 Raw file conversion, 102, 199-200 Rotate command, 210 saving images, 210-212 screen-sized copy, creating, 264-267 shadows, adjusting image, 222, 223-225 stitching tools, 178 toolbox, 208, 209 versions, 208 Adobe Photoshop Express software, 48 Adobe Photoshop software, 49–50, 181. 207, 208, 230-231 Adobe RGB color model, 83-84, 85, 243, 308 Adobe Web site, 290 AF mode. See autofocus Al Servo, 28, 143-144, 171, 292, 303 airport scanners, effect on camera equipment, 39 albums, creating, 254-255 all-in-one printer/scanner devices, 236 ALZO Camera Flipper bracket, 56 angles, shooting from, 164, 165, 282 animals, images of, 166, 172, 214 anti-shake feature. See stabilization, image aperture, described, 106, 301 aperture settings. See also manual exposure automatic, 113-114 available, 106-107 depth of field, effect on, 108, 147-148 f-stop value and, 107 function, 105 indicators, 114 influences on, 65 scene modes, 65

aperture settings (continued) selecting, 113-114 side effects, 106-108 Aperture software, Apple, 50, 51 aperture value controls (A or Av), 20 aperture-priority autoexposure described, 20, 116, 301 uses, 66, 148, 167, 173, 176 using, 118–120 Apple Aperture software, 50, 51 Aquarium scene mode, 182 ArcSoft Panorama Maker software, 178 ArcSoft PhotoImpression software, 48 Art Explosion Scrapbook Factory Deluxe software, 42 artifacts, image, 97, 100, 301 aspect ratio, 247, 301 Aurora Borealis images, 175 Auto ISO, 113 auto rotate feature, 64 auto shut-off feature, 63, 292 autoexposure. See also aperture-priority autoexposure; shutter-priority autoexposure described, 301 lock function, 117, 179–180, 301 options, 114 shutter technique, 282-283 timing of exposure adjustment, 283 using, 117-118 variable programmed, 116 autoexposure (AE) lock, 117, 179-180, 301 autofocus area used for, 140 auto-servo, 144 camera technique, 73, 140-144 capabilities, 139 continuous-servo, 28, 143-144, 171, 292, 303 markers, 142 one-shot, 142-143 selecting, 65 shutter technique, 171, 282-283 systems, 141–142 troublesome subjects, 144–145

automatic exposure bracketing, 126–127, 175–176 auto-off function, 63, 292 auto-servo autofocus, 144

backgrounds, image, 166 backlighting, 129, 183, 301 Backlighting scene mode, 183 backpack-style camera bags, 45, 46 backups, 241, 299 bags, camera, 45–47, 295, 311 Bamboo Fun table, Wacom, 56 banding defect, 85 batteries, 30, 60, 63, 291–292 bit depth, 85, 101, 301 bits, defined, 85, 301 Black Rapid camera straps, 56 black-and-white images, 85. See also grayscale images blink detection, 25–26 blown highlights, 131, 132, 134 Bluetooth image transfer, 29, 30, 190, 244 blur, preventing, 138-139 blur effects, 172, 174 bracketing, exposure, 126-127, 175-176 bracketing, white balance, 21, 157 brackets, tripods/monopods, 56 brightness value, described, 80 brightness/contrast controls (Adobe Photoshop Elements software), 218-220, 222, 223-224, 229 bulb mode, 175 Burkholder, Dan, 181 burst mode, 26–27, 70, 73, 171, 301 byte order option (Adobe Photoshop Elements), 211 bytes, defined, 302

cables camera to flash, 22 camera to PC, 188–189, 197, 296, 309

for portable storage devices, 44 cathode-ray tube (CRT) monitors, 32 printer, 250 CCD (charge-coupled device) sensors, video, 274 78, 302 calibration, monitor, 200, 252 CD-ROMs, 40-42 Camera Armor camera cases, 47 center-weighted metering, 121, 122 camera manufacturer Web sites, 290 CGI International camera cases, 47 Camera Raw file format. See Raw file format channels, color, 80-82, 223 camera shake, 24. See also stabilization, charge-coupled device (CCD) sensors, 78, 302 camera cameras, digital children, images of, 166, 172 choosing, 33 CIE Lab color model, 86, 302 evolution, 1 circular polarizing filters, 184 fixed-focus, 140 cleaning, camera, 294–295, 298–299 lens focal length, 21 close-up images, capturing, 176-177 point-and-shoot, 12, 19, 21, 65 Close-up mode, 69, 144, 176 pricing, 35 Cloud Dome light cube, 135 protecting, 45-47, 295, 311 CMOS (complementary metal-oxide purchasing/returning, 33 semiconductor) sensors, 78, 302 resources on, 33, 313-314 CMS (color management systems), 252 setup, initial, 59–64 CMY color model, 83 SLR, 10-11, 19, 65 CMYK color model, 82, 83, 243, 251, 302 start-up speed, 26 coffee table books, 254-255 structure, 78, 79 cold, camera care in, 296-297 updating firmware, 60, 295–296 color upgrading, 30-31 balance correcting, 157–159, 227–228 cameras, film capturing, 79-80 color control, 151-152, 153 correcting, 302 film speed, 111 effects filters, 161–162 image creation, 73, 77, 151–152 matching print/on-screen, 156, 251-252 image editing, 207 out-of-gamut, 84 lens focal length, 21 saturation, 161, 225-226 Canon ImageBrowser software, 203 temperature, 152-153, 157, 302 Canon Web site, 290 color channels, 80-82, 223 Canon ZoomBrowser EX software, 203 color control. See also white balancing card readers. See also memory cards film cameras, 151–152, 153 computer connection, 189 light sources, 129, 152, 154 deleted file recovery, 201 Color Efex Pro plug-in software, 51–52 described, 188, 302 color emphasis, Landscape/Portrait mode, downloading from, 193-196, 293 67, 68, 161 memory card compatibility, 36 color management, 84, 252, 311 resources on, 312 color management systems (CMS), 252 for television display, 274 color models care, camera. See maintenance CIE Lab, 86, 302 cars, shooting from, 182-183 CMY, 83 cases, camera, 45-47, 295, 311 CMYK, 82, 83, 243, 251, 302 catchlight, 214, 302 described, 302

color models (continued) grayscale, 85-86 HSB, 86, 305 HSL, 86, 305 RGB, 83-84, 85, 243, 308 sRGB, 83, 84 color presets, 161 color spaces. See color models Color Variations (Adobe Photoshop Elements), 227 color-balancing filter, 227 CompactFlash memory cards, 36, 293, 302 complementary metal-oxide semiconductor (CMOS) sensors, 78, 302 compositing, defined, 302 composition, image action shots, 172 angles, 164, 165, 282 backgrounds, 166 children, 166 closeness, 164, 166 drawing the eye, 165 framing, 23, 71, 163–164, 169, 172 pets, 166 portraits, 169 posing subjects, 166 rule of thirds, 165, 282, 308 techniques, 282 compressed air, 295 compression, image file, 100, 302, 305. See also lossy compression computers. See also monitors, computer camera connections, 32, 188-189, 197-198 card reader connections, 189 hard-drives, 40 hardware requirements, 31-32, 300 image file sizes, 31 maintenance, 300 memory card slots, 193 operating system, 32 scratch disk space, 300 software, 32 continuous autofocus, 28, 143–144, 171, 292, 303 continuous capture, 26-27, 70, 73, 171, 301

continuous-servo autofocus, 28, 143-144, 171, 292, 303 contrast controlling, 218-220, 222, 223-224, 229 defined, 303 factors affecting, 101–102 copyright protection, image, 270 Corel Painter software, 52, 53 Corel PhotoImpact X3 software, 48 Costco photo printing services, 235 Creating Keepsakes Scrapbook Designer Deluxe software, Encore, 42 Creative Zen Vision W portable media player, 44, 45 crop factor, 21 cropping images, 13, 93, 214-217, 303 CRT (cathode-ray tube) monitors, 32

DAM (digital asset management). See storing images data storage. See storing images date/time setup, 61-62 deleted images, recovering, 201, 293 depth of field aperture setting effects, 108, 147–148 controlling, 119-120, 139, 147-152 described, 18, 146-147, 303 digital zoom and, 149 effects on, 18, 20, 65 extending, 68 focal length effects, 149–151 in Landscape mode, 68 lens types, effect of, 149 in Macro mode, 69, 176 in Portrait mode, 67, 148-149, 167 proximity to subject, 149 shutter speed effects, 147-148 destination folder for images, 192 diffusers, light, 128-129, 135, 168, 177 Digimarc security products, 270 digital asset management (DAM). See storing images Digital Foci Photo Safe II, 43

Digital Negative Format (DNG) file format, 103 digital painting software, 52 digital photo processing, retail. 234-235, 248 Digital Photography 101 Web site, 290 Digital Photography Review Web site, 288 digital print order format (DPOF), 244, 303 digital zoom, 19, 149, 283, 303 diopter adjustment controls, 61, 139, 303 display images image quality required, 257 image resolution, 93-95 monitor resolution, 260-264, 267 options, 258-260 sizing, 263-264, 268 DNG (Digital Negative Format) file format, 103 docking stations, camera, 189-190, 197 dots per inch (dpi), 96, 241, 303 downloading images. See also card readers; organizing image files camera/computer connection, 32, 188-189, 197-198 described, 303 docking stations, 189-190, 197 downloading service, 190 drag-and-drop, 192, 194 reader/memory card compatibility, 36 speed, 38, 190 transfer options, 192 transfer software, 190-192 while traveling, 43-45 wireless image transfer, 29, 30, 190, 244 dpi (dots per inch), 96, 241, 303 DPOF (digital print order format), 244, 303 Drive mode, 26–27, 70, 73, 171, 301 drivers, software, 250, 303 dSLR cameras, 10-11, 19, 65 DVD players, memory card slots on, 274 DVDs, 42, 275 dye-sublimation (dye-sub) printers, 240, 303 dynamic autofocus, 28, 143-144, 171, 292, 303 dynamic range, described, 180

· E ·

easy-orientation brackets for tripods/ monopods, 56 edges, described, 91, 230, 231, 303 editing, image. See also image-editing software adjustment layers, 224 artistic effects, 284 bit depth adjustments. 85 brightness/contrast controls, 218-220. 222, 223-224, 229 color balance, 157-159, 227-228 color saturation, 161, 225-226 color to gravscale, 252-254 cropping, 13, 93, 214-217, 303 film, 207 focus, 229-231, 308, 309 hardware, 56 in-camera, 28 at instant-print kiosks, 234 levels filters, 220-223, 225 midtones, adjusting, 221, 222 for on-screen use, 94, 95 options, 284 pixels, adding/removing, 280 shadows/highlights, adjusting, 222, 223-225 effects filters, color, 161-162 electronic image stabilization (EIS), 24 electronic viewfinders (EVF), 23, 304 e-mail, sharing photos via, 259 e-mail functions, in-camera, 28 **Encore Creating Keepsakes Scrapbook** Designer Deluxe, 42 Epson P-5000 drive/viewer combo, 43-44 Epson Stylus Photo RX680 multi-purpose printer, 236, 237 Essentials for Adobe Photoshop Elements plug-in, 52 EV (exposure) compensation. See exposure compensation evaluative metering, 121, 122 EVF (electronic viewfinders), 23, 304 exchangeable image format (EXIF), 203, 304, 306

DNG, 103

exposure	DPOF, 244, 303
described, 304	EXIF, 203, 304, 306
display, camera, 114–115	file size, 102
flash, 116	GIF, 268, 269, 271, 304
indicators, 114	JPEG 2000 format, 268, 305
metering, 117, 121–122, 126, 142, 306	Photoshop Raw, 212
nighttime images, 175	PNG, 268
overexposures, 122	recommendations, 103
Portrait mode, 67	selecting, 72, 95–97, 100
portraits, 167	filenames, image, 63–64, 100, 193, 200
scene modes, generally, 66, 116	file-recovery software, 201
sunrise/sunset images, 174	files, image. See also file formats;
underexposures, 122	online display
exposure bracketing, 126–127, 175–176	e-mailing, 95
exposure (EV) compensation	size, 95–96
benefits, 125–126	fill flash, 130, 169, 177, 304
described, 20, 124–126, 304	film cameras. See cameras, film
flash, 22	filters, 161–162, 184, 227, 295
metering mode, 126	fireworks images, capturing, 183–184
uses, 114, 118	Fireworks scene mode, 184
exposure guide, 63, 122–124, 220–221,	firmware, camera, 60, 295–296
304–305	fixed-focus cameras, 140
exposure modes. See also aperture-	flash
priority autoexposure; exposure	action shots, 70, 171
compensation; manual exposure;	battery use, 292
shutter-priority autoexposure	built-in, 22, 129–130
A-DEP, 116, 149	camera connections, 22
automatic, 66–70, 115–116	color effects, 158
availability, 106	exposure compensation, 22, 304
full auto, 66–68	exposure modes, 116
selecting, 115	external, 22–23, 132–133
semi-automatic, 114	fill, 130, 169, 177, 304
types, 20	in Landscape mode, 68
variable programmed autoexposure, 116	maintenance, 291
exposure value (EV). See exposure	manual control, 22
compensation	no flash setting, 130–131
Extensis Portfolio software, 204–205	portraits, use in, 168–169
external flash, 22–23, 132–133	power use, 23
Eye-Fi SD memory card, 30	recycle time, 23
Lyc 11 bb memory cara, oo	red-eye reduction, 131, 168, 192
- T -	slave units, 133
• F •	slow-sync, 131–132, 309
for a second the fortune OF OC	in Sports mode, 70
face recognition feature, 25–26	flash EV compensation, 22, 304
file formats. See also JPEG file format; Raw	flexible programmed autoexposure, 116
file format; TIFF	fluorescent lighting, 153, 154
described, 304	focal length, 18, 19, 21, 149–151
DNG, 103	10cai leligili, 10, 13, 21, 143-131

focus. See also autofocus: depth of field: manual focus action shots, 171 diagnosing problems, 138-139 editing, 229-231, 308, 309 fixed, 140 infinity mode, 144 landscape techniques, 173-174 macro techniques, 144 multi-spot, 141 point-and-shoot camera options, 65 setting, 65 shutter speed, influence on, 65 single-spot, 141 SLR camera options, 65 switching between manual and auto-focus, 140, 141 too-close, 138, 139, 140 focus-free cameras, 140 force flash, 130, 169, 177, 304 formatting memory cards. 38, 62, 96, 292-293 frames, digital photo, 260, 275-276 framing images, 23, 71, 163-164, 169, 172 f-stop, 107, 304. See also aperture. described Fujifilm Web site, 290 full-frame sensors, 21

• G •

galleries, online photo. See online display Gamma control, 221, 222 gamut, defined, 83, 304 GIF (Graphics Interchange Format) image format, 268, 269, 271, 304 gigabyte, defined, 95, 304 glass, shooting images through, 181, 182, 184 golden hours, 127, 175 Google Picasa software, 48 Gorillapod, Joby, 54 grain, film, 111 Graphics Interchange Format (GIF) image format, 268, 269, 271, 304 graphics tablets, 56 gray cards, 156–157

grayscale color model, 85–86 grayscale images, 82, 86, 242, 252–254, 304

hard drives, portable, 43-44 hardware-based image stabilization, 24 HDR (high-dynamic-range) imaging, 180 - 182HDRSoft Photomatrix software, 181 heat, camera care in, 296-297 help, in-camera, 25 High Point control, 222 high-bit images, 85, 181, 301 high-dynamic-range (HDR) imaging. 180 - 182Highlight Tone Priority (Canon), 122 highlights, adjusting image, 222, 223-225 histograms, exposure, 63, 122-124. 220-221, 304-305 Hoodman HoodLoupe LCD shade/ magnifier, 57 hot lights, 133 hot shoe, 22 HP Photosmart D7460 printer, 235 HSB color model, 86, 305 HSL color model, 86, 305 hybrid tripod/monopods, 55 hyperlinks, images as, 268

icons, book, 3–4
image maps, 268
image review, automatic, 63, 172
image sensors. See sensors, image
image size, 88, 91, 264–265
image stabilization. See stabilization, image
ImageBrowser software, Canon, 203
image-cataloging software, 51
image-editing hardware, 56
image-editing software. See also Adobe
Photoshop Elements software
advanced, 49–51
basic, 48–49
bundled with camera, 48

image-editing software (continued) color effects, 162 hardware requirements, 31-32 image organizing features, 205 improving images with, 283-284 poor performance, 210 saving file format, 100 selecting, 48 sources, 48 uses, 48 images. See also downloading images; storing images auto rotation, 64 capturing, shutter technique, 73-74, 282-283 capturing, timing, 127 creating screen-sized, 263-267 creation, digital cameras, 78, 79-80, 105-107 creation, film cameras, 73, 77, 151–152 filenames, 63-64, 100, 193, 200 organizing, 193, 201-205 protecting printed, 241 transferring to computer, 32, 188–189, 197-198 images, improving. See also composition, image compression, 281 digital zoom, disabling, 283 editing images, 283-284 manual, camera, 286 noise reduction, 184, 282 practice, 285 printing, 285 resolution, 280 shutter technique, 282-283 image-sharing features, 28, 29–30, 190, 244. See also printing images image-transfer software, 190-191 image-viewing software, 32 The Imaging Resource Web site, 288 infinity focusing mode, 144 ink cartridges, 237-238 inkjet printers, 236-238, 241-242, 285 instant review feature, 63, 172

instant-print kiosks, 234
interlaced image files, 271
iPhoto software, Macintosh, 190–191, 202
ISO (International Standards Organization)
setting
action shots, 171
automatic, 113
described, 16, 305
effects, 16, 24, 111–113, 282
function, 105
indicators, 114
manual, 111, 113
scene modes, 111
selecting, 72, 111, 113–114
sensor sensitivity, 110–111

jaggies, 91, 305 Jill-e camera bags, 46 Joby Gorillapod, 54 JPEG (Joint Photographic Experts Group) file format. See also lossy compression advantages, 281 characteristics, 97-100 converting to, 212 described, 305 effects, 16, 17 EXIF variant, 203, 304, 306 file size, 72, 97 nonprogressive, 271 for online display, 268, 269 progressive, 271, 272-273 Raw+JPEG file option, 103 saving files as, 281 saving Raw files as, 200 JPEG 2000 file format, 268, 305

Kaidan tripods, 180 Kata camera cases, 47 Kelvin scale, 152, 157–158, 305 Key plate, 83 kids, images of, 166, 172 kilobyte, defined, 305 Kingston card reader, 193–194 kiosks, instant-print, 234 Kodak Web site, 290 Konica Minolta laser printer, 239

. [.

labs, photo, 234-235, 248 landscape focusing mode, 144 landscape images, 173–176. See also Landscape scene mode Landscape scene mode aperture setting in, 65 color emphasis, 68, 161 depth of field, 68, 149 described, 144 flash, 68 uses, 67-68, 173 large files, tools for, 269 laser printers, 238–239 Lastolite light tent, 135 layer compression option (Adobe Photoshop Elements), 211 LCD (liquid crystal display) camera monitors. See monitors, LCD camera LCD (liquid crystal display) computer monitors, 32 Lensbaby, 55 lenses characteristics, 17–19 cleaning, 294-295 focal length, 18, 19, 21, 149-151 Lensbaby, 55 optical zoom, 19, 307 for portraits, 167 quality, 17-18 telephoto, 18, 149 wide-angle, 18, 149, 167 zoom, 18-19, 149 levels, tripod, 179 Levels filter (Adobe Photoshop elements), 220–223, 225 light cubes, 135, 184

light tents, 135, 184 lighting. See also flash action shots, 70, 171 from behind subject, 129, 183, 301 blown highlights, avoiding, 131, 132, 134 close-up images, 177 color casts, 152 color control, 129, 152, 154 diffusing, 128-129, 135, 168, 177 external, additional, 133-134 fluorescent, 153, 154 hot, 133 manipulating, 127, 128-129 portraits, 168-169 reflective objects, 131, 134-135 resources on, 311 timing, 127 tips, 128-129 line art, 85-86 liquid crystal display (LCD) camera monitors. See monitors, LCD camera liquid crystal display (LCD) computer monitors, 32 Live View feature, 11 lossless compression, 305 lossy compression controlling, 270–273 described, 17, 281, 305, 306 results of, 97-100 timing, 212 Low Point control, 221, 222 LowePro camera bags, 45, 46 LumiQuest diffusers, 129 LZW compression option (Adobe Photoshop Elements), 211

· M ·

Mac Leopard "Quick Look" image viewing, 32 Macintosh iPhoto software, 190–191, 202 macro focusing mode, 144 Macro scene mode, 69, 144, 176 macro shots, 176–177 Made Products camera cases, 47

magic hours, 127, 175	printer compatibility, 244
maintenance	reader compatibility, 36
batteries, 291–292	resources on, 312
computer, 300	selecting, 37–38
firmware updates, 60, 295–296	shooting without, 63
flash, 291	speed, 28, 37–38
image backups, 299	starter, 36
image sensor, 298–299	storage, 39
lens/LCD, 294–295	types, 36, 38, 78, 308, 309
memory cards, 38–39, 292–294	wireless, 30
printers, 251	Memory Sticks, 36, 306
temperature extremes, 296–297	metadata, image, 62, 115, 203, 285, 306
water, 297–298	metering modes, exposure, 117, 121–122,
Manfrotto tripods, 180	126, 142, 306
manual exposure	Midpoint control, 221, 222
availability, 106, 114	midtones, adjusting image, 221, 222
bulb mode, 175	MiniSD memory cards, 36
color adjustments, 161	mired measure, 156
described, 20, 27, 116, 306	monitors, computer
uses, 66, 110, 170, 179	brightness adjustment, 63
manual focus	color calibration, 200, 252
described, 306	color space, 156
selecting, 65, 140, 141	hardware requirements, 32
techniques, 145	resolution, 260–264, 267
uses, 144, 171, 179	types, 32
manual white balance, 21, 153, 155	monitors, LCD camera
manuals, camera, 286	battery conservation, 292
matrix metering, 121, 122	cleaning, 294–295
MediaRECOVER software, 201	color space, 156
megabyte, defined, 306	described, 305
Megapixel.net, 288	exposure settings display, 114–115
megapixels, 12, 91, 306. See also resolution,	features, 28, 29
camera	markers, 142
memory cards	shading devices, 57
camera setup, 60	monochrome images, 82, 86, 242,
capacity, 36, 37	252–254, 304
computer slots for, 193	monopods, 54–55, 56, 306
deleting images from, 293	motion, shooting while in, 182–183
downloading images from, 193-196, 293	multimedia presentations, 260
DVD players, slots on, 274	MultiMediaCard, 306
formatting, 38, 62, 96, 292–293	multi-purpose printers, 236
image file location, 194	multi-spot focus, 141
maintenance, 38–39, 292–294	multizone metering, 121, 122
prices, 36	Museum scene mode, 63, 169, 182

· N ·

nighttime flash, 131–132, 309 nighttime images, exposure settings, 175 Nighttime Portrait scene mode, 111, 168 nik Color Efex Pro plug-in software, 51–52

Nikon Web site, 290 No Flash scene mode, 63, 169, 182 no flash setting, 130–131 noise, camera, 63 noise, image, 16, 111–113, 184, 282, 306 nonprogressive JPEG images, 271 normal focal length lenses, 18 Northern Lights images, 175 NTSC video format, 275, 307

. () .

one-hour printing, 234 one-shot autofocus, 142-143 one-shot shutter-release mode, 73 online display file formats, 268 image file size, 95, 266, 267-268, 269 image security, 270 options, 258-259 pixels for, 14–15 recommendations, 267–270 sharing photos, 258–260 software, 258-259 Online File Folder, GoDaddy, 269 online image storage, 260 online print ordering, 234–235 online resources, 287–290, 311–314 operating system, computer, 307 optical image stabilization, 24 optical viewfinders, 23 optical zoom lenses, 19, 307 Optimize Image feature (Nikon), 161 organizing image files, 193, 201-205 out-of-gamut colors, 84 Output Levels, adjusting image, 222

output resolution, 88–91, 246–247, 266–267, 280, 307 overcoat, printed, 242 overexposures, correcting, 122

Paint Shop Pro Photo X2 software, 50 Painter software, Corel, 52, 53 PAL video format, 275, 307 Panorama Maker software, ArcSoft, 178 panoramic images, 177–180 paper, photo, 245, 250, 254, 285 parallax errors, 23, 71 pattern metering, 121, 122 PC Cards, 307 PCMCIA Card, defined, 307 PCPhoto magazine, 288 Pelican Product camera cases, 46 pets, images of, 166, 172, 214 photo galleries, online. See online display Photo Safe II, Digital Foci, 43 photo sharing resources, 312. See also online display Photo X2 software, Paint Shop Pro, 50 photobooks, 254-255 photocentric printers, 236 Photodex Corporation slide-show software, 51 Photodex ProShow Gold software, 260, 261 Photography Review Web site, 289 PhotoImpact X3 software, Corel, 48 PhotoImpression software, ArcSoft, 48 PhotoJoJo Web site, 289 Photomatrix software, HDRSoft, 181 Photo.net, 289 photos. See images photo-sharing Web sites, 235 Photoshop Elements software, Adobe. See Adobe Photoshop Elements software Photoshop Express software, Adobe, 48 Photoshop Raw file format, 212 Photoshop software, Adobe, 49–50, 181, 207, 208, 230-231

PhotoWorkshop Web site, 290 Picasa software, Google, 48 PictBridge, 28, 244, 307 picture elements (pixels). See pixels picture quality. See file formats; ISO setting; resolution, camera Picture Styles feature (Canon), 161 pictures. See images pixelation, 91, 307 pixels (picture elements). See also resolution, camera adding to existing image, 92 described, 12, 307 dimensions, 88, 91, 264–265 effect of quantity, 13, 15, 93 in images, 86-88 print quality and, 88–93 pixels per inch (ppi), 13, 280, 307 platform, computer, 307 plug-ins, software, 51-52, 307 PMPs (portable media players), 44–45 PNG file format, 268 The Pod. 54 point-and-shoot cameras, 12, 19, 21, 65. See also cameras, digital polarizing filters, 184 portable hard drives, 43-44 portable media players (PMPs), 44–45 Portfolio software, Extensis, 204–205 Portrait scene mode. See also Nighttime Portrait scene mode aperture setting in, 65 color emphasis, 67, 161 depth of field, 67, 148–149, 167 exposure settings, 67 ISO setting, 111 uses, 67, 167, 174 portraits, 166, 167, 168–169. See also Portrait scene mode posterization defect, 85 ppi (pixels per inch), 13, 280, 307 practice, photography, 285 presentations, multimedia, 260 preserving printed images, 241 print functions, in-camera, 28, 244

print size, 88, 245, 246-248, 250

printed images, protecting, 241 printers, photo advantages, 235-236 cables, 250 costs, 244 dye-sub, 240, 303 getting best results, 250-251 for grayscale images, 253-254 inkjet, 236–238, 241–242, 285 laser, 238–239 maintenance, 251 memory cards, compatible, 244 multi-purpose, 236 photocentric, 236 resolution, image, 96 resources for choosing, 244 shopping tips, 240–242, 244 software, 250 speed, 242 printing images as backup, 42 CMYK color model, 251 CMYK/RGB color model, 243 color matching, 251–252 color space, 156 grayscale, 253–254 in-camera features, 28, 244 lab, 234-235, 248 paper for, 245, 250, 254, 285 PictBridge, 28, 244, 307 pixels for, 13, 14 process, 248-250 recommendations, 250–251 resolution, 88-93, 245-248, 250, 280 resources on, 312 Printroom.com photo gallery service, 270 progressive JPEG images, 271, 272-273 ProShow Gold software, Photodex, 260, 261 protective gear, camera, 311. See also bags, camera

RAM (random-access memory) requirement, computer, 300

Raw converters, 100, 101–102, 198–200, 308 Raw file format advantages, 100-101 characteristics, 100 color control, 159-160 converting images, 198–200 creating, 212 described, 302 device compatibility, 44 disadvantages, 101-102, 281 downloading images, 196, 198 effects, 16-17 file names, 200 in-camera converters, 28, 103 manufacturer-specific names, 100 metadata, 203 software conversion, 160 standardization, 103 unavailability, 116 viewing, software for, 198 viewing images, 101–102, 202 Raw+Basic file option, 103 Raw+JPEG file option, 103 rechargable batteries, 30 recovering deleted images, 201, 293 red-eye, 131, 168, 192, 212-214, 308 reflective objects, images of, 131, 134-135, 184 reflectors, photographic, 127 registration, product, 60 Release mode, 26–27, 70, 73, 171, 301 remote-control shutter-release mode, 73, 146 resampling, 246, 248, 264-265, 280, 308 RescuePRO software, 201 resolution, camera, 12-15, 71-72, 92-94, 308 resolution, computer monitor, 260–264, 267 resolution, image. See also pixels compression, 100 described, 308 for display images, 93–95 file size and, 95–96 images, improving, 280 measuring, 88

output, 88–91, 246–247, 266–267, 280, 307 pixel count, 91 pixel size, 91 printing, 88–93, 245–248, 250, 280 prints, required for, 91 setting, 93 resolution, printer, 96 retouching images. See editing, image review, instant image, 63, 172 RGB color model, 83–84, 85, 243, 308 RGB images, capturing, 79–80 R-Strap camera straps, 56 rule of thirds, 165, 282, 308

Save Image Pyramid option (Adobe Photoshop Elements), 211 Save Transparency option (Adobe Photoshop Elements), 211 scanners/printers, all-in-one, 236 scanning devices, effect on camera equipment, 39 scene modes. See also Landscape scene mode; Portrait scene mode; Sports scene mode Aquarium, 182 Backlighting, 183 color emphasis, 161 described, 23-24 exposure modes, 116 Fireworks, 184 Macro, 69, 144, 176 Museum, 63, 169, 182 Nighttime Portrait scene mode, 111, 168 scenery images, 173-176. See also Landscape scene mode Scrapbook Factory Deluxe software, Art Explosion, 42 scrapbooking software, 42, 53 scratch disk, Adobe Photoshop Elements, 210 scratch disk space, computer, 300 screen savers, 260

SD (Secure Digital) memory cards, 36, 38, 308	uses, 170
SDHC (Secure Digital High Capacity)	using, 118–120
memory cards, 36, 308	shutter-release modes, 73
	single mode shutter-release mode, 73
self-timer shutter-release mode, 73, 146	single-lens reflex (SLR) cameras, 10–11, 19,
semi-automatic exposure mode, 114	65. See also cameras, digital
sensors, image	single-servo autofocus, 142–143
cleaning, 298–299	single-spot focus, 141
crop factor, 21	slave flash units, 133
described, 305	slide show software, 51, 260, 261
full-frame, 21	slide shows, 260
ISO setting effect, 110–111	slow-sync flash, 131–132, 309
maintenance, 298–299	SLR (single-lens reflex) cameras, 10–11,
noise caused by, 16	19, 65. See also cameras, digital
size, effect on quantity, 15	SmartMedia memory card, 309
types, 78, 302	Smartparts digital photo frames, 275–276
shadows, adjusting image, 221, 222	smile detection, 25–26
shadows, in images, 128	software. See also image-editing software
Shadows/Highlights filter (Adobe	color-management, 84, 252
Photoshop Elements), 222, 223–225	computer operating system, 32
sharpening filter, 229–231, 308, 309	digital painting, 52
shiny objects, lighting, 131, 134–135	drivers, 250, 303
Shooting mode, 26–27, 70, 73, 171, 301	file-recovery, 201
shut-off, auto, 63, 292	high-dynamic-range, 181
shutter, described, 106, 308	image-cataloging, 51
shutter button technique, 73–74, 174,	image-organizing, 201–205
282–283	image-transfer, 190–192
shutter speed. See also stabilization,	image-viewing, 32
camera	metadata viewer, 203
action shots, 65, 170	online display tools, 258–259
available, 108–109	plug-ins, 51–52, 307
depth of field, effect on, 147–148	Raw file viewing, 198
described, 108–109, 308	resources on, 312–313
effects, 282	scrapbooking, 42, 53
focus, influence on, 65	slide-show, 51, 260, 261
function, 105	stitching, 177–179
indicators, 114	storing images, 204
manual, 110	wizards, 48
outdoors, 176	software-based image stabilization, 24
selecting, 113–114	Sony Memory Sticks, 36, 306
side effects, 109–110	Sony Web site, 290
slow, controlling movement during, 65	sound effects, camera, 63
Shutterbug Web site, 289	Sports scene mode
shutter-priority autoexposure	advantages/limitations, 138
color adjustments, 161	described, 27
described, 20, 27, 116, 308	flash in, 70

ISO setting, 111 settings, 69-70 shutter speed, 65, 170 uses, 67, 69, 182-183 spot metering, 121, 122, 142 sRGB color model, 83, 84 stabilization, camera alternate types, 54 importance, 53, 119 monopods, 54-55, 56, 306 resources on, 314 techniques, 146, 174 tripods, 53-56, 110, 179-180, 309, 314 stabilization, image choosing, 25 described, 24 enabling/disabling, 65, 292 hybrids, 55 limitations, 25 types, 24 uses, 110, 146 stitching images together, 177–178 stitching tools, 177–179 storing images backups, 40, 41, 42 on CDs, 40–42 challenges, 39 on computer hard drive, 40 on DVDs, 42, 275 online, 260 resources on, 311 software, 204 space required, 31 straps, camera, 56, 60 sunrise/sunset images, exposure settings, 174

• T •

tablets, graphics, 56 Tagged Image File Format (TIFF). See TIFF telephoto lenses, 18, 149 television, viewing photos on, 260, 273–275 temperature, color, 152–153, 157, 302 temperature extremes, camera care in, 296–297
thermal dye printers, 240, 303
ThumbsPlus software, 204–205
TIFF (Tagged Image File Format)
advantages, 100, 104, 281
described, 309
disadvantages, 104, 268
replacement by Camera Raw format, 96
saving images as, 211–212
time value controls (S or Tv), 20
time/date setup, 61–62
tripods, 53–56, 110, 179–180, 309, 314
TWAIN software interface, 309
24-bit images, 301

• U •

ultraviolet (UV)/haze filters, 295
underexposures, correcting, 122
underwater photography, 298
Universal Serial Bus (USB) connectivity,
32, 188–190, 197, 309
Unsharp Mask feature (Adobe Photoshop
software), 230–231
unsharp masking, 229–231, 308, 309
updates, camera firmware, 60, 295–296
uploading, defined, 309
upsampling, 92
USB (Universal Serial Bus) connectivity,
32, 188–190, 197, 309
UV (ultraviolet)/haze filters, 295

variable programmed autoexposure, 116
Variations filter (Adobe Photoshop
Elements), 227
vertically oriented images, auto
rotation, 64
vibration compensation/reduction. See
stabilization, image
video capture, 28
video format, 275, 307

video-out features, 29 viewfinders adjusting, 61, 139 cleaning, 139 exposure settings display, 114–115 markers, 142 traditional, lack of, 23 types, 23, 304 volume, sound, 63

Wacom Bamboo Fun tablet, 56
wallpaper, desktop, 262
water, camera exposure to, 297–298
water images, 174. See also underwater
photography
watermarking, digital, 270
Web sites, sharing photos on. See online
display
white balancing
automatic, 20–21, 153, 154
bracketing, 21, 157
color effects, 157–159, 227–228

custom via gray card, 156–157
described, 20, 153, 309
manual, 21, 153, 155
in mixed lighting, 154
portraits, 169
presets, 21
shift options, 21, 154, 156
white-balance correction, 21, 154, 156
wide-angle lenses, 18, 149, 167
Windows image transfer tool, 190–191
Windows Vista Explorer image viewing, 32
wireless image transfer, 29, 30, 190, 244
wizards, software, 48
Wrap-Up camera case, 47

· / ·

xD-Picture memory cards, 36, 309

• Z •

zoom lenses, 18–19, 149 ZoomAlbum, 255 ZoomBrowser EX software, Canon, 203

0-470-04529-9

0-7645-8958-X

0-7645-7208-3

0-470-04894-8